Lee Broughton is a freelance writer, crit
in film and cultural studies. He is the c_____ __ _____ _____ __
the Western: From A Fistful of Dollars to Django Unchained (2016) and
Reframing Cult Westerns: From The Magnificent Seven to The Hateful
Eight (2020). He has contributed chapters and articles to numerous edited
collections and academic journals.

'Within this book Lee Broughton considers the diverse meanings Westerns have obtained through contact with various historical, cultural and political contexts – avoiding a merely US-centric framework – and in doing so contributes to the much-needed discourse that places the genre within global networks of cultural blending. What provocatively and intriguingly emerges is that, where progressive representations of ethnicity and gender in Westerns were concerned, the Europeans got there first.'

Austin Fisher, Senior Lecturer in Film and Television Studies at Bournemouth University, UK, and author of *Radical Frontiers in the Spaghetti Western: Politics, Violence and Popular Italian Cinema* (I.B.Tauris, 2014)

'Sergio Leone once observed that "the Western belongs to everyone", not just to Hollywood. Broughton's bold, perceptive and well-informed study looks closely at West German "Winnetou" films, middle-period Italian Westerns and British Westerns between 1939 and the early 1970s, to discover strong counter-cultural representations of Native Americans, African Americans and women. Broughton also explores the reasons why. The analysis of *A Town Called Bastard* and *Hannie Caulder* in particular is a tour de force.'

Sir Christopher Frayling, Professor Emeritus of Cultural History, Royal College of Art

'Broughton's uniquely comparative study traces the legacies of national traumas in European Westerns of the 1960s and '70s. He locates a counter-politics to contemporaneous Hollywood productions in allegories of race and gender on screen, and in doing so expands the critical conversation about regional revisionism in an important and fascinating genre.'

Joanna Hearne, Associate Professor of English and Film Studies, University of Missouri, USA, and author of *Native Recognition: Indigenous Cinema and the Western* (2012)

THE EURO-WESTERN

REFRAMING GENDER, RACE AND THE 'OTHER' IN FILM

Lee Broughton

BLOOMSBURY ACADEMIC

LONDON • NEW YORK • OXFORD • NEW DELHI • SYDNEY

BLOOMSBURY ACADEMIC
Bloomsbury Publishing Plc
50 Bedford Square, London, WC1B 3DP, UK
1385 Broadway, New York, NY 10018, USA

BLOOMSBURY, BLOOMSBURY ACADEMIC and the Diana logo
are trademarks of Bloomsbury Publishing Plc

First published in Great Britain by I.B. Tauris 2016
Paperback edition published by Bloomsbury Academic 2021

ISBN: HB: 978-1-7845-3389-2
PB: 978-1-3502-1792-8
ePDF: 978-0-8577-2738-1
eBook: 978-0-8577-2942-2

Series: Cinema and Society

Typeset by Out of House

To find out more about our authors and books visit
www.bloomsbury.com and sign up for our newsletters.

Contents

Contents

Acknowledgements

I would like to thank to the trustees of the Frank Parkinson Scholarship (whose kind funding made the research that this book is based on possible), Jeffrey Richards and Anna Coatman at I.B. Tauris for editorial duties, Kate Reeves for expert copy-editing and John Power for initial proofreading assistance.

Thanks also go to Vassilis Barounis, Tom Betts, Jonathan Bingley, Marco Brunello, Ulrich Bruckner, Edward Buscombe, Derringdo, Glenn Erickson, Austin Fisher, Christopher Frayling, Riek Gladys, Thomas Klein, Rick Knight, Andy Kosanovic, Ally Lamaj, the Leverhulme Trust, Mario Marsili, Cindy Miller, Lucia Nagib, Lance Pettitt, James Rose, Bill Shaffer, Richard Smith and Neil Washbourne.

With the kind support of the Leverhulme Trust I have recently organised and hosted two major Westerns-themed events - *Current Thinking on the Western* (workshop, June 2014) and *Current Thinking on the Western II* (symposium, March 2015) – and two research seminar series – *Film and History: the Western* (2013/14) and *Revisiting Cult Westerns* (2014/15). I would like to thank all of the speakers and attendees of these events for their illuminating papers and riveting Westerns-related discussions.

Finally, special thanks to my family for the love, support and encouragement that they provided while the doctoral research that this book is based on was being undertaken and written up.

Parts of Chapter III have previously appeared as 'Upsetting the Genre's Gender Stereotypes: *Ramsbottom Rides Again* (1956) and the British Out West' in *International Westerns: Re-Locating the Frontier,* ed. by Cynthia J. Miller & A. Bowdoin Van Riper. Lanham: Scarecrow Press, 2014, pp.

121-141. Parts of Chapter II will appear as 'Emancipation *all'Italiana*: Giuseppe Colizzi and the Representation of African Americans in Italian Westerns' in *Spaghetti Westerns at the Crossroads,* ed. by Austin Fisher. Edinburgh: Edinburgh University Press, forthcoming in 2016.

General Editor's Introduction

From its earliest days the Hollywood Western has been synonymous with American cinema, seen as a potent means of articulating and defining national identity and national values. The cowboy has been regarded world-wide as an enduring symbol of American masculinity. But from the 1960s onwards a new phenomenon appeared in cinemas – the Euro-Western. These films were widely disparaged as inauthentic, failed imitations of their Hollywood counterparts. But in this thoughtful revisionist analysis, Lee Broughton persuasively argues for the value of Euro-Westerns as providers of a positive alternative vision to the often conservative images of Indians, African Americans and women in the Hollywood Western. He examines the heroic image of Indians in German Westerns, tracing it initially to the popularity of the novels of Karl May and his imitators and to the Romantic celebrations of landscape in the work of painters like Caspar David Friedrich and in the Mountain films of the 1920s and 1930s. But he also sees German Westerns responding to contemporary German anxieties: concern about the effects of American cultural imperialism, relations with racial 'Others' in the form of foreign migrant workers and a desire to exorcise the memories of the Nazi past. He looks at the image of African Americans, both male and female, in Italian Westerns, seeing them as more assertive and independent than their Hollywood analogues. He attributes their appearance in part to racial tensions in Italian society, both in attitudes to darker-skinned Southerners who became an under-class when they migrated to the North and in the cultural legacy of Italy's colonial involvement in Africa. Finally, he analyses the image of strong and spirited females in British Westerns. He discerns the roots of the image in the distinctive British music hall and Gothic fiction traditions. But he relates its appearance to a crisis of masculinity and authority resulting from Britain's imperial and international decline. Throughout the book he maintains a comparative perspective, continually contrasting the Hollywood

ix

images of Indians, African Americans and women with those of the Euro-Western. He backs up his broader survey with individual close readings of key cinematic texts such as *The Treasure of Silver Lake, Winnetou the Warrior, Lola Colt, Boot Hill, Hannie Caulder* and *A Town Called Bastard.* The whole adds up to a positive and eye-opening re-evaluation of a previously despised genre.

<div align="right">Jeffrey Richards</div>

Introduction

The Western is a film genre that is inextricably linked to the United States of America. As Jim Kitses observes, the Western 'is American history ... American frontier life provides the milieu and *mores* [Kitses' emphasis] of the western' (1969: 8). It is no surprise then that Susan Hayward has noted that the Western is routinely 'considered [to be] an exclusively American genre' (2000: 463). As a result of this outlook, serious studies of the genre have continually sought to employ theoretical methodologies and historical schema that link ongoing developments observed in the Western's form and content to just two overriding factors: technical and stylistic innovations initiated periodically within Hollywood and sociocultural/political changes experienced within American society itself. In choosing to tease out the correlations that might exist between Western films and American society, these studies tend to exclude critical examinations of Westerns that were produced outside the USA, even if those films did play on American cinema circuits. This has resulted in the establishment of a received evolutionary model for the genre that features American Westerns only.

Hollywood's close cultural and historical links to the Western are undeniable but, as Kitses notes, this does not mean that Italians cannot make Westerns (1969: 8). Since Hollywood has a global reach and the Western was its most recognizable genre for much of the twentieth century,

the fact that most European countries have made their own Westerns at some point in the history of their national cinemas should come as no surprise (Broughton, 2014: 103). However, the Westerns produced by the national cinemas of Italy, West Germany and Great Britain hold a special significance. During the 1960s and early 1970s these three countries produced Westerns in such numbers that, between them, they often exceeded Hollywood's own yearly Western production count. Furthermore, it is possible to chart the flow of peaks of interest in producing Westerns from country to country in a chronological manner: Great Britain (late 1950s), West Germany (early 1960s), Italy (mid- and late 1960s) and Great Britain again (early 1970s). Perhaps the most important aspect of the Westerns produced by these three countries is the fact that significant numbers of them were successfully exported to the USA for exhibition. Mary Louise Pratt's (1992) work in the field of transculturation theory argues that cultural influence can be a two-way process, flowing back and forth across the national borders that separate the metropolis and its peripheries. As such, Pratt's work would support the possibility that European-made Westerns hold the potential to influence American-made Westerns. And yet any significance that the Westerns produced by West Germany, Italy and Great Britain might hold in terms of the organic evolution of the Western genre has continually been overlooked.

By embracing Lucia Nagib's call for world cinema to be understood as a 'global process' that 'has no centre' (2006: 35), this book seeks to break new ground by bringing an international dimension to our understanding of the Western's ongoing development. Hence I focus critical attention upon key and – in most cases – previously overlooked Westerns that were produced by the three European national cinemas noted above. Critics have long alluded to an often vague sense of 'difference' – usually perceived in a negative way – that distinguishes European Westerns from 'regular' American Westerns. The early stages of my research for this book sought to determine whether European Westerns really do possess a tangible and consistent sense of difference and the results were illuminating. After critically viewing countless European Westerns, one overriding sense of difference did become apparent. The Western is a genre that is readily associated with stories and symbolism that work to support the values of white patriarchal society. Indeed, Edward Buscombe and Roberta E. Pearson

observe that 'the conventional view is that the Western is sexist and racist, that it purveys a white male, indeed a middle-aged white Anglo-Saxon Protestant male view of the world' (1998: 3). By contrast, the European Westerns included in my study offer consistently positive and progressive representations of racial and gendered 'Others'.

Having noted that a significant number of West German, Italian and British Westerns include notable representations of Native Americans, African Americans and strong women respectively, this book seeks to determine precisely why these national cinemas' engagements with the Western genre should result in such distinctive representations of each respective 'Other'. Close textual analysis of key European Westerns subsequently reveals the presence of elements that are determinedly local and/or nationally specific in nature. I thus seek to investigate how the social-cultural-political histories of each country – and the idiosyncrasies associated with their respective national film industries – might have influenced the Westerns that they produced. I do not make the claim that these European Westerns influenced American Westerns. But in comparing key European Westerns to American Westerns that were also noted for their representations of the 'Other', I argue that the European Westerns' progressive representations of Native Americans, African Americans and strong women prefigured the appearance of similarly progressive representations in American Westerns.

The precise nature of the overarching problem that I tackle here can be illustrated with a brief example. By writing a book titled *Blacks in Films: A Survey of Racial Themes and Images in the American Film*, Jim Pines is able to comfortably declare that 'as for the black woman in the west, Lena Horne's portrayal of Claire Quintana … in [Alan Smithee's] *Death of a Gunfighter* (1969), is the outstanding example' (1975: 95). Claire Quintana was in fact the only major black female character to appear in a mainstream Hollywood Western during the 1960s but by limiting his frame of reference to Hollywood, Pines overlooks the groundbreaking black female characters – Lola (Lola Falana) in Siro Marcellini's *Lola Colt* (1967) and Pauline (Vonetta McGee) in Sergio Corbucci's *The Great Silence* (*Il grande silenzio*, 1968) – whose appearances in Italian Westerns actually prefigured the appearance of Horne's Claire. When the representational strategies employed to construct the character of Claire are reassessed

by comparing them to those employed in the construction of Lola and Pauline, a change of perception is immediately effected. Looked at from Pines' US-centric perspective, Claire Quintana is indeed an exceptional and welcome representation of a black female in a Western by virtue of her uniqueness if nothing else. But when an international optic is adopted and Lola and Pauline are taken into account, Claire becomes a rather stereo-typical and noticeably constrained character. As such, my findings prob-lematize the received – US-centric and long-unchallenged – evolutionary model that has served to chart developments in the way that the Western has represented the 'Other'.

Discussing the Western: the critical landscape

Binary oppositions have always been a fundamental element of the Western genre. In examining American attitudes to the experience of Westward expansion, both historical and fictional, Henry Nash Smith encounters two diametrically opposed viewpoints. In its early stages the West was perceived to be a 'garden': a virginal land which would become a natural home to a growing community of idealized farmers whose agrarian work and lifestyle would provide them with a rewarding existence (1950: 138). By contrast, when westward expansion finally reached the Great Plains, the West was perceived to be a 'desert': a wild place of drought, dust and wind where only the uncivilized might feel at home (1950: 202). Kitses subsequently finds a whole catalogue of antinomies at play within the Western: the individ-ual/community, freedom/restriction, purity/corruption, the West/the East, savagery/humanity, agrarianism/industrialism, America/Europe and so on (1969: 11). Interestingly, the binary opposition of America/Europe would take on a new significance during the 1960s when European Westerns began being pejoratively deemed the 'Other' in relation to the American Western. I will argue here that European Westerns in turn embraced the 'Other' and subsequently represented him/her in progressive ways.

In his structural study titled *Sixguns and Society*, Will Wright focuses only upon those Westerns made between 1930 and 1972 that grossed ticket sales in excess of $4,000,000 in the USA and Canada during the year of their initial release (1975: 29). As such, three of Sergio Leone's Italian Westerns are name-checked by Wright but the films attract no

further relevant discussion beyond the observation that they 'were just fill-in Italian Westerns until they caught on' (1975: 14). Wright detects a development in the Western's form and content that can be broken down into four recurring plots that appeared consecutively between 1930 and 1972: the classical plot, the transition theme, the vengeance variation and the professional plot. Wright subsequently concludes that the structures of these plots, and thus the Western's evolutionary model itself, ultimately reflect the effects that 'the change from a competitive, market society to a planned corporate economy' had on US society and the social experiences of American cinemagoers (1975: 131).

In *Westerns: Aspects of a Movie Genre*, Philip French is forthright regarding his exclusion of European Westerns, asserting 'I cannot abide European Westerns, whether German, Italian or British' (1973: 9). French's thesis, which focuses on the post World War II period, suggests that the style and content of key American Westerns that figure in the genre's ongoing evolution is reflective of the backgrounds, personalities and ideological outlooks of notable American political figures: John F. Kennedy, Barry Goldwater, Lyndon Johnson and William Buckley respectively (1973: 15). Again, the political, historical and cultural forces that are credited with shaping the Western in French's work are exclusively American. The same US-centric approach can be found in numerous academic studies of the Western's evolution. At a more populist level, Walter C. Clapham (1974) and Brian Garfield (1982) – amongst many others – have presented histories of the Western that choose to confine European Westerns to small stand alone chapters or appendixes where they are duly treated with critical disdain because of their perceived sense of difference.

Finding an approach that could afford equal space to – and objective assessments of – Westerns produced worldwide has proved to be a difficult task. For example, Howard Hughes' 'Filmgoers' Guide' series features two distinct volumes – *Once Upon a Time in the Italian West* (2004) and *Stagecoach to Tombstone* (2008) – which detail Italian and Hollywood Westerns respectively. One notable exception is Phil Hardy's *The Western* (1991). Hardy's book is a huge volume that features over 1,800 capsule reviews of Westerns produced internationally between 1929 and 1990. These reviews are presented in chronological order based on the films' original release dates. While nothing like every Western ever produced is featured

here – and European Westerns remain somewhat under-represented – the reviews do represent a record that loosely plots the development of the Western genre worldwide. However, *The Western* is billed as a 'viewing guide' (1991: vii) and Hardy's objective but necessarily brief reviews lack the kind of detailed comparative analysis that is needed to fully track the genre's development at an international level.

A small number of detailed studies of European (mainly Italian) Westerns have appeared but their focus on European cinema means that, once again, the chance to bring together the critical study of both American and European Westerns is lost. Laurence Staig and Tony Williams' *Italian Western: The Opera of Violence* (1975) possesses a defensive tone but the book represents an early effort to present Italian Westerns as films that demand serious assessment. That serious assessment was realized in Christopher Frayling's *Spaghetti Westerns: Cowboys and Europeans from Karl May to Sergio Leone* (1981). Employing a transdisciplinary approach that embraces a range of theoretical perspectives (narrative analysis, genre studies, structuralism, the sociology of the cinema, political sociology and Marxist critique), Frayling's book covers many crucial areas. Most notably it offers in-depth investigations into the origins and the ongoing development of two types of European Western: the West German Karl May adaptations and the Italian Westerns of Sergio Leone and others.

In critiquing Wright's US-centric approach in *Sixguns and Society*, Frayling constructs what he calls the 'Italian plot' (in actuality, three recurring plot variants which reflect different phases in the Italian Western's evolution) before arguing that the presence of such a plot would have given Wright's schema a much-needed international dimension (1981: 50). Indeed, Frayling asserts that the Italian plot's presence would have accommodated the possibility that some of Hollywood's Westerns from the late 1960s and early 1970s might have been influenced by the content and style of key Italian Westerns (1981: 50–51). My study adopts a working method that is concerned primarily with comparing representational strategies rather than recurring plot points per se, but it does look to offer precisely the kind of international dimension that Frayling calls for.

Frayling uses a mix of comparative analysis and direct testimony from Sergio Leone in order to chart the ways in which a handful of American Westerns might have influenced Leone's work (1981:

141–159). Then, in an appendix, Frayling considers what impact the Italian-made Spaghetti Westerns might have subsequently had on US Westerns (1981: 280–286). Frayling cautions that 'questions of "impact" or "influence" must always be problematic: "influences" on a given film can seldom be detected with certainty' (1981: 280) before presenting a catalogue of – what he personally takes to be – 'the more obvious Spaghetti elements [found] in post-1966 American Westerns' (1981: 280). His introductory caution not withstanding, the 'Spaghetti elements' that Frayling detects in Hollywood's post-1966 Westerns – the presence of Italian Western icons Clint Eastwood and Lee Van Cleef, new attitudes towards the depiction of violence, Mexican Revolution narratives filmed in Spain and the employment of certain narrative and stylistic approaches (1981: 280–286) – form a convincing argument regarding the Italian Western's ability to influence Hollywood Westerns. Incidentally, Frayling explains that although American critics originally used the term 'Spaghetti Western' in a pejorative way, he uses it in both a 'descriptive sense' and 'as a term of endearment' with no 'racist' slur intended (1981: xi). My own use of the term throughout this book is employed in precisely the same spirit.

Further volumes dedicated to the Italian Western have appeared sporadically. Alex Cox's *10,000 Ways to Die* (2009) considers Italian Westerns from a film director's perspective while Austin Fisher's *Radical Frontiers in the Spaghetti Western* (2011) focuses primarily on 'political' Italian Westerns. As for European Westerns, Kevin Grant's *Any Gun Can Play: The Essential Guide to Euro Westerns* (2011) is a generic historical account that focuses mainly on Italian Westerns. Thomas Klein, Ivo Ritzer and Peter W. Schulze's edited volume titled *Crossing Frontiers: Intercultural Perspectives on the Western* (2012) features exploratory chapters on West German, Italian and British Westerns amongst others. However, these often-cursory chapters tend to discuss each national cinema's Westerns in isolation. Cynthia J. Miller and A. Bowdoin Van Riper's edited volume titled *International Westerns: Re-Locating the Frontier* (2014) also features chapters on West German, Italian and British Westerns amongst others. Although its content is grouped into five key themes, the chapters in this book also tend to discuss each national cinema's Westerns as largely isolated phenomena.

A number of single chapters in books about Italian or European cinema have been devoted to Italian Westerns. One such chapter by Dimitris Eleftheriotis (2002) offers cogent insight into why non-American Westerns are continually excluded from critical accounts of the genre. Having noted the role that the value judgements imposed by critics play in the creation of a genre's essential characteristics, and the establishment of a body of films that will necessarily belong to that genre, Eleftheriotis goes on to observe that when American critics labelled Italian-made Westerns 'Spaghetti Westerns', they transformed the Italian Western into a separate, hybrid genre that connoted foreignness, inferiority and a sense of contamination (2002: 92). Eleftheriotis suggests that the critics who equate the genre classification 'Western' with 'American western' have thus created 'a hegemonic position within historical, critical and theoretical discourses' that privileges American-produced Westerns over all others (2002: 95).

As such, any Western that exists outside 'the historic production basis of the [American] western', is regarded as a transformative foreign body that cannot be placed within the Western's 'organic evolutionary model' (Eleftheriotis, 2002: 96). Ultimately, Hollywood's hegemonic position continually results in the formal characteristics of Italian Westerns being 'defined, analyzed and judged only in relation to Hollywood cinema, while frames of reference other than a simplified, essentialized notion of Italianness, are overlooked' (Eleftheriotis, 2002: 96). Eleftheriotis' observations concerning Italian Westerns can be readily applied to any Western feature produced in a country outside the USA. And yet, as he points out, affording proper attention to other frames of reference can illuminate 'the national and cultural specificity of' those genre films made outside of the USA (2002: 96). Indeed, Frayling asserts that any deep analysis of European Westerns 'should be able to distinguish the specifically "European" elements (technical, cultural or ideological) from the extensions of Hollywood "forms" or "dominant codes"' (1981: 29). This is precisely what my book sets out to do by adopting an interdisciplinary approach that is centred around film studies and cultural studies.

Clearly a gap exists for a comparative study that affords equal space and equally objective consideration to both European and American Westerns. I seek here to fill that gap by employing narrative, textual and comparative analysis techniques in order to contrast previously overlooked European

Westerns with American Westerns in order to ascertain key areas where European Westerns were responsible for bringing important representational innovations to the genre. Each country's take on the genre might then be understood to bear the influence of national filmmaking traditions in terms of their formal construction while their underlying thematic content might in some way reflect attitudes, social mores or even historical events that are of specific relevance to the local audience. My study seeks to highlight these 'local' elements and consider their wider impact on the representation of the 'Other' in European Westerns.

Incidentally, since German, Italian and British Westerns were produced within national film industries that did not always possess the financial resources or the technical expertise that is commonplace in Hollywood, some of the European Westerns reviewed in my study are low budget films that often lack cinematic finesse. However, as Ian Charles Jarvie observes, 'even a poor film may raise or explore an interesting social, moral, or personal problem' (1970: xv). As such, all of the films in my study are treated objectively and since the study revolves primarily around narrative and textual analysis and the representational strategies found within the films there is little need for their technical merits per se to be judged. Interestingly, Tag Gallagher has criticized the application of evolutionary approaches to the Western genre as he feels that they usually amount to 'invidious comparisons between a couple of titles – a "classic" Western versus a "self-conscious" western – selected specifically to illustrate' a particular assertion (1995: 248). However, my samples take in more than just a couple of titles – sustained consistency within national cinemas is at the heart of my argument – and my comparisons are not intended to be invidious: my study should not be read as being an anti-Hollywood tract.

The Hollywood Western's representation of the 'Other' in brief and the structure of my study

It must be acknowledged that Hollywood's representation of the 'Other' has never followed a strictly teleological sense of progression. That is, such representations have not followed a linear trajectory that starts at a negative point in Hollywood's distant past and ends at a positive point in the

enlightened present. For example, Molly Haskell indicates that female characters in early Hollywood films were often assertive, active and sexually aggressive 'without being stigmatized' (1987: 91). However, Haskell explains that the introduction and enforcement of the Motion Picture Production Code in the early 1930s resulted in the representation of women in Hollywood films being brought into line with the outlook of the National Legion of Decency (1987: 117). The Production Code also sought to control Hollywood's representations of racial 'Others'. The Code was changed and challenged on various occasions – it was informally amended a number of times during the 1950s (Doherty, 2007: 318), began being routinely broken by Hollywood filmmakers during the 1960s and was ultimately replaced with the Motion Picture Association of America's more lenient ratings system in 1968 (Doherty, 2007: 334) – in order to accommodate Hollywood filmmakers who wished to better reflect changing public sensibilities. However, the Western was one Hollywood genre that was generally reluctant to take advantage of these opportunities to represent the 'Other' in new or progressive ways. In fact, for much of the 1960s the Hollywood Western strictly conformed to its reputation for purveying racist and sexist discourses: its Indians regressed to being wild faceless savages, only a handful of major black characters appeared and interesting female characters were in noticeably short supply too. As such, the Hollywood Western's sexist and racist depictions of the 'Other' cannot be blamed entirely on the Code. It should of course be noted that European filmmakers were able to operate without being constrained by rules of the American Production Code or the Motion Picture Association of America's ratings system.

The major turn for the Hollywood Western's representation of the 'Other' is generally recognized to be the early 1990s when notable cycles of single issue Westerns arose. Lee Clark Mitchell observes that Kevin Costner's *Dances With Wolves* (1990), Mario Van Peebles' *Posse* (1993) and Sam Raimi's *The Quick and the Dead* (1995) each respectively led cycles of pro-Indian, pro-black and pro-feminist Westerns (1996: 257). However, some critics and scholars have celebrated the Hollywood Western's representation of the 'Other' in previous time periods too (e.g. the pro-Indian Westerns of the early 1970s, the pro-black 'Blaxploitation' Westerns from the same period and various one-offs that featured strong women) but,

by focusing exclusively on Hollywood's output, their work has served to obscure or overlook the often earlier and more sustained representational innovations found in European Westerns. My study takes issue with this by providing reassessments of key Hollywood Westerns – and critiquing what has previously been written about them – in light of the new critical optic that this book's international dimension brings.

Thus my study is divided into three chapters that each focus on one European national cinema's engagement with the Western genre. The structure of each of these chapters is the same. Each opening section offers a brief outline of the distinctive approach to representing the 'Other' that is found in the national cinema under review, an investigation into the local cultural, social and political circumstances that may have prompted such a distinctive approach and details of the international critical reception that the country's Westerns duly received. The second section of each chapter serves a number of purposes. Firstly, existing writings on the representation of each type of 'Other' in American Westerns are examined in order to construct a comprehensive set of representational 'rules' that were routinely adhered to by Hollywood's practitioners. Close readings of key Hollywood Westerns, including those that have traditionally been judged to feature significant representations of each type of 'Other', are then undertaken in order to illustrate the constraining nature of these rules and to determine the extent to which they were actually transgressed in meaningful ways by American filmmakers. In doing so, celebratory assertions found in earlier critiques of these films are reassessed where necessary. The remaining sections of each chapter offer close readings of key Westerns produced by the three European national cinemas covered by my study. These close readings illustrate evidence of local cultural input and ultimately argue that these local elements resulted in these particular European Westerns introducing progressive representations of the 'Other' that prefigured the appearance of similarly progressive representations in Hollywood Westerns. To this end, a variety of narrative, textual and comparative analysis techniques are employed in conjunction with theories that are linked primarily to the disciplines of film studies and cultural studies.

Chapter I focuses on the West German film adaptations of Karl May's *Winnetou* stories that were produced between 1962 and 1968. Noting that these Westerns are distinguished by their positive treatment of the

Apache Indian chief Winnetou and his people, this chapter provides close readings of *The Treasure of Silver Lake* (*Der Schatz im Silbersee*, Harald Reinl, 1962), *Winnetou the Warrior* (*Winnetou – 1. Teil*, Harald Reinl, 1963), *Last of the Renegades* (*Winnetou – 2. Teil*, Harald Reinl, 1964) and *The half-breed* (*Winnetou und das Halbblut Apanatschi*, Harald Philipp, 1966). Clearly the terms Indian and half-breed are problematic – indeed offensive – expressions but their use in this chapter simply reflects their use within the films under review. Chapter II focuses on a selection of Italian Westerns that were produced during the second half of the 1960s. Noting that these Westerns are remarkable in the way that they allot lead character status and important narrative functions to assertive black characters, this chapter features close readings of *Lola Colt* (1967), *The Great Silence* (1968), *Ace High* (*I quattro dell'Ave Maria*, Giuseppe Colizzi, 1968) and *Boot Hill* (*La collina degli stivali*, Giuseppe Colizzi, 1969). Chapter III focuses upon two cycles of British Westerns that were produced within two separate time frames: Western parodies that were produced between 1939 and 1966 and more serious efforts that were produced during the early 1970s. Both cycles are distinguished by their striking representations of strong and active women. This chapter provides close readings of *Ramsbottom Rides Again* (John Baxter, 1956), *A Town Called Bastard* (Robert Parrish, 1971) and *Hannie Caulder* (Burt Kennedy, 1971). By structuring my study in this way I have been able to pursue an international approach to the study of the Western while simultaneously highlighting the significance of previously overlooked European films.

PART I

Indians in Europe

Indianthusiasm and the Representation of American Indians in West German Westerns

Paul Simpson asserts that the literary works of the German writer Karl May offer 'emphatic proof that, as early as the late nineteenth century, the myth of the West was doing strange things to the European imagination' (2006: 247–248). The sense of strangeness that Simpson alludes to in May's incredibly popular, Western-themed novels is undoubtedly attached to the books' promotion of heroic and noble Indians, most notably the young Apache chief Winnetou. Indeed, Richard H. Cracroft asserts that 'the dreaming power of May's vivid imagination', when combined with his exhaustive research on anthropological facts relating to the Indians, served to produce 'an original and unusual image of the redskin' (1967: 254). May's tales of friendship between Indians and whites were surely influenced in part by James Fenimore Cooper's Western stories but May's *Winnetou* novels from the 1890s are distinguished by the presence of German adventurer-pioneer characters like the hardy strongman, Old Shatterhand.

As a consequence, Rudolf Conrad indicates that 'for the German reader, Karl May's Indian novels established a deeply effective romantic-emotional tie to the American Indian' (1989: 458) and, as a result, Hartmut Lutz maintains that 'to this day, *Indianer* remain deeply implicated in German popular culture' (2002: 179). Thus, when West German filmmakers began making Westerns during the early 1960s, they quite naturally chose to

draw directly upon May's enduringly popular works. As a consequence, eleven Western feature films based on May's writings were produced in West Germany between 1962 and 1968. And each of these adaptations feature empowered and heroic racial 'Others' who command as much narrative importance and respect as their white counterparts. This chapter will thus explore the groundbreaking ways in which these West German Westerns represent Native Americans by comparing their content to typical Hollywood Westerns.

Firstly, it should be noted that the East German film studio DEFA also produced a number of hugely popular Indian-themed Westerns during the 1960s. The ideological products of a communist state, the DEFA Westerns sought to use stories set in the Wild West to tell allegorical tales that critiqued imperialism and capitalism. As such, these films featured consistently positive representations of Native Americans too. The May adaptations were banned in East Germany for ideological reasons and Ute Lischke and David T. McNab indicate that DEFA subsequently felt compelled to make their own Westerns because significant numbers of East German citizens were electing to travel to Prague in order to watch the May films (2005: 286). Interestingly, Gerd Gemünden goes as far as to assert that:

> both before and after its division into two national states, there exists a common, widespread, and existential identification with Indians that seems to surpass that of other nations ... The *Indianerfantasien* [Indian fantasies] of both East and West Germany are clearly interchangeable because they both stem from the same tradition.
>
> (2002: 254)

The East German people's desire to see the May adaptations, and the subsequent box office success of DEFA's own Westerns, seemingly offers evidence that confirms the German people's deep-seated affection for Native Americans.

The iconic cinematic image of May's Apache chief Winnetou endures within Germany to this day. But film historians have largely overlooked the remarkable representations of Indian characters – and the positive depictions of interracial romance – that are found in the *Winnetou* films from the

1960s. Kim Newman notes that 'one would be hard pressed to pick through Westerns made since 1972 and find an unsympathetic, disrespectful portrayal of a Native American' (1990: 54). This perceptible change of attitude with regard to the representation of Indians in Hollywood films at the turn of the 1970s was made all the more noticeable by the fact that, whenever Indians appeared in Hollywood Westerns during the 1960s, filmmakers consistently chose to employ the savage Indian stereotype. The suggestion that Hollywood productions like Ralph Nelson's *Soldier Blue* (1970), Arthur Penn's *Little Big Man* (1970) and Elliot Silverstein's *A Man Called Horse* (1970) approached their Indian subjects with a newfound sense of sympathy, respect and fairness is indisputable. However, I argue that this change of attitude can first be detected in the West German Westerns of the 1960s.

Brian Garfield observes that 'the history of the [Hollywood] Western is spotted with a fair, although not huge, number of Indian-oriented movies' before adding that 'in thousands of movies Hollywood did treat the Indian shabbily. But it was not done with absolute consistency' (1982: 54). Garfield's observations are essentially correct. American Westerns produced prior to 1970 that are relatively sympathetic to Native Americans can be found in two distinct periods: between 1908 and 1911 and during the early 1950s. However, overtly negative representations of Indians remained prevalent in American films during both of these periods too. Clearly the West German Westerns of the 1960s were not the first to offer positive representations of Native Americans, but I argue that acknowledging the West German films does problematize the Western genre's received evolutionary model. These West German productions represent a cycle of films that is at once consistent, unforced and sustained in its efforts to cast the Indians as positive characters and they appeared at a time when Hollywood had reverted to portraying Indians as faceless savage hordes. As such, these positive representations of Native Americans prefigure those seen in Hollywood's pro-Indian films of the early 1970s.

1

West German Westerns: International Reception and Local Influences

Tim Bergfelder suggests that Rialto Film, the production company that made the May adaptations, sought to 'de-Germanise' May's America in order to appeal to an international audience (2005: 183). However, the company's efforts evidently did not go far enough as reviews and critiques by international commentators clearly indicate that a perceptible sense of foreignness and difference still pervaded the films. Indeed Simpson, like numerous others, uses the term 'sauerkraut' Western in order to set up a cultural distinction between Hollywood Westerns and the West German Westerns, which he describes as being 'kitsch tongue-in-cheek formula' films (2006: 248). Tim Lucas suggests that an attendant sense of 'inauthenticity' was one of the reasons why the films did not perform well in English-speaking markets (2006: 87). Writing about Alfred Vohrer's *Among Vultures* (*Unter Geiern*, 1964), Robin Bean suggests that the apparent lack of authenticity found in the film's *mise-en-scène*, costumes and props 'might give [genre] enthusiasts a few grey hairs' before concluding that Martin Böttcher's soundtrack score represents the film's 'only real Western flavour' (1965a: 54). Bean observes that the content of *Among Vultures* 'provides many chuckles' and he makes specific mention of 'the general confusions' found in the film's action sequences, which give the impression that the

'extras haven't the faintest idea what is going on' (1965a: 54). Since Vohrer's film is representative of the series as a whole, Bean's comments can perhaps be taken as an assessment of the May adaptations in general.

Garfield argues that 'the German Westerns, with one or two exceptions ... exemplify "Z" [grade] moviemaking at its worst' (1982: 367) while Clapham asserts that 'to the eye of the Western connoisseur they are laughable. ... Naive, awkwardly synthetic, they are an oddity' (1974: 7). George N. Fenin and William K. Everson suggest that the films are nothing more than B movies that represent exercises in 'the outright *imitation* [Fenin and Everson's emphasis] of the [American] Western' (1962: 327) and John Lenihan agrees, adding that the May adaptations 'were unimaginative, stiffly acted rehashes of Hollywood themes' (1985: 168). A common feature found in most of these critiques is the suggestion that the films are somehow inferior or inauthentic imitations of Hollywood Westerns.

Kevin Grant (2011) approaches the May Westerns in an objective manner but the key points of his appraisal of the films largely mirror the opinions of earlier commentators. Grant detects 'the mechanical melodramatics of B-westerns at their most banal' in the May adaptations and he describes the films as being 'almost childishly naive' before making reference to their 'dime-novel morality, saddle-sore plot conventions, stilted dialogue and trite characterisations' (2011: 55). Phil Hardy's capsule reviews of a handful of the May Westerns are generally fair in tone too, but his brief assessments do tend to be littered with negative adjectives and phrases: 'inconsequential' (1991: 283), 'piece of fluff', 'thin and banal' (1991: 288), 'routine' (1991: 290) and 'indifferent' (1991: 300). Although none of the critiques make a negative issue out of the films' patently un-generic representations of Indians, I would suggest that this does actually play a part in generating the perceived lack of authenticity that the critics repeatedly refer to.

Early affiliations and Nazi propaganda

The local elements found in the May Westerns are many and varied but most of them are linked to the enduring idea that the German people are somehow culturally inclined to identify and empathize with Native Americans. Indeed, the May films appeared after more than a century's

worth of German cultural activity that revolved around imagined and real encounters with Indians. Lutz has referred to the German people's long-standing and ongoing 'romantic infatuation' and 'obsession' with Native Americans as a cultural phenomenon that he dubs 'German Indianthusiasm' (2002: 167). Since Edward Buscombe indicates that, beyond Karl May's own work, 'more than a thousand fictional Indian stories were published in Germany between 1875 and 1900' (2006: 188–189) it would seem that German Indianthusiasm was bolstered and coloured by the positive depictions of Indians that May and his fellow writers provided. However, the sense of cultural connection and identification that served to link Germans to Native Americans might actually predate May's work.

Historically minded Germans seemingly find the roots of Indian-thusiasm planted deep in the country's turbulent past. Michael Kimmelman notes that Johannes Zeilinger, the curator of a May exhibition at the Deutsches Historisches Museum in Berlin, detects a link to Native Americans in the Roman historian Tacitus' description of the ancient German tribes: 'uncorrupted, primitive, fierce and at one with nature, a people on the edge of a corrupt and voracious empire' (quoted in Kimmelman, 2007). And Susan Zantop suggests that towards the end of the eighteenth century, 'when the German states were trying to redefine themselves against imperial(ist) France', a 'collective sense of inferiority, resulting from military and political defeat' led to the German people forming 'a collective identification with "the Indian" as the underdog' (2002: 5). Clearly it is possible for this kind of identification to be linked to any period in German history that saw the country defeated and/or occupied by a foreign power. As will be discussed later in this chapter, America's occupation of Germany after World War II is of particular significance since it provides a common occupier that directly links the Germans to Native Americans.

Colin G. Calloway has detailed the popularity of numerous performing Indian shows in Germany throughout the late nineteenth and the early twentieth centuries (2002: 71). These shows – the most famous example being 'Buffalo Bill' Cody's touring Wild West Show – featured genuine Native American performers. Although such shows played throughout Europe, George Moses reports that Cody's 1890 tour of Germany 'caused a sensation', adding that 'the enthusiasm in Germany seems to have been greater than anywhere else in Europe' (quoted in Calloway, 2002: 71).

Certainly, these touring shows provided much needed employment for their Native American participants but the power relations that the shows were built around (white Europeans paying to gaze upon exoticized and essentialized ethnic performers) bring to mind those of the colonial World Fairs and Expositions that were popular in Europe and America during the same time period. Indeed, it is clear that the Native Americans who performed in travelling Wild West shows provided white audiences with a stereotypical representation of Indian history and behaviour.

In common with most European countries, Germany has been producing Westerns since the days of silent cinema and early titles – *The Deerslayer and Chingachgook* (*Lederstrumpf, 1 Teil: Der Wildtoter und Chingachgook*, Arthur Wellin, 1920), *Last of the Mohicans* (*Lederstrumpf, 2 Teil: Der letzte der Mohikaner*, Arthur Wellin, 1920) and *Red Bull, The Last Apache* (*Red Bull, der letzte Apache*, Phil Jutzi, 1920) – indicate an obvious interest in producing Indian-themed Westerns. Similarly, the German public's continued enthusiasm for Karl May's work soon saw his writings being presented via a more physical and dynamic medium. Katrin Sieg indicates that May's Indian novels were adapted into stage plays in 1919 (2002: 82) while reporting that Indian clubs came into existence in Germany at around the same time (2002: 121). The members of such clubs were enthusiastic hobbyists who would meet up, dress as Indians and interact in ways that celebrated their understanding of Native American culture and it should be noted that these early Indian clubs came into being soon after the American-led Allies defeated Germany in World War I. This suggests that, in part, German identification with the Indians can indeed be linked to a need to identify with a historical 'underdog'.

Later in the century, the Nazi Party's propaganda was able to capitalize on the German people's seemingly inherent willingness to relate to Native Americans. Lutz reports that a raft of literary formats, including children's literature, were used by the Nazis to stress 'the affinity between Germans and Indians' by 'reading Native American resistance to European encroachment as a reenactment' of German myths such as 'Arminius's fight against the Romans' (2002: 177–178). Ultimately, the ideology that exoticized and lauded a pointedly stereotypical image of one racial 'Other' (the

Indian) was part of a racist discourse that duly fed into a wider spread of propaganda that sought to negatively stereotype and demonize another racial 'Other' (the Jew). In revealing that Adolf Hitler was an admirer of Karl May's Western novels, Klaus Mann goes as far as to suggest that May was Hitler's literary mentor (1940: 393). However, it is clear that Germans of all political persuasions read May's work, and Frayling has uncovered quotations to this effect from the likes of Albert Einstein (1981: 108) and the pro-communist Dadaist George Grosz (1981: 105). Evidently the contents of May's *Winnetou* novels are polysemic enough to be agreeable to both right- and left-wing political mindsets. In terms of film production at this time, Luis Trenker directed a Western in 1936 titled *The Emperor of California* (*Der Kaiser von Kalifornien*). Frayling notes that the film plays like a variant of the German 'mountain film' (1981: 19) while observing that its German hero 'has much more in common with the Indians than with vicious, money-grubbing Americans' (1981: 105). These key elements of *The Emperor of California* can be linked to the content of the later *Winnetou* films.

The post war years and ethnic drag

Defeat by the American-led Allies, the subsequent occupation of Germany and the question of culpability for the Holocaust led to further Indian-related debate and activity inside Germany. Jennifer Fay describes how the American authorities that occupied Germany after World War II provided public screenings of Hollywood films in order to culturally re-educate the German populace (2008: 80). It was thought that films 'concerned with American Westward expansion and the history of immigration' would 'teach Germans about democracy' (Fay, 2008: 80). Ironically, Fay suggests that watching two of these films – John Ford's *Drums Along the Mohawk* (1939) and *Stagecoach* (1939) – together presented a 'version of history' in which 'genocide is not just the founding violence of American statehood, it is constitutive of its sustainability' (2008: 78). Indeed, in describing the doctrine of Manifest Destiny that was used to justify the settlement of the West, Harry M. Benshoff and Sean Griffin conclude:

> Genocide, which means the deliberate destruction of an entire
> cultural group of people, is a very strong word, but one that
> in recent years has been applied to official (and not-so-official)
> US policies towards Native Americans during the nineteenth
> century.
>
> (2009: 98)

Clearly some parallels can be drawn between the philosophy of Manifest Destiny and its subsequent effects and the Nazi philosophy of blood and soil that led to Germany's aggressive, genocide-driven expansion throughout Europe during the 1930s.

As such, Fay indicates that in the immediate post war years Germans largely chose to reject Hollywood Westerns because to identify with the American cowboys and pioneers who slaughtered Indians would only serve to 'doubly inscribe their genocidal guilt' (2008: 81). It is telling that, when the Germans began producing their own Indian-themed Westerns based on May's novels, they endeavoured to show peaceful relations existing between white Germans and Indians. Furthermore, Bergfelder reports that in West Germany the *Winnetou* films 'outperformed ... any "original" Westerns produced by Hollywood' (2005: 172), which suggests that the May adaptations' alternative narratives appealed directly to the German public's psyche.

As with the post World War I period, the notion that some Germans might regard themselves to be victims akin to Native Americans becomes apparent. Paul Cooke indicates that in the immediate post World War II period ordinary Germans tended to identify with two distinct forms of victimhood: they were victims 'of the Hitler dictatorship on the one hand and of the Allied campaign and subsequent occupation on the other' (2006: 78). Whilst the Germans publicly acknowledged that the Americans were liberators who rescued them from National Socialism, it would seem that privately some Germans felt that they and the Native American had experiences in common: both parties were defeated in battle by American forces who then occupied their homelands. Thus, as Sieg reports, the number of Indian clubs in Germany increased dramatically following World War II (2002: 121). Sieg suggests that those Germans who joined the Indian hobbyist clubs at this time were specifically driven by a sense of emasculation

and victimization which they sought to 'symbolically redress through the ritual of ethnic masquerade' (2002: 117).

Sieg has coined the term 'ethnic drag' in order to describe ritualized performances 'of "race" as a masquerade' that serve to allow both the performer and their audience to consciously take 'up an outsider's perspective' (2002: 2). Furthermore, in openly showing itself to be a 'simulacrum of "race"', the act of ethnic drag ultimately 'challenges the perceptions and privileges of those who would mistake appearances for essence' (Sieg, 2002: 3). Conflating appearance with essence had played a key role in the Nazis' racist propaganda programmes. Sieg reports a further significant example of ethnic drag found in Germany at this time: the televised open-air stage performances of Karl May's *Winnetou* stories that have been performed since 1952 at Bad Segeberg's annual Karl May festival (2002: 74). Appearing shortly after the close of the Nuremberg war crimes trials, Sieg suggests that these performances ultimately allowed Germans to use the American West as a 'displaced theatre for the racial imagination' (2002: 10) that effectively:

> facilitated not only a geographical and historical distancing of genocide, but also offered spectators different identifications in the story of racial aggression. Ethnic drag allowed Germans to align themselves with the victims and avengers of genocide, rather than its perpetrators and accomplices.
>
> (2002: 13)

In this instance, Sieg suggests that the Indians who the Germans masqueraded as onstage became surrogate Jews, thus effecting a process of sympathetic identification with a wronged racial 'Other' that also brought with it an element of catharsis (2002: 113). I will consider how Sieg's line of thought might be applied to the *Winnetou* feature films when I offer close readings of them later in this chapter.

Interestingly one of the few pro-Indian Hollywood Westerns of the 1960s, John Ford's *Cheyenne Autumn* (1964), appears to pass comment on the contradictions apparent in the German populace's respect for the Indian as a racial 'Other' and their racist and genocidal actions during World War II. The film details how a band of Cheyenne Indians undertakes to walk from

their inhospitable reservation in Oklahoma to their old homelands in Wyoming. Along the way some of the Cheyenne are forced to seek help at a US military fort and the fort's German commander, Captain Wessels (Karl Malden), warmly welcomes them initially. Wessels is keen to express his interest in Indian culture and, when referring to the rows of books housed in his sizable book cabinets, he observes 'half the volumes you see here are about Indian life and culture … most of them written in German'. However, when he receives orders to keep the Cheyenne under restraints until they can be returned to the reservation, Wessels imprisons the Indians in a sub zero warehouse and duly withdraws their food and water. With the Indians freezing and starving to death, Wessels excuses his actions with the words 'orders are orders … I am responsible for nothing … I have simply been the instrument of an order'. Wessels' words seemingly mirror those of the Nazi war criminals who stood trial for racially motivated war crimes at Nuremberg while his surname appears to be a reference to Horst Wessel (the Nazi activist who wrote the lyrics for the Party's official anthem).

Cheyenne Autumn was not the first Hollywood Western to draw a comparison between the extermination of the Indians and the Holocaust. Bob Herzberg observes that in Felix E. Feist's *Battles of Chief Pontiac* (1952) the Prussian leader of a troop of Hessian mercenaries, Colonel Von Webber (Berry Kroeger), is 'a racist and psychopath who believes all Native peoples to be inferiors who should be exterminated' (2008: 130). To this end, Von Webber orders that 'blankets treated with the small-pox virus' should be distributed amongst a tribe of Ottowas Indians (Herzberg, 2008: 130). The officers responsible for racist violence in both of these films are variations of the 'bad' German stereotype that appeared across a number of different Hollywood genres following World War II. It is made clear that these officers are rogue operators whose actions do not reflect standard US Army policy. Ironically, German political activists would soon find a way to directly associate actual American military action with Nazism. Cooke notes that in the late 1960s German activists viewed the USA's aggressive imperialism (as seen in Vietnam in particular) as 'a new form of fascism' and their chants of 'USA – SA – SS' outside '"America House" in Berlin' served to 'make this link explicit' (2006: 85). It is perhaps significant that the *Winnetou* film series began at a time when a new generation of Germans were being forced to come to terms with the horrific activities

of their parents in relation to the racial 'Other' during World War II and ended when that generation had come of age and were confident enough to publicly articulate their opposition to the activities of the American military in relation to the racial 'Other' in Vietnam.

The USA had its own political upsets at the tail end of the 1960s in the form of civil rights and anti-war protests. And it is precisely when American political activists themselves began to liken America's state apparatuses to those of fascist states that Hollywood began producing a short wave of pro-Indian films that showed the US Army (now sans German officers) carrying out genocidal activities. At the start of *Little Big Man* (1970), a historian offers a definition of the word genocide and adds 'that's practically what we did to the Indian'. Lenihan suggests that the racist atrocities represented in *Soldier Blue* (1970) and *Little Big Man* served to 'attack in a none-too-subtle allegorical fashion America's military efforts in Vietnam' (1985: 49). However, their obviously genocidal nature inevitably also serves to liken the US military to Nazis. The contents of these films echo those of the earlier West German Westerns like Harald Reinl's *Last of the Renegades* (1964), which featured an aggressive and racist US Army colonel. Using language that inadvertently strengthened the idea that America exhibited fascist tendencies when dealing with the racial 'Other', Pauline Kael observed in her review of a Hollywood-made pro-Indian Western, Abraham Polonsky's early twentieth century-set *Tell Them Willie Boy is Here* (1969), 'if Americans have always been as ugly and brutal and hypocritical as some of our current movies keep telling us, there's nothing for us to do but commit genosuicide' (1980: 163). Ugly, brutal and hypocritical Americans had been appearing in German Westerns a good seven years prior to Kael noticing that Hollywood films had begun to follow suit.

Tassilo Schneider reports that the incredible success of the *Winnetou* film series in West Germany resulted in a huge number of exceedingly diverse but highly popular spin-off products (1998: 142). Bergfelder indicates that the German youth magazine *Bravo* awarded an 'Indian figurine called Otto' as a prize to its readers' 'most popular film and pop music stars' and the actors who played Indian characters in the *Winnetou* series, Pierre Brice and Marie Versini, 'gained top position as best male and female star in five consecutive years between 1964 and 1969' (2005: 195). Clearly the 1960s marked a period where the attention of huge swathes of the West

German public was, in one way or another, focused upon representations of Native Americans in some shape or form. It should also be noted that the 1960s saw another significant association arising between Germans and Indians. Following the release of J. Lee Thompson's escapist war adventure *The Guns of Navarone* (1961), Glenn Erickson notes that – in terms of Hollywood's output – Germans (as Nazis) and Indians came to share the distinction of being repeatedly cast as 'all-purpose bad guys' (2009).

Anthropology, Romanticism and German popular cinema

Besides these popular cultural manifestations of Indianthusiasm, Yolanda Broyles-Gonzalez indicates that German academics have also produced an inordinate amount of work that relates to Native American culture (1989: 76). In keeping with the central tenets of the German Romantic tradition, links between Germans and Native Americans have also been made in terms of both cultures' reputations for respecting and seeking harmony with the natural world. Actively playing upon such stereotyping, Lutz reports that Dr Hans Rudolf Rieder wrote in 1929 that 'the Indian is closer to the German than to any other European. This is perhaps due to our partiality to the world of Nature ... As young lads ... we find in the Indian an example and a brother' (2002: 177).

And this notion persists to this day via a new generation of German hobbyists that pursue an interest in learning about and re-enacting Native American culture as part of their personal commitments to a green lifestyle. In summarizing Broyles-Gonzalez's (1989) study of 'the Black Forest Cheyenne' (a group of German hobbyists who practice Native American culture in the Black Forest region), Sieg observes that, by impersonating Indians, club members were able to 'express fear of modernization, grief over geographical and social displacement, and mourning of lost indigenous traditions' (2002: 136). However, Marta Carlson contends that the activities of such German enthusiasts only serves to further extend 'a long and deeply problematic historical progression' that has involved white Germans hegemonically appropriating 'American Indian culture and spirituality' for use within an 'exotic hobby' (2002: 213). For Carlson (who is of Native American descent), the German engagement with 'exoticized

colonized peoples' is problematic for three reasons: a white anthropo-
logical spirit motivates it, it serves to diminish the 'power and identity' of
genuine Native Americans and it makes 'entertainment out of genocide'
(2002: 214–215).

Significantly, the expressions of fear, grief and mourning that
Broyles-Gonzalez's (1989) German hobbyists sought to articulate via
their Indianthusiasm can be linked to notions of German Romanticism.
Romanticism's central concerns about the effects of the Industrial
Revolution and the subsequent paintings produced by the movement's
artists have had a lasting influence on German culture and German cin-
ema. Morse Peckham reports a shift in the themes employed by German
romantic painters as they moved from the late eighteenth century to the
early nineteenth century: paintings from the earlier period were natural
landscapes that were both 'sublime and beautiful' wherein 'the human fig-
ures are so small, so buried in the natural world as to become part of it'
(1985: 49). By contrast, the paintings from the later period often showed
'a single large figure' stood with 'his or her back to the observer', facing
towards vast and unnaturally symmetrical landscapes (Peckham, 1985: 49).
While the former style celebrates the naturalism of the classical world,
the latter style chronicles and laments 'the imposition of human interest
upon the natural world' (Peckham, 1985: 49). As such, these later paint-
ings might be taken as examples of Romanticism's negative reaction to the
Industrial Revolution. The *Winnetou* films celebrate Romanticism's earlier
period, presenting expansive long shots in which characters are dwarfed by
their natural surroundings.

The emphasis on both beautiful and sublime locations and concerns
about the exploitation of natural resources found in the *Winnetou* films
serves to link them to earlier indigenous German film forms such as the
Mountain films of the 1920s and the *Heimat* films of the 1950s. *Heimat* is
normally translated as 'home' or 'homeland' but the term is understood
to be loaded with 'considerably more connotative baggage than any avail-
able translation' can convey (von Moltke, 2002: 18). Anton Kaes reports
that 'twelve million refugees from the former German territories in Eastern
Europe' moved to Germany after the war (1989: 14) and countless other
indigenous Germans were forced to move to new areas within the coun-
try because their homes had been destroyed. As such, the *Heimat* films

of the 1950s set out to provide a collective sense of 'home' for all of those Germans who had lost their own homelands or homes at the end of World War II. Interestingly, parallels can be drawn between the Native Americans who lost their homelands and were forced to relocate to government reservations and the various types of displaced German refugee.

In this section I have suggested that a variety of local cultural and historical circumstances resulted in the West German film industry producing Westerns that featured progressive representations of Native Americans. Before discussing in detail just how progressive these representations were, it is necessary to first offer as a point of contrast an overview of the way that Native Americans have traditionally been represented in American Westerns.

2

The Representation of Indians in American Westerns

Prior to the appearance of Hollywood's revisionist, pro-Indian Westerns of the early 1970s, the Indians who appeared in American Westerns invariably possessed stereotypical characteristics that resulted in mostly negative representations and limited onscreen activity. Here I will offer an overview and a re-evaluation of the ways in which Indians were represented in Westerns produced in the USA. Thus when the West German Westerns of the 1960s are examined later, the extent to which they offered a consistently more positive, personalized and fairer representation of Indian characters will become evident. Hollywood's treatment and representation of Native Americans has generated much in the way of academic and critical writing and this section will review and critique some of this work in order to illustrate a catalogue of representational 'rules' that were employed to constrain and 'Other' the Indians in Hollywood Westerns.

Although American Westerns have tended to reflect and reinforce the supremacy of white patriarchal society, Scott Simmon notes that some of the silent Westerns that were made between 1908 and 1911 did feature relatively pro-Indian sentiments (2003: 29). Similarly, Hollywood produced a cycle of Westerns that were relatively pro-Indian during the early 1950s but this cycle was equally short-lived. The positive representations of Native Americans found within these films were unable to obscure the American

Western's dominant Indian stereotype: the savage Indian. The savage Indian stereotype appeared in countless American Westerns prior to the 1970s and thus became deeply ingrained in the worldwide cinema-going public's consciousness. As such, providing a catalogue of this stereotype's various component clichés is relatively easy. It is not possible to discuss all of the American Westerns that have featured Indians so I will simply draw upon a small number that can be regarded as being a representative sample.

Perhaps the most obvious thing to note about Hollywood's Indians is the fact that they are consistently positioned as the 'Other': the binary opposites – and most usually the enemies – of the white man. Roberta E. Pearson notes that Hollywood's representation of the Indians has traditionally been characterized by a further binary perspective: that 'of the "noble savage," whose untutored instincts render him superior in some respects to the white man, and the "savage savage," so low on the evolutionary ladder that he merits only swift and certain extermination' (2001: 247–248). And it is the 'savage savage' variant that has figured most prominently in Hollywood Westerns. The tenets of Manifest Destiny ably justified the presence of white Euro-Americans on land that belonged to the Native Americans. Thus the screen Indians who were continually seen attacking wagon train pioneers, homesteaders and railroad engineers were coded as savage faceless hordes. Examples of popular silent Westerns that promote Indians as savage and indiscriminate marauders include James Cruze's *The Covered Wagon* (1923) and John Ford's *The Iron Horse* (1924).

Rather than being presented as real characters, Hollywood's Indians were usually presented as stereotypes who were either 'good' or 'bad'. Good Indians were placed in the backgrounds of town-set shots in order to signal to the viewer that a particular film's narrative was taking place in the Wild West, while bad Indians were employed as hazardous-but-fleeting plot devices: bad Indians were simply one of many perils (treacherous mountain passes, rapid rivers, rattlesnakes, devastating storms, rock falls) that had to be faced and overcome by white characters who travelled the West. Bad Indians tended to be briefly wheeled out whenever a Western demanded an exciting action set piece that could serve to confirm a white hero's masculinity or a cavalry squad's bravery. Indeed, Jon Tuska's observation that taking a stand against marauding Indians could even serve as an

exercise in redemption for white villains (1985: 253) gives some indication of just how negatively Native Americans were portrayed in the majority of Hollywood's Westerns. This tendency to intermittently use the Indians as background scenery or as the savage instigators of predictable action set pieces means that relatively few American Westerns prior to 1950 provide enough Indian-related content to sustain extended close readings. As such, the critiques that follow will at times necessarily focus upon brief but pertinent scenes rather than whole films.

'Bad' Indians outnumber 'good' Indians: *The Big Trail* (1930)

The content of an early sound Western, Raoul Walsh's *The Big Trail* (1930), can be used to illustrate many of the stereotypical elements that quickly became associated with Hollywood's Indian. The film tells the story of the woodsman Coleman (John Wayne), who is employed to guide a wagon train of settlers to new homes out West, and it is quite explicit in foregrounding the notion of good and bad Indians. Michael Hilger stresses the dichotomy that is typically present between Noble Indians and Savage Indians: Noble Indians 'are good because they are friends to the whites and realize they must adapt to white culture or face extinction' while Savage Indians 'are bad because they are enemies to the whites and obstacles to Westward expansion' (1995: 3). A brief early scene in *The Big Trail* shows three good Indians at work in a white fur trader's store. But although two of the Indians are initially placed in the foreground of the scene's expansive establishing shot, it is clear that they are merely silent extras who are there to add a dash of local colour to proceedings and to forewarn viewers that this is a Western set in Indian country. As soon as Coleman walks into the store a jump cut serves to obscure the Indians by focusing the viewer's attention solely upon Coleman and the white storeowner.

Simpson indicates that another variation on the good Indian is the 'helpful scout' who chooses to offer his skills to the white man (2006: 210) while Jacqueline K. Greb notes that the Indian-as-buffalo-hunter is another popular Hollywood stereotype (1998: 129). Coleman employs the services of two friendly Pawnee scouts and he duly uses them to help him

hunt buffalo as well. In an audacious but wholly typical effort to reinforce the idea of white superiority, the film has Coleman lead and instruct the novice-like Indians during the subsequent buffalo hunt sequence. Later in the film, Coleman's wagon train is confronted by a band of Cheyenne Indians on horseback who are first seen in an ominously framed extreme long shot. This shot represents the point of view of Coleman and his associates and it effectively conveys the great number of Indians that they are facing. Benshoff and Griffin include bows and arrows and feathered headdresses in their catalogue of items that a classical Hollywood Indian stereotype should possess (2009: 108) and a subsequent, right-panning long shot reveals that the Cheyenne are suitably attired and equipped to fit this stereotype. As it turns out, their leader Black Elk is a friend of Coleman's and the tension initiated by the Indians' threatening introduction is quickly diffused.

Hilger indicates that the Hollywood Indian stereotype tends to be a male chauvinist of some description (1995: 67) and Black Elk deeply offends the film's love interest, Ruth Cameron (Marguerite Churchill), when he refers to her as 'Coleman's squaw' and subsequently tries to buy her for Coleman by presenting her brother with a team of horses. After offering viewers these glimpses of good Indians, the film soon changes tack and introduces some bad Indians in the form of a Crow tribe. Jane Tompkins describes Hollywood's Indian stereotype in terms of 'that yipping sound on the sound tracks ... the beat of the tom-toms ... tepees, campfires, dogs and children running around, squaws in blankets ... Warriors – war paint, feathers, spotted horses' (1992: 9). Tompkins' words could easily be describing the content of the extreme long shot that introduces the Crow's camp and the subsequent six shots that offer a closer look at the camp's caricature-like inhabitants. In the space of seven shots that last a mere twenty-five seconds, director Raoul Walsh uses filmic shorthand and already well established stereotypical images to inform the viewer that the Crow are hostile, angry Indians who are ready to hit the war path.

The action set piece that follows is representative of another well established Hollywood cliché. Having spotted ominous smoke signals in the distance, Coleman orders the wagon train to form a protective circle. As the Crow circle the wagons, they launch their spears at the settlers but none are seen to connect with their targets. Their spears spent, the Crow simply

continue to circle the wagons, waving their tomahawks and bows and allowing the pioneers to cut them down with gunfire. The Indians retreat before returning and repeating the same battle tactics. When they suffer more casualties, the Indians are driven off for good. Fenin and Everson assert that in Hollywood films the Indians' main function 'consisted of providing a convenient mass enemy, and a series of spectacular moving targets' (1962: 39) and this assertion is certainly confirmed by *The Big Trail's* big action set piece.

Camera coverage during the Indian attack sequence clearly privileges the white settlers, whose anguish and determination is telegraphed via medium shots that frame their desperate-but-brave defensive actions and subjective point of view shots, which show their hostile attackers. Seen mostly in extreme long shots, these homogenous looking and savage Indians seemingly possess an incessant desire to wage war against the white man. Tuska notes that Hollywood Indians 'very seldom pick up their dead, much less bury them – another indication of their lack of civilization' (1985: 246) and the retreating Indians in *The Big Trail* adhere to this stereotype when they leave their dead behind. By contrast, the white settlers are seen burying their dead in emotional scenes that are underscored on the film's soundtrack by an instrumental reworking of the Christian hymn 'Abide With Me'. Although *The Big Trail* features stereotypical representations of both good and bad Indians, it is the bad Indians who leave a lasting impression on the viewer thanks to the dramatic nature of the Indian attack sequence and its emotional aftermath.

Routed by the US Army: savage Indians and the 'Cavalry Trilogy' (1948–1950)

The way that Indians were represented in American Westerns remained largely unchanged throughout the 1930s and 1940s. However, the presence of good Indians did become diminished over time and Angela Aleiss argues that by the late 1940s Indian-themed Westerns were exclusively about 'white heroism [fighting] against a red menace, the latter bordering on barbarism and savagery' (2005: 60). As such, John Ford's contemporaneous 'Cavalry Trilogy' can fruitfully be used to further plot the stereotypical

representation of Indians in American Westerns. All three films – *Fort Apache* (1948), *She Wore a Yellow Ribbon* (1949) and *Rio Grande* (1950) – are concerned with the US cavalry's ongoing mission to ensure that hostile Indians do not upset the government's expansionist land policy.

After observing that the 'Indians have speaking roles and conflict is either the fault of white prejudice or young [Indian] hotheads, [and therefore is] not inherent in the Indians' nature', Buscombe asserts that, in the first two films of the trilogy at least, a 'generally more sympathetic' approach to the representation of Indians can be found (2006: 97). However, as close readings of the trilogy will show, all three of the films do serve to perpetuate stereotypical images of savage Indians whilst granting them little screen time and even less in the way of character development. By contrast, each of the films dedicate much of their running time to introducing their respective military protagonists and developing the relationships and intrigues that they share with each other and their female companions. R. Philip Loy indicates that white paternalism often plays a part in creating stereotypical Hollywood Indians who are portrayed as being 'victims of their own ignorance' because they 'remain prisoners to their traditions' and thus need a white man to show them 'the benefits of progress' (2001: 225). Although John Wayne's characters in the first two films can relate to Indians and sympathize with them to an extent, they remain paternal white men who want the insurgent Indians to return to the inhumane confines of their reservations one way or another. And in all three films, derogatory terms like 'savage', 'uncivilized', 'devils' and 'scourge' are used to describe the Indians.

Fort Apache's reliance upon stereotypes can be detected within the opening four shots of its front title sequence. These four shots – which in turn feature empty landscapes, cavalry troops and armed Indians – allow Ford to boil down the narratives of contemporary Hollywood Westerns that featured Indians to just two key elements: the open land and the collision course that brings together the two parties who are prepared to fight for dominance of it. Beyond the shots that act as a backdrop to the front titles, no Indians are seen in the first hour of the film but expositional dialogue and evidence of their savage and murderous activities reveal that local Apaches have left their reservation in order to link up with the renegade Indian Cochise (Miguel Inclan). Along the way they have attacked an army repair wagon and roasted its occupants upon its burning wheels. When the Indians do

make their belated first appearance proper, it is within an extreme long shot that shows them as a row of homogenous warriors that stretches from one edge of the screen to the other. Even when Ford presents a closer medium shot of the Indians it is impossible to pick out individual characters: their leader is only identified when he raises his rifle and fires a shot in order to signal an attack on another cavalry wagon. A suitably dramatic and exciting chase ensues but the arrival of Lieutenant Colonel Thursday (Henry Fonda) and his men results in the Indians being chased off.

When the cavalry visit the vacated reservation, a number of clichés associated with Hollywood Indians are subsequently drawn upon. Buscombe refers to the Hollywood Indians' sometimes 'childlike nature' (2006: 97), which results in them desiring worthless or meaningless decorative items like watches, medals and baubles. Lenihan observes that Hollywood has promoted the idea that guns are destructive and dangerous when placed in the hands of Indians (1985: 12–13) and Loy mentions the drunk Indian stereotype (2004: 248), who causes havoc after imbibing a bellyful of firewater. All three clichés are presented in one fell swoop when Captain York (John Wayne) declares that the greedy Indian agent Meacham (Grant Withers) has been selling the Indians 'cheap, shoddy trash … Winchester seven shot repeaters … whiskey but no beef, trinkets instead of blankets … [thus] turning [them] into drunken animals'.

The film blames the Indians' revolt on Meacham's actions rather than the US government's expansionist policy and York is shown to be sympathetic to their plight. But while Cochise and his right hand men are granted a handful of medium shots and medium close-ups towards the film's end, and are portrayed as essentially noble warriors, there is little in the way of character development or personality present. Cochise gets to air his complaints about Meacham but Thursday's disrespectful, elitist and martinet-like attitude scuppers any chance of peace. Having completely underestimated the Indians, Thursday chooses to engage them in a needless battle. Most of his soldiers die in an initial hail of bullets fired by the Indians and the survivors meet their doom when the Indians charge and overcome them in what is staged as a savage and merciless attack. Cochise spares York and his men, who took no part in the aggression, but the press are later allowed to blame the massacre of Thursday and his troops solely on the Indians' propensity for savagery.

Wayne Michael Sarf observes that Thursday's 'deliberate sacrifice' and 'valiant demise atones for a multitude of sins' allowing him to 'find glory in defeat' (1983: 184). York adds insult to injury by eulogizing Thursday to the press, falsely declaring that, 'no man died more gallantly, or won more honour for his regiment'. If Ford meant for an element of irony to be detected in York's words, John Wayne failed to fully communicate this. Ken Nolley has suggested that the film's ending is perhaps a self-conscious comment concerning 'the relationship between history and myth' typically found in Ford's films (2003: 74) and Hollywood Westerns more generally, which prefigures the newspaper editor's much quoted declaration – 'When the legend becomes fact, print the legend' – from the end of Ford's *The Man Who Shot Liberty Valance* (1962). If York's false eulogy is actually meant to be a backhanded swipe at the Hollywood Western's propensity for showing legend instead of fact, one wonders how many contemporary viewers read it as such. Either way, there is no denying that within the diegetic world of *Fort Apache* the reporters' stories will further serve to demonize the Indians and justify their destruction.

At the start of *She Wore a Yellow Ribbon* a voiceover informs the viewer that 'Custer is dead and … ten thousand Indians … are uniting in a common war against the United States Cavalry', thus setting the scene for conflict between Captain Brittles (John Wayne) and a band of renegade Indians. *Yellow Ribbon*'s faceless masses of marauding Indians – typically seen in long shots which are underscored by martial nondiegetic 'Indian' music – have even less personality than those encountered in *Fort Apache* and they are portrayed as being even more savage, which in turn generates more in the way of violent skirmishes and exciting chases. One of their attacks leaves a stagecoach way station burnt out and white children orphaned. When an unscrupulous white trader attempts to sell guns to the Indians he gets an arrow in his chest and the Indians simply steal the guns. One of the trader's assistants gets an arrow in the back while the other is repeatedly thrown onto the Indians' raging campfire. Loy mentions that a popular Indian stereotype that featured in 1950s and 1960s Hollywood Westerns was the savage who lusted after white women and sought to kidnap them (2004: 243). The fact that Brittles' troops are escorting two female civilians to safety, and the hints given with regard to what would happen to the women if the Indians should capture them, serve to introduce elements of this stereotype here.

Benshoff and Griffin observe that stereotypical Hollywood Indians often smoke peace pipes (2009: 108) and, when Brittles visits the elderly Chief Pony-That-Walks (John Big Tree), the pair duly share a peace pipe. Buscombe notes that Indians in American Westerns tend to speak 'very slowly in deep voices, in the stereotypical "me heep big chief" style that Hollywood employed to represent racial difference' (2006: 97) and Pony-That-Walks talks in this broken-language way. Adhering to two further aforementioned Hollywood stereotypes, the old Indian simply wants to get drunk and go buffalo hunting. Brittles ultimately saves the day without suffering any casualties: his troops spring a surprise night time charge that scares the renegade Indians' horses into stampeding and they wreck the Indians' camp before galloping off. Emasculated and rendered unable to carry out further raids without their horses, the cowed Indians surrender. The triumphant Brittles tells his men to 'follow the hostiles all the way back to the reservation … Walking hurts their pride. Your watching will hurt it worse.' Loy suggests that Brittles' non-violent solution means that *Yellow Ribbon* 'is not an anti-Indian Western' (2001: 223). However, the savage acts that the Indians are seen to perpetrate against white characters do effectively serve to demonize them and they are deeply humiliated and emasculated at the film's end. The fact that William K. Everson cites *Yellow Ribbon* as being *the* Hollywood Western of the 1940s that treated the Indians most sympathetically (1969: 201) surely speaks volumes about their treatment in the decade's other Westerns.

In *Rio Grande* Ford offers representations of Indians at perhaps their most savage yet, an impression that is underscored by the fact that the renegade Indians never directly converse with any white characters. The film opens with Captain Yorke's (John Wayne) men returning from patrol with a number of surly and dangerous looking Indian prisoners. Ford's dramatic editing strategy here makes it clear that these hostile Indians will at some point in the film endanger the women and children who are observing their arrival. Ella Shohat and Robert Stam assert that 'the Indian raid on the fort, as the constructed bastion of settled civilization against nomadic savagery', became a stereotypical occurrence in American Westerns (1994: 116) and such an assault is seen here when the Indian prisoners are rescued during an attack on Yorke's fort. At the height of the attack, Ford includes a sequence in which Quincannon's (Victor McLaglen)

terrified young niece runs to him screaming and seeking safety in his arms. The women and children are subsequently sent to a neighbouring fort but they are attacked en route. Loy indicates that the kidnapping of white children became stereotypical behaviour for Indians in American Westerns produced during the 1950s and 1960s (2004: 243) and the Indians subsequently retreat with the convoy's children and their female guardian as their captives. When Yorke and his troops set out to track the Indians, they find the woman's mutilated body.

Loy indicates that stereotypical Hollywood Indians were often superstitious (2004: 244), allowing the advice of medicine men and the outcomes of tribal rituals to guide their actions. In *Rio Grande* an army scout tails the Indians to a Mexican village where their drunken state, medicine drum playing and wild dancing signals that they intend to kill the children at dawn, the slaughter being the culmination of a vengeance dance ritual. The children are being held in an old church and three troopers sneak in and prepare to rescue them. Loy observes that 'normally Indians were portrayed [in Hollywood films] as engaging in frontal charges whether or not they worked' (2001: 232) and, when the alarm is raised, the Indians repeatedly charge at the church doors only to be cut down by the soldiers' gunfire. Here Ford presents close-ups of the terrified children's faces, which serves to demonize the Indians further. Yorke and his men charge in to bolster the rescue and – since no Indian prisoners are subsequently seen – the savage aggressors are presumably completely eradicated. Although *Rio Grande* features the most savage and the most faceless Indians of Ford's 'Cavalry Trilogy', the film does offer two small representations of 'good' Indians: at the film's start, Yorke offers his thanks to his unit's Indian scouts and, at the film's end, one Indian scout is honoured for bravery. However, since so little actual screen time is granted to these Indians, the recognition of their bravery might be seen as mere lip service.

Race relations and the pro-Indian Westerns: *Broken Arrow* (1950)

As the 1950s dawned, the civil rights movement began highlighting concerns about race relations in the USA and these concerns were tentatively

reflected in a small number of contemporary dramas produced by Hollywood. However it became apparent, as Claudia Gorbman observes, that 'race relations could be treated with even more frankness once safely couched in the guise of a Western' (2001: 188) and so a cycle of Westerns that promoted racial tolerance and understanding between white colonialists and Native Americans duly appeared. These Westerns are taken to be allegorical meditations about race relations in post World War II America and their Indians can be read as racial symbols who represented the modern day African American community. As will be detailed in Chapter II, this new approach to the representation of the racial 'Other' resulted in black characters disappearing almost completely from Hollywood Westerns during the 1950s.

The first of these new pro-Indian Westerns was *Broken Arrow*. The film is a liberal Western whose content is effectively a plea for racial harmony and understanding that reflects the contemporaneous concerns of the civil rights movement, and much of its liberal message is relayed via the dialogue spoken by its main characters. The film's opening long shot shows a gold prospector, Jeffords (James Stewart), riding through open country. Jeffords subsequently provides a narrative voiceover that makes it clear that he is telling the film's story after the fact. When Jeffords comes across a badly wounded Apache boy, he elects to help him despite noting that 'his kind was more dangerous than a snake ... For ten years we'd been on a savage war with his people.'

As the boy recovers the pair form a personal relationship that culminates in the Indian telling Jeffords that 'Apaches pray for all white men to die but now I pray to keep you safe.' When a band of five Apache warriors come looking for the boy, he successfully appeals for Jeffords' life to be spared. Jeffords is seen communicating with the Indians in a selection of medium and medium close-up shots that are framed and blocked in order to offer equal coverage to both the white man and the Indians. Jeffords' voiceover subsequently recalls that he 'learned things that day. Apache mothers cried about their sons. Apache men had a sense of fair play.' However, the film quickly offers a representation of Indian savagery when the Indians spot a team of miners who have Apache scalps about their person. Jeffords is bound and gagged while the Indians kill and torture a number of the miners. But while he is horrified by what he sees,

Jeffords pragmatically observes that 'this was war and there was terrible cruelty from both sides'.

Arriving in Tucson, Jeffords employs a friendly Indian, Juan, to teach him the ways of the Apache and he hatches a plan to broker a peace deal with Cochise (Jeff Chandler) that would start with the Indians allowing US mail carriers safe passage. Juan is a good but somewhat stereotypical Indian: he superstitiously takes the hooting of an owl to be an ill omen, he possesses a deep voice and he speaks in a stilted way. When Jeffords finally gets to meet Cochise, the Indian leader is coded in a very different way. Introduced via a commanding medium close-up shot, Cochise is handsome, intelligent, dignified, muscular and of good stature. The Indian leader cuts a noble figure and later shots of him are often taken from a low angle, thus serving to underline his majestic and powerful status. Cochise respects Jeffords' bravery and when the two become involved in private negotiations the shot–reverse shot set-up that covers their conversation offers equal coverage to both men. While arguing that letting the mail through unhindered could be the first step towards lasting peace, Jeffords tells Cochise 'my people have done yours great wrong, I say this to you as I've said it to them … [But] is it not possible that your people and mine can some day live together like brothers?' Cochise responds with the words 'why should not the white man act first? Do you want me to be better than the white man?' These words clearly correspond with the kinds of debate that surrounded the contemporaneous civil rights struggle.

Jeffords stays with the Indians overnight and observes one of their tribal dances, after which he tells Cochise that 'it is good to understand the ways of others. I respect your people, Cochise.' Jeffords also meets a beautiful Indian girl, Sonseeahray (Debra Paget), and the pair fall in love. Hilger indicates that Hollywood Westerns tend to promote two different female Indian stereotypes: beautiful 'Pocahontas' types and savage squaws who are often derided for not being beautiful (1995: 3–4). The attractive, slim and graceful Sonseeahray is undoubtedly a 'Pocahontas' type. Sporting luxurious hair and stylish tight-fitting clothes, Sonseeahray's beautiful face is captured in a number of glamorous medium close-up shots and her image can be contrasted with the Indian woman who is seen going to collect water from the river in a sequence that details Jeffords having a morning shave. Seen in a long shot only (that comes directly before a

shot in which Sonseeahray is lovingly framed as an inquisitive reflection in Jeffords' shaving mirror), this female Indian is overweight, plain-looking and wears baggy clothes.

Jeffords soon links up with General Howard (Basil Ruysdael), a military man who wants to meet with Cochise to negotiate a new peace treaty. Howard signals his good intentions by declaring 'the Bible I read preaches brotherhood for all of God's children ... My Bible says nothing about the pigmentation of the skin.' The Bible reading Howard brings a religious angle to the film's race relations debate, which again chimes with the contemporaneous civil rights struggle. Cochise is pragmatic when the new peace treaty is offered but not all of the Apaches agree with him and the outspoken Geronimo (Jay Silverheels) elects to keep on fighting the white men. Loy makes mention of two Indian stereotypes that often necessarily appear together: 'the wise old chief' who is willing to consider peace in order to prevent the eradication of his people and 'the hot-headed young brave' who wants to fight on to the death against the whites (2001: 219). This stereotypical dynamic, which pits variants of the 'noble savage' against variants of the 'savage savage' can clearly be detected here in the characters of Cochise and Geronimo.

The armistice goes well initially despite Geronimo's best efforts and Jeffords and Sonseeahray are married. However, at the film's end racist whites who are intent on spoiling the peace ambush Jeffords, Cochise and Sonseeahray and in the ensuing fight, Jeffords is injured and Sonseeahray is killed. Cochise despatches the main instigators of the ambush but some escape. When Jeffords finds one of the attackers wounded he wants to kill him but Cochise will not allow it. He tells Jeffords that 'Geronimo broke the peace no less than these whites. And as I bear the murder of my people so you will bear the murder of your wife ... no one on my territory will open war again. Not even you.' At the film's denouement a party from Tucson visits Jeffords and advises him that those who played a part in the ambush have been rounded up and will feel the full measure of the law. General Howard then advises Jeffords that 'your very loss has brought our people together and the will to peace. Without that will, treaties are worth little or nothing.' Speaking in voiceover, Jeffords now takes comfort from the fact that 'the death of Sonseeahray put a seal upon the peace'.

The death of Sonseeahray actually represents a stereotypical narrative contrivance that is in keeping with Hollywood's conservative attitudes towards the filmic representation of interracial romances. Buscombe notes that a number of Hollywood Westerns from the 1950s possessed an 'obsessive interest in the question of mixed marriage' (2006: 125). However, despite citing a handful of Hollywood Westerns that feature relatively happy endings for their interracial lovers, Buscombe concedes that in most cases 'the only good Indian wife is a dead Indian wife' (2006: 126–127). By extension, in those instances where an interracial romance bore children, Hollywood employed stereotypical representations of 'half-breeds'. These half-breed characters are usually shown to endure a troublesome existence that is blamed on their mixed parentage. Jenni Calder indicates that these half-breeds are often 'tragic' characters who are routinely 'rejected by [both] red and white' racial groupings although they can sometimes act as 'essential bridges between the two' (1974: 53). Although good and bad variants of mixed-race characters appeared in Hollywood Westerns, Calder maintains that half-breeds are traditionally coded as villains (1974: 54).

Broken Arrow instigated a cycle of Westerns that used white friendships with Indians to promote racial tolerance and understanding and other key titles include *They Rode West* (Phil Karlson, 1954), *White Feather* (Robert D. Webb, 1955) and *The Indian Fighter* (Andre de Toth, 1955). However, for much of the 1950s Hollywood would continue to produce Westerns that featured narratives wherein sympathetic groups of whites were besieged by hordes of Indians who were cast in the same old faceless marauding savage mould. Key examples include *Apache Drums* (Hugo Fregonese, 1951), *The Searchers* (John Ford, 1956) and *The Guns of Fort Petticoat* (George Marshall, 1957). As M. Elise Marubbio observes, these 'anti-Indian' and sometimes 'vehemently racist' Westerns 'would [duly] eclipse the assimilationist pro-Indian westerns and maintain prominence until the early 1970s' (2006: 65). General trends in Hollywood's representation of the Indians during the 1950s, 1960s and 1970s are illustrated by Hilger's endeavours to document the filmic appearances of what he loosely terms 'the Savage' – 1950s, over 100 (1995: 111–128); 1960s, nearly fifty (1995: 159–167); 1970s, less than twenty (1995: 189–192) – and 'the Noble Red Man' – 1950s, over eighty (1995: 128–145); 1960s, less than twenty (1995: 167–175); 1970s, nearly thirty (1995: 192–201). As is clear from the

figures, even in the 1950s – the decade of a notable pro-Indian film cycle – representations of savage Indians outnumbered representations of noble Indians, and the situation grew worse during the 1960s.

Before moving on, reference must be made to Peter Perry Jr's *Revenge of the Virgins* (1959). In this obscure exploitation Western, which was written by Edward D. Wood Jr of *Plan 9 from Outer Space* (1959) fame using the pseudonym Pete La Roche, a group of avaricious gold prospectors are picked off one by one when they pan for gold on land that belongs to an all-female tribe of Indians. Here the savage Indians are victorious, defeating the intruders and returning the stolen gold to its source. However, there is still an element of racial hierarchy present in this film: the tribe's chief is a blonde white woman who was kidnapped by the Indians as a small child and brought up as one their own. The film's female warriors appear topless at times and this focus on nudity appears to have obscured the fact that Wood had actually written a Western that subversively allowed its Indians to successfully defend their land and its natural resources.

Indians and Hollywood in the 1960s

After acknowledging that the cycle of relatively pro-Indian films instigated by *Broken Arrow* had faded away by the end of the 1950s, Newman asserts that 'it was taken for granted in 1960s [Hollywood] Westerns that Indians weren't just there to be killed' (1990: 73). However, this assertion cannot be fully supported. Philip French notes that 'from around 1950, the Indian in the contemporary allegory can stand for the Negro when the implications are social or for the Communist when the implications are political' (2005: 49). This would explain the presence of both pro and anti-Indian Hollywood Westerns during the 1950s. However, as the civil rights movement grew stronger during the 1960s black characters began appearing in American Westerns in major roles, thus negating the need to use the Indians as positive racial stand-ins. With the Cold War quickly reaching new levels of intensity at the start of the 1960s, the Indians were increasingly called upon to act as stand-ins for the communist enemies of America.

As will be discussed in Chapter II, a significant number of Hollywood Westerns from the 1960s – such as *Rio Conchos* (Gordon Douglas, 1964),

Major Dundee (Sam Peckinpah, 1965) and *Duel at Diablo* (Ralph Nelson, 1966) – featured narratives where black and white characters settled their differences and came together to fight a common enemy: namely faceless savage hordes of Indians. Perhaps not surprisingly, Buscombe's chapter titled 'The Liberal Western' (2006: 101–150) largely finds little to say about Hollywood Westerns from the 1960s and he refers briefly to just two films from that decade: *Cheyenne Autumn* and *Tell Them Willie Boy Is Here*. Buscombe essentially jumps straight from the 1950s to the 1970s in one sentence when he declares that 'by 1971 views of Indians were changing, moving beyond the limited alternatives offered in *Broken Arrow* … [and Hollywood's] Indian Westerns too were changing' (2006: 132–133). However, if the pro-Indian Westerns that were produced in West Germany throughout the 1960s are taken into account a new sense of continuity and progression in the cinematic representation of Indians becomes apparent. As will be revealed in the next section's close readings of the West German Karl May adaptations, this sense of continuity and progression ultimately problematizes the received model of the Western's evolutionary development.

3

The Representation of Indians in West German Westerns

Given that significant sections of German society have displayed a tendency to identify with American Indians and deeply sympathize with their plight, the fact that the West German production company Rialto Film decided to produce Westerns based on Karl May's enduringly popular stories concerning German–Indian friendships should come as little surprise. Schneider indicates that the German film industry was facing economic disaster at the start of the 1960s but Rialto Film's first May Western, Harald Reinl's *The Treasure of Silver Lake* (1962), was actually West Germany's most expensive film to date (1998: 141–142). This would suggest that the production company was confident about the film's chances of success. *Silver Lake*'s main characters were played by internationally known actors but, since May's literary work was still immensely popular in West Germany at the start of the 1960s, it cannot be argued that Rialto Film's casting choices were intended to dupe the German public into believing that they were watching a Hollywood Western (a tactic that was initially employed by the producers of Italian Westerns prior to the success of Sergio Leone's *A Fistful of Dollars / Per un pugno di dollari* in 1964). Instead, it would seem that the international casts were engaged in order to secure worldwide distribution for the film and its sequels.

The French actor Pierre Brice, who had starred in a number of Italian historical adventure films at the turn of the 1960s, played the Apache Indian Winnetou in all eleven of the May adaptations and he was paired with a white friend on each occasion: Old Shatterhand (Lex Barker) appeared in seven of the films, Old Surehand (Stewart Granger) appeared in three of them and Old Firehand (Rod Cameron) appeared in just one. Of Winnetou's three 'Old' friends it is Barker's Old Shatterhand who makes the biggest impression within the series: Old Shatterhand proclaims his loyalty to and affection for Winnetou when he becomes the Indian's blood brother and Winnetou in turn dies saving Old Shatterhand's life. With debate concerning Germany's racially motivated war crimes during World War II raging publicly during the early 1960s, the pair's interracial friendship is clearly of significance and I will discuss the films in the context of the Adolf Eichmann and Auschwitz trials later in this chapter. As such, I will focus most critical attention here upon the films that feature Old Shatterhand. Barker had taken over the role of Tarzan from Johnny Weissmuller in 1949 and he enjoyed Hollywood success in the role throughout the early 1950s. However, the actor relocated to Italy in the late 1950s where he starred in a number of popular historical adventure films before moving to Germany in 1961 in order to appear in *Krimi* (crime-mystery) films. Incidentally, Stewart Granger was cast in the series by virtue of the fact that he shared an agent with Barker (Bean, 1965b: 50) while the ageing Hollywood Western star Rod Cameron's involvement appears to have come about thanks to his appearances in a couple of contemporaneous Italian Westerns.

Before leaving Hollywood Barker had appeared as 'Natty' Bumppo in Kurt Neumann's *The Deerslayer* (1957). Based on the novel of the same name by James Fenimore Cooper, Barker's turn as the wilderness wandering adventurer with a Mohican blood-brother surely granted him some advantage when the part of Old Shatterhand was being cast. However, Barker's physical appearance was undoubtedly of huge significance too. Recognized the world over as a Hollywood Tarzan, German spectators would have been fully aware that Barker was an American. However, given the ongoing popularity of May's literary work inside West Germany, it is safe to assume that German cinema audiences automatically perceived Old Shatterhand to be a German hero even if his actual nationality was played

down onscreen and an American actor was portraying him. Muscular, blond, blue-eyed and tall, Barker's Old Shatterhand is the living personification of the kind of mythic German heroes promoted by Nazi visual culture. Given that the trial of Adolf Eichmann throughout 1961 and 1962 had resulted in renewed public discourse about Germany's Nazi past, the casting of Barker initially appears to be somewhat questionable and ill-judged. However, an ideological agenda of sorts can perhaps be detected here. Old Shatterhand is an intensely honourable character who abides by treaties, befriends the racial 'Other' and seeks justice for all. Jennifer M. Kapczynski notes that in the German war films of the 1950s, Nazi ideologues were the only German soldiers to 'exhibit any desire for bloodshed' (2010: 21). Old Shatterhand only uses his gun when he has to and, where possible, he does not shoot to kill. And so, when viewed using the codes of contemporary German cinema, this distinctly German action hero is clearly presented as a combatant who possesses a 'non-Nazi' mindset. In casting Barker, the films' producers effectively repossessed and ultimately rehabilitated the traditional-if-stereotypical physical attributes of German manliness that had been corrupted by Nazi propaganda and ideology. Thus Barker's Old Shatterhand is a hero cast in an obviously Germanic mould but he is a hero with whom the contemporary German public could identify without suffering guilt or recriminations. Ultimately, at a representational level, Old Shatterhand's supremely moral actions can be understood to overwrite and replace the wholly immoral actions of the Nazis.

Furthermore, the films' guest characters who are specifically indicated to be German are particular character types (parents and their offspring or displaced persons) whose inter-generational conflicts, secretive activities or status as victims chime with the experiences of post war Germans. In addition, the influence of German Romanticism found in earlier German film forms can also be detected in the narrative themes that dominate the May Westerns. For example, Bergfelder notes that the *Heimat* films' narratives 'often centred on the dichotomies between a "healthy" countryside and the corrupting influences of urban life', which resulted in 'rural and pre-industrial arcadia[s]' being confronted by the 'technological and social progress of modernity' (2005: 42). Kaes concurs that in the *Heimat* films 'the characters move about as if they were in an Arcadia of trivial myth where evil obtrudes only in the form of an outsider, typically someone

from the city' (1989: 15). These very tropes are found within the May films too: trouble only arises when capitalist outsiders in the form of railroad developers, oil barons and the like invade the utopian Arcadias that are occupied by the Indians and their white friends.

The May adaptations have – just like the *Heimat* films that preceded them – tended to be viewed as the kind of simple and formulaic *Papas Kino* (Daddy's cinema) that was denounced by the young German directors who signed the Oberhausen Manifesto in 1962 and the New German Cinema generation that followed them. However, Rachel Palfreyman indicates that recent reappraisals of the 1950s *Heimat* films have revealed 'their capacity to engage with pressing social questions' (2010: 145) and I argue that similar importance can now be attributed to the May Westerns. Indeed, in allegorically addressing the concerns of contemporaneous West German society and confronting troubled memories of Germany's recent past, the content of the May Westerns actually prefigures some of the critical themes that are associated with the films of the later New German Cinema generation.

Julia Knight observes that 'American culture was very much part of everyday life' in post war Germany and this led to several New German Cinema directors highlighting 'the influence of Hollywood cinema by drawing on the conventions of American films while dealing with specifically German subject matter' (2004: 74). For instance, Rainer Werner Fassbinder's films from the 1970s include personal and localized reworkings of Hollywood genres like the gangster film, the melodrama and the Western. Crucially, Knight notes that while the New German Cinema films were keen to pay homage to American cinema they also featured criticisms of the USA's imperialist foreign policy (2004: 75). While the May Westerns involve a different approach artistically and were made within a different context of production I argue that they were essentially born out of the same process: the films necessarily pay homage to Hollywood Westerns but they also rewrite the genre's key themes and ultimately serve as a critique of American imperialism while also appealing directly to those German viewers who identified with the Indians as victims of American domination.

Furthermore, reading the films at an allegorical level reveals an engagement with other themes that would subsequently preoccupy later German filmmakers. Knight highlights five key themes that 'recur

across the new [German] cinema's films – namely the presence of the *Gastarbeiter* [foreign guest workers], the rise of urban terrorism in the 1970s, the Nazi past, the experience of American cultural imperialism and the influence of the women's movement' (2004: 46). My readings of the May Westerns suggest that allegorical ruminations on three of these themes can be found in the *Winnetou* films. The films' obvious comments on the experience of American cultural imperialism have already been briefly noted above. German relations with racial 'Others' (Indians as opposed to the *Gastarbeiter*) also figure prominently too. And concern about the Nazi past can also be found within the films: here harsh militaristic figureheads defy treaties and indulge in genocide as they plot to steal the valuable natural resources found on other people's land. Furthermore, Thomas Elsaesser observes that the post war German family was a 'fatherless family' on two counts: fathers were either absent because they had been killed during the war or completely ineffectual because 'their credibility was compromised by active or passive collaboration with a criminal political regime and an indefensible war' (1989: 241–242). Consequently, the fatherless family and generational conflict provoked by Germany's Nazi past became key themes in the New German Cinema films of the late 1960s and 1970s. The fatherless family and generational conflict are themes that are also found throughout the May Westerns too.

Sieg asserts that, in the wake of the Nuremberg war crimes trials that ran from 1946 to 1949, the televised Karl May stage productions that debuted in 1952:

> captured and cathartically purged the central ambivalences and conflicts of that time: the traumatic experience of shame along with the denial of collective responsibility, the resentment against the accusers and victims of genocide as well as grief and the wish for atonement.
>
> (2002: 78–79)

As such, it could be argued that the May films of the 1960s functioned in a similar way in relation to the public discourse generated by the trial of Adolf Eichmann that ran from 1961 to 1962 and the Auschwitz trials that ran from 1963 to 1965. Fay suggests that post war Germany's rejection

of Hollywood's Indian-themed films and the increase in Indian hobby-ists 'intimates that to recover from the Nazi era, Germans did not need to become *more* [Fay's emphasis] like Americans but to find new paradigms of "ethnological correctness" and ethnographic sympathy' (2008: 81). I would suggest that the May Westerns of the 1960s can be understood as being another stage in this very process.

A new kind of cinematic Indian: Winnetou and *The Treasure of Silver Lake* (1962)

The narrative of Rialto Film's first May Western, *The Treasure of Silver Lake*, is set some time after the Apache brave Winnetou (Pierre Brice) and the German adventurer Old Shatterhand (Lex Barker) have become blood brothers. This move was not particularly problematic in narra-tive terms since most contemporary German viewers would have been familiar with the initially confrontational nature of the duo's first meet-ing and the subsequent back-story that led to them becoming friends. However, it did allow director Harald Reinl to open the film (and the series) with an image of interracial harmony and cooperation: a short prologue begins with Winnetou and Old Shatterhand framed within a medium shot as they leisurely ride over an open plain together. The duo are then seen circumventing craggy and mountainous rock formations on foot. Imagery like this, which ultimately serves as a link back to the German Mountain films of the 1920s in which the protagonist's heroism was measured by their ability to negotiate nature's more dangerous path-ways, is found throughout the series. The duo then gallop off towards the adventure that will unfold when the subsequent front credits have rolled. These opening shots feature a voiceover that serves to inform the viewer that, while the old West was populated with a multitude of vil-lainous types, Old Shatterhand and his blood brother Winnetou were on hand to 'fight for the cause of justice'. Given that the film was released after the Eichmann trial and in close proximity to the Auschwitz trials, it is significant that the German Old Shatterhand and his ethnic friend Winnetou are presented as a united front that seeks to bring evildoers to justice.

As the film's narrative gets underway, it is revealed that a German character, Eric Engel, has come by a map that leads to the legendary Indian treasure that is hidden at Silver Lake. Engel figures that he has safeguarded the treasure by tearing the map in two and leaving the second half with his business partner Patterson (Jan Sid) while he attempts to lodge a land claim for Silver Lake at the registry office in Salt Lake City. However, the intervention of the villainous Colonel Brinkley (Herbert Lom) and his army of cutthroats results in Engel being murdered and his half of the map being stolen. Engel's son Fred (Götz George) asks Old Shatterhand to bring Brinkley to justice and when Patterson elects to continue the quest for the treasure Old Shatterhand and Winnetou agree to accompany him as they are convinced that Brinkley will be following on close by. Also along for the ride are Fred, Patterson's daughter Ellen (Karin Dor) and three of Old Shatterhand and Winnetou's friends, the mountain men Sam Hawkens (Ralf Wolter) and Uncle Gunstick (Mirko Boman) and the English nobleman Lord Castlepool (Eddi Arent).

Winnetou and Old Shatterhand are introduced to the story proper via an extreme long shot that shows the pair slowly emerging from a ravine that is formed by jagged mountains that stretch off into the distance. Seemingly drawing upon symbolism linked to German Romanticism and the Mountain films, the shot suggests that the mountains have given birth to the pair. Furthermore, the buckskin outfits that the duo wear confirm that they are wilderness men who are at one with nature, a conceit that has been stereotypically attached to both Indians and Germans. When Winnetou and Old Shatterhand pass by the site of Eric Engel's murder it is Winnetou who intuitively knows that something untoward has occurred in the vicinity. Winnetou's ability to read the significance of marks on the ground ('Five horses. One without rider. Come from that way. And here they leave horses...') allows him to take charge of the situation and he authoritatively orders Old Shatterhand to 'follow them' when the cluster of footprints that he has spotted forks into two divergent directions. Of the pair, Winnetou gets the most screen time and the most dialogue in this introductory scene and it is he who decides what their next course of action should be. It is already clear from this early sequence that Winnetou is a new type of cinematic Indian.

Winnetou's central and commanding presence

Buscombe notes that it is rare to find 'an Indian whose existence is presented direct, unmediated, without some kind of representative in the film of the white audience' (2006: 18). While this observation does in part apply to the *Winnetou* films – Old Shatterhand and Winnetou's other white companions can be regarded as representatives of the white audience – the films do not readily conform to Hollywood's typical way of mediating an Indian's lived experience. In Hollywood's pro-Indian films, whether they be from the early 1950s, early 1970s or the 1990s, the Indians' experiences and stories tend to be mediated via a central white character who passes comment (often via a reflective voiceover) on what (s)he observes as (s)he interacts with the Indians. These white characters are often revealed to be recounting past events and the Indians' experiences effectively become memories or stories told from the white characters' perspectives.

However, there is little sense of this in the *Winnetou* films because the perfunctory voiceovers that introduce each film have a documentary-like quality: the featured voices do not belong to any of the films' characters and so no white character has been granted the privilege of recollection. Furthermore, Winnetou is the only constantly recurring character in the series. If the series can be said to have an overriding story arc, it is the story of Winnetou and it is essentially mediated to the viewer via Winnetou's own point of view and autonomous actions. Quite often, Winnetou and his white companions are forced to split up and work independently and this is the case in *Silver Lake*: an early scene in the film has Winnetou electing to bravely track Brinkley and his men alone before undertaking a dangerous and suspense-laden mission to infiltrate their hideout. The scenes that feature Winnetou acting unaccompanied carry as much narrative importance as the corresponding scenes where Old Shatterhand works alone. And Winnetou is constantly at liberty to angrily berate, threaten and even kill the white men he is in conflict with. In a scene where Winnetou tracks down Brinkley's men and, with his rifle held aloft, shouts 'pale faces who dare to break peace treaty will die', it is perfectly clear that his threat is real and that he has the means to carry it out.

Indeed, the events from an earlier time frame depicted in Reinl's next film in the series, *Winnetou the Warrior* (1963), reveal just how special

and unique an Indian character Winnetou actually is. As we saw earlier in this chapter, American Westerns traditionally employed two divergent Indian stereotypes: the noble Indian (who is pragmatic and peaceful) and the savage Indian (who is martial and seeks to attack white intruders). In terms of the savage Indian, Loy mentions 'the hot-headed young brave' who elects to fight to the death against the whites (2001: 219) and this is precisely the kind of Indian Winnetou is when we first meet him in *Winnetou the Warrior*. In a provocative act, that film's villain, Santer (Mario Adorf), has begun laying railroad tracks on Apache land and murdering any Apaches that he chances upon. As a consequence, Winnetou is riled and ready to go to war. He does in fact lead a revenge attack upon a town populated by Santer's gang and the railroad workers at one point, during which he attacks and almost kills Old Shatterhand. Hilger defines the savage Indian as being one who is an obstacle to Westward expansion (1995: 3) and this definition can be applied to Winnetou for a portion of *Winnetou the Warrior*.

In terms of the noble Indian, Vine Deloria highlights the 'wise and sentimental' 'old chief', who is 'always in favor of love and understanding and never advocates that' Indians 'should take up violence against those who have wronged' them (1980: xi). In *Winnetou the Warrior*, Winnetou is guided by an 'old chief' substitute in the form of a German-gone-native father figure, Klekih-petra (Hrvoje Svob), who reminds the headstrong warrior that the whole tribe will rely upon him when he succeeds his father to become chief. By the film's end both Winnetou's father and Klekih-petra are dead (in a reversal of the tropes associated with Hollywood Westerns, the white man Klekih-petra sacrifices himself to save Winnetou's life) and Winnetou has been reminded (thanks to his encounter with Old Shatterhand) that not all white men are bad. Thus, in succeeding his father, Winnetou is forced to strike a balance between his propensity to be a savage warrior and the demands of being a noble, wise and sentimental chief who is responsible for his people's welfare. It is surely the volatile mix of both savage and noble traits that make Winnetou such a powerful yet sympathetic Indian character. Interestingly, Deloria notes that in Hollywood Westerns the wise old chief usually feels compelled to tell his white confidant 'secrets that nearly a hundred generations of Indians have kept close to their hearts and enshrined in their memories' (1980: xiii). This is not

the case with Winnetou: when Winnetou travels to the Apache's secret gold mine in *Winnetou the Warrior*, Old Shatterhand and the other white characters are not permitted to accompany him on the final stage of the journey.

All of this makes Newman's assertion that 'Tonto made a comeback in the form of Karl May's Indian hero Winnetou' (1990: 73) somewhat perplexing. Tonto was the friendly Indian sidekick of the West's fictional masked righter of wrongs, the Lone Ranger. The interracial duo have enjoyed countless adventures in American-produced radio serials, films, comic books, cartoons and television series since their first appearance in 1933 but the character of Tonto has been roundly criticized for being a particularly negative Indian stereotype. Donald L. Kaufmann observes that 'whatever the Lone Ranger was, Tonto was less – less fast, less a sharp-shooter, less domineering … when the Lone Ranger judged a situation, Tonto played out his role as monosyllabic yea man' (1980: 30). Winnetou and Old Shatterhand are evenly matched when it comes to skills such as shooting and horse riding and Winnetou does not use the kind of 'mono-syllabic' 'clipped baby talk' that Kaufmann attributes to Tonto (1980: 30). Winnetou does sometimes speak in slightly broken sentences in the May films, but he is not inarticulate and he possesses an excellent understanding of the white man's language. As such, his powers of communication are never coded as a lack that signifies low intelligence or racial inferiority. In many instances throughout the series, like the early scene from *Silver Lake* where Winnetou and Old Shatterhand find the site of the stagecoach massacre, it is actually Winnetou who takes on the responsibility of assessing the situation.

John A. Price complains that Tonto was a character who was 'clearly subservient to a white man' (1980: 86) while Greb notes that Tonto was 'a stereotypical [ethnic] sidekick who was inarticulate, faithful, and trustworthy' (1998: 136). Winnetou is faithful and trustworthy but these traits are born out of, and are symbolic of, sincere friendship and inter-racial respect and understanding rather than being evidence of defer-ential subservience that is based on racial hierarchies. And, as is again evidenced in the scene from *Silver Lake* where the duo come across the stagecoach massacre site, Winnetou has the authority to issue instruc-tions and orders to Old Shatterhand when the situation demands such

action. Loy notes that typical Indian sidekicks in the mould of Tonto hardly ever amounted to being 'more than a cheerleader' for their white partner's heroic exploits (2001: 220). This is definitely not the case with Winnetou. Winnetou and Old Shatterhand are both vocal in expressing the mutual appreciation that they share for each other's skills but, more often than not, it is Old Shatterhand who acts as a cheerleader for Winnetou. Time and again it is Old Shatterhand who has to praise and thank Winnetou for saving him with yet another well-timed rescue mission.

Of the Lone Ranger and Tonto, it would seem obvious that the heroic masked Ranger was the character that most American viewers were supposed to identify with. Whether West German audiences would choose to identify with Old Shatterhand over Winnetou is less easy to determine given the pre-existing affection that Germans held for the Winnetou character and the more equal footing that he shares within the films' narratives. The spectator's sense of identification with a film character can be theorized in a number of different ways. At a formal level, identification can be encouraged by careful editing and the use of devices such as establishing shots, shot/reverse-shot set ups, eye-line matches, point of view shots and close-ups. The *Winnetou* films do tend to be constructed in a way that sets Winnetou up as *the* character that the audience *should* be identifying with. For example, in some films in the series the opening scene features Winnetou carrying out a heroic deed alone. And identification is further positively encouraged by the role that Winnetou subsequently has in driving sections of the films' narratives, the commanding nature of his placement within shots and the close-ups and point of view shots that he is afforded. Furthermore, Winnetou is able to openly express a range of emotions that show his human side. Buscombe asserts that, prior to *Little Big Man* (1970), Hollywood Indians had stereotypically 'been conceived as solemn, stoney-faced and statuesque' individuals (2006: 178) but Winnetou does not conform to this stereotype since he is able to adopt a wide range of facial expressions. Completely at home in mountainous regions, Winnetou is often featured in dramatic shots that show him standing atop craggy buttes or looking over the edges of cliffs. Whenever he is positioned in these elevated locations, Winnetou's point of view is powerful and all-encompassing, allowing him the ability to silently observe

events as they unfold below him. These sequences again serve to link the May Westerns to the German Mountain films.

Allegorical references to the recent past 1: the aesthetic of war

Brinkley's search for the second half of the treasure map in *Silver Lake* leads to an attack on Peterson's home, Butler's Farm. Interestingly, the staging of Brinkley's attack on Butler's Farm inverts the way that Hollywood traditionally staged Indian attacks on army forts. Butler's Farm is a large property with many worker-inhabitants and the four fortified wooden walls that mark its rectangular perimeter make it look like a fort. Heavy double gates and a corner watchtower complete its stockade-like appearance and a series of long shots reveal that the Colonel and his men are patiently waiting close by in a single ominous row that stretches from one edge of the screen to the other. This is a formation that earlier Hollywood Westerns like *Fort Apache* had traditionally employed to introduce aggressive Indians. Significantly, the revisionist Hollywood Western *Little Big Man* (1970) uses this same formation to ominously introduce General Custer's men as they prepare to attack the Indians at the Battle of the Little Bighorn.

Brinkley's mastery of martial strategy is evidenced when it is revealed that his men possess a number of bulletproof shields that they have made by tightly binding woollen blankets into thick cylindrical rolls. The bulletproof rolls, which each effectively allow one man to safely crouch behind them, are slowly pushed towards the farm by Brinkley's men. The slow rolling nature of these devices, and the fact that the men who are pushing them will soon unleash a torrent of flaming torches and exploding grenades, makes this scene play like a tank attack sequence from a war film. When he sees the blanket rollers Old Shatterhand cries 'they're going to set us on fire!' and much of what follows (shots of burning buildings, explosions, close-quarters gunplay and desperate hand-to-hand combat that is shrouded in wafts of thick black smoke) seems designed to evoke the trauma of modern urban warfare.

The use of fire as a weapon is a trait that is most generally associated with Indians in Hollywood Westerns like *Stagecoach*. And once Brinkley's men have set Butler's Farm ablaze in *Silver Lake* they duly

attack the stockade in much the same way that Indians would attack a fort in a Hollywood Western. Brinkley's men ride around the farm in circles, allowing some of their number to be picked off, before its walls are eventually breached and its front gates forced open. Given that Greb has observed that, in Hollywood Westerns, the Indians were employed 'as the props [that were] necessary to bring out the cavalry' (1998: 129) this scene's next development is very striking. When all seems lost, it is not the cavalry but Indians who come to the rescue here. Instead of the traditional sound of a military bugle signalling impending relief, it is the generic war cry of Indians (a sound that the inhabitants of a farm or fort in a Hollywood Western would dread to hear). As it turns out, Winnetou has enlisted the help of a tribe of heroic Osage Indians who engage the Colonel's men and successfully drive them off, thus saving the day. Old Shatterhand greets Winnetou with the words 'my brother' (an affectionate term that both characters use throughout the series) and Winnetou tells him that 'the Osages are our friends'. Bemoaning Hollywood's representations of Native Americans, Greb wonders whether the Indians will ever be 'successful against the white man' (1998: 142). The Osages are clearly successful against Brinkley's men in *Silver Lake*. This scene, which highlights the fearsome fighting skills possessed by a party of Indians warriors but casts them as a heroic force that is acting for a 'good' cause is surely a significant moment in the history of the cinematic Indian's rehabilitation.

The attack on Butler's Farm introduces a number of themes that resurface in later films in the *Winnetou* series. Writing about *Among Vultures*, Bean observes that an 'important ingredient in German Westerns now is to have a fire, no matter what the reason, and it helps to fill the Cinemascope screen' (1965a: 54). Close inspection of the *Winnetou* series reveals an inordinate number of set pieces that revolve around the devastatingly destructive use of fire and explosives as weapons. In *Among Vultures*, a German character's ranch is set ablaze by villains and extreme long shots of burning buildings and close-ups of fiery timbers are employed to telegraph the ferocity of the fire. The series' obsession with representing fire's destructive properties perhaps reaches its zenith in Harald Reinl's *Last of the Renegades* (1964). Here the villains dynamite an oil reserve resulting in a gigantic firestorm that duly consumes scores of hapless workers who had

been press-ganged into forced labour. Shot after harrowing shot shows the burning workers desperately trying (but ultimately failing) to outrun the firestorm. A close-up of one man's hands and burning shirtsleeves reveals that he is desperately trying to claw his way up a hill to safety but the following long shot shows the man and his companions falling backwards into a pit of flames.

Similarly, a war film-like aesthetic is found throughout the series. In *Last of the Renegades* the villains again use slow-moving, tank-like shields (thick tree branches that are lashed together and attached to rolling wagon wheels) to advance upon Winnetou, Old Shatterhand and Lord Castlepool. When this tactic fails the villains construct rudimentary catapults that are used to launch explosives at the cornered trio. Harald Philipp's *The half-breed* (1966) ends with ordinary civilians locked in close-quarters combat with an army of villains and the battle is waged amongst the streets of a town that is being shattered by dynamite-induced explosions. Set amongst the shattered cities that had been bombed by the Allies, the post war German Rubble films dealt with the destructive after effects of warfare on ordinary citizens. Rather than simply being a device that serves to fill the screen with spectacle, I would argue that the intense fire and explosives-orientated scenes encountered throughout the *Winnetou* series are designed to allegorically show what the Rubble films did not: the harrowing moment of destruction when ordinary citizens perished amidst the explosive firestorms of World War II. As such, it is possible that these pyrotechnics-laden scenes worked to evoke the German cultural memory of Allied tank and plane attacks on cities like Dresden and Berlin and actually functioned as allegorical reminders of German victimhood.

The familiar dynamics of the Indian attack scenarios that were commonly found in Hollywood Westerns were subverted in further set pieces that appeared throughout the *Winnetou* series. For example, in *Among Vultures*, Old Surehand (Stewart Granger) and his German associates Annie Dillman (Elke Sommer) and Martin Baumann junior (Götz George) are travelling in a wagon train that is attacked by bandits. The wagon train forms itself into a circle (the traditional defence pattern that wagon trains adopt when they are attacked by Indians in Hollywood Westerns) and the bandits duly act like Hollywood Indians (circling the wagons, allowing themselves to be picked off and using fire as a weapon). When all seems

lost, Winnetou rides to the rescue with a squad of heroic Shoshone Indian warriors (as opposed to the cavalry). Interestingly, at the height of the battle a small boy grabs a rifle and attempts to assist with the defence of the wagons. Despite their desperate circumstances, Old Surehand refuses to let the child fight and he confiscates the rifle and deposits the boy in the back of a wagon. As such, this detail plays like a critique of the Nazis' decision to send boys into battle during the final days of World War II. Ultimately, the Indians replace the cavalry as the saviours of innocent (often German) characters in most of the *Winnetou* films.

Allegorical references to the recent past 2: fascist figureheads, genocide and war crimes trials

Given that the German war films of the 1950s sought to mark a distinction between regular German foot soldiers and the Nazi officer class (who were shown in a questionable light), the fact that *Silver Lake*'s chief villain, Colonel Brinkley, is an ex-military officer who possesses a number of stereotypically fascist attributes and characteristics provides a sense of continuity here. Brinkley demands that his every order is obeyed in an authoritarian manner that is reminiscent of Nazi attitudes. When one of his men questions his strategies he snarls 'you refuse to obey?' before shooting the man dead and asking his stunned underlings '[does] anyone else have something to say?' When Brinkley holds Patterson and Ellen as prisoners during the siege at Butler's Farm he tells his men 'if they try to escape, shoot to kill', and he plans to burn down the farm and hang any prisoners if his demands for the second part of the treasure map are not met. When Brinkley holds Fred and Ellen as prisoners at the end of the film he gets Fred to reveal the location of the treasure by pointing his gun at Ellen and barking 'talk or she'll pay with her life'. Brinkley also sports a pair of black leather gauntlet gloves and he uses his ever-present whip to flog those who displease him. As noted by Susan Sontag (1980), these kinds of accoutrement typically serve to make up the fetishitic image of the Nazis that has become common in post war culture.

Furthermore, Brinkley employs the kind of body language, posturing and oratorical bluster that is commonly associated with Adolf Hitler and Benito Mussolini. Towards the end of the film, Brinkley's exhausted

men begin to flag and are reluctant to move when he tells them that they must continue on to the next stage of their journey without sufficient rest. Sensing that the time is right to reveal the true nature of their quest, Brinkley flatters his men, telling them that 'it's a big job and I absolutely need every single one of you' as he positions himself atop a high stone wall. Brinkley is framed within a medium shot, which is shot from below in order to represent his men's point of view and to underscore his commanding presence. Brinkley places his hands on his hips in an authoritative manner and gently elicits curiosity from his weary men by asking them 'have any of you men ever heard of a treasure that's supposed to be at Silver Lake?' A reverse-angle long shot of Brinkley's despondent men shows them slowly taking interest in what he is saying and cautiously moving towards him to hear more. Another medium shot of Brinkley – still with his hands placed confidently on his hips – has him pointedly glancing at individuals in his audience before telling them that 'our objective is to find the treasure of Silver Lake!' He pauses for dramatic effect before sharply thrusting his arms skywards and demanding 'Are you with me!?' A second reverse-angle long shot of the instantly reinvigorated men shows them running towards the Colonel with ecstatic and adulatory expressions on their faces and their loyalty to their leader is soon reaffirmed via frenzied cheers and triumphantly waved rifles.

Perhaps confirming the suggestion that Brinkley represents a hateful Nazi-like figure, the Colonel and his men actually commit an act of genocide. As they journey to Silver Lake after the siege at Butler's Farm, a left-panning long shot follows Patterson and the treasure seekers who are riding in single file until Winnetou, who is leading the party, instructs them to halt. The camera continues panning to the left and Ellen is heard to ask 'What's all that smoke?' The camera comes to rest and focuses on the billows of smoke that can be seen in the far distance. The shot is held for emphasis and somebody is heard to reply that it 'must be a campfire', before Winnetou's voice is heard grimly intoning 'No. This smoke [is the] smoke of death.' A subsequent medium shot shows Winnetou and Old Shatterhand firing knowing and concerned glances at each other before cautiously riding forwards. As the non-diegetic soundtrack music takes on a mournful air, a shot that frames the top of a soot-marked totem pole and the peak of a charred wigwam slowly tilts

downwards to reveal a scene of absolute devastation. As the camera pans first left then right, it takes in a series of burnt out wigwams that are set amid smouldering ashes. Among the ashes are the bodies of dead Indian women and children. In *Broken Arrow*, Jeffords makes an oral reference to the wholesale murder of Indian women and children by whites but no visual depiction of any kind is offered. Indeed, Hollywood Westerns rarely (if ever) provided visual evidence of such atrocities until the revisionist Westerns of the 1970s. Old Shatterhand deduces that Brinkley and his men are responsible for the carnage and Winnetou confirms that 'they have murdered all women and all children … [while] all the men out hunting buffalo'.

By overseeing the systematic slaughter of the village's women and children Brinkley has effectively committed an act of genocide: the village's new blood in the form of its children is gone, as is its ability to produce more children. Gemünden asserts that the *Winnetou* films 'make an effort to deflect any connections to recent German history' by casting non-Germans as lead and supporting actors (2002: 249) but this act of genocide, the fact that it was ordered by a fascistic military man and the use of fire in a way that produces a recognizable 'smoke of death' would all seem to make this sequence a pointed reference to the Holocaust and the ovens and chimneys of Nazi extermination camps. The early 1950s televised stage productions of *Winnetou – 1. Teil* appeared soon after the Nuremburg war crimes trials. As such, Sieg suggests that Old Shatterhand's trial for the deaths of Indians, his subsequent vindication, the blossoming of his friendship with the initially hostile Winnetou and the acts of ethnic drag that were necessarily employed to bring Winnetou and his tribesmen to life possessed important functions (2002: 13). They allowed Germans to put some 'geographical and historical' distance between themselves and the concept of genocide while also providing 'different identifications in the story of racial aggression' which duly allowed 'Germans to align themselves with the victims and avengers of genocide, rather than its perpetrators and accomplices' (Sieg, 2002: 13). With *Silver Lake* appearing just after the trial of Adolf Eichmann, its explicit discourses about genocide, culpability and German relations with the racial 'Other', along with its use of ethnic drag, might be presumed to have functioned in exactly the same way.

Just as with the attack on Butler's Farm, the film inverts another staple of the Hollywood Western with its presentation of an attack on an Indian village: when the males of the village suddenly return from hunting, it is the white characters (and Winnetou) who are forced to cower in a burnt out wigwam which offers inadequate protection while the angry Indians launch an assault. At this point Old Shatterhand calls to them 'It wasn't us. *We* didn't destroy your village ... *We're* friends. Friends of the Indians.' Given that the film was produced when war trials crimes were provoking public discourse about the Holocaust, it is possible to read this scene's content on two levels. Within the diegesis of the film, Old Shatterhand is asking the Indians to accept that not all white men are hostile towards Indians. But, given that Old Shatterhand's 'we' includes at least two German characters, his words also work to symbolically distance 'good' Germans from acts of genocide. The treasure-seekers eventually drive off the Indians without bloodshed by following Old Shatterhand's orders to shoot their horses out from under them.

During the course of the attack Ellen flees and is captured by Brinkley, who issues another ransom demand for the treasure map, which prompts Old Shatterhand to formulate a plan. Fred will tell Brinkley that the Indians killed the rest of the party, resulting in the loss of the map, but he will offer to use his memory of the map's content to guide the villains to Silver Lake, albeit via a roundabout route. Winnetou will watch over Fred and Ellen from a distance while Old Shatterhand and company use the map to get to Silver Lake first, thus giving them time to set a trap. However, when Old Shatterhand's party get closer to Silver Lake they are attacked by a band of Utah Indians and another debate about culpability for the genocide ensues.

Old Shatterhand asks them 'What have we done that the Utah should attack us?' Big Wolf, Chief of the Utah replies 'You destroyed a village. Killed women and children.' Old Shatterhand responds by exclaiming 'That's not true! We're sorry but it wasn't us who burned your village to the ground. ... I've never lied in my life! None of us has ever harmed the Utahs.' The question of justice for the genocide victims is raised and Big Wolf demands that the white men 'come with us and be judged by tribal council'. Old Shatterhand asks 'As friends?' only to be told 'As prisoners!' Old Shatterhand refuses but when the Chief again demands 'Do you agree to accept judgement of tribal council!?' he acquiesces with the words

'Alright. If you promise to treat us as guests.' Here the Indians are justifiably aggressive in their efforts to seek justice and the scene grants them a sense of entitlement and empowerment rarely afforded to the Indians found in Hollywood Westerns. But the scene also demands to be read as an allegorical comment on the contemporaneous question of culpability for the racially motivated war crimes committed by the Third Reich. The scene elicits sympathy for the Indians' violent loss and acknowledges that they are victims who deserve justice, but it also suggests that the perpetrators must be properly identified before being sent to trial in an appropriately legal and impartial manner. Parallels can thus be drawn between this scenario and the discourse surrounding the Nazi war crimes trials of the early 1960s.

Criticizing Hollywood's representations of Indians, Greb wonders when a realistic representation of an Indian living 'with his wife, [and] happily enjoying his children' might be seen onscreen (1998: 142). Although it falls short of the kind of detailed scenario that Greb would like to see, *Silver Lake* does feature a sequence that shows that the Utah Indians are family men who live in a family orientated society. As the Utah warriors are returning to their village with Old Shatterhand and company, a young squaw who is gathering firewood on the outskirts of the village notices them approaching. Happy to see them, she drops the wood and rushes back to the village to announce their arrival. The influence of Romanticism can perhaps be felt in the series of short but detailed shots that subsequently offer a snapshot of the Indians' simple but idyllic family life: young children are seen happily playing games, while their mothers are busy cooking and their fathers are busy treating animal furs.

The tribe's medicine man dances and its drummers drum while the tribe's elders discuss the trial that Old Shatterhand must undergo. All of this is presented in a very matter of fact way that avoids the kind of threatening hyperbole found in Hollywood Westerns that feature similar scenarios: here the Indians' drum beats are not doom-laden, the tribe's medicine man does not indulge in frenzied, superstitious or aggressive behaviour and the tribal council's discussions are thoughtful and measured. None of these Indians consume alcohol, behave wildly or cruelly torment their captives: they instead stand in silence, patiently and respectfully waiting until their council announces the details of the trial. Old Shatterhand must face

Big Wolf in combat and a noticeable sense of racial hierarchy akin to that found in Hollywood Westerns is perhaps present here in the sense that Old Shatterhand defeats the Indian by knocking him out cold. But Old Shatterhand is magnanimous in his victory, telling the gathered Indians that 'his scalp belongs to me. But I don't want it. I'm a friend of the red men. He's not dead. I give you his life.'

The significance of the landscape

The Utah Indians honour Big Wolf's agreement to let the white men leave in the event of Old Shatterhand winning the trial and the party resume their journey to Silver Lake. However, while Big Wolf is still unconscious a disgruntled warrior, Rolling Thunder, cajoles the Utah warriors into pursuing Old Shatterhand and company with violent intent. Thankfully Winnetou has come looking for Old Shatterhand after realizing that Brinkley is winning the race to Silver Lake and the Indian spots the pursuing Utah warriors and formulates a plan to broker a peaceful solution. It is on the final leg of the journey to Silver Lake that scenery becomes a particularly important element. Much like the German Mountain films, Bergfelder notes that the *Heimat* films displayed 'a marked priority of "scenery" and location in relation to narrative progression, a priority that manifests itself in an obsessive use of panoramic long takes and digressive shots of animals and mountain vistas' (2005: 40). Bergfelder duly acknowledges that a similar approach can be found in the May Westerns too (2005: 197).

On the way to Silver Lake, both parties pass through increasingly greener landscapes and an extreme long shot captures Brinkley's gang travelling across the top of a lush plateau. As the camera slowly pans left to right in order to follow their progress, the viewer is struck by the spectacle of huge mountains that stretch for miles into the distance while also being slightly unnerved by the revelation that the plateau's dirt track gives way to a severe long drop that has an attractive, slow-running and winding river at its base. At the next stage of their journey, the party is dwarfed (quite literally figures submerged in a landscape) when it passes by sheer rock faces that are enlivened by beautiful waterfalls before encountering a series of small lakes. Director Harald Reinl is clearly drawing attention to the scale and beauty of the film's natural and noticeably scenic *mise-en-scène*

at this point but nothing can prepare the viewer for the sublime magnificence of the picturesque land encountered at Silver Lake itself. Accessed via a womb-like tunnel in a rock face, a series of painterly shots reveal that the tranquil and crystal clear Silver Lake is guarded by dense leafy forests while being fed by a series of charming waterfalls. Brinkley's men immediately begin to despoil this area of natural beauty by felling trees in order to build a raft.

Lotte H. Eisner observes that 'German cinema is a development of German Romanticism' (1973: 113) and this is certainly reflected in Reinl's approach to capturing the landscape here. However, the sublimely beautiful landscapes seen around Silver Lake also mirror the kind of pastoral settings seen in early US Westerns that were shot in lush green areas near America's East coast. Simmon details a cycle of early American Westerns that were produced between 1908 and 1910, whose general look and narratives were greatly informed by James Fenimore Cooper's literary work (2003: 51). The visual style and narrative themes of these silent pro-Indian films were soon discarded by Hollywood and forgotten by the film-going public. However, Cooper's influence on May seemingly results in some of their key tropes and symbols resurfacing in the *Winnetou* films. In the early East Coast Westerns, Simmon sees a 'green and watery woodland' that represents 'a simpler, more childlike' world (2003: 20) wherein white–Indian friendships can flourish and efforts can be made 'to reconcile certain irreconcilable claims about possession of the land' (2003: 22). When Simmon acknowledges the influence of the Cooper stories that cast 'the frontier as a place of fragile harmonies, all the more valuable for its susceptibility to ecological ruin' (2003: 15), the concerns of German Romanticism are also brought to mind. The final scenes in *Silver Lake* (in common with a number of films in both the *Winnetou* series and DEFA's East German *Indianerfilme* series) share these self-same properties. Interracial harmony and the reconciling of disputes concerning the possession of land are the key themes of the scenes that unfold at Silver Lake and, after being established here, these concerns dominate the remainder of the *Winnetou* film series.

Silver Lake is set within the hunting territory of the Utah Indians who are at liberty to defend the land from any trespassers. However, when Big Wolf regains control of the Utah warriors after deposing the disgruntled Rolling Thunder, the Utah Indians see fit to make peace with Old

Shatterhand and company, effectively forming an interracial/intercultural defence force in order to jointly tackle Brinkley and his men. Simmon notes that the 'image of leisurely canoeing across a smooth lake that mirrors the forest' was the 'filmic shorthand for harmony' in America's Cooper-influenced silent Westerns (2003: 16). As such, Reinl spectacularly employs what might be considered the ultimate symbol of interracial harmony out West when Old Shatterhand and Winnetou share a canoe ride across the sublimely beautiful Silver Lake. A long shot captures the pair paddling in unison and, significantly, it is Winnetou who is seated at the front of the boat in a commanding position. It is clear that, by dint of Cooper's influence on May, the *Winnetou* films do in part feature the long-forgotten visual style and tropes that are associated with America's early Cooper-influenced Westerns. This link would also perhaps explain why the diegetic West of the *Winnetou* films has been erroneously criticized for being too simplistic and naive.

Simmon asserts that early East Coast American Westerns briefly promoted a new myth of the West, a 'myth that has something to do with creating an ideal community' whose sense of inclusiveness even welcomes Indians (2003: 25). The same approach is found in the *Winnetou* films. All manner of eccentric white characters who lack normative social skills – the hobo-esque Sam Hawkens, Uncle Gunstick (the proto-beatnik 'poet of the prairie'), Lord Castlepool (the daffy English butterfly hunter), the jittery Old Wabble, Lord Tuff-Tuff (the eccentric photographer) and Kantor Otto Hampel (the oddball opera-composer) – are comfortably integrated into an ideal community where right-minded whites and Indians are able to promote and foster peaceful co-existence. Indeed, Sam Hawkens actually functions as a symbol of forgiveness: throughout the series Hawkens openly shows that he has been in conflict with Indians in the past by revealing that he has been scalped. However, he bears no grudges, taking each Indian as he finds them and choosing to befriend Winnetou and others. Interestingly, Sabine Hake indicates that 'symbolic acts of reconciliation' and 'the confrontation with difference and its successful assimilation and incorporation' are also key elements of the German *Heimat* films (2008: 118) which again suggests that the *Heimat* films and the *Winnetou* films actually functioned in similar ways.

Romanticism, Mountain films, inter-generational conflict and notions of Heimat

At the end of *Silver Lake*, nature herself effectively despatches the villainous Brinkley. Carsten Strathausen notes that Romantic painting and nature poetry often feature 'the allegorization of nature's interior ... which often represents the unconscious or dark side of human nature that the hero has to explore, frequently with devastating consequences' (2001: 177). In *Silver Lake*, the eponymous treasure is made of gold – a natural element mined from the earth's interior – and it is hidden in a cave, the literal representation of the inside of a mountain. Romantic imagery is subsequently put to good use here: once inside the cave, the dark side of Brinkley's nature possesses him and he murders three of his own men as they fight among themselves for possession of the gold. But before Brinkley can enjoy his ill-gotten gains, the elderly Indian charged with guarding the gold triggers a booby-trap which sends Brinkley and the gold crashing down a crevice and into a pit of quicksand. Strathausen makes reference to sequences that depict 'the classic plunge into the abyss' in Arnold Fanck's Mountain films (2001: 176) and, with an avalanche of golden trinkets replacing snow and ice, Brinkley's fall into the crevice in *Silver Lake* is staged and shot in a similar manner to the dramatic falls seen in countless German Mountain films. Significantly, confrontations inside caves and falls down rock faces play a part in the deaths of a number of villains throughout the *Winnetou* series. Slowly sinking in the quicksand, the noise of nearby waterfalls drowns out Brinkley's cries for help.

It is possible to read an anti-capitalist subtext in May's original stories and the white characters' avaricious lust for treasure results in the gold's potentially destructive nature being repeatedly foregrounded throughout *Silver Lake*. Fred Engel's changing attitude towards the gold is particularly illuminating. At the start of the film, Fred is in an excitedly delirious state as he waits for his father to return with a claim to the land at Silver Lake. He has been sworn to secrecy but he cannot resist smugly boasting to his drinking partners that his family will soon be 'rich! Really rich!' Later, when his father has been killed, Fred tells Old Shatterhand 'I don't want the treasure anymore now. You can have it. If you'll help me find my father's killer.' The

honourable and wise Old Shatterhand has no interest in the gold, replying 'No, my friend, you can't buy me. However, for the sake of justice, I'll help you.' When Brinkley lays siege to Butler's Farm, Fred wants to exchange the second half of the treasure map for the captured Pattersons and he sadly observes that 'this treasure has already caused too much unhappiness. We managed without it before.' When the Pattersons are subsequently rescued, Fred tells Ellen that 'the old Indian chief was right, the treasure will only bring us misfortune. It was a miracle you weren't killed like my father was.'

This last comment throws serious doubt upon the integrity of Fred and Ellen's fathers. Despite the warning given by the old chief who gave them the map, Engel and Patterson both took deliberate actions that set the treasure hunt in motion. Both men were also aware that the treasure belonged to – indeed was situated on the hunting grounds designated to – the Utah Indians but they were happy to falsely lay claim to the land and, by default, the treasure. This element of the film's narrative mirrors Romanticism's concerns about modernity's encroachment upon the trad- itional idyll: a simple pen stroke on a seemingly innocuous land claim form in an office miles away in Salt Lake City holds the potential to take land and treasure away from its rightful owners, the Utah Indians. The duo's callous attitude is perhaps reflected in the fact that they choose to tear the treasure map into two halves, symbolically ripping apart and despoiling the sublime landscape of Silver Lake. There is much irony in the fact that Silver Lake is a dreamy idyll of outstanding natural beauty but the white men only see value and significance in the golden treasure that is hidden there.

As it turns out, the treasure is guarded by an elderly and frail Indian, who is mercilessly battered about the head when he tries to prevent Brinkley's men from taking it. It must be presumed that Eric Engel and Patterson would have used similar force against the elderly Indian if their original plans had come to fruition. Furthermore, the duo's plans would have ultimately resulted in the Utah Indians being driven from their homelands. The loss of their homelands (or *Heimat*) is an experience that, historically, Native Americans and Germans have shared and the loss of Indian homelands is a theme that bubbles away below the central narra- tives of most of the *Winnetou* films. It is this theme that primarily serves as an ongoing critique of American imperialism within the series. In terms of the Indian characters, its most significant manifestation is presented

in Harald Reinl's *Desperado Trail* (*Winnetou – 3. Teil*, 1965). In this film, Winnetou's Apaches are forced to retreat from their homelands because of the threat posed by the villainous Rollins (Rik Battaglia) and the army of Jicarilla Indians that he has co-opted for his land-grabbing cause. The Apaches' subsequent struggle for justice is so titanic and hard-fought that it actually results in the death of Winnetou. The producers of *Desperado Trail* could not avoid including Winnetou's emotionally charged onscreen demise here, as the noble Apache's heroic death was a commonly known feature of the Karl May novel that the film was based on. But Winnetou would, nonetheless, return for further adventures in later films.

There is a sense of lost homeland that affects the films' white characters too. When Curly Bill and eighty of his men invade a town in *The half-breed*, the locals have no choice but to evacuate. With wagons loaded, one old timer tells Old Shatterhand that 'We don't know where we're going, but we're going.' When Old Shatterhand sees the local doctor leaving, he implores of him 'Doc, you've got to stay, you're needed here.' With women being sexually molested, houses looted and citizens being shot at as they speak, the doctor adds 'I would stay but tell me, who needs me since every one of my patients here will be going too.' Harald Philipp's *Rampage at Apache Wells* (*Der Ölprinz*, 1965) features a further German émigré, Kantor Otto Hampel (Heinz Erhardt), who has 'just arrived from the Old Country' and feels completely lost out West. Hampel is searching for a new home with his widowed sister and the film features a variety of two-shots that show the pair riding atop the wagon that contains all of their worldly possessions. When Hampel is bullied and cheated by local villains, his sister observes that 'these people take advantage of foreigners'. These scenarios involving white refugees and German émigrés in particular possess obvious parallels to the post World War II upheavals experienced by the Germans who fled the Eastern territories. Alasdair King indicates that, within the *Heimat* films, 'social and ideological problems, often concerning territory and identity, achieve a positive resolution' (2003: 133) and the same is true of the *Winnetou* films. All of the above films end with their morally sound characters (both Indian and white) returning to – or, in the case of Hampel, finding – a happy homeland.

Silver Lake's central narrative (greed-driven lust for a legendary natural treasure that is hidden in a mountain cave) and much of its visual

iconography (mountains, streams, lakes, leafy hills, idyllic valleys, waterfalls, shots of sublime landscapes that are overwhelming in both their scale and beauty, death by falling) can be fruitfully compared to Leni Riefenstahl's iconic German Mountain film, *The Blue Light* (*Das blaue Licht*, 1932). In that film, a mountain girl, Junta (Leni Riefenstahl), tries to hide the secret of a mountain route – that leads directly to a cave full of precious crystals that glow in the moonlight – from avaricious locals and visiting city folk alike. Eric Rentschler suggests that the diegetic landscape in Riefenstahl's film represents a 'true homeland' set in a 'sublime and special space' that ultimately 'sanctifies elemental nature and its enchanting powers' (1996: 30). The same could be said of Silver Lake and several other diegetic locations found throughout the *Winnetou* series. However when viewed with Brinkley's coding as a fascistic figurehead in mind, the themes of wilful land-grabbing and the wanton theft of natural resources and cultural treasures that are central to *Silver Lake*'s narrative read like allegorical critiques of Nazi Germany's aggressively expansionist foreign policy. Again, similar themes litter the whole *Winnetou* series.

Interestingly, the series regularly features fathers/father figures who have kept secrets (usually pertaining to gold) from their children. When these secrets are made public or are discovered by third parties, the fathers/father figures either die or have their relationships with their children negatively affected. The air of suspicion that these secrets often arouse and the subsequent sense of dislocation that they prompt between fathers/father figures and their children can be likened to the themes of the later New German Cinema films. At the start of *Silver Lake*, Fred proudly declares to his drinking partners in the saloon that 'there's not a better nor a more honest man alive than my own father'. As it turns out, this is not entirely true: Fred's father's greed eventually results in his integrity being called into question by his son and his subsequent death leads to Fred becoming fatherless. Similarly, at the film's denouement, a gulf is apparent between Ellen and her father. As the treasure hunters fan off in order to begin their journey home, it is clear that Ellen has rejected her morally ambiguous father and is now aligned to the morally sound younger generation in the form of Fred. This represents a real turnabout as when we first meet Ellen, she is a 'daddy's girl' who is out fishing with her father.

The film's final long shot of Winnetou and Old Shatterhand waving goodbye to their friends is significant too. In Hollywood's pro-Indian films from the early 1950s, the early 1970s and the 1990s, possession of the final shot of the film tends to be the sole privilege of the pro-Indian white character. Often, as in *Broken Arrow*, these final shots are imbued with an explicit assertion that time has passed and the Indian characters (and their interracial friendships) are a memory of a time that no longer exists. In *Silver Lake*, Winnetou and Old Shatterhand share the final shot on an equal basis and the fact that they are seen galloping back into the womb of the mountainous wilderness from whence they emerged at the start of the film suggests that their adventures together (and the interracial friendship that they share) are set to continue. In this respect, the ending of *Silver Lake* – and those of a number of other films in the *Winnetou* series – represents a further marked progression in the way that white–Indian relations have been depicted on cinema screens.

Indeed, even the Hollywood Westerns of the 1970s that sought to show their Indians in a more realistic and sympathetic light featured endings where distance or dislocation disrupted their white–Indian relationships. In *Little Big Man*, Jack Crabb (Dustin Hoffman) is an extremely old man who is telling the story of his long life – including those episodes that feature his long-dead Indian friends and family – to a historian. In *Soldier Blue*, Cresta (Candice Bergen) is a white woman who sees most of the Cheyenne Indians she has lived amongst – and, in particular, her estranged Indian husband – massacred by the cavalry. In *A Man Called Horse*, John Morgan (Richard Harris) leaves the Indian camp where he has become accepted as an equal when his Indian wife, brother-in-law and mother-in-law die. In J. Lee Thompson's *The White Buffalo* (1977), two warrior legends of the West, Wild Bill Hickok (Charles Bronson) and Crazy Horse (Will Sampson), team up to hunt down a monstrous white buffalo that has been visiting them in nightmares. With their mission in multiracial cooperation accomplished, both men sadly acknowledge that the colour of their skin means that if they should ever meet again it will be as enemies. Even *Dances With Wolves* (1990), a later but much celebrated pro-Indian Hollywood Western, ends with its white protagonist Dunbar (Kevin Costner) leaving behind the Indians who he has lived amongst.

Groundbreaking representations of interracial romances: *Winnetou the Warrior* (1963) and *Last of the Renegades* (1964)

The *Winnetou* films are also groundbreaking in the way that they represent interracial romances and the mixed-race offspring that are born of such relationships. Buscombe notes that:

> the most striking thing about … [the pro-Indian Hollywood Westerns of the 1950s] … is their almost obsessive interest in the question of mixed marriage … Fully half of the forty films viewed [from this period] contain a character who engages in some sort of sexual relationship across the racial divide, but never without difficulty; that is to say, the relationships are never 'normal' or 'natural' – instead there is always a problem of some kind.
>
> (2006: 125)

Jacquelyn Kilpatrick asserts that most interracial relationships found in Hollywood Westerns are 'doomed': 'if the relationship involves a white man and an Indian woman … the Indian woman will die' (1999: 63). Buscombe contends that these interracial relationships sometimes result in 'happy endings' but he was only able to find five loose examples of this in the Hollywood films that he examined (2006: 127). The trajectory of the interracial romance found in *Winnetou the Warrior* largely conforms to the Hollywood model: Old Shatterhand falls in love with Winnetou's sister Nscho-tschi (Marie Versini) but she is killed by villains before the relationship can fully develop.

However, the representation of Old Shatterhand and Nscho-tschi's flirtatious and loving relationship in *Winnetou the Warrior* was actually a boldly revisionist move on the part of the film's West German producers. Sieg notes that in the original novel, and very early stage adaptations, Nscho-tschi is a strong woman who is Winnetou's equal and this Amazon-like huntress talks back to Old Shatterhand – who begins to have doubts about the marriage – while occasionally dressing in masculine clothes (2002: 95). Furthermore, Sieg indicates that versions of the novel published during the Nazi era and stage productions produced during the 1950s all dismissed outright the possibility of Old Shatterhand entering

into a mixed marriage and Nscho-tschi's love for the German was emphasized to be unrequited (2002: 108). As such, the decision to present a reciprocal interracial love affair in Reinl's film (albeit one with a conservative and tragic ending akin to a Hollywood Western) appears to be a conscious move that in turn signalled that the German people were now able to relate to racial 'Others' in romantic ways.

In *Winnetou the Warrior*, Nscho-tschi is a beautiful 'Pocahontas' type but she is headstrong enough to defy Winnetou and she succeeds in a mission to find the proof that confirms that Old Shatterhand surreptitiously freed Winnetou from his Kiowa enemies. Interestingly, when Old Shatterhand is erroneously set to stand trial for race crimes against the Apaches and pleads his innocence, Nscho-tschi counters with the words '[he] who does not prevent injustice is as bad as the guilty man' – a line that brings to mind Martin Niemöller's famous quotation concerning the German public's apparent acquiescence in the Nazis' sectarian purges ('First they came for …'). The film does feature a second, more incidental interracial romance that does represent a break with Hollywood's representation of such relationships. Sam Hawkens charms an Indian girl who is precisely the kind of female Indian who would be mocked in a Hollywood Western: plain looking, overweight and not naturally sexually attractive, she brings to mind the love-struck Indian woman Look (Beulah Archuletta) who inadvertently becomes married to Martin (Jeffrey Hunter) in *The Searchers*. Look is mocked and treated appallingly by both Martin and Nathan (John Wayne) before being callously assaulted, interrogated and rejected by Martin. Unlike Martin, Hawkens wants to be with his Indian girl but she makes it plain that it must be on her terms ('No marriage, no love') and, when his wig comes off and reveals his scalping scars, it is she who rejects him. Again, this interracial love affair has a conservative ending but it is significant because all of the power lies with the ethnic female in this instance.

Furthermore, as the *Winnetou* series progressed it was able to represent an interracial romance that did enjoy a happy ending. *Last of the Renegades* opens with Winnetou rescuing an Assiniboine Indian woman, Ribanna (Karin Dor), from a wild bear. While Ribanna looks like a 'Pocahontas' type, she is actually a strong female: although she has been badly mauled, she is seen ferociously fighting with the bear until Winnetou intervenes

and kills it. Ribanna subsequently declares that she 'does not feel pain' and proves to be an expert shot with a bow and arrow. Winnetou falls in love with Ribanna and is set to marry her but she eventually agrees to marry a young US Army Lieutenant, Robert Merril (Terence Hill), in order to secure a peace deal. Alas, Winnetou's peace plans are put in jeopardy when Forrester (Anthony Steel), a ruthless oil baron who wants to drill for oil on Indian land, has his men massacre a tribe of Ponca Indians. And further complications arise when Colonel J. F. Merril (Renato Baldini) – who is Robert's father and the Army's chief negotiator – is revealed to be an insensitive military man who prefers to meet the Indians' calls for justice with acts of aggression.

On one level, Colonel Merril can be understood to represent the *Winnetou* series' most scathing critique of American imperialism. However, the two Merrils also appear to allegorically represent two distinct generations of Germans. An unquestioning cog in the military machine, Colonel Merril maintains that 'as a soldier I carry out the orders issued [to] me'. As with Wessels in *Cheyenne Autumn*, Merril's words seemingly mirror those of the Nazi war criminals who stood trial for racially motivated war crimes at Nuremberg. When Forrester's right-hand man, Lucas (Klaus Kinski), dupes Colonel Merril into believing that Assiniboine Indians have attacked a wagon train, the Colonel sanctions genocide when he tells his men to 'shoot to kill every last Assiniboine you can locate and destroy … I order my soldiers not to show any mercy at all'. Merril's son represents a new generation and a new way of thinking. When peace talks begin to break down because of his father's belligerent attitude, Lieutenant Merril declares 'I believe that the white man and the Indian must live together in peace'. When the racist Colonel Merril orders him to stop talking in such a way, Lieutenant Merril refuses and instead cajoles the members of the visiting Indian council to sanction his marriage to Ribanna. This act leads to Lieutenant Merril's dismissal from the Army and a rupture in his relationship with his father that can be likened to the scenarios of inter-generational conflict typically found within both the *Heimat* and the New German Cinema films.

The younger Merril's attitude seemingly chimes with contemporaneous developments within Germany's own armed forces. The idea that the longstanding Prussian military code of absolute obedience had played a

significant role in the war crimes that were committed by the German army during World War II had to be addressed when the question of restoring Germany's armed forces arose in the early 1950s. Kapczynski notes that a top secret document, the Himmeroder Memorandum, served to articulate 'a new concept of soldiering' in Germany by foregrounding the principles of 'inner guidance' and 'the citizen in uniform' in order to promote a more democratically structured army that was 'compatible with the preservation of civilian liberties' (2010: 17). We see precisely this kind of attitude evidenced again later in the film when the reluctant officer who has been ordered to lead the extermination of the Indians visits ex-Lieutenant Merril in the hope that bloodshed can be avoided. The officer tells the younger Merril 'I'm a soldier and I must follow the orders that I am given. I shouldn't be here revealing them to you but you're my friend and I had to. I thought you might be able to do something.' This scenario also brings to mind Old Shatterhand's outlook in *Winnetou the Warrior*. Old Shatterhand is a loyal and trusted employee of the Great Western Railroad but he refuses to simply toe the company line when he discovers that rail tracks have been laid on Apache territory in violation of a peace treaty and instead acts as a responsible citizen. *Last of the Renegades* seemingly seeks to reflect further on Germany's Nazi past during an episode in which Old Shatterhand and Lord Castlepool endure a spell in one of Forrester's forced labour camps where the summary execution of dissenters is the norm.

Merril and Ribanna's joint effort to warn the Indians and their subsequent cooperation when protecting the Indian women, children and old folks who are left in their care results in the interracial couple developing true loving feelings for each other. After an interracial attack force (the Indians working in conjunction with the Army) routes Forrester's men and the Assiniboine Indians execute their revenge against Forrester, the film ends with Merril and Ribanna getting married. Simmon notes the importance of the interracial handshake to both Cooper's work and the early silent American Westerns (2003: 23) and the same symbolic act is employed to great effect when Colonel Merril and Ribanna's father settle their differences and shake hands at the start of the wedding ceremony. Furthermore, Aleiss notes that, on occasion, early US Westerns 'successfully paired' Indian women with white men (2005: 23). Thus *Last of the Renegades'* thematic content again suggests that the *Winnetou* films are better understood

when viewed with the long-forgotten tropes of those early silent Westerns in mind.

However, the film's theme of interracial romance is also reflective of wider contemporaneous debates that were going on within West Germany. The German economic miracle of the 1960s resulted in around two million foreign workers migrating to Germany. Hake suggests that the German *Ferienfilm* (vacation films) that were popular during the 1950s had 'prepared West German audiences for dealing with different cultures and nationalities' (2008: 119) and a strand of New German Cinema would subsequently concern itself with examining German attitudes towards the *Gastarbeiter* during the 1970s. In terms of detailing German relations with the racial 'Other', the *Winnetou* films would seem to act as a bridge that links these two divergent but distinctively German film forms/movements. The New German Cinema films that cast West Germany's guest workers as the victims of racial prejudice provided an important space for discourses regarding public attitudes towards the 'Other'. Rainer Werner Fassbinder's *Fear Eats the Soul* (*Angst essen Seele auf*, 1974) is a pertinent example: set in the 1970s, Fassbinder's film details the trials and tribulations of an interracial marriage that is entered into by an older German woman (Brigitte Mira) and a dark-skinned immigrant worker (El Hedi ben Salem).

Although attitudes towards depicting interracial relationships more generally had begun to change in Hollywood by the 1970s, the American Western still remained uncomfortable about representing white–Indian love affairs with positive endings. As noted earlier, in *Soldier Blue* Cresta's estranged Indian husband dies in the film's climactic massacre. This turn of events is not so surprising. While love affairs featuring white males and Indian females could be portrayed with some degree of sympathy and hope before the female invariably died, Buscombe notes that Hollywood has 'found the notion of an Indian man having sexual relations with a white woman altogether more difficult' to sanction (2006: 127). As such, Hollywood films that 'present relations between white women and Indian men [tend to] do so through the structure of the captivity narrative' (Buscombe, 2006: 128). While relationships born of the captivity narrative can produce a pragmatic form of love, the initial action of kidnap and rape means that the Indian male must ultimately be punished by death. But even wholly consensual white male–Indian female relationships have fared badly in latter-day

Hollywood films and this confirms just how remarkable the content of West German Westerns such as *Last of the Renegades* actually were.

For example, in *Little Big Man*, Jack Crabb is adopted by a Cheyenne Indian tribe and marries an Indian girl who becomes pregnant. Buscombe notes that Hollywood Westerns often attribute a 'free and easy sensuality ... to women of other races' (2006: 126) and *Little Big Man* is guilty of this, featuring a scenario wherein Crabb is called upon to sexually service his wife's three sisters while she is away giving birth. In an ensuing massacre carried out by General Custer's (Richard Mulligan) men, Crabb's wife and her sisters, the newborn baby and most of the tribe are murdered. Similar scenarios are played out in other Hollywood Westerns from this period. In *A Man Called Horse*, Morgan's initial status as a captured slave changes when he kills two Shoshone Indians and he eventually takes a Sioux Indian wife who becomes pregnant. Morgan's wife and unborn child both die when the Shoshone Indians subsequently attack their camp. And in Sydney Pollack's *Jeremiah Johnson* (1972), the Indian wife gifted to the film's eponymous mountain man (Robert Redford) by a Flathead Indian chief dies along with his adopted white son when the idyllic wilderness home they have built together is attacked by Crow Indians.

The complications of interracial sexual relations are deftly avoided in *Dances With Wolves* thanks to the convenient presence of Stands With a Fist (Mary McDonnell), a white woman living among the Lakota Indians who Dunbar duly bonds with. The historic reality – and later fictional re-workings – of the life of the Powahatan Indian girl Pocahontas fits readily with Hollywood's longstanding attitude to white male–Indian female love affairs. In reality, Pocahontas married the English nobleman John Rolfe and moved to England where she died of smallpox in 1617 aged just twenty-one. In Mike Gabriel and Eric Goldberg's Disney cartoon, *Pocahontas* (1995), the Indian girl falls in love with an Englishman, Captain John Smith, but decides to stay with her own people when he returns to England.

Positive representations of 'mixed-blood' characters: *The half-breed* (1966)

The revisionist Hollywood Westerns of the 1970s' insistence that white male–Indian female relationships should not be blessed with children who

survived for long conveniently meant that the question of mixed-race characters – characters that classical Hollywood Westerns had sometimes included, albeit usually in a range of stereotypically negative ways – did not have to be addressed in detail. Calder observes that 'traditionally the half-breed is the villain … a renegade combining the worst features of both races' (1974: 54). This is not always the case but if sympathetic half-breed characters are presented they are inevitably shown to be lonely and unful-filled individuals. Ward Churchill notes that, in Hollywood Westerns, 'by and large, children of mixed parentage have been consigned either to their [Indian] mother's society rather than their [white] father's … or [forced] to drift in anguish through an existential netherworld located somewhere between' the two (2003: 192). This is precisely the trajectory followed by Steve McQueen's eponymous half-breed character when he sets out to avenge the deaths of his parents in Henry Hathaway's *Nevada Smith* (1965). Often, the sympathetic half-breed character will die at their film's end, as is the case in Don Siegel's *Flaming Star* (1960). Here the half-breed character Pacer Burton (Elvis Presley) meets an untimely end after hostilities break out between local white men and Kiowa Indians.

A sympathetic but disconsolate half-breed character, Nick Tana (Robert Forster), is also found in Robert Mulligan's *The Stalking Moon* (1968). Here a savage Indian, Salvaje (Nathaniel Narciso), is tracking down his escaped white wife and their young half-breed son who are now under the pro-tection of Sam Varner (Gregory Peck). Tana bravely assists his old friend Varner but his actions inevitably cost him his life. Tana is a lonely, melan-choly and rootless figure and the viewer is left to presume that Salvaje's son, who (quite remarkably) is still alive at the film's end despite his question-able behaviour when in white company, will grow up to endure a similarly isolated and tormented life. There is a half-breed character, Batise (Jean Gascon), in *A Man Called Horse* and he is presented as a pathetic individ-ual. Born of a French father and Flathead Indian mother, Batise is a prisoner of the Sioux Indians who have crippled him in order to prevent his escape. Batise is forced to entertain his captors' children with foolish acts for which he receives food and when freedom does suddenly appear to be within his grasp he is abruptly killed. Kilpatrick notes that normally 'the Hollywood formula for a mixed-blood would call for someone mean, duplicitous, or just stupid … a "Hollywood half-breed" jerk' before applauding the fact

that Franc Roddam's modern day Western, *War Party* (1988), avoids using such a stereotype (1999: 108).

However, the West German Western *The half-breed* featured two fairly presented half-breed characters a good twenty years before *War Party*. Young Happy (Marinko Cosic) is introduced during the film's prologue. In keeping with the *Winnetou* films' thematic foregrounding of mountains, the sublime and the concerns of German Romanticism, Happy is seen using a rope ladder to descend down a mountain's perilously sheer cliff face in order to access an eagle's nest. When the angry eagle attacks the boy, Winnetou hears his cries, comes to his rescue and berates him for disturbing the nest. Shots that are angled to emphasize both the dangerous height at which Happy and Winnetou are working and the vast size and beauty of the surrounding mountains serve to literally overawe the viewer. As it turns out, the ecology-minded youngster was after a loose feather (to give to his sister) and not the eagle's precious eggs. The son of a German man, Haller (Walter Barnes), and an Apache woman, Mine-Yota (Marija Crnobori), Happy is coded as having inherited the deep respect for nature and the sense of oneness with the countryside that has been stereotypically attached to both Germans and Indians.

Winnetou is visiting the Hallers' homestead (which actually looks like a 'picture postcard' log cabin from a German *Heimat* film rather than a frontier house and is set in a particularly pastoral location) in order to wish their half-breed daughter Apanatschi (Uschi Glas) a happy twenty-first birthday. It is revealed that Apanatschi is naturally good with animals and is an expert hunter and both of these skills serve as stereotypical reminders of her Indian heritage. Later in the film, both of the Haller children quickly learn Apache horse riding tricks (hanging onto the far side of their horses so that the horses appear to be riderless to observing villains), leading Winnetou to happily observe 'You certainly know how to ride. Winnetou is proud of you.' Throughout the film, the Haller children's inherent Indian skills are coded as natural and positive attributes and this contrasts with the way that Hollywood Westerns tend to code such skills as alien or 'savage' when their half-breed characters possess them. Similarly, while the sympathetic half-breeds encountered in Hollywood Westerns are lonely and troubled individuals who feel out of place in the world, Happy and Apanatschi are well-adjusted, contented

and part of a loving family. Apanatschi is even engaged to her white sweetheart Jeff (Götz George). Furthermore, the Haller children retain good relations with their Apache kinfolk. When Apanatschi observes 'sometime I'd like to visit the Apaches in your village and go hunting with Winnetou' the Indian replies 'Apanatschi will always be welcomed by the Apaches'.

Before long it is revealed that years earlier Haller found a gold seam nearby but he swore to keep it a secret until Apanatschi came of age. Despite Winnetou's warnings, Haller reveals the gold's whereabouts to his daughter and, before long, two avaricious friends of the family, Pinky and Sloan, have murdered Haller and placed Happy and Apanatschi in great danger. Mine-Yota is safe because she does not know the location of the gold but the fact that her white husband dies while she survives represents a break with the conventions of Hollywood Westerns where traditionally happy interracial love affairs end with the Indian woman's death. When the villainous Curly Bill and his gang of eighty cutthroats hear about Apanatschi's gold, Winnetou and Old Shatterhand are forced to intervene and the Haller children spend some time living amongst the Apaches.

When Apanatschi dresses in Indian clothing she looks like a 'Pocahontas' type but her spirited involvement in the violent and explosive final battle against Curly Bill's men reveals that she is a resilient and dependable fighter. Winnetou's Indian warriors not only come to the rescue and help the local townsfolk to defeat the villains, they also offer to help rebuild the dynamite-shattered town. Furthermore, Apanatschi decides to gift her gold to her 'loyal [white] friends' so they can use it to finance the rebuilding of the town. The film ends with Apanatschi and Happy's stable home life restored by their return to their mother and the prospect of Apanatschi's impending marriage to Jeff. Significantly, the two Haller children have two communities and two support networks, Winnetou's Apaches and the local white townsfolk, who have both taken them to their hearts. This marks a stark contrast to the limited prospects that are left open to the lonely half-breed characters who are lucky enough to still be standing at the end of Hollywood Westerns. Ultimately, these positive representations of interracial romances and half-breed characters feed into the West German Western's favourable representations

of all things Indian. Christopher Frayling indicates that the success of the early *Winnetou* films 'created a commercial context which made the Italian Westerns possible' (1981: 115). Chapter II will focus on Italian Westerns and the local circumstances that led to a number of those films featuring groundbreaking representations of African Americans out West.

PART II

Emancipation *all'Italiana*

The Representation of African Americans in Italian Westerns

Paul Simpson observes that 'there may be only one Monument Valley – in America – but that hasn't stopped filmmakers across the world making Westerns' (2006: 241). The fact that two Italian Westerns, Sergio Leone's *Once Upon a Time in the West* (*C'era una volta il West*, 1968) and Damiano Damiani's *The Genius* (*Un genio, due compari, un pollo*, 1975), feature sequences that were shot within Monument Valley – an iconic location that is forever associated with the classic American Westerns of John Ford and John Wayne – is perhaps indicative of the extent to which Italian filmmakers successfully established themselves as the premier producers of Westerns during the 1960s and early 1970s. Indeed, in excess of 450 Spaghetti Westerns were made between 1962 and 1978. Many of the Southern European actors and extras who appeared in Italian Westerns possessed dark Mediterranean skin tones which led to most Spaghetti Westerns featuring Texas–Mexico border settings that were populated by vividly drawn Mexican characters. And since most of the visiting Hollywood and North European actors who starred alongside them had pale complexions, narratives that dealt with racial conflicts between dark skinned Mexicans and white skinned gringos became a staple element of the films. The theme of racial difference was further highlighted in a significant number of Spaghetti Westerns that featured African American characters.

Unlike most Hollywood Westerns, Italian Westerns sometimes fea-
tured major Mexican characters who were 'good' or anti-heroic types and
such characters became particularly popular following Damiano Damiani's
A Bullet for the General (*Quien Sabe?*, 1966), which was the first of a number
of overtly 'political' Spaghetti Westerns. In these political films anti-heroic
Mexican protagonists become embroiled in fights against manipulative
bourgeois capitalists, oppressive dictators and white imperialists who are
exploiting the Mexican proletariat. A growing but still small body of work
has detailed the significance of these progressive Mexican characters and
the way that they might connect to Italy's contemporaneous history, cul-
ture and politics. However, nothing has thus far been written about the
Italian Western's progressive representations of African Americans or the
films that these black characters appeared in.

Jonathan Dunnage observes that when Italy's post war economic mir-
acle came to an end in the early 1960s it was abundantly clear that not all
Italians had enjoyed the benefits of the miracle equally (2002: 150–152).
Around three million Southern Italians had been forced to migrate
North in search of work during the 1950s and the rude reception that
these dark-skinned Southerners received in Northern cities – and the
poverty-stricken living conditions that they had to endure – resulted in
the longstanding economic, cultural and racial tensions that had tradition-
ally existed between the North and South of Italy becoming the subject of
growing public discourse. The Italian Western was born out of this his-
torical moment and, as the 1960s wore on, these films were often used to
allegorically comment on the very societal tensions that would eventually
result in a wave of radical political activity sweeping through Italy dur-
ing 1968 and 1969. As such, the Italian Western was ideally situated to
articulate ideas regarding the treatment and social standing of the racial
'Other' and it did so via its striking representations of Mexican and African
American characters.

Flagging up the racial and cultural differences that were perpetuated
by Italy's North–South divide, Maggie Günsberg suggests that parallels
can be drawn between 'historically-specific perceptions of ... uncivilized,
Southern Italian, peasant non-whiteness' and the depictions of 'Mexican
non-whiteness' that were foregrounded in Spaghetti Westerns (2005: 210).

However, similar historically specific parallels centred around notions of non-whiteness and social standing can be drawn between Southern Italians and African Americans. The Northern Italians who travelled south in order to unify Italy by force during the mid-nineteenth century were quick to cast the dark-skinned Southern Italians as racial and cultural 'Others'. Indeed, numerous historical accounts exist wherein Northern Italian observers equate Southern Italy and its people with Africans and barbarism (Dickie, 1996: 28–29). Unification did little to improve the social standing of most Southern Italians and a significant number of Northern Italians continue to view the South as an inferior 'Other' country. Such was the lot of the Southern Italians that during the 1940s the writer Leonida Règaci and other Italian intellectuals promoted the idea that drawing parallels between the plight of African Americans and poor Southern Italians might actually be a way to argue for meaningful social change in post war Italy (Leavitt, 2013: 9). Interestingly Bruce Chadwick notes that, in America at the turn of the twentieth century, Southern legislators tended to lump Italian immigrants in with 'the hated blacks at the bottom of the social ladder' (2001: 147). Indeed, Chadwick reports that in Alabama in 1910, white vigilantes chose to lynch five Italian workers when they were 'unable to determine who was to blame' for the theft of a goat (2000: 147). The shared social experiences of poverty, exploitation in the work place and racial prejudice will thus be used in this chapter to suggest a tangible link between Southern Italian and black American identity.

Sarf asserts that the presence of black cowboys on America's Western frontier has 'traditionally been overlooked' by Hollywood filmmakers (1983: 224). A handful of Hollywood Westerns that were produced during the 1960s – Gordon Douglas' *Rio Conchos* (1964) and Ralph Nelson's *Duel at Diablo* (1966) are key examples – did attempt to reflect the concerns of the US civil rights movement by featuring major African American characters but, as will become apparent, these black characters had their onscreen activities governed by a set of highly prescriptive race-related rules that had their origins in America's Motion Picture Production Code of 1930. Even the black gunslingers who appeared in American Westerns produced during Hollywood's briefly pro-black 'Blaxploitation' phase of the early

1970s were liable to suffer some sort of narrative punishment if they trans-gressed these rules in overt ways (Blaxploitation is a term that was coined by Junius Griffin in 1972 when he merged the words 'black' and 'exploit-ation' together in order to describe the contemporary wave of US films whose content was designed to appeal primarily to an African American audience).

This was not the case with Italian Westerns. Woody Strode and several other black actors were given starring roles in a number of key Spaghetti Westerns that were produced during the late 1960s and the atypical char-acters that they played were uncommonly bold and assertive. In addition, a dialogue concerning 'the Black Venus' (Italy's cultural obsession with the figure of the sexually available black female that is linked to the coun-try's colonial adventures in Africa) can be found in a number of Italian Westerns which in turn leads to the emergence of assertive black female characters whose activities and sexualities defy the stereotypes more gen-erally found in both American and Italian films. As such, this chapter will explore the progressive ways in which these Italian Westerns represent African Americans by comparing their content to Hollywood Westerns that featured black characters.

Italy's own internal racial tensions and the country's colonial links to Africa are not the only local cultural, political and social circumstances that served to position the Italian Western as a film form that was ideally situated to introduce groundbreaking representations of black ethni-city out West. For example, it remains significant that the first wave of Spaghetti Westerns to feature African American actors in major roles cast them as itinerant performers who are first seen within street fair and circus locations. I argue that these cultural entertainment spaces can be understood to be a significant aspect of the films' Italian origins. Furthermore the spatial zones generated by these cultural entertainment forms, much like the spatial zones generated by their Italian anteced-ents (the carnival and the *commedia dell'arte*), have been theorized to be spaces that engender a perceived sense of equality. For example, in Europe the internal politics of the late nineteenth century circus granted black performers improved representation and equal billings that they did not enjoy elsewhere (Loxton and Jamieson, 1997: 78). As such, I will draw upon Mikhail Bakhtin's (1984a and 1984b) work concerning the

egalitarian nature of the carnival throughout much of this chapter. Ultimately the Italian Western's representation of strong and defiant black characters that prefigure the appearance of similarly coded characters in American Westerns serves to problematize the Western genre's received evolutionary model.

4

Italian Westerns: International Reception and Local Influences

Critical reassessments of a limited number of Italian Westerns (mostly those directed by Sergio Leone) have been undertaken in recent years but the cursory discussions concerning more general Italian Westerns that appear in books about the broader history of the Western genre (see Garfield, 1982) tend to have the same negative and dismissive air as the films' original American and British trade reviews. Beyond a handful of objective early treatises by the likes of Raymond Durgnat (1968), Christopher Frayling (1970) and Mike Wallington (1970), most contemporary reviews of Italian Westerns written by American and British film critics were negative in nature. Frayling reports that even Leone's films were 'invariably panned' by these reviewers, who clung to the assumption that, because they were 'made at Cinecitta Studios, Rome, [and] had no "cultural roots" in American history or folklore, they were likely to be cheap, opportunistic imitations' of American Westerns (1981: 121). Indeed, it was these very critics who coined and used the term 'Spaghetti Western' in a wholly pejorative way in order to highlight the perceived cultural distinctions found in Italian Westerns (Frayling, 1981: xi). The critical rejection of Leone's innovative and masterfully executed Westerns by American reviewers resulted in the

Italian Westerns that followed his films to America being routinely dismissed as inferior products too.

The critical reception of Spaghetti Westerns in the UK was generally equally scathing. For example, *The Monthly Film Bulletin*'s reviewer found Sergio Corbucci's (now highly regarded) *A Professional Gun* (*Il Mercenario*, 1968) to be 'an overlong and improbably plotted imitation Western' (1969: 270). The argument that Italian Westerns are culturally inauthentic, failed imitations of Hollywood Westerns is one that has been employed by a multitude of writers and critics. Clapham dismisses all Italian Westerns outright, referring to them as 'a tedious and unsavoury' 'cul-de-sac' while asserting that the best Westerns are those that are made by Americans (1974: 146). Clapham also complains that the violence seen in Italian Westerns 'consciously degenerated into downright sadism' while observing that a 'mean, nasty and ugly' flavour ran through the films (1974: 146). Clapham's pointed focus on the violence featured in Italian Westerns echoes the obsessive concerns of several critics. When Austin Fisher examined the reviews of fifty Italian Westerns from contemporary US and UK publications he found that the words 'violence' or 'violent' appeared in reviews of thirty-two of the films, the words 'bloodthirsty', 'bloody', 'bloodlust', 'bloodbath', 'bloodshed' or 'blood' appeared in twenty-two while the words 'sadism' or 'sadistic' appeared in seventeen (2011: 175–176). Garfield attempts to infantilize Italian filmmakers by asserting that 'with very few exceptions the spaghetti Westerns appear to be the crude fantasies of bloodthirsty children' (1982: 367–368). The sun-bleached Spanish landscapes that Italian filmmakers employed as a stand in for the American West were often criticized for their lack of authenticity but these distinctive looking shooting locations have since become sites of intense touristic interest for latter day fans of the films (Broughton, 2011: 312).

Although Garfield suggests that Leone's films effectively corrupted the Western genre (1982: 55), other writers have indicated that Italian Westerns did influence the American Western in positive ways. Beyond the ongoing work of Christopher Frayling, which has led to a wider re-evaluation of Leone's films and Italian Westerns in general, Robin Buss suggests that Leone's films brought a new sense of realism to the Western genre (1989: 165). Stephen McVeigh suggests that the Italian Western served to reinvigorate the Western genre's 'appeal and voice', which allowed a younger

generation of American filmmakers 'to use the Western form as commentary upon such cataclysmic events as the war in Vietnam' (2007: 169). Furthermore, McVeigh acknowledges that Clint Eastwood, an actor who proved important to the American Western's ongoing struggle for survival in the final decades of the twentieth century, first found worldwide film stardom in Italian Westerns (2007: 169). But no commentator has yet acknowledged the part that Italian Westerns played in the development of substantial and progressive black characters out West.

Political stirrings

It would seem clear that the strong and active black characters who appeared in Italian Westerns during the late 1960s were symbols that reflected the defiant mood of Southern Italians and other marginalized groups who were demanding social change in contemporary Italy. Dunnage notes that the 'fairer, more democratic society' that many Italians assumed would emerge following the bitter internal conflicts that the country endured towards the end of World War II simply never materialized (2002: 144). Consequently, the 'desire for social, political and cultural emancipation', a desire that would have appealed to the Southern Italian workers who were based in both the North and South of Italy, resulted in a 'wave of mass protest that spread through many parts of the country' during the late 1960s (Dunnage, 2002: 148). Furthermore, Italian cinema – which had been used as a tool for promoting left-wing political ideals ever since the emergence of neorealism in 1944 – became more forthrightly radical in 1968 when the Italian filmmakers' association ANAC (Associazione Nazionale Autori Cinematografici) 'became reorganised round a core of politicised directors including [Pier Paolo] Pasolini, Elio Petri and Gilo Pontecorvo' (Forgacs, 1990: 146).

While not all Italian filmmakers were left-wing radicals, Gian Piero Brunetta notes that before long 'the spirit of 1968 rubbed off on directors and screenwriters' throughout the industry who felt compelled to make films that were 'in touch with the spirit of the times' (2009: 178). Thus revolutionary political ideas and symbolism were soon incorporated into Italy's more popular film forms. For key examples of Spaghetti Westerns that follow this trend see Sergio Sollima's *Run, Man, Run* (*Corri uomo corri,*

1968) and Sergio Corbucci's *A Professional Gun*. These films were often internationalist in their approach, employing Mexican Revolution-related political symbols and allegories that were aimed at both Italy's proletariat and oppressed peoples throughout the world. I would argue that the Spaghetti Westerns that featured supposedly emancipated but still racially persecuted African Americans out West were intended to function in the same way. Reported by news agencies internationally, the high profile activities of the civil rights movement in the USA during the 1960s provided both a model and encouragement for organized mass political protests worldwide. Thus the examples of historically situated inequality and racism that are seen in the black-orientated Spaghetti Westerns of the 1960s act as allegorical reminders of contemporaneous inequality and racism. Furthermore, the rebellious natures and subversive actions of the films' black gunslingers allegorically offer encouraging examples of minority group assertiveness and insurgency. All of which would clearly resonate with the contemporaneous social and political struggles that were unfolding throughout Italy and beyond.

Leone, Morricone and examples of the more obviously 'local'

The producers of the very first Italian Westerns from the early 1960s tended to cast a recognizable American actor in their film's lead role while also allotting anglicized pseudonyms to their European cast and crewmembers. It was hoped that these measures would make audiences believe that the films were Hollywood productions. The fact that these initial Italian Westerns reproduced generic storylines and sought to disguise themselves as Hollywood films perhaps indicates that their producers were conscious that the production of Westerns by non-Americans would necessarily raise questions concerning cultural authenticity. However, Sergio Leone's *A Fistful of Dollars* (1964) represented an attempt to take the Western in a new direction by bringing a distinctly Italian cultural perspective to the genre. Leone's film featured Catholic religious symbolism and its foregrounding of Mexican characters – and their habitats and culture – resulted in the film being infused with a strong Latino-Hispanic ambience. Furthermore, Peter

Bondanella observes that Ennio Morricone's unique soundtrack score made use of 'traditional Sicilian folk instruments' (1983: 256).

A Fistful of Dollars soon became the most financially successful Italian film to date and the Italian film industry responded by producing a number of similarly themed Westerns. In their efforts to repeat Leone's success, the more astute Italian directors attempted to emulate both the look and the sound that had made *A Fistful of Dollars* such a noticeably striking and stylish film. This new wave of Italian Westerns was thus easily distinguished from those produced in Hollywood. Furthermore, the continued focus on banditry, untrustworthy politicians, corrupt or cowardly lawmen, Catholic symbolism, vendettas and clans who privileged the family above all others resulted in a body of films that, at some levels, appeared to reflect key if somewhat stereotypical aspects of Southern Italian life. As such, Paul Smith suggests that Italian filmmakers seized a dominant model of American filmmaking and reworked it so that it possessed 'different signifying ends and social functions within … [the Italians'] … own cultural [system]' (1993: 5). Indeed, what follows is a catalogue of the local social, cultural and political elements that duly made the Italian Western an ideally situated film form for the introduction of atypical black Western characters.

The Southern Italians as 'Others'

In discussing the Southern Italians who spoke local dialects and subsequently struggled to find acceptance when they moved North during the 1960s, Fisher asserts that 'in a very real sense' these 'people were foreigners in their own country' (2011: 54). The dark Mediterranean skin tones possessed by these Southern Italian migrants undoubtedly contributed to the Northerners treating them like foreigners. In fact, the people of Southern Italy (which, generally speaking, is made up of the lower third portion of mainland Italy and the islands of Sicily and Sardinia) had been cast as the 'Other' to the people of the North ever since the time of the *Risorgimento* movement, which succeeded in unifying Italy by force during the 1860s. In 1864 an officer in the Italian army recorded that the Southern locals were 'a population which, although in Italy and born Italian, seems to belong to the primitive tribes of Africa' (quoted in Dickie, 1996: 28–29).

Effectively a colonized people who saw no real benefits from the unification process, the people of the South would become locked in a cycle that saw them perpetually recast as a powerless subordinate populace: brigands and mafia clans, powerful landowners and their armed guards and the military representatives of the Fascist Party would all in turn effectively govern huge swathes of the Southern populace by force. And, towards the end of World War II, the Southern Italians paid host to the Allied army of occupation. The lot of the Southern Italians was little improved when they migrated North during the 1950s and 1960s. Forgacs indicates that the migrants from Southern Italy became 'a social underclass in the North' (1990: 136), usually living in isolation in the *borgate*, ramshackle ghettoes made up 'of sub-standard housing' that were located on the outskirts of big cities (1990: 12).

Vanessa Maher makes mention of 'the illegal exploitation of Southern workers' in the North (1996: 166) before adding that Northern Italians often allotted xenophobic markers to the Southern Italian migrants, referring to them as being '*africano* [African]' and '*marocchino* [Moroccan]' (1996: 162, 172). The difficulties that Southerners encountered in the North were detailed in contemporaneous Italian films such as Luchino Visconti's *Rocco and his Brothers* (*Rocco e i suoi fratelli*, 1960), whose content was designed to show, according to Visconti, that 'we [Italians] have our racism too' (quoted in Fisher, 2011: 54). Brunetta describes how the impoverished Sicilian workers who appear in Pietro Germi's *Il cammino della speranza* (1950) are racially abused by locals as they pass through Northern Italy en route to a new life in France: ' "What are you saying, you dirty southerner [*terrona*]? Sounds like Abyssinian! Darkie!" ' (2009: 144). Furthermore, Dunnage's observation that during the 1950s, 'the number of workers killed by the police [during industrial demonstrations] remained high' while 'farmworkers continued to be killed by landowners or their agents during agricultural strikes' (2002: 156) reveals the alarming lack of civil rights present in Italy at this time. Indeed, Robert Lumley notes that although the mass demonstrations of 1968 in which Southern Italian workers played key roles (alongside political activists, students and the members of a variety of social movements) were initially about employment-based 'questions of pay and conditions', the continued demonstrations and insurrections of the 'Hot Autumn of 1969' were couched as 'a more general attack on social injustices' (1990: 167). These demands

for civil rights from a long-exploited and impoverished sector of the Italian public that had also been discriminated against culturally and racially serve to link the Southern Italians' plight and social identity to that of contemporary African Americans.

Italy, Africa and images of black ethnicity in Italian cinema

Italian cinema, both art house and popular, holds a long tradition of providing spaces for representations of black ethnicity. This tradition is undoubtedly connected to Italy's geographical closeness to Africa and the empire-building endeavours that Italy historically pursued within that continent. As such, some of Italian cinema's representations of black ethnicity can be judged to be of a colonial, orientalist or even exploitative bent. Gino Moliterno observes that one of the very first heroes of Italian cinema was the strongman African slave Maciste (Bartolomeo Pagano) who appeared in Giovanni Pastrone's historical epic from 1914, *Cabiria* (2008: 56). And Sandra Ponzanesi indicates that the orientalist fetish for images of the 'Black Venus', namely 'beautiful, docile and sexually available' African women, was particularly widespread amongst Italian males during the 1920s and 1930s and its influence endures in the country's media and advertising industries to this day (2005: 173–182). Indeed, a dialogue concerning the Black Venus is present in two of the Italian Westerns that will be examined later in this chapter.

James Hay notes that Italian cinema audiences were exposed to images of Africa during the 1920s and 1930s via a series of ethnographic documentaries (1987: 185) and 'colonial' films that celebrated Italy's empire there (1987: 181). Significantly, Hay asserts that the colonial film *Under the Southern Cross* (*Sotto la croce del sud*, Guido Brignone, 1938) 'clearly demonstrates how Italian popular cinema attempted to *naturalize* [Hay's emphasis] Africa and how African culture [subsequently] begins to inform Italian popular culture' via the cinema, fashion and music (1987: 197). The Fascist Party's attempts to naturalize African culture and imagery inside Italy at this time are clearly the actions of an imperialist power seeking to actively display evidence of its colonial spoils in a celebratory way while

simultaneously encouraging further colonial activity. However, African imagery would in time become a permanent and sometimes less obviously imperial aspect of Italy's own cultural productions. In terms of Italian cinema, this meant a noticeable presence of black subjects in documentaries and black characters in dramatic features.

Aine O'Healy has noted 'the association between black womanhood and sexual availability that overdetermines traditional representations of African femininity in Italian cinema' (2009: 177). Italy's colonial films often included documentary-like footage of Africa and its inhabitants and this pseudo-documentary approach to filmmaking can also be found in a later Italian film form that was popular during the 1960s, the *Mondo* film. Clearly playing a key role in Italy's ongoing obsession with the Black Venus, the most famous *Mondo* films (as pioneered by the directors Gualtiero Jacopetti and Franco Prosperi) included 'ethnographic' sequences that invariably featured naked African women performing tribal dances. Furthermore, O'Healy notes that somewhat objectified black women often appeared in Italian art house films during the late 1950s and early 1960s where they were usually seen performing exotic dance routines or cabaret acts (2009: 181). Italian cinema's obsession with the Black Venus would continue into the 1970s and beyond. The long-running series of *Black Emanuelle* sexploitation films that were produced in Italy during the 1970s and starred Laura Gemser as an ethnic, globetrotting and sexually available photojournalist is one example of this trend.

Representations of black ethnicity that take on a more positive and progressive shape can be found in Italian cinema's more political film forms. Italian neorealism's attempts to reflect the reality of Italian life during and immediately after World War II resulted in a number of films that featured black American GIs in prominent and sympathetic roles. Two key examples of this trend are Roberto Rossellini's *Paisan* (*Paisa*, 1946) and Luigi Zampa's *To Live in Peace* (*Vivere in pace*, 1947). Thomas Cripps notes that the Marxist ideals that underpin the narratives of these films resulted in a newfound sense of cinematic equality for their black characters: essentially, 'the black soldier is as one with the white masses of the world' (1993a: 271). Black characters also appeared with regularity in more popular Italian film forms. The historical epic/fantasy films produced in Italy during the late 1950s and early 1960s featured

black actors in particularly active roles – Van Aikens' appearance as a brave swordsman in Giacomo Gentilomo's *Goliath and the Vampires* (*Maciste contro il vampiro*, 1961) is a key example – and Erickson notes that Archie Savage's role in Antonio Margheriti's Italian science fiction film *Space Men* (1960) might actually be the cinema's first representation of a black astronaut (2001).

Furthermore, as noted earlier, left-wing political concerns dominated Italian cinema during the late 1960s. Films such as Valerio Zurlini's *Black Jesus* (*Seduto alla sua destra*, 1968) and Gillo Pontecorvo's *Burn!* (*Queimada*, 1969) featured hard-hitting, anti-colonialist narratives that gave voices to insurgent black African and South American characters who were pitted in bitter struggles against white European oppressors. While these films can be read as allegorical criticisms of Italy's own colonial past they also possessed the potential – indeed the desire – to incite revolution in the present. Pontecorvo has confirmed that *Burn!* was intended to be 'a call for revolution' (quoted in Ebert, 1969), so connections were clearly being drawn between the social positioning of black subalterns historically and present day ethnic groupings such as Southern Italians and African Americans. Interestingly, Pontecorvo states that his earlier film, *The Battle of Algiers* (*La battaglia di Algeri*, 1966), sought to allegorically champion the dispossessed and encourage them to fight for their rights, and this film was subsequently embraced by black audiences in the USA (quoted in Ebert, 1969).

The racial palimpsest in Italian Westerns

The account of Italian cinema's representation of black ethnicity presented in the preceding paragraphs highlights a dichotomy that has been acknowledged by Derek Duncan, who observes that:

> The possibility that the colonial gaze of fascist cinema may have exceeded the regime in longevity is potentially resonant for the study of how issues of race and ethnicity are negotiated in post-war Italian cinema. It proposes both a continuation up to the present day of Fascism's racializing project, and the contrary possibility that inter-racial identification may invite the Italian spectator into explorations of transnational or transcultural identities.
>
> (2008: 198)

As indicated earlier, Italy's indigenous population possesses a range of skin tones (with the darkest tones traditionally being found in the South) and Günsberg indicates that perceptions of whiteness thus differ from region to region and class to class (2005: 210). Indeed, this circumstance has led Duncan to refer to 'the uncertain place that Italians [have] occupied in a racial hierarchy that [has] placed Black and White at opposite ends of the scale of civilization' (2008: 200). This sense of racial uncertainty seemingly led to scenarios that embarrassed the fascist ideologues who oversaw Italy's African colonies. Giulia Barrera suggests that the race laws that were implemented in fascist Italy's African colonies were required chiefly because the increased presence of 'Italian working-class settlers made racial hierarchies dangerously unclear: the more class blurred the divide between colonizers and colonized, the more race laws were needed to clarify this divide' (2003: 430). Furthermore, Donald Martin Carter has reported on the institution of *madamismo*, which was the practice of temporary marriages between Italian colonizers and Ethiopian women (quoted in Maher, 1996: 167). *Madamismo* can of course also be linked directly to Italy's cultural desire for the figure of the Black Venus. Interestingly, Ian Jane (2004) reports that Jacopetti and Prosperi's *Mondo* documentary *Africa Blood and Guts* (*Africa addio*, 1966) features a scene in which the duo are forced from their car at gunpoint by an angry African soldier who subsequently releases them when their Italian passports signify to him that his captives are not white men. All of which offers further evidence of the – at times – confused and permeable nature of the racial and cultural boundaries that were transgressed by Italians and their African neighbours.

Christopher Wagstaff indicates that, of the 450 or so Italian Westerns that were made, approximately 350 were low budget features that were produced specifically to play in the third run cinemas that were mostly found in Italy's rural and working class Southern areas (1992: 247–248). This fact, when aligned to the large number of Mexican protagonists who appear in Italian Westerns, leads Günsberg to suggest that tangible parallels might be drawn between the ethnic identities of Southern Italians and the Mexicans that they saw represented on cinema screens (2005: 210). If some Southern Italians truly do consider themselves to be non-white, they would surely be the Italian spectators who were most likely to entertain the kind of 'inter-racial

identification' that Duncan has talked about (2008: 198). Given the shared social experiences of Southern Italians and African Americans, it remains possible that Southern Italian spectators were able to identify with the oppressed but defiant black characters that were seen in Spaghetti Westerns.

Interestingly, there is evidence to suggest that Italian Westerns were particularly popular with black American cinemagoers. For example, the industry press book produced to aid the promotion of Tonino Cervi's *Today We Kill ... Tomorrow We Die!* (*Oggi a me ... domain a te!*, 1968) during its run in American cinemas specifically instructs publicists to advertise the film in 'black papers' and on 'black radio' stations (Cinerama Releasing Corporation, 1971: 1). As such, it remains possible that the black American spectators' own sense of non-whiteness allowed them to relate to the images of Mexican non-whiteness that were foregrounded in Italian Westerns. The Cuban actor Tomas Milian – noted for his roles as proletarian Mexican everymen who emerge victorious from the situations of oppression that they initially find themselves in – suggests that through his work in Italian Westerns he became a recognizable 'symbol of poverty and revolution' to 'third world cinemagoers' (quoted in Frayling, 1981: 239). Similarly, Milian has suggested that 'the Third World figure' he played in a variety of Spaghetti Westerns 'could in some sense have also been an Italian sub proletarian' (quoted in Fisher, 2011: 141).

Milian's comments further encourage the idea that a shared sense of non-whiteness amongst a variety of international ethnic audiences could subsequently result in any oppressed non-white character who appeared in an Italian Western acting as a kind of racial palimpsest that different dispossessed ethnic viewers worldwide could relate to. This line of thinking appears to be encouraged in Sergio Leone's *A Fistful of Dynamite* (*Giu la testa*, 1971). When a group of Mexican bourgeois elitists who are travelling in an ornate stagecoach talk hatefully about Mexican peasants in terms of their perceived ignorance, laziness and promiscuous ways, an American businessman interjects with the words 'Every country has its own plague. [They are] just like them niggers we got back home.' Fisher has correctly noted the narrative similarities and images of ethnic insurgency that connect the lead Mexican character seen in Sergio Sollima's *The Big Gundown* (*La resa dei conti*, 1966) to the lead African American character seen in Melvin Van Peebles' politically radical American Blaxploitation film *Sweet*

Sweetback's Baadasssss Song (1971). Van Peebles' film is set in the present day but Fisher observes that 'belligerent assertions of a black urban sensibility' would duly appear in the early 1970s Blaxploitation Westerns that followed in *Sweet Sweetback*'s wake (2011: 191). The American Blaxploitation Westerns from the 1970s remain striking films because, as Jim Pines notes, 'the Western is not a genre that one normally associates with images of black people' (1988: 68). Pines adds that:

> The history of black representations in the Western can be divided into three brief periods. The first includes the series of Black Westerns made during the period of so-called 'race' movies in America, from the 1900s to the late 1940s. This was followed by a second cycle in the 1960s, when a number of mainstream Westerns began to experiment with civil rights or race relations motifs. Finally, there was the cycle of 'blaxploitation' Westerns made during the Hollywood black exploitation boom in the 1970s.
>
> (1988: 68)

Neither Pines nor Fisher mention the key Italian Westerns from the 1960s that provided pivotal and positive roles for black actors *before* the Blaxploitation boom of the 1970s. I suggest here that the radical politics embraced by the producers of Italian Westerns during the late 1960s, when combined with local social and cultural elements, resulted in the Italians finding a logical space for a new kind of black character in their Westerns. In terms of local cultural elements, the circus and the street fair are key examples.

The circus and the street fair

Distinctly Italian cultural entertainment forms like the street fair and the circus dominate the Italian Westerns examined here and I argue that the sense of equality that these entertainment forms are understood to generate assists in the emergence of strong black characters. Rupert Croft-Cooke and Peter Cotes note that the modern circus 'can be traced by the historically-minded to similar shows ... seen in the Circus Maximus and the ampitheatres of Ancient Rome' (1976: 7). The Circus Maximus was a site of harsh imperialistic repression for those individuals who were

forced to perform within it. However, Croft-Cooke and Cotes note that its patrons were 'polyglot and inter-racial' (1976: 178) and they refer to the Circus Maximus as being a 'theatre of democracy' because it was the one place in Rome where 'public ridicule of both Emperor and Senate was freely expressed' and completely tolerated (1976: 21). Furthermore, Nicolas Bentley observes that the Roman circus was a unique form of public entertainment because it allowed men and women to sit together in the audience (1977: 4). The suspension of social norms enjoyed by the patrons of the Circus Maximus – and elements of the more theatrical-leaning entertainments that they saw there – resurfaced in and wholly informed the folk culture carnivals and fairs that ran counter to those that were designed to mark key religious dates in Italy's Catholic calendar during medieval times.

Mikhail Bakhtin provides the definitive scholarly account of the significance of the medieval carnival in *Rabelais and His World* (1984a). Bakhtin notes that the carnival represented 'a second world and a second life outside officialdom' (1984a: 6). More importantly, Bakhtin asserts that the:

> Carnival celebrated temporary liberation from the prevailing truth and from the established order; it marked the suspension of all hierarchical rank, privileges, norms, and prohibitions ... all were considered equal during carnival. Here, in the town square, a special form of free and familial contact reigned among people who were usually divided by the barriers of caste, property, profession, and age ... People were, so to speak, reborn for new, purely human relations.
>
> (1984a: 10)

Bakhtin observes that, although it is now somewhat diminished, the spirit of the carnival continues to be felt in certain cultural practices and forms of entertainment (1984a: 33–34). Two forms of entertainment that bear the carnival's influence are the Italian *commedia dell'arte* and the modern circus. The *commedia dell'arte* first emerged in the mid-sixteenth century and this entertainment form generated a sense of egalitarianism because, as Kenneth and Laura Richards note, its troupes consisted 'of actors ultimately drawn from diverse social and educational backgrounds' (1990: 40) who performed largely in 'the streets and market places' to audiences 'drawn from all levels of society' (1990: 80). Marcia Landy

(2000: 191) has drawn some cursory links between the *commedia* and Sergio Leone's Italian Westerns. However I will argue that two Spaghetti Westerns directed by Giuseppe Colizzi possess stronger and more pertinent links to the *commedia*.

Howard Loxton and David Jamieson confirm that 'the concept of the circus clown is closely linked with the tradition of the Italian *Commedia dell'Arte*' (1997: 76). Bentley observes that the circus as it is known today first emerged in England during the late eighteenth century under the guidance of the equestrian expert Philip Astley (1977: 11). However, the circus and its clowns in particular seemingly register as an Italian phenomenon in the eyes of much of the public worldwide. Certainly many of the most famous clowns cited by Croft-Cooke and Cotes used names that signal or affect an Italian heritage: the Fratellinis, Delprini, Renato, the Great Sabatini, Ron and Sandy Severini and so on (1976: 142–150). And Roberto Zanola reports that since 1968 the Italian state has recognized that the circus plays an important role in promoting the culture of Italy (2010: 160). The films of Federico Fellini, in which the circus remains a persistent theme, have undoubtedly served to forge a further link between the circus and Italy. Given Fellini's prominent positioning as an Italian director of great importance, I propose that the numerous Italian Westerns that feature circuses or circus-inspired action must be viewed with Fellini's work and influence in mind. To this end, Fellini's observations concerning clowns in particular will be drawn upon later in this book.

Interestingly, Alex Cox identifies a number of Italian Westerns that he dubs 'circus Westerns' (2009: 238) while Howard Hughes refers to Italian Westerns that are carnival-like (2004: 218). However, both writers focus in detail upon the films of the director Gianfranco Parolini whilst ignoring the Colizzi films that predate Parolini's work. Curiously, Fellini claimed that the personality traits and characteristics associated with the white face clown (the graceful but authoritarian and cold bully) and the *Auguste* clown (the shabby, rebellious but sympathetic victim) could also be attached to certain character types that he observed within Italian society (1976: 125–129) and variations of these same character types can often be found in the Italian Westerns that I examine in this chapter. Crucially, the egalitarian space that Bakhtin found in the carnival (1984a and 1984b) is often reproduced in the circus, both in reality and at a representational

level. Loxton and Jamieson report that during the late nineteenth century, the black clown Chocolat received equal billing when appearing with his white English partner Funny Footit (1997: 78), while Antony Hippisley Coxe notes the significance of the circus' circular and elevated seating arrangements, which results in the audience holding 'the spectacle in its midst' and actually becoming 'a part of the spectacle' themselves (1980: 24).

Moreover, this sense of the circus acting as an agent for equality has been present in some of Hollywood's more outré films too. In *Freaks* (Tod Browning, 1932), an unjustly rejected and cruelly reviled community of sideshow attractions are able to successfully exact their revenge upon the 'normal' people who plot to murder and defraud one of their number. In the Marx Brothers' *At the Circus* (Edward Buzzell, 1939), one key scene involves Harpo Marx performing for – and with – an excluded community of impoverished African Americans, whose performance even manages to reference the subversive redemption song 'Swing Low, Sweet Chariot'. And in *The Trip* (Roger Corman, 1967), it is within a vision of a surreal carnival-cum-circus space that Peter Fonda's insular and sullen director of television commercials is judged and subsequently reminded that he is 'one with, and part of, an ever-expanding, loving, joyful, glorious and harmonious universe'.

It is clear that Italy's proximity to and past relations with Africa have had an impact on cultural production inside Italy. Furthermore, the idea that a sense of 'non-whiteness' has been attached to some Southern Italians prompts intriguing possibilities with regards to the way that this 'non-white' audience might relate to dark-skinned film characters. And given the sense of ethnic and social imbalance that has long been associated with Italy's North–South divide, one can understand the appeal of local entertainment forms – the street fair and circus – that engendered a temporary sense of equality and relief. The presence of these local influences in the Italian Westerns that I examine here clearly led the creation of a cinematic space where it was possible to represent bold, emancipated and defiant black characters. Interestingly, when talking about Hollywood's Blaxploitation Westerns of the 1970s, Susan Hayward suggests that Antonio Margheriti's Italian Western *Take a Hard Ride* (*La parola di un fuorilegge ... è legge!*, 1975) is 'guilty of exploiting the blaxploitation moment' (2000: 470). I would counter however, that the film

was merely the latest in a steady line of Italian Westerns featuring strong black lead characters – a line that started in 1967, four years before Blaxploitation arose. In order to fully appreciate the groundbreaking nature of the black characters that appeared in Italian Westerns during the 1960s, it is necessary to first offer an overview of the way that black characters have traditionally been represented in American Westerns.

5

The Representation of Blacks in American Westerns

The representation (or, indeed, the lack of representation) of black characters in American Westerns was for many years a particularly contentious aspect of the genre. Hayward observes that 'you can count Black Westerns on just about one hand (if you include black presence in a major role)' before concluding that 'the major spurt of Black Westerns occurred in the early 1970s' (2000: 470). Prior to the appearance of the early 1970s Blaxploitation Westerns, the majority of the black characters who appeared in Hollywood Westerns possessed stereotypical characteristics while being granted minimal screen time. On the odd occasions that major black characters did appear (usually during the 1960s) their onscreen activities and general demeanour were governed by a set of highly prescriptive 'rules' that had their origins in America's Motion Picture Production Code of 1930.

Here I will offer an overview and a re-evaluation of the stereotypical ways in which African Americans were represented in Westerns produced in the USA prior to the Blaxploitation boom. Thus when the Italian Westerns that were produced during the late 1960s are examined later, the extent to which their depictions of black characters broke the genre's race-specific rules will become apparent. John Lenihan laments the lack of studies concerning black-orientated Westerns but observes that the lack is understandable 'given the formula's minimal inclusion of black Americans

until recent years' (1985: 55). A very small body of work does exist regarding Hollywood's treatment and representation of blacks out West and this section will review and critique some of this work in order to illustrate a catalogue of representational 'rules' that were employed to constrain and 'Other' black characters in Hollywood Westerns.

Early representations

Sarf reports that black independent filmmakers did produce 'a few' black-orientated Westerns during the 1910s (1983: 227) and David Walker indicates that the renowned black rodeo rider Bill Pickett starred in a Western produced in 1922, Richard E. Norman's *The Crimson Skull* (1999: 17). However, the implementation of the Production Code seemingly brought the positive representations of blacks in mainstream Hollywood films to an end. On the odd occasions that African Americans did appear in US Westerns, they were invariably granted minimal screen time and represented in a crudely stereotypical manner. R. Philip Loy notes that the popular B Westerns of the 1930s and 1940s tended to draw upon four black stereotypes: 'Blacks as loyal servants who want to be cared for by white people, blacks as pursuing menial occupations, blacks as naturally funny and cowardly, and blacks as dancers and entertainers' (2001: 184). Loy also notes that black characters only travelled the West if they were accompanying a white hero as their loyal and subservient sidekick (2001: 190). Clyde Taylor indicates that America's black community were outraged by the black stereotypes that appeared in Hollywood films and so the production of independent black films 'which presented black life with honesty, dignity and some affection' (quoted in Bowser and Cram, 1994) was initiated. To this end, Taylor reports that over 500 so called 'race movies' featuring all-black casts were produced between 1910 and 1950 (quoted in Bowser and Cram, 1994). A small number of these 'race movies' were Westerns and these Black Westerns endeavoured to defy some of the prescriptive race-related rules that governed Hollywood Westerns.

The most significant 'race movie' Westerns were those made during the 1930s which starred the singer Herb Jeffries (AKA Herbert Jeffrey) as a heroic singing cowboy. In *Two-Gun Man from Harlem* (Richard C. Kahn, 1938), *The Bronze Buckaroo* (Richard C. Kahn, 1939) and *Harlem Rides the*

Range (Richard C. Kahn, 1939), Jeffries gets to act just like a white singing cowboy hero: he travels wherever he pleases, handles guns, has fistfights with villains, rescues damsels in distress and wins their hearts. Thomas Cripps bemoans the fact that the content of Jeffries' Westerns tended 'to mirror the most gimmicky white musical horse operas' (1993b: 337) but it is important to appreciate how groundbreaking these films were in terms of representing active and heroic blacks within a Western setting. Sarf observes that:

> Prior to the postwar era, it was considered fairly daring to show blacks as *victims* [Sarf's emphasis] of violence (or anything else), let alone show them inflicting it on others, a prerequisite for standard horse-opera heroism. A Hollywood black possessing positive and manly qualities was a rare find.
>
> (1983: 225)

As such, Jeffries' achievements were quite remarkable but they could only take place in films with all black casts that would only ever play in segregated cinemas to all-black audiences. Sarf observes that black characters in the 'race movie' Westerns were at liberty to handle guns because the presence of all-black casts 'sidestepped the [Hollywood] taboo on having blacks shoot whites' (1983: 227). In this regard, Loy does note that black Western characters were occasionally allowed to impede a white villain by aiming a gun at them but only if doing so assisted the white hero's cause (2001: 193). Essentially, black on black gun violence was acceptable but black on white gun violence was not. Interestingly, Simpson notes that Jeffries' films conformed to a kind of 'colour caste convention' which saw dark-skinned blacks playing villains and lighter-skinned blacks playing heroes and heroines (2006: 40). However, this was not a hard and fast rule of the 'race movie' Westerns. In Bud Pollard's *Look Out Sister* (1947), a dark-skinned hero Louis (Louis Jordan) defeats a light-skinned villain (Monte Hawley).

A new black archetype: *Vera Cruz* (1954)

Noticeably fewer black characters appeared in Hollywood Westerns during the 1950s but a significant new Black Western archetype was born

during that decade. In Robert Aldrich's *Vera Cruz* (1954) Archie Savage appears as a black gunslinger called Ballard. Ballard is a minor character – one man in a large gang of mercenaries who have travelled to Mexico to fight in a revolutionary war – and as such he does not receive a great deal of screen time. But he is a man of action. Close readings of the film reveal that, in order for such a figure to appear in this mainstream Hollywood Western, it was necessary to grant specific characteristics to Ballard and observe certain plot details. As will become apparent, these characteristics and plot details would set a template that was followed by the handful of 1960s American Westerns that featured major black characters. Firstly, Ballard is a former Union soldier – he still wears his uniform – which indicates that he has provided a useful service to the United States and in turn justifies his knowledge of and use of firearms. Secondly, Ballard's free-roaming ways and displays of manly qualities take place outside the USA (in Mexico) and the only adversaries he shoots at are Maximilian's demonized Mexican and French soldiers, meaning that the Hollywood taboo concerning blacks shooting at or aggressively attacking white Americans remains unbroken. Evidently, the Hollywood powers-that-be still felt that it was necessary to contain and punish assertive, gun-wielding Black men like Ballard because he is duly gunned down during *Vera Cruz*'s finale.

Towards the end of the decade, Robert Parrish's *The Wonderful Country* (1959) briefly featured a troop of black Union soldiers. These brave troopers are undertaking a mission in Mexico when they come into conflict with Indians. However, when their white commanding officers are killed or incapacitated the film questions the black soldiers' abilities to think for themselves. The black sergeant Sutton (Leroy Paige) declares 'I don't know what to do, I don't know where I am, I don't know anything' before letting a passing American gun-for-hire, Brady (Robert Mitchum), take command. With the exception of Ossie Davis' runaway slave in Sydney Pollack's *The Scalphunters* (1968), the few major black characters who appeared in American Westerns during the 1960s would all be soldiers, former soldiers or law enforcement agents engaged in fights with 'Othered' enemies (Indians, Mexicans, foreign troops or enemies of the state), preferably in locations based outside the USA (most usually Mexico).

The 'civil rights' Westerns of the 1960s

A number of black actors had secured decent sized and relatively digni-fied and sympathetic roles in a small number of mainstream Hollywood films during the 1950s and things improved further during the 1960s. Sidney Poitier led the way, promoting a screen personality that Donald Bogle refers to as 'the intelligent, kindhearted black man' (2001: 215), and he set a precedent when he won the Best Actor Oscar in 1963 for his role in Ralph Nelson's comedy-drama *Lilies of the Field* (1963). Poitier duly starred in a Western that Nelson directed, *Duel at Diablo* (1966), and this film – which is essentially a cavalry film – will be examined later in this chapter. Richard Slotkin notes that in cavalry films white characters 'merge their differences to present a solid front to the enemy, and in later "civil rights" variations ... Blacks are integrated into the regimental society that opposes the demonized Apache' (1998: 377–378). The black man as an American soldier who fights for the good of the nation state appears to have been the most ideologically acceptable way for Hollywood to allow black actors to have a major, action-based presence in Westerns. However, the American Westerns produced during the 1960s do largely reflect Shohat and Stam's assertion that, at this time, 'the taboo in Hollywood was not so much on "positive images" [of blacks] but rather on images of racial anger, revolt, and empowerment' (1994: 203). A degree of empowerment was allowed in the American Westerns under review here but it was an empowerment sanctioned and controlled by white officialdom and white military superi-ors. As Michael Coyne notes:

> Major Black characters gained acceptance within white America primarily by asserting their physical authority on behalf of the prevailing [white] power structure, hence the heroics of Black troops in *Sergeant Rutledge, Rio Conchos*, and *Major Dundee*.
>
> (1997: 135)

With the exception of *The Scalphunters*, the remainder of the American Westerns from the 1960s that feature a black character in a major role – *Duel at Diablo, The Professionals* (Richard Brooks, 1966), *Sam Whiskey* (Arnold Laven, 1969) and *100 Rifles* (Tom Gries, 1969) – possess this same ideological outlook. In all of these films, black soldiers/former soldiers/

law enforcement agents are constituent elements of fighting forces that set aside any personal differences in order to present a universal front in their fights against their designated enemies.

· Hollywood's strict adherence to this ideologically acceptable theme is reflected in the fact that, when efforts were made to squeeze the Rat Pack (Frank Sinatra, Dean Martin, Sammy Davis Jr, Peter Lawford and Joey Bishop) into a Western vehicle, the result was John Sturges' *Sergeants 3* (1962). A loose rewrite of Rudyard Kipling's *Gunga Din*, the black Davis appears as a trumpet-playing former slave who tags along behind Sinatra, Martin and Lawford's Indian-fighting army sergeants in the hope that he might be enlisted as a trooper. It should be noted that the large size of the army platoon that ventures into Mexico in *Major Dundee* (Sam Peckinpah, 1965) means that the film's handful of black soldiers are hardly seen: they only come to the fore in two or three short but effective scenes. Similarly, although Jim Brown's Sergeant Franklyn in *Rio Conchos* (Gordon Douglas, 1964) and Woody Strode's Sharp in *The Professionals* each represent one quarter of the specialist teams that undertake missions in Mexico, these black characters receive less screen time and camera coverage than their companions. Franklyn is often placed furthest away from the camera, bringing up the rear in sequences that show his quartet travelling, and he is noticeably absent from a number of shots that feature the other group members together. Similarly Sharp tends to be positioned in the background of the group shots that he intermittently appears in.

Reassessing black presence in 1960s US Westerns: *Duel at Diablo* (1966)

Bogle asserts that Poitier's horse-dealer Toller in *Duel at Diablo* is 'a conventional cowboy' (2001: 216) while Sarf suggests that the film's content confirms that 'Blacks had moved easily into action roles that were not only he-man but essentially color-blind' (1983: 228). However, the race-specific 'rules' of the Western genre are still played out here and Toller is undoubtedly constrained by these rules. Poitier's star status means that he receives generally good camera coverage but it should be noted that *Duel at Diablo* – like most of the other American Westerns discussed in this section – does

feature a number of shots early on where its black character appears to have been purposefully placed in the background. Toller, who is the last of the film's major characters to be introduced, initially seems to be an empowered and independent black man. But he also comes across as being a less than sympathetic protagonist, seemingly lacking the intelligence and the kind heart that cinemagoers generally associated with Poitier's characters.

Toller, who is playing poker and smoking a long cigar in a saloon when the camera first settles on him, is a somewhat overdressed Western character. Falling somewhere between the gaudy zoot suits associated with pre-1960s black stereotypes and the flamboyant pimp-wear associated with black stereotypes from the 1970s Blaxploitation films, Toller's flash outfit and his cocksure attitude suggest that he is indulging in the kind of stereotypical behaviour that William B. Helmreich describes as 'symbolic status striving' and 'compensatory consumption' (1984: 86) in order to signify to those around him that he is as good as any white man. When he cockily butts in on a conversation that is taking place between the film's nominal hero, the scout Jess Remsberg (James Garner), and the cavalry lieutenant Scotty McAllister (Bill Travers), Toller's insensitive approach leads him into conflict with Remsberg. Toller draws his gun while Remsberg goes for his knife. However, quick as a flash, McAllister knocks Remsberg out and asserts that he has saved Toller's life by doing so. This narrative contrivance effectively allows the film to show the tough guy credentials of its two leading characters without having to fully present the taboo spectacle of actual violence taking place between a black man and a white American.

When Toller and Remsberg subsequently bump into each other on a quiet street, it appears as though they are going to have a gunfight. However, despite an effective build up of tension and the noticeable employment of the kind of shots and editing that traditionally indicate that a gunfight is about to take place (a shot–reverse shot set-up captures an exchange of some particularly provocative dialogue), the pair manage to settle their differences before either of their guns are drawn and they part on good terms. Once again the film provides generic excitement via this confrontation but then seemingly pulls back from the brink, not daring to show Toller take action against one of its main white protagonists. Mild black-on-white violence is seemingly deemed acceptable in a later scene because Toller is now acting in the cause of the heroic Remsberg: Remsberg rescues Ellen Grange

(Bibi Andersson) from four white would-be rapists and takes them on in a fistfight. When one of them moves to stab Remsberg with a pitchfork but freezes, a left-panning medium close-up shot reveals that Toller is holding his gun to the man's head and the following medium shot shows Toller knocking the man out.

Bogle notes that Poitier's screen characters tended to be 'non-funky, almost sexless and sterile' (2001: 176) and this is true of Toller. Ellen becomes the film's love interest and, of the two male lead characters, it is Remsberg who makes a romantic connection with her. Melvin Donalson notes that Jim Brown fashioned a screen 'persona that emphasized a physical toughness, sexuality, and ethnic pride [that was usually] absent from the black male characters of the Civil Rights era' (2006: 42) and, in *100 Rifles*, Brown's Lyedecker becomes the only major black character to express his sexuality in an American Western from the 1960s. However, although Lyedecker's love interest Sarita (Raquel Welch) is a Yaqui Indian, Hollywood's concerns about representing interracial sex onscreen seemingly meant that Sarita had to be punished by death before the film's end.

Just as with Ballard in *Vera Cruz*, it is revealed that Toller has only recently left the Union Army (McAllister was his commanding officer), which suggests that he has provided a useful service to the United States and justifies his knowledge of and use of firearms. Similarly, both Lyedecker in *100 Rifles* and Jed Hooker (Ossie Davis) in *Sam Whiskey* are revealed to be former Union soldiers. Toller is still loosely tied to the Army, having been contracted to provide forty saddle-broke horses for McAllister's new recruits, which perhaps serves to suggest that a black man cannot successfully function as a civilian without the continued support of the Army. This ties in with Erickson's observations concerning the content of John Ford's *Sergeant Rutledge* (1960). Ford's film focuses on an honourable black cavalry officer, Sergeant Rutledge (Woody Strode), who stands falsely accused of murder and rape. The affection for and devotion to military service that Rutledge and his fellow black troops show leads Erickson to argue that the film appears to imply that the Army is the 'proper place [for blacks] to find a "home" in society' (2006). This in turn can be linked to Frank Manchel's mention of the ideological theory that suggests 'that if African Americans could distinguish themselves in combat, black people as a group would benefit in American life' (1997: 248).

Significantly, McAllister goes on to question Toller's worth as a man outside the military: he tells the erstwhile soldier that he was 'a pretty good sergeant once' but is now 'just another money-hungry civilian'. Toller tells McAllister that he will never pull rank on him again but McAllister does just that when it transpires that the recruits must leave for Fort Concho immediately and Toller must travel with them, taming the remaining unbroken horses along the way, if he wants to get the balance of his pay. It is clear already that Poitier's seemingly independent black character is in fact wholly constrained. Narrative contrivances limit his ability to commit violent acts against whites and he is unable to completely free himself from the military's shackles. Furthermore, since John G. Cawelti observes that in white Southern popular mythology 'the black slave or servant is often shown to have a special understanding and skill with horses' (1999: 77), Toller's job as a horse-breaker would appear to perpetuate another element of the essentialist black stereotype.

On the way to Fort Concho, Apaches attack the troops and Toller's primary concern is for the safety of the unbroken horses that he has not been paid for yet. However, when McAllister is injured, Toller rides to his rescue and helps to fight off the Indians. When McAllister becomes fully incapacitated, Toller agrees to command the troops and fend off further Indian attacks. Furthermore, it is Toller who takes on the duty of helping the injured McAllister get on and off of his horse, resulting in a series of shots that show McAllister placed high in the frame and Toller placed low. While this narrative development and others serve to confirm that deep down Toller is another of Poitier's generic kind hearted black men, these shots effectively conjure up the image of a servile black man physically supporting his white superior.

Having spent part of his advance payment on flashy clothes and indulging in gambling, the newly independent black man has essentially returned to the army like a humbled prodigal son. The 'money-hungry civilian' has gone and Toller is once again fulfilling what the film indicates is his true and most useful calling: being 'a pretty good sergeant' for the US army. The untamed and uncouth sense of empowerment that Toller projected as a civilian at the start of the film has now been negated and replaced with a disciplined sense of empowerment that is sanctioned and controlled by the white power structure's military machine. Interestingly,

Toller wears a military jacket when he joins Remsberg and two troops on a nighttime mission to kill Apache guards. However, Toller's racial difference is highlighted in this scene when, in order to blend into their dark surroundings, the white men realize that they need to blacken their faces while Toller does not.

Duel at Diablo does possess a fairly unusual take on race relations. Remsberg once had a Comanche Indian wife, while Ellen Grange has a baby who was fathered by an Apache. When Remsberg, Ellen and the baby meet up with the beleaguered troops, Ellen's estranged husband Willard (Dennis Weaver) – a trader who is travelling with the soldiers – begins insulting Ellen and the baby. Toller intervenes and aggressively yanks a rifle from the trader's arms. When Willard orders him to pick it up there is a mild suggestion that Toller thinks that Willard is expecting him to act deferentially. The pair go through the motions of a traditional gunfight (a shot–reverse shot set-up again captures some provocative exchanges of macho dialogue) and both men in fact draw their guns (Toller is the fastest) but Remsberg intervenes before a shot can be fired. Again it seems that while the film is happy to show Toller being assertive, entering into conflict and generating generic excitement and tension, narrative contrivances are used to find ways to prevent him from inflicting violence on a major white character. In this case, it would seem that the film's producers were consciously trying to avoid showing the taboo image of a black man responding violently to a racial slur. Similar examples can be found in *Major Dundee* and *Rio Conchos*: when black characters are racially abused or discriminated against in these films, a sympathetic white character quickly takes it upon themselves to physically punish the abusers before the black characters have time to respond and act for themselves.

Despite the prohibition on him attacking white characters, Toller is free to kill countless marauding Indians during the second half of the film and he carries himself bravely and heroically in the film's action scenes. Similarly Toller makes for a very capable military leader and tactician and he ensures that Ellen is protected from the Indians while Remsberg is away gathering an Army rescue party, which promptly saves the day. Slotkin suggests that the generic themes of military Westerns like *Duel at Diablo* serve to imply that 'anti-Black racism can be undone only by scapegoating the Indians' (1998: 631). Essentially, blacks and whites get along in these

films because they are given a common 'Othered' enemy to fight in the form of the Indians. As such, Von Porter's observation that in *Sergeant Rutledge* black men, 'in order to gain their freedom, are taking away the freedom of other men of color (not to mention killing them) for the white system' (1999: 25) can be applied to the majority of American Westerns from the 1960s that feature black characters. Admittedly, the Indians seen in *The Scalphunters* pose less of a direct threat but they remain the narrative device that unifies the film's black and white protagonists.

Interestingly, the bond between the runaway slave Joseph Lee and the trapper Joe Bass (Burt Lancaster) in *The Scalphunters* is so strong that Lee is allowed to accidentally kill a villainous white man, Jim Howie (Telly Savalas), when he acts to save Bass' life. Howie dies when Lee wrestles him to the ground and tries to disarm him. Significantly, the gun (sandwiched between the two wrestling men's bodies) is not seen to discharge and it is unclear whose finger was on the trigger. As such, Lee is not punished for his actions. *The Scalphunters* was only the second mainstream US Western of the 1960s to show a major black male character play a part in the death of a white American character. The first was Sergeant Franklyn in *Rio Conchos* and his actions necessarily meant that he died before the film's end. When Major Lassiter (Richard Boone) is apprehended by a renegade Confederate who is intent on selling guns to the Apaches, Franklyn comes to Lassiter's aid and runs the Confederate through with an Indian spear. Significantly, the use of the spear bypasses the Hollywood taboo concerning blacks shooting white Americans whilst simultaneously reminding the audience of Franklyn's African heritage. A similarly coded reminder of cultural difference and ethnicity is seemingly employed in *The Professionals* when it is revealed that the black bounty killer Sharp's weapon of choice is a bow and arrow. Joseph Lee and Sergeant Franklyn both kill whites in order to save the lives of other whites. Thus their actions are merely a violent extension of the Hollywood B Western convention that allowed black sidekicks to point guns at white villains if doing so assisted the white hero's cause.

Reflecting the positive change that the civil rights movement sought to bring about, the black male characters who appeared in the American Westerns from the 1960s that I have reviewed above were generally honest, reliable and brave individuals. The fact that these few major black

115

characters appeared in American Westerns at all was highly noticeable and a cause for celebration. However, these celebrations have tended to obscure the fact that these black characters are still stereotyped to a degree and are still constrained by the genre's race-related rules. For the sake of clarity and completion, brief mention must also be made of three notable race-inflected films that nevertheless sit outside the main body of black-orientated Hollywood Westerns from the 1960s that I have previously discussed. Woody Strode does make an impression as Pompey in John Ford's *The Man Who Shot Liberty Valance* (1962) but Pompey is a fairly marginal character who is missing from much of the film's narrative. Pompey is also somewhat stereotypical in terms of his loyalty and devotion to John Wayne's Doniphon. The mixed-race creole gunfighter Jules Gaspard d'Estaing in Stanley Kramer's *Invitation to a Gunfighter* (1964) is a man of action who breaks a number of the Western's race-related rules but he is actually played by a Caucasian actor, Yul Brynner. Even so, d'Estaing is punished for his transgressions at a narrative level when he is gunned down at the film's end. Finally, a gang of minor black characters appears towards the end of Lee Frost's obscure American exploitation Western *The Scavengers* (1969). Frost employs the band of free black men as a provocative *deus ex machina* device that initiates the resolution of the film's central white versus white conflict. The former slaves elect to attack the film's villains, namely a gang of renegade Confederate troops who are holding a Union officer (Warren James) and his fiancée Faith (Maria Lease) as prisoners. But while the black gunmen do manage to kill a handful of Confederates they are all punished at a narrative level: every one of them dies during the attack.

The representation of black females in American Westerns

Discounting their roles as sympathetic love interests in the all-black 'race Westerns' produced in the USA during the 1930s, black actresses who appeared in American Westerns were usually cast in small and stereotypical roles. Mae King has observed that, traditionally, four basic types have been used to represent black females in Hollywood films: the sex object, the

tragic mulatto, the comical domestic servant and the matriarchal mammy (cited in Lawrence, 2008: 80). Of these four types, the mammy and the comical domestic servant made appearances in pre-1950s Hollywood Westerns that were set in the Southern states before or during the Civil War. Key examples of both the mammy and the comical domestic servant can be found in Victor Fleming's *Gone With the Wind* (1939), played by Hattie McDaniel and Butterfly McQueen respectively.

Only one major black female character of note appeared in a main-stream American Western during the 1960s. In *Death of a Gunfighter* (Alan Smithee, 1969) Claire Quintana (Lena Horne) is the black owner of a saloon-brothel-gambling house. All of her working girls are 'Others' (blacks and Asians) who look healthy and happy in their work. By contrast, the white prostitutes who work for a rival concern all look unhappy, depressed and driven to despair by their work. bell hooks has written about the perpetuating stereotype that serves to suggest that all black women are 'sexually permissive, ... depraved, immoral, and loose' (1982: 52) and Quintana and her exotic prostitutes are clearly modelled on this stereotype. When Quintana's white boyfriend, the Marshall Frank Patch (Richard Widmark), finally gets around to marrying her he is promptly killed and their doomed relationship can be read as another example of Hollywood's – and the American Western's – firm reluctance to endorse positive depictions of interracial relationships.

It should be noted that *The Scavengers* also features an interesting black female character, Nancy (Roda Spain). Somewhat stereotypically coded, Nancy is a domestic maid who remains subservient and loyal to her white Northern mistress, Faith. When Faith and her Union officer fiancé are kidnapped by rogue Confederates, Nancy is treated as a sex object and raped because she objects to the Confederates mistreating her mistress. Pre-figuring the activities of Pam Grier's later Blaxploitation action film heroines, Nancy goes on to use her sexuality to seduce a white guard before killing him during a moment of unguarded passion. She then flees to a nearby community of free black men and asks them to attack the Confederates so that her white employers can be saved. Since she is acting in the cause of her white employers, Nancy's murder of her white guard goes unpunished though, as was noted above, all of the black men who take up arms die during the course of the attack.

117

The Blaxploitation Westerns of the 1970s

In the post 1971 Blaxploitation film boom, a number of American Westerns would feature a new breed of black gunfighters. No longer tied to the army or forced to limit their aggression to Indians only, these black gunmen were assertive and independent and fully able to shoot and kill white enemies. Indeed, Sidney Poitier's appearance in the Blaxploitation Western *Buck and the Preacher* (Sidney Poitier, 1972) can be fruitfully used to highlight some of these changes. Although Poitier's wagon master Buck is identified as being a former military man, he is very different to Toller from *Duel at Diablo*. Buck is at liberty to shoot and kill white enemies and he has a love interest. Buck's love interest here builds upon the romantic and paternal relationships that were granted to Bill Cosby's Caleb Revers (another former soldier) in the earlier Blaxploitation Western *Man and Boy* (E. W. Swackhamer, 1971). However, although they are never mentioned in conventional histories of the Western genre, it is my contention that the black gunmen who appeared in Italian Westerns during the late 1960s were the first black Western characters to sport all of these groundbreaking traits. Furthermore, while the Blaxploitation wave did eventually produce a major black female Western character who could handle guns and shoot white men, Thomasine (Vonetta McGee) in *Thomasine and Bushrod* (Gordon Parks Jr, 1974), the black female gunfighter's first emergence can be traced to Lola Falana's starring role in Siro Marcellini's Italian Western, *Lola Colt* (1967). Clearly, if the black-orientated Westerns that were produced by Italian filmmakers during the latter half of the 1960s are taken into account a new sense of continuity and progression in the cinematic representation of African Americans out West becomes apparent. As will be revealed in the next section's close readings of a number of Italian Westerns, this sense of continuity and progression ultimately problematizes the received model of the Western's evolutionary development.

6

The Representation of Blacks in Italian Westerns

While Italian filmmakers made a significant number of Westerns that featured major black characters during the 1970s – key examples include *Chuck Moll* (*Ciakmull – L'umo della vendetta*, Enzo Barboni, 1970), *Trinity and Sartana are Coming* (*Trinita e Sartana figli di ...*, Mario Siciliano, 1972) and *Take a Hard Ride* (Antonio Margheriti, 1975) – their most significant black-orientated Westerns were actually made during the previous decade. Black characters had been noticeably present in some of the earliest Italian Westerns but these early representations tended to be stereotypical in nature. For example a black manservant appears in Sergio Corbucci's *Minnesota Clay* (1964) and a female 'mammy' domestic servant type appears in Albert Band's *The Tramplers* (*Gli uomini dal passo pesante*, 1965). But in 1967 more sympathetic and detailed black characters began appearing in Italian Westerns in increasingly larger roles.

In Alfonso Brescia's *Days of Violence* (*I giorni della violenza*, 1967) Nathan (Harold Bradley) is initially a somewhat stereotypical Southern black servant who chooses to stay on and work for his disabled former owner, Evans (Andrea Bosic), when Union forces take control of the locality. However, when Evans' daughter Christine (Beba Loncar) is kidnapped by a former lover turned Confederate outlaw, Nathan plays a key role in tracking the pair down and ensuring that Christine is returned home

safely. In Giulio Petroni's *Death Rides a Horse* (*Da uomo a uomo*, 1967) a black character, Vigro (Archie Savage), is temporarily taken under the wing of the vengeance-seeking gunman Bill Meceita (John Phillip Law). When Vigro is cheated out of his stake money, beaten up and thrown into the street, Bill marches him back into the local saloon, gets him his money back and punishes the white men who wronged him. Of significance here is the fact that Vigro comes to experience a sense of equality and belonging after being cheated while gambling. In his work on the carnival, Bakhtin describes how the random nature of games of chance essentially works to make all of their players equals (1984a: 235). The white gamblers who actively cheat Vigro put him at a disadvantage in their games of chance, thus breaking a carnival 'law', and it is this disruption that brings Vigro to Bill's attention and prompts him to establish Vigro's right to a sense of equality that extends beyond the limits of the gaming table. Bakhtin's (1984a and 1984b) work on the carnival will be drawn upon throughout this chapter when I discuss how the presence of itinerant performers, street fairs and circus spaces contributed to the emergence of pioneering black characters in a number of Italian Westerns that include Siro Marcellini's *Lola Colt* (1967) and Giuseppe Colizzi's *Ace High* (1968) and *Boot Hill* (1969).

Boot Hill's star, the African American actor Woody Strode, remains a key figure in terms of the Italian Western's representation of strong and active black males who are able to defy the Western genre's prescriptive race-related 'rules'. Strode had initially travelled to Italy to star in Valerio Zurlini's political film *Black Jesus* (1968). Representative of Italian cinema's defiantly left-wing turn during the late 1960s, Zurlini's film details the capture and imprisonment of a Congo rebel leader (Strode) while promoting an obviously anti-colonialist theme. Sergio Leone subsequently cast Strode as Stony in *Once Upon a Time in the West*. He may only feature in the opening twelve minutes of the film but Stony leaves a lasting impression on viewers. As he and two other gunmen (Jack Elam and Al Mulock) patiently wait at a desolate train station for the locomotive that is carrying Harmonica (Charles Bronson), Leone provides a detailed visual character study of all three gunmen. The introduction of Strode's black gunman in what is only the third shot of the film is particularly noticeable given the paucity of black characters in Hollywood Westerns at this time. Here

a slow-moving upward tilt takes in all of Stony's body, starting with an extreme close-up of his boots and ending with an extreme close-up of his face. Many more close-ups of Stony follow. Indeed, commenting on one sequence where drops of liquid from a railway water tower are seen falling onto Stony's hat, Strode observed: 'the close-ups, I couldn't believe. I never got a close-up in Hollywood. Even in *The Professionals*, I had only three close-ups in the entire picture. Sergio Leone framed me on the screen for five minutes' (Strode and Young, 1990: 237). According to Strode, Leone had effectively set a new paradigm for the visual representation of blacks in Westerns.

Furthermore, Stony is a villainous character. The dividing lines between 'good' and 'bad' characters in Italian Westerns tend to be less distinct than those found in traditional American Westerns but Stony's membership of Frank's (Henry Fonda) gang, and the part that he plays in the intimidation and confinement of an elderly railroad employee, indicates that Stony is a 'bad' guy. Which serves as a striking reminder that no mainstream American Western from the 1960s had featured a prominent black villain. Interestingly, Stony's gun – a leg-holstered and phallic-like mini-rifle that is by far the biggest weapon seen in the opening sequence – serves to underscore the overt sense of confidence, menace and masculinity that the character exudes. Indeed, the one bullet that hits and wounds Harmonica is fired by Stony.

The director John Ford had once advised Strode that the colour of his skin would inevitably result in star status eluding him (Strode quoted in Manchel, 1995). However, after working with Leone, Strode became a major star in the Italian film industry and he would go on to appear in a number of Italian Westerns. Later in his life the actor would reflect upon the fact that 'the Italians could never understand why I wasn't a star at home' (Strode and Young, 1990: 235). Furthermore, Strode experienced a kind of racial empathy with his Italian work colleagues, which led him to comment 'I was as comfortable in Italy as I would have been with my own [African American] people … [The Italians are] … the only white group I know that act like natives' (Strode and Young, 1990: 241). While Strode's use of the word 'natives' is ambiguous, his comments suggest that the Italians that he worked with had more in common with minority groups than white mainstream society. This would tie in with Günsberg's

observation that perceptions of whiteness differ from region to region and class to class in Italy (2005: 210). Certainly it would seem that Strode found himself working in an environment where race relations were different to those that he had encountered in America. Strode's first starring role in an Italian Western was in Giuseppe Colizzi's *Boot Hill*, in which he plays a vengeance-seeking trapeze artist called Thomas, and a measure of the worth that Colizzi saw in Strode is indicated in the actor's rate of pay for the shoot. Strode reports that while he generally earned $1,000 a week when shooting American films, Colizzi offered him 'a star's salary ... $75,000, the most money I had ever seen' (Strode and Young, 1990: 240–241).

Brock Peters had laid down the groundwork for Strode to some extent when he appeared as an equally defiant black character in Colizzi's earlier Spaghetti Western, *Ace High*. Also called Thomas, Peters' character is a street fair tightrope walker. Significantly, the two black actors that Colizzi chose to work with had both appeared in iconic roles as falsely accused black men in Hollywood films that were judged to have caught the mood of the emergent civil rights movement's calls for equality in America: Peters starred as Tom Robinson in Robert Mulligan's *To Kill a Mockingbird* (1962) and Strode starred as the eponymous military man in John Ford's *Sergeant Rutledge* (1960). Thus, the presence of Peters and Strode in Colizzi's Italian Westerns – and the racial antagonisms that their characters suffer and overcome – acts as a bridge that connects Hollywood's symbolic representations of contemporaneous social and political struggles to those that were also being produced in Italy. Crucially, Strode's Italian Westerns would have a tangible effect on later Hollywood Westerns that possessed a politically militant outlook: the American producer-director Larry G. Spangler has confirmed that it was a conversation with Woody Strode on the set of a Western being shot in Italy that convinced him to produce two of the Blaxploitation wave's most controversial and hard-hitting Westerns, *The Legend of Nigger Charley* (Martin Goldman, 1972) and *The Soul of Nigger Charley* (Larry G. Spangler, 1973) (quoted in Rausch, 2009: 149–152).

A sense of Italy's contemporary political mood can also be detected in two further Italian Westerns – Siro Marcellini's *Lola Colt* (1967) and Sergio Corbucci's *The Great Silence* (1968) – that serve to play an instrumental role in introducing major black female characters who are both assertive and in possession of atypical sexualities. When women appeared in Italian

Westerns they were usually treated harshly and, unlike the female characters encountered in the British Westerns discussed later in this book, they rarely transgressed the prescriptive gender-related 'rules' that were associated with American Westerns. However, *Lola Colt* and *The Great Silence* are both significant from a racial perspective because they seemingly represent a politicized moment in Italian national cinema's history wherein a serious effort was made to rethink Italian popular culture's imperialist and essentialist representations of the Black Venus. The African American star of *Lola Colt*, Lola Falana, was a hugely popular singer and sex symbol in Italy during the 1960s and the film is essentially a vehicle for her pre-existing star persona. By contrast, future Blaxploitation star Vonetta McGee was virtually unknown to cinemagoers when she made *The Great Silence*.

Rethinking the Black Venus: *Lola Colt* (1967) and *The Great Silence* (1968)

Numerous commentators have noted the groundbreaking nature of the black female characters that appeared in a number of Hollywood action films produced throughout the early 1970s. There is little doubt that the commercial success of the Blaxploitation cycle initiated by Melvin Van Peebles' *Sweet Sweetback's Baadasssss Song* in 1971 soon resulted in Hollywood rethinking its approach to the representation of black women onscreen. The lead character status and the active and assertive behaviour exhibited by the eponymous black female characters in Blaxploitation action films such as *Cleopatra Jones* (Jack Starrett, 1973), *Coffy* (Jack Hill, 1973) and *Foxy Brown* (Jack Hill, 1974) represented a wholly noticeable departure from the Hollywood norm. However, the self-same departure can in fact be found in two Italian Westerns that were produced during the 1960s. In *Lola Colt* a troupe of itinerant dancers led by the black performer Lola (Lola Falana) arrives in the town of Santa Anna. Larry Stern aka El Diablo (German Cobos) and his army of villains have been terrorizing the town and its residents have lost their will to resist. El Diablo is attracted to Lola but she has a reason to hate murderous bullies and she manages to convince the townsfolk that they must fight back. As will become apparent, it is significant that Lola – just like her male counterparts in Giuseppe Colizzi's films – is a character that is imbued with the spirit of the carnival.

123

In *The Great Silence* a corrupt justice of the peace, Pollicut (Luigi Pistilli), lusts after a local black woman, Pauline (Vonetta McGee). Pollicut engineers the murder of Pauline's husband in the hope that her impoverished circumstances will force her into his bed. Instead, Pauline hires a mute gunman, Silence (Jean-Louis Trintignant), and seeks vengeance against Pollicut and his villainous gang of bounty killers.

Lola Colt can be linked in the first instance to another equally atypical Italian Western, *Rita of the West* (*Rita nel West*, Ferdinando Baldi, 1967), which starred Rita Pavone. Both films were conceived as vehicles for popular female singers and they each feature some content that is centred upon singing and dancing. Unlike the British Westerns examined later in this book, the representations of strong females who can shoot that are found in these two Spaghetti Westerns slavishly follow the prescriptive gender-related 'rules' of the Hollywood Western: their female characters appear in tomboyish or masculine clothing whenever there is any action or shooting to be undertaken and they are both 'tamed' by the end of their films by either giving up their guns, entering into normative romantic relationships with dominant males or needing to rely on a male's help in order to finally vanquish their enemies. However, what distinguishes Lola and makes her wholly significant to this chapter is the fact that she is black.

Yvonne D. Sims asserts that 'a black actress starring in a genre dominated by actors was unheard of until the early 1970s' (2006: 17). That may well have been the case in Hollywood but both Lola Falana and Vonetta McGee did just that when they starred in Italian-made Westerns during the 1960s. Lola Falana's remarkable role in *Lola Colt* is quite unlike any black female role found in any pre-Blaxploitation era Hollywood Western. Italian popular culture has long made a fetish of images of the Black Venus and Falana's status as a sex symbol in Italy undoubtedly played a part in her being cast in Marcellini's film. Indeed, *Ebony* magazine confirms that contemporary 'Italian magazines glamorized' Falana 'as the "Black Venus" on their covers' while also noting that 'in Rome she was mobbed on the streets' (*Ebony*, 1967: 114). And when we initially observe Lola performing her sexy dance routines, it does at first glance appear as if she is simply being presented as a stereotypical black sex object. However, a close reading of *Lola Colt* reveals that much like – and, indeed, prefiguring – the actresses who would eventually appear in the female character-led

Blaxploitation action films of the 1970s, Falana is able to balance the sex object aspects of Lola with pioneering instances of assertive behaviour. Mikel J. Koven notes that the Pam Grier-starring Blaxploitation action film *Coffy* is groundbreaking because it presents an 'image of a strong black woman stopping at nothing to do what she feels is right' (2001: 48) but the same can undoubtedly be said of *Lola Colt*, which was produced six years earlier. In addition, *Lola Colt* also provides an atypical representation of black female sexuality (something that cannot always be said of Blaxploitation films such as *Coffy*). Indeed, Lola completely transgresses the prescriptive race-related rules that were associated with American Westerns and Hollywood films more generally during the years preceding the Blaxploitation boom.

Empowering the restricted black gaze

Laura Mulvey notes that 'in a world ordered by sexual imbalance, pleasure in looking has been split between active/male and passive/female' and she further asserts that, in classical Hollywood cinema, it is dominant male characters who control the power of the 'gaze' which is represented onscreen by their ownership of point of view shots (1986: 203). bell hooks has argued that a further imbalance, based on racial difference, can be found within the pleasure of looking: active/white and absent or restricted/black (1992: 129). Referring to black Americans historically, hooks observes that slavery and its attendant race-based power relations resulted in black slaves effectively being 'denied the right to gaze' (1992: 115). hooks determines that because the slaves could be brutally beaten just for looking at the white people they were serving, they were forced to cultivate 'the habit of casting the gaze downward so as not to appear uppity' (1992: 168). hooks indicates that representations of black females found in Hollywood films traditionally revolved around characters who were 'there to serve': as such, these characters had their gaze restricted just like the historically placed slaves and servants that they were portraying (1992: 119).

However, hooks argues that the gaze can be 'oppositional', 'a site of resistance' for 'rebellious' black people who can learn 'to look a certain way in order to resist' those who would deny them the right to look (1992: 116). She goes on to explore the implications that the absent or

restricted black gaze – as represented onscreen – holds for black female spectators. However, I am more concerned with observing how the traditionally restricted black gaze – again, as represented onscreen – is seen to be made active by the black female characters who appear in *Lola Colt* and *The Great Silence*. Certainly in terms of the Western genre, both films offer a markedly new approach: the idea that only small or marginalized roles could be allotted to black actresses, the routine representation of stereotypical black sexualities in films and the notion of a restricted black gaze are all roundly rejected by these two remarkable genre entries.

Lola's introductory scene in *Lola Colt* features examples of a resistant and active black female gaze. Extreme long shots of the dancers' stagecoach pulling into town are intercut with a number of medium and medium long shots of a variety of white townsfolk looking at the coach as they walk towards it. Given the severe paucity of significant black female characters in Westerns, the viewer is somewhat surprised when the coach door swings open and Lola emerges. This sense of surprise is reflected on the film's soundtrack, where the gasps and outraged mumblings of the attendant townsfolk can be heard. The next shot is a medium close-up that frames five stern-looking white women who are staring directly at Lola in a disapproving way. The dancers' manager makes himself known and advises the townsfolk that one of the girls, Virginia, is sick. However, he is quickly told that the town has no doctor and he is instructed to take Virginia to the next town, which is twenty miles away.

Lola immediately takes charge of the situation, shaking her head and asserting 'We'd better stop right here in that case. Virginia would never make it.' Lola is then seen to circle the stagecoach in a determined manner, looking directly out towards – and thus returning the intrusive and disapproving gazes of – the white townsfolk who have surrounded her. She remains unfazed when one woman contradicts her husband and insists that the couple's hotel has no vacant rooms. Furthermore, Lola becomes assertive and defiant when the five stern women who were seen observing her earlier in the scene aggressively walk up to her and try to force her out of town. It is implied that it is Lola's status as a dancing girl that upsets the town's women – as opposed to the colour of her skin – but extreme prejudice of one kind or another is clearly at work and Lola refuses to be beaten by it. She employs a resistant facial expression and an oppositional

stare – that is communicated via a close-up – that sees the women off. It is tempting to draw parallels between Lola's rude reception here and the rude receptions received by dark-skinned Southern Italians when they travelled North during the 1950s and 1960s.

Lola possesses the power of the gaze and close observation of her face and the eyeline matches that lead to shots of her point of view reveal that she does not employ the traditional downward gaze associated with black female characters who have been cowed by dominant whites. Later, when Lola experiences a flashback which shows her family being massacred for fun by white attackers – itself a groundbreaking representation of black victimhood and suffering – the flashback is bookended by two extreme close-ups of Lola breaking the 'fourth wall' by staring directly at the camera: in essence, Lola is staring at each person who views the film. By doing so, she is returning their gaze, declaring her right to do so whilst defiantly imparting a tale of black victimhood directly to them. Furthermore, by having Lola break the 'fourth wall' director Siro Marcellini ensures that each spectator is fully alert to the harrowing nature of the memory that Lola imparts. Crucially, later in the film Lola actually explains how possessing the power to look has empowered her in her struggle against El Diablo. When Rod (Peter Martell), the white man with whom she will forge a romantic relationship, chastises her for going to El Diablo's secret hideaway alone she explains 'I had to *see* all his guards and where the prisoners are kept. Plus the road to the ranch.'

The black gaze employed in *The Great Silence* is slightly different and it chimes more closely with hooks' historical account of black looking. Pauline possesses a strong, unflinching and defiant gaze and a good posture when she is first introduced. When the bounty killer Loco (Klaus Kinski) comes looking for her husband, Pauline stands tall and the shot–reverse shot set-up that is employed to cover their heated exchange of words features close-ups of Pauline staring unwaveringly into Loco's heartless eyes. When her strong gaze subsequently focuses upon the murder of her husband, Pauline becomes a broken woman. While she should be mourning, she is forced to deal with situations that would fall outside her comfort zone at the best of times: hiring a gunman for revenge and carrying out financial negotiations with the man who plotted her husband's death.

Pensive, seething and hurting, during the film's mid-section Pauline often appears in medium shots where she is posed in a slightly hunched position, with her head bowed and her sad eyes downcast or looking away from the person she is talking to. As such, Pauline is reminiscent of the historically placed blacks that hooks indicates were forced to adopt a downward gaze for fear of appearing 'uppity' (1992: 168). However, by employing this approach, director Sergio Corbucci is able to make the instances when Pauline does raise her gaze all the more effective and meaningful in terms of communicating her defiance and anger. hooks observes that black people learnt 'to look a certain way' in order to express resistance (1992: 116) and Pauline's raised gaze, and the close-ups of her large, expressive and angry eyes, communicate her resistant and oppositional stance perfectly. By the film's end, Pauline has fully recovered her strong, unflinching and defiant gaze and her good posture. She stands tall and watches as Silence is gunned down by Loco and she stares directly into Loco's eyes as he in turn shoots her. In what might be coded as an act of ultimate defiance, Pauline's eyes remain open after she has died.

Freeing the fixed black female body

hooks observes that nineteenth century painters often composed pictures that contrasted 'white female bodies with black ones in ways that reinforced the greater value of the white female icon' (1992: 64) before arguing that the presence of black women in films often serves a similar purpose: the black female body is there 'to enhance and maintain white womanhood as object of the phallocentric gaze' (1992: 119). This is absolutely not the case in the two Italian Westerns under discussion here. In both *Lola Colt* and *The Great Silence*, shots are present in which a black female shares the frame with a white female. And, after taking account of hooks' observations, these shots can be read as being progressive in nature. An early medium shot in *Lola Colt* has Lola standing alongside one of the white dancers. Both women are dressed similarly and the camera placement neither privileges nor adds greater value to either one of them. Furthermore, the introduction of Rod's fiancée Rose and his subsequent attraction to Lola presents another quite novel disruption of the Western genre's 'rules'. Within American Westerns there is a pattern of

representation that generally codes fair-haired or light-skinned women as decent and morally sound and dark-haired or dark-skinned women as fallen or morally dubious women. Inevitably, if forced to choose, the typical Western hero will almost always settle down with a white Anglo-Saxon protestant blonde.

Lola Colt is very unusual in that it sets up a dark versus fair competition between Lola and the blonde, blue-eyed and beautiful (but jealous, spiteful and spoiled) Rose which Lola actually wins. This is remarkable because Lola is more than simply dark-haired: she is black skinned. In *The Great Silence*, Pauline shares a number of shots with the red-haired prostitute Regina (Marisa Merlini). There is no competition between the two women, only an acute sense of female solidarity, and the camera privileges neither woman. Regina is middle-aged and overweight and Pauline in no way serves to enhance and maintain Regina as the 'object of the phallocentric gaze' as hooks' thesis (1992: 119) would argue. Regina is a moral and caring person despite her profession and she further subverts another convention of the Western. Calder notes that 'a significant number of the Western's spunky but respectable heroines have red hair. It suggests spirit without vice, virtue without insipidness' (1974: 171). Regina works in the vice trade and her profession would seemingly prohibit her from being described as respectable but she is a virtuous person who possesses great spirit: she publicly berates Pollicut and she tries to shoot Loco as he and the bounty killers search for Silence and Pauline, an action that results in her own death. Interestingly, a sense of connection and equality is forged between Pauline and Regina on a number of levels. They both enter into romantic relationships with enemies of Loco (who he subsequently kills) and Pauline and Regina both die when they in turn try to kill Loco. Since Percy Allum notes that women's groups were among a number of new social and political protest movements that arose in Italy during the late 1960s (2000: 26), the sense of female solidarity promoted by *Lola Colt* and *The Great Silence*, and the films' pointed celebration of marginalized females (dark-skinned women, dancers and prostitutes), would seem to reflect the political mood of contemporaneous Italian society.

hooks has spoken about the cinematic 'white male gaze that seeks to reinscribe the black female body in a narrative of voyeuristic pleasure where the only relevant opposition is male/female, and the only location

for the female is as victim' (1992: 129). This can be linked to Ponzanesi's description of the colonial gaze, as found in some strands of Italian cinema, that seeks to capture and control the Black Venus: this 'gaze is always bound up with power, domination and eroticisation. It is a voyeuristic, fetishized, white male gaze' (2005: 170). *Lola Colt* and *The Great Silence* both seemingly work to highlight and then deconstruct these notions concerning the deviant white male gaze since they both feature short sequences that position the viewer as a voyeur spying on a fetishized Black Venus but then make an obvious point of refusing to supply the expected eroticized payoff. In *Lola Colt*, a camera that is focused on some leafy treetops pans down to a river where Lola can be seen swimming in the distance. As she nears the far bank, a zoom in on Lola is initiated but the shot is teasingly cut short just as Lola begins to emerge from the water. In effect the voyeuristic viewer is denied the expected pleasure of seeing Lola's naked body. A brief close-up, side-angled panning shot shows only Lola's smiling face as she dashes into nearby bushes to get dry. A zoom lens is then frantically employed in a voyeuristic manner but rather than bringing Lola's body into focus the lens instead causes the tangle of bush leaves that it is being shot through to become a blurred mass in the foreground of the shot. This blurry mass duly obscures Lola's naked body and further frustrates the voyeuristic viewer. As if to further (and completely) diffuse any sexual charge that might have been generated by this sequence, when Lola emerges from the bushes she is unexpectedly presented as a masculine figure as she is dressed in male 'cowboy' clothing rather than feminine attire. In *The Great Silence*, when Silence retires to Pauline's open plan loft, his point of view is presented via a high angled long shot: Silence sees Pauline undressing, putting on her night clothes and getting into bed. Once in bed, Pauline's open and worried eyes make it clear that her mind is racing and she cannot sleep. Rather than arousing Silence, what he sees reminds him that – just like Pauline – he too has been a victim and he turns his gaze away from her and loses himself in his own thoughts: he immediately experiences a flashback which reveals that his parents were murdered by bounty hunters in the pay of Pollicut.

When performing her song and dance routines, Lola connotes what Mulvey refers to as 'to be looked at-ness' (1986: 205). This concept involves a female character being offered as a pleasurable (usually erotic) spectacle that is captured by the gaze of a male character and thus relayed directly

to the film's male audience members via point of view shots (1986: 205). Certainly, in most of these sequences Lola's showgirl outfits (colourful basques, stockings, boots and boas) have an element of fetishistic 'sexiness' about them. However, these sequences also work to signify black female resistance and freedom on a number of levels. Bakhtin stresses that itinerant performers possess a sense of freedom that can be 'contrasted to all the well-ordered and established world': they are essentially 'removed from the sphere of conventions and binding rules' (1984a: 106). As an itinerant dancer, Lola can be understood to be a free spirit at a basic personal level. But her performances serve to break further restrictive boundaries. Ponzanesi notes that the colonial gaze that seeks out the Black Venus is a 'white male gaze [that] desires to unveil the female body but also fixes the black woman in her place' (2005: 170). Referring to the flamboyant dances by black females seen in Spike Lee's *School Daze* (1988), hooks celebrates the fact that the dancing girls do not represent 'the still bodies of the female slave made to appear as mannequin. They are not a silenced body' (1992: 63). Since her dancing style is wild and exuberant (anachronistic go-go dancing that matches her equally anachronistic up-tempo R&B songs), Lola represents a free black body that is neither still nor silenced.

A further sense of freedom is telegraphed by the fact that Lola refuses to be fixed in place by the boundaries of the saloon's small stage. For her first performance, Lola starts singing and dancing at the top of the saloon's internal staircase. Shot from the foot of the staircase, Lola is seen in an elevated and powerful position. After descending the stairs, Lola chooses to ignore the stage initially and she dances around the saloon floor instead, which allows her to interact with the customers: she playfully pushes one man from the edge of the stairs and allows two others to carry her aloft. It should be noted that these interactions – like Lola's performances – are not the kind of purposefully staged and choreographed routines that are normally presented as stand alone interludes or spectacles in musical films. They are supposed to be unfolding in a natural and unforced way as part of the film's realist narrative. Bakhtin describes how in festive and carnivalesque celebrations and performances 'there are no footlights, no separation of participants and spectators' (1984a: 265) and the same applies to Lola's interactive performances. Of particular significance here is that, instead of dancing on the stage, Lola dances on the saloon's roulette table much of the

time. Representing what might be the ultimate game of chance, the roulette table links back to Bakhtin's carnival-based games of chance that served to engender a sense of equality amongst their players (1984a: 235).

Although Lola's first performance is announced as being for 'gentlemen and others', most of the women who are present choose to leave, which does admittedly result in the performance being largely taken in by male gazes. Lola's second performance at the saloon is part of a ruse that she herself concocts: Lola invites El Diablo and his men to a private performance with the hope that Rod and a group of local men will be able to capture and defeat him. Lola again refuses to be confined to the stage, walking amongst and interacting with El Diablo's men. However things do not go as planned and Lola has to brandish a gun in order to stop Rod and El Diablo fighting. When Lola eventually comes up with a plan that defeats El Diablo she is the toast of the town and she insists that the best way for the town to show its appreciation is for everybody – even the town's disapproving women – to attend her third and final performance. Lola makes her entrance via the saloon's staircase again but this time she is dressed in a gospel singer's robes and she sings 'Swing Low, Sweet Chariot'. This Negro spiritual song was originally a 'signal' or 'coded' song whose lyrics spoke of Southern slaves escaping and travelling North to find freedom. The song became popular again during the years of the civil rights movement and its inclusion here adds a pointedly political dimension to the film.

Here the song seemingly underscores both the townsfolk's emancipation from El Diablo's brutal oppression and the whole town's acceptance of Lola as an equal. That being the case, parallels can be drawn between the film's narrative of revolt and the struggles for a more equal and just society that were being fought on Italy's streets and factory floors at this time. Once again, Lola moves amongst the audience, who become part of the performance in a carnivalesque manner by clapping out the song's beat. A medium long shot reveals that the previously stern and judgmental women are enjoying the performance and a close-up of the local priest shows him sporting a benevolent and approving look. These key shots suggest that the more temperate members of the town now no longer see Lola's act as being overtly sexual or improper. Perhaps not surprisingly, Lola concludes the song atop the roulette table. In this elevated position she receives a standing ovation and, taking on a newly liberalized stance, the leader

of the stern women tells her 'I'd like to offer my apologies. I've learnt one thing from all of this. No one has the right to judge anyone else.' Lola then takes off her robes to reveal her showgirl outfit before reprising the wild song and dance routine from her very first performance. The fact that Lola is able to switch between outfits that both cover and expose her body suggests that she is in control of her own representation. Furthermore, this time around everybody stays to watch and Lola receives another standing ovation. It would seem that Lola has succeeded in demystifying the exotic nature of the Black Venus: she has proven to be a moral woman, her performance has been desexualized in the eyes of the white townsfolk and it can now be enjoyed by both the male and female gaze for the simple entertainment that it is.

'Sticking it to the Man' and interracial relationships

Koven notes that the very first Blaxploitation film, *Sweet Sweetback's Baadasssss Song*, foregrounded 'perhaps *the* [Koven's emphasis] most salient theme of Blaxploitation Films … the idea of "sticking it to the Man," of resisting the authority of those who say they are in charge' (2001: 17). Both Lola and Pauline prefigure the Blaxploitation films in the way that they 'stick it to the Man'. Significantly, Lola is seen to move onto the saloon's roulette table when she commits one of her most notable acts of defiance. Towards the end of her first performance Lola is on the saloon's stage when El Diablo's men burst in. Empowered by the low angle of the long shot that frames her, Lola stands with her arms folded and a defiant look on her face. When El Diablo – who is essentially a dictator that the townsfolk have learnt to obey – enters, Lola steps forward onto the roulette table and he orders her to 'go ahead, [and] sing'. An extreme close-up of Lola staring directly at El Diablo and defiantly replying 'I don't give any performances unless I hear the word "please"' follows. El Diablo acquiesces and asks 'Will you kindly sing for us, please.' After another close-up, which shows Lola giving a sarcastic nod, she dances on the roulette table. In *The Great Silence*, Pauline openly defies Loco when he orders her not to bury her husband's body. Loco actually provides one of the film's more explicit representations of racism at this point: after killing Pauline's husband he remarks 'What times we live in when a black's worth as much as a white

man.' Interestingly, the film's snow-laden *mise-en-scène* serves to accentuate the African American characters' dark skin tones and it is also employed to introduce another racist incident when Pollicut's assistant says to Pauline 'Cold, ain't it? If the weather doesn't get better, I'd go back to Africa if I were you.' This is precisely the kind of racist slur that migrating dark-skinned Southern Italians had directed at them by resentful Northerners during the 1950s and 1960s.

Remarkably, both Lola and Pauline are seen to offer acts of resistance at a sexual level, which serve to run counter to stereotypical representations of both black female sexuality generally and the Black Venus in Italy. hooks notes that, historically, white male slave owners would effectively force black women to act like prostitutes by offering them bribes before they initiated demands for sexual favours (1982: 25). Furthermore, Ponzanesi describes how period photographs of Black Venuses depicted African women as being 'sexually loose, inviting the beholder to look at them as beautiful objects that can be possessed and fulfil unconscious desires' (2005: 176). El Diablo and Pollicut respectively regard Lola and Pauline as beautiful objects to be possessed and they both labour under the impression that the black women they desire can be bought like prostitutes.

When Lola is summoned to El Diablo's secret lair he tries to force her to kiss him but she pushes him away. El Diablo then tries to bribe Lola into prostituting herself. As he escorts her around his luxurious abode and offers evidence of his great wealth, El Diablo tells her 'Stick with me, this is all for us. I'll make you rich.' But Lola dismisses him with the words 'I'm not for sale.' In *The Great Silence*, Pollicut sets about trying to bribe Pauline as soon as her husband has been killed, offering to 'supply anything she wants' if she 'is in dire straits'. Pauline eventually visits Pollicut to negotiate the sale of her home in order to raise the $1,000 that she needs to pay Silence. Pollicut tells her 'I wouldn't take advantage of your situation for a thousand dollars. I want you to have it' before grabbing her and forcing her to kiss him. Pauline assertively pushes him off, spits in his face and snaps 'I wish it was poison' before leaving. Later in the film, Pollicut makes a more determined effort to rape Pauline but she is able to resist him until Silence comes to her assistance. hooks observes that, historically, 'those black women who resisted sexual exploitation directly challenged the [white patriarchal] system' (1982: 27) and both

Lola and Pauline can be classed as pioneering cinematic representations of such women.

Interestingly, hooks suggests that while film and television depictions of loving relationships between white women and black men were becoming more commonly accepted in America during the early 1970s, similar depictions of black women with white men could still provoke 'outrage and anger' amongst the general American populace (1982: 64). Novotny Lawrence adds that the early 1970s Blaxploitation action film heroines that were played by the likes of Pam Grier were significant because both black and white men desired them (2008: 20). Furthermore, these black females remained 'in control of their sexuality' and 'often dictate[d] the circumstances of their erotic encounters' (Lawrence, 2008: 20). Lola and Pauline possess these attributes too but the pair are not only desired by white characters, they actually enter into romantic relationships with them. And so *Lola Colt* and *The Great Silence* are both groundbreaking in their depictions of black women entering into normative relationships with white men. Italy's cultural obsession with the Black Venus may well be the local circumstance that prompted the production of these films but their black female characters are seen to move beyond and overwrite the negative connotations that both the cult of the Black Venus and Hollywood films had previously attached to their representations of black female sexuality.

Although Lola is initially coded as a fallen woman by virtue of her status as a dancing girl and her skin colour, she is revealed to be a thoroughly moral and decent character. After Rod and El Diablo fight, Lola and Rod share a spur-of-the-moment kiss. Lola is clearly attracted to Rod but she will not allow their relationship to develop any further while Rod is still engaged to Rose. At the film's denouement, Rod ends his relationship with Rose and subsequently flags down the dancers' stagecoach as it passes through the countryside. He and Lola enjoy a passionate embrace and the pair then head off for a future together. Lawrence asserts that before the arrival of the Blaxploitation films 'black female sexuality [in American cinema] was either nonexistent or deviant because it resulted in biracial offspring' (2008: 19–20). Lawrence's observations apply readily to the only Hollywood Western of the 1960s to feature a major black female character: as noted earlier, *Death of a Gunfighter*'s white male hero is killed within hours of his marriage to his black, brothel-owning girlfriend. But

135

Lawrence's observations do not apply to Lola and Rod's loving and optimistic relationship.

Pauline's relationship with Silence is perhaps more complicated. When Pauline turns down Pollicut's $1000 and rebuffs his sexual advances, she returns home and begins to explain to Silence that she would be willing to sleep with him if he would accept her body as payment for killing Loco. She has her back to the gunman and the camera is focused on her face when the sound of the front door slowly closing on the soundtrack indicates that Silence has in fact left before she has finished explaining her proposition. When Silence returns, having failed to kill Loco and wounded to boot, he takes to his bed and Pauline dresses the bullet hole in his shoulder. During the course of the wound dressing, the pair moves ever closer to each other and eventually make love. It becomes clear that this act is not payment – after all, Silence has not technically fulfilled his side of the bargain – and Pauline has therefore not prostituted herself. Two broken people who have been hurt by the same two men (Pollicutt and Loco) have simply come together for mutual comfort.

The beautiful and emotion-charged non-diegetic soundtrack music that accompanies this modestly represented sexual encounter suggests that the scene is intended to be erotic rather than titillating. That said, by using a series of oddly framed and angled shots that are edited together in a jarring, almost jump-cut-like manner, director Sergio Corbucci appears to be trying to prevent viewers from connecting closely to the characters onscreen and any erotic charge that the scene may hold is largely diffused. Later Pauline confesses that she loves Silence, thus indicating that her heart rather than her libido motivated her actions. Ultimately, the content of *Lola Colt* and *The Great Silence* runs counter to O'Healy's observation that 'the association between black womanhood and sexual availability … overdetermines traditional representations of African femininity in Italian cinema' (2009: 177). Both Lola and Pauline are attractive women and they do carry an erotic charge at times but this does not obscure their other sides. The pair can still be sexually desirable while also being able to exercise choice and openly display their intelligence, their resourcefulness and their anger.

The fact that both Silence and Pauline die at *The Great Silence*'s denouement could be interpreted as signalling disapproval of the pair's interracial relationship. However, it seems that the film's ending actually possesses a

liberal agenda that chimes with the revolutionary mood that was sweeping contemporaneous Italian society. Sergio Corbucci's widow Nori has indicated that her husband wished to draw correlations between the righteous Silence and Pauline's noble deaths – they die trying to free falsely criminalized men and women from Loco and his gang of corrupt law enforcers – and the deaths of Che Guevara and Malcolm X (quoted in Cox, 2009: 189). Crucially, Pauline dies with a gun in her hand, cursing those who would oppress her instead of quietly leaving town like the newly widowed black woman Claire Quintana in *Death of a Gunfighter*. For Silence and Pauline, it is better to die gun in hand, acting for a cause they believe in than to live life as victims of cruel oppressors.

The black female action heroine

Beyond the progressive and atypical representations of black femininity and sexuality that are found in *Lola Colt* and *The Great Silence*, Lola's action scenes also serve to distinguish *Lola Colt*. Sims observes that, during 1973 and 1974, the black actresses 'Pam Grier and Tamara Dobson brought a new character to the screen that was instrumental in reshaping gender roles, particularly those involving action-centred story-lines' (2006: 8) before adding that Blaxploitation era films showed 'tough, no-nonsense women who were capable of holding their own among men and using justifiable violence to achieve their ultimate objective' (2006: 30). I would argue that Lola Falana was in fact responsible for introducing the character type that Sims describes. At *Lola Colt*'s end, it is Lola who inspires and organizes the town's cowed citizens to revolt against El Diablo. Gun in hand, she leads the attack on El Diablo's stronghold and instructs her manager to use his bow and arrow skills to silently eliminate El Diablo's guards. When one arrow misses and the guard turns on the advancing townsfolk, Lola shoots him dead. This act surely represents the first instance in a 1960s Western of a black person wilfully shooting a white person in plain view of the camera. Lola goes on to dynamite El Diablo's front gates, cosh two guards and release the prisoners El Diablo was holding, all while discharging her gun in the direction of El Diablo's white henchmen. Lawrence asserts that the Blaxploitation era films that feature black action heroines are notable because they serve to:

either challenge or work in direct opposition to the traditional portrayals of black women. Several of the movies depict African American women as strong, three-dimensional characters who exercise a great deal of agency as they fight the establishment on their terms.

(2008: 81)

But the same could be said of both *Lola Colt* and *The Great Silence*, thus challenging the view that such characters did not appear on cinema screens until the emergence of Blaxploitation films.

That said, in keeping with the Western's traditional gender-related rules, Pauline dies and Lola has to rely on a man's help during *Lola Colt*'s climactic gun battle: Rod arrives and orders Lola to get the prisoners to safety while he deals with El Diablo personally. Nevertheless, for a black female, Lola's action scenes and her ability to kill a white man prefigure any similar scenarios in Hollywood Westerns by a number of years. The Blaxploitation era did produce one significant black female Western character, Thomasine (played by Vonetta McGee of *The Great Silence*) in Gordon Parks Jr's *Thomasine and Bushrod* (1974). Thomasine is introduced as a bounty killer who is capable of tracking and killing white male criminals but – this being an American Western – her fate becomes doubly sealed when she becomes romantically involved with the black gunman Bushrod (Max Julien) and they start robbing banks: the pair are both shot dead as they prepare to undertake their final robbery. When Koven asserts that Grier's Coffy character from 1973 is 'one of the few strong and active women characters in exploitation cinema, let alone strong active black women' (2001: 48) and Lawrence stresses that Tamara Dobson's Cleopatra Jones character from 1974 challenges 'previous constructions of black females as asexual or mere erotic objects' (2008: 87), the groundbreaking but overlooked significance of the major black female characters that appear in *Lola Colt* and *The Great Silence* becomes acutely apparent.

Reimagining the black male Westerner: *Ace High* (1968) and *Boot Hill* (1969)

Ace High and *Boot Hill* are the final two chapters in Giuseppe Colizzi's highly popular trilogy featuring the characters Cat Stevens (Terence Hill)

and Hutch Bessy (Bud Spencer). Both films also incorporate major black protagonists. Although the first film in the trilogy – *God Forgives, I Don't* (*Dio perdona ... Io no!*, 1967) – does not feature a major black character, it does include a carnivalesque funeral sequence that incorporates a black Dixieland jazz band. Colizzi covers the black musicians in great detail here, granting them several close-ups, and this sequence is an early indication of his obvious desire to incorporate representations of both black ethnicity and the carnivalesque within his personal vision of the West. In *Ace High* an itinerant black street fair tightrope walker, Thomas (Brock Peters), links up with Cat, Hutch and the Greek immigrant Cacopoulos (Eli Wallach) and assists them in their struggle against a crooked casino owner, Drake (Kevin McCarthy), who is running for political office. In *Boot Hill* Woody Strode stars as a different Thomas. This Thomas is an itinerant black trapeze artist turned vengeance-seeker whose revenge mission sees him teaming up with Cat, Hutch and the mute strongman Baby Doll (George Eastman) in order to take on a villainous businessman, Honey Fisher (Victor Buono), who is exploiting local miners. Both of these black characters are completely independent men and they are free to act as any white character might.

Colizzi's Westerns are undoubtedly imbued with the spirit of the carnival. However, the un-generic entertainment spaces that they promote (the street fair and the circus), the character types that they foreground, the physicality of the action scenes that these characters are involved in and the comic tone that often underscores such scenes also serves to link his films to two popular entertainment forms that are direct descendants of the carnival: the Italian *commedia dell'arte* and the modern circus. Thus it can be argued that the theoretically egalitarian spaces created by the carnivalesque atmospheres and entertainment spaces found in Colizzi's films subsequently serve to encourage the emergence of black gunmen who are able to defy the race-related rules that governed contemporary Hollywood Westerns.

Finding the carnivalesque in Colizzi's films

Colizzi had worked as Sergio Leone's assistant on the set of *The Good, the Bad and the Ugly* and his Westerns are formally quite similar to those directed by Leone. However, Colizzi's films feature more directly comedic

interludes. Furthermore, Hill and Spencer's characters are notably more 'physical' than typical Leone characters. Mel Gordon observes that 'the athleticism and clowning of the Commedia dell'Arte were always among its best known features' and he notes that characteristic activities included 'tumbling, stilt walking, handsprings, diving, [and] tightrope walking' (1983: 9). In Colizzi's films Cat is repeatedly seen to undertake much in the way of impressive acrobatic action and the rope and acrobatic skills displayed by each Thomas can also be linked directly to the *commedia*'s stagecraft. Gordon notes that comic violence played a part in the *commedia* (1983: 14) and this is replicated in the often slapstick approach that Colizzi employs when choreographing his overly physical brawls and fight scenes in *Ace High* and *Boot Hill*. Furthermore, Gordon adds that some *commedia* characters were known to take on the attributes of animals (1983: 9). The aptly named Cat is often seen climbing onto the roofs of buildings with ease while the strongman Hutch is often used like a strong or load-bearing animal. Indeed, on a number of occasions Cat can be heard calling Hutch an 'ox' or a 'donkey'. In *Boot Hill*, Thomas is likened to a 'bald eagle' by virtue of the fact that he can 'fly' and is also bald. It is interesting to note that by dubbing Thomas a bald eagle, Colizzi is effectively equating a black man with the national symbol of America. Given that the film was produced during the civil rights era, this detail again suggests that Colizzi's films possess a political subtext.

Gordon observes that the *commedia*'s comic routines were known as *lazzi* (1983: 5) and he refers to *lazzi* that revolved around acts of 'trickery' which served to establish 'a division of character type' between schemers and dupes (1983: 51). Colizzi's films are, on one level, very much concerned with both schemers and dupes and some of the scenes that Cacopoulos (the schemer) and Hutch (the dupe) share in *Ace High* function just like 'trickery' *lazzi*. Significantly, *Ace High* actually includes a restaging of a documented *lazzi*: Gordon describes how the *Lazzi of the Card Game* involved a thief teaching 'Zanni a new card game. Zanni loses everything since the thief keeps making up new rules as it suits him' (1983: 51). In *Ace High*, a desperate Cacopoulos intimidates a merciless debt collector into playing card games that he continually loses because Cacopoulos keeps changing the rules. Similarly, Gordon makes reference to 'word play' *lazzi*, which often involved 'storytelling' (1983: 55) and the humorous parables

that Cacopoulos credits to his grandfather throughout *Ace High* would qualify as examples of this.

Further and more fruitful understandings of the characters and other key elements found in Colizzi's films can be achieved if the character types and activities associated more specifically with the *commedia's* descendent, the modern circus, are employed in a comparative manner. The Italian director Federico Fellini was noted for incorporating clowns and circus motifs into his films and their inclusion can be understood to possess a political dimension. The European circus tradition condensed the *commedia's* humorous characters into two types of clown – the bullying white face clown and the lowly but rebellious *Auguste* clown – and Fellini took a great interest in these two character types. He observes that the *Auguste* clown:

> is an image of the proletariat: the hungry, the lame, the rejected, those capable of revolt ... [He] is always the same type. He never changes his clothes, can never change them. He is the tramp, the child, ragged and dirty.
>
> (1976: 125–126)

By comparison, Fellini asserts that the *Auguste* clown's oppressive tormentor, the white face clown:

> is a bourgeois, in his appearance as in everything else. He is startlingly splendid, rich and powerful. His face is white and ghostly, his haughty eyebrows are eloquently used, and his mouth is a single, cold, unattractive line.
>
> (1976: 125)

Fellini also makes reference to an occasional third type, who is *Auguste*-like in appearance but supportive of the white face clown: 'a bribed beggar ... [who is] halfway between authority and villainy' (1976: 125).

Bondanella reports that Fellini observed and identified certain people in modern Italian society who seemingly possessed 'the same character traits as the two kinds of clowns' found in the circus (1992: 187). Bondanella indicates that Fellini saw some members of the provincial working classes – lecherous and vulgar types who indulged in drunken scuffles and

arguments while remaining distinctly sympathetic individuals – as *Auguste* clowns (1992: 187). By contrast, Fellini saw figures of strict and cruel authority – 'some of the nuns who had run nursery schools ... [and] certain stout fascists' – as white face clowns (1976: 129). Ultimately, as Tullio Kezich observes, Fellini's theories, and quite often his films, use the circus as a global metaphor to divide humanity into two types: 'the master and the slave – the arbiter of the system and the rebel, the rich and the poor' (2007: 300). The abundance of circus-related imagery and carnivalesque occurrences found in Colizzi's Westerns results in Fellini's stock types coming to the fore and the same metaphor of resistance to cruel oppression being played out.

In the same way that Italian neorealist films utilized scenarios wherein the socially levelling effects of World War II were drawn upon to align dispossessed black characters to the world's similarly dispossessed white masses, Colizzi's Westerns employ the egalitarian atmosphere of the street fair and the circus to align oppressed but rebellious black characters with similarly situated and inclined white and ethnic counterparts. These oppressed characters ultimately come together to partake in 'collective action' in order to defeat oppressive bourgeois villains and it is significant that Allum indicates that 'collective action' was a crucial aspect of the street protests that took place in Italy during the late 1960s (2000: 26). Colizzi's protagonists effectively represent the poor and the hungry who possess the desire and the ability to rebel, just like the *Auguste* clown. In *Ace High* in particular, Cat, Hutch, Cacopoulos and Thomas live a financially impoverished existence for the bulk of the film. And Hutch and Cacopoulos both bring to mind the *Auguste* clown. Hutch is revealed to be a character who can never change his clothes: even when he fleetingly comes into money and buys a new suit in *Ace High*, his penchant for getting involved in slapstick brawls results in the suit being ruined and he returns to wearing his battered old outfit. And there is a sense of comic grotesqueness attached to his body and his physical needs: his coarse yawning, his habit of slapping his own head in frustration, the speedy and spluttering way he quaffs (and occasionally spits out) his drinks and his obvious love of food. Cacopoulos is perhaps even coarser and more comically grotesque: he is openly lecherous and his clothes are infested with fleas. Beryl Hugill notes that the *Auguste*

clown 'appears stupid and clumsy, but he has a fair share of cunning and comes out on top in the end' (1980: 8), which reads like a perfect description of Cacopoulos and his story arc within *Ace High*.

By contrast, the films' chief antagonists are clearly white face clowns. Drake in *Ace High* has set himself up as a bourgeois town elder and he delights in bullying Cacopoulos. Rich, powerful and dressed in fine clothes, the aloof Drake perfectly matches Fellini's description of the white face clown, right down to his 'white and ghostly' face, 'his haughty eyebrows' and his 'cold' smile (1976: 125). In their final confrontation, Drake calls Cacopoulos a 'clown' and his cruel insults clearly upset the Greek. Hippisley Coxe notes that the *Auguste* clown 'walks the knifelike edge which divides humor and pathos' (1980: 213) while Fellini observes that he is both 'the victim of jokes and the joker' (1976: 146). Both observations describe Cacopoulos perfectly. While the rotund Honey Fisher in *Boot Hill* is slightly less eloquent than Drake, he is essentially another well-dressed, rich and powerful bourgeois bully in the white face clown mould.

Significantly, clowns are also alluded to at the end of *Boot Hill*. Fisher dismisses Thomas and company's actions against him as 'buffoonery' and when he spots a midget clown, he tells the insurgent miners 'they're not the clowns tonight, you are'. Mamy (Lionel Stander), the circus ringmaster, counters 'You're the one who'll wind up being the clown, Mr Fisher'. The murderous thugs that seemingly respectable businessmen like Drake and Fisher employ surely represent the occasional third type of clown that Fellini mentions: *Auguste*-like but villainous individuals whose support is bought by the white face clown (1976: 125). At an allegorical level, these three types can also be taken to be representative of three key sectors of Italian society – the proletariat workers, the bourgeois state and landowners and their apparatus of governance (the police and private guards) – that came into conflict at the end of the 1960s due to the country's ongoing racial and social inequalities.

Cox has detected a strand of Italian Westerns that he calls 'circus Westerns', a strand that he asserts director '[Gianfranco] Parolini either invented or enthusiastically made his own' (2009: 264). While Parolini's films do feature much in the way of acrobatic stunts, a circus proper and its attendant iconography did not appear in a Parolini film until 1971's *Return of Sabata* (*E tornato Sabata … hai chiuso un'altra volta*). Indeed,

Ace High and *Boot Hill*'s prescient natures are reflected in Kier-La Janisse's somewhat exasperated observation that '*the 1970s* [my emphasis]' were the years when 'every spaghetti western had to have something to do with the fucking circus' (2007: 68). Hughes correctly observes that 'Parolini's protagonists resemble a circus troupe, with acrobats, trick-shooters, knife-throwers, cardsharps and clowns on the bill' (2004: 218). However, the 'circus troupe' analogy could be more readily applied to Colizzi's earlier *Ace High*. Thomas is a tightrope walker, Cacopoulos is a clown and a cardsharp, Hutch is an archetypal strongman and Cat is both an acrobat and a knife-thrower. In addition, all four men are skilled trick-shooters. Similarly, in *Boot Hill* Thomas the trapeze artist and Baby Doll the strongman-cum-clown-cum-mime artist are added to Cat and Hutch's circus 'troupe'. Thus the same carnivalesque and egalitarian ethos that allowed the circus to grant black artistes like Chocolat equal billing during the nineteenth century (Loxton and Jamieson, 1997: 78) serves here to allow black characters connected to the street fair and the circus to enjoy equal rights within Colizzi's 1960s Westerns.

But it is not just the characters in *Ace High* and *Boot Hill* that can be understood in terms of the circus. In both films the very locations that the characters visit are the sites of carnivalesque and circus-related occurrences. Bakhtin notes that 'clowns and fools ... were the constant, accredited representatives of the carnival spirit in everyday life out of carnival season' (1984a: 8) and Colizzi's clownish characters become caught up in carnivalesque situations wherever they travel. At the beginning of *Ace High*, a trip to the marketplace by Cat and Hutch soon erupts into a slapstick brawl with Hutch doing his strongman routine and Cat showing off his acrobatic fight moves. When Cacopoulos steals Cat and Hutch's money, he becomes the clown-fool who spreads the carnival spirit when he gives the money away to those in need. As Cat and Hutch track Cacopoulos they come across the carnivalesque happenings that their lost money has funded: a feast and a dance for a family of homesteaders and a masked carnival for a Mexican community.

It is while they are searching for Cacopoulos that the duo first meets the tightrope walker Thomas and his wife at a street fair. The significance of the events that unfold during this first meeting – and at two further carnivalesque locations (another street fair and a casino) – will be discussed

in detail later in this chapter. When Cat, Hutch and Cacopoulos become caught up in a Mexican revolt, Cat and Hutch use a plank of wood and a barrel to construct a rudimentary teeter-board – as used by circus acrobats – that Hutch jumps onto in order to propel Cat onto a nearby roof. And at the start of *Boot Hill*, it is as if the magic of the circus has oozed out of the big top and infused the surrounding area. After introducing a performance that is taking place inside the circus space that will figure prominently in the film, Colizzi employs a series of cross-cuts to depict action that is also unfolding outside the big top and much of this action draws upon circus motifs too. Cat is being pursued by a group of villainous gunmen and in an effort to escape them he first uses his acrobatic skills to somersault through two closed windows. When they manage to corner him, Cat's pursuers act like circus trick-shooters: they torment him by shooting down the shop sign that he is standing beneath and blasting off one of his spurs. When he tries to shield himself by precariously perching upon the protruding wheel axle of a cart, his tormentors skilfully shoot the spokes of the wheel out. Their activities are just as theatrical and as potentially fatal as the trapeze act that is simultaneously taking place inside the big top.

Finally, the circus and the world beyond it become fused when a wounded and desperate Cat manages to hide in one of the circus wagons. The carnivalesque nature of Cat's character is seemingly confirmed by the contents of the wagon that he chooses to hide in: a wheel of fortune and a clown's medicine ball frame his head while brightly coloured circus costumes hang over his prone body. Bakhtin reports that parodical prophecies of future events were a popular feature of the carnival (1984: 233) and it is therefore significant that the circus' owner, Mamy, is seen to be a fortune-teller who uses a crystal ball to conjure up generic prophesies for his customers: 'For you [I see] nothing but health and happiness.' Interestingly, an interlude that features a sense of magic realism reveals that Mamy's crystal ball actually works and he foresees trouble coming to the circus. Furthermore, the circus in *Boot Hill* has a band that is made up of midgets who dress as clowns and Colizzi gives the band members much camera coverage and numerous close-ups during the circus-set sequences. The circus dominates *Boot Hill* to such an extent that it clearly annoys those critics with a preference for more traditional Western iconography. Janisse suggests that the film 'suffers substantially from director Colizzi's

weird obsession with the circus' (2007: 60) while Thomas Weisser refers to 'Colizzi's preoccupation with acrobatics, a mania which taints both this film and *Ace High*' (1992: 43). Weisser concludes that *Ace High* places 'too much emphasis on circus-style acrobatics' (1992: 4).

Connecting the carnivalesque to Colizzi's black characters

The remainder of this chapter will connect the carnivalesque specifically to Colizzi's black characters while offering a detailed account of the ways in which these characters subsequently defy the race-related rules that governed contemporary American Westerns. By calling both of his distinct black protagonists Thomas, Colizzi appears to be seeking to draw comparisons between his characters and the stereotypical 'toms' or 'Uncle Toms' that regularly appeared in Hollywood films. Bogle observes that 'always as toms are chased, harassed, hounded, flogged, enslaved, and insulted, they keep the faith, n'er turn against their white massas, and remain hearty, submissive, stoic, generous, selfless, and oh-so-very kind' (2001: 4–6). Bogle offers early examples of American films that feature toms – Sidney Olcott's *Confederate Spy* (1910) and Harry A. Pollard's *Uncle Tom's Cabin* (1927) – while noting that the stereotype endured for decades (2001: 6–7). Significantly, Colizzi's Toms barely relate to Hollywood's toms/Uncle Toms on any level other than the colour of their skin.

In both films, Colizzi's black protagonists are coded as free spirits. Both men are itinerant performers who travel in wagons and Bakhtin describes the overt sense of freedom that this circumstance connotes (1984a: 106). Bakhtin also asserts that the itinerant performer's wagon serves as a vehicle that 'spreads the festive carnival atmosphere' (1984a: 106) and the jubilant endings of both films under discussion here include long shots of the black characters' wagons as they travel off to new adventures. In this regard, Donalson's assumptions concerning the black-orientated American Western *Buck and the Preacher*'s failure to attract a large domestic audience and critical acclaim in 1972 offer an interesting point of contrast:

> Perhaps, black cowboys and settlers were still too far removed
> from the traditional images of African Americans, and the

sense of triumph suggested by the film's final freeze-frame – of Buck, the Preacher, and Ruth riding into the sunset – was too foreign a concept for [contemporaneous American] audiences'.

(2003: 33)

Donalson's speculations are illuminating on a number of levels. Firstly, they serve to confirm just how groundbreaking the narratives of Colizzi's films actually were. Secondly, Colizzi's Westerns were ranked within the top twenty highest grossing Spaghetti Westerns of all time at the Italian box office (Fridlund, 2006: 263–265), which is an impressive feat given that in excess of 450 Italian Westerns were produced between 1962 and 1978. Thus it would seem that Italian cinemagoers were culturally distinctive in terms of significant numbers of them being willing to pay to watch Westerns that featured triumphant black characters.

Thomas in *Ace High* is first seen atop a tightrope when a low angled long shot captures him in an elevated position as he traverses the rope. Gordon Graham indicates that tightrope walking is an act of 'overcoming': the 'laws of physics to which human bodies are subject' are at once exploited and overcome 'in order to accomplish something that those same laws would seem to make impossible' (2007: 173). Crucially, Colizzi introduces Thomas in *Boot Hill* in a similar manner: a low angled long shot shows Thomas perched on a trapeze swing in an elevated position. Hippisley Coxe asserts that trapeze acts are exciting because of their 'sense of bird-like freedom and the [attendant] fascination of seeing the human figure in a new perspective' (1980: 150). It would seem clear that Colizzi's use of the tightrope and the trapeze is intended to symbolically show assertive black men who have necessarily overcome certain prohibitive laws or barriers in order to physically project themselves into elevated positions that allow them to experience a new sense of freedom. This symbolism can also be read as a metaphor for the struggles for social equality that were undertaken by both the US civil rights movement and Italy's own dispossessed citizens during the late 1960s.

Bakhtin notes that the carnival space allowed the working out of '*a new mode of inter-relationship between individuals* [Bakhtin's emphasis], counterpoised to the all-powerful socio-hierarchical relationships of noncarnival life' (1984b: 123), and the same might be said of the circus. At a micro

level, the harmonious interracial trapeze team who are dubbed 'Thomas' Flying Men' in *Boot Hill* (two whites and two blacks) do represent a new mode of racial interrelationship between individuals. But, just like the carnival, the circus' sense of egalitarianism also permeates outwards from the performers and incorporates the audience too. Hippisley Coxe notes the significance of the circus' circular seating arrangements: 'tier upon tier of seats [that] rise steeply in concentric circles' that completely surround the performance area, thus resulting in the audience holding 'the spectacle in its midst' and actually becoming 'a part of the spectacle' themselves (1980: 24). Indeed, during the first circus performance sequence in *Boot Hill*, male members of the audience are seen to mingle and cavort with the circus' cancan girls.

When Mamy introduces the Flying Men, the trapeze artists are initially booed by the crowd but the new mode of interrelationship observed at the micro level soon spreads to the macro level when the whole audience (even the boisterous men who want the cancan girls back) deigns to give the Flying Men a chance and subsequently becomes so impressed by their act that they accept them as equals and offer them a standing ovation. The egalitarian and carnivalesque space of the circus (and the street fair) would thus seem to be the ideal space for the introduction of active and assertive black Western characters who can operate on equal terms with their white counterparts. Furthermore, while the carnival's egalitarian magic only worked for one day per year in reality, the characters in Colizzi's films are at liberty to generate carnivalesque magic every day: all they need do is pitch their circus tent or set up their tightrope stand.

In both films, men who do not respect equal rights for all invade carnivalesque spaces and it is their very presence and actions that galvanize Colizzi's black gunmen. In *Ace High*, Thomas is performing his act at a street fair when a group of white men in the crowd begin abusing and molesting his wife. Since these men do not attack the white women seen in the crowd, their actions must be presumed to be racially motivated, seemingly tying in with the concept of the always sexually available Black Venus and bell hooks' observation that, historically, black women continued to be sexually assaulted by white men 'long after slavery ended' (1982: 52). His wife's cries serve to make Thomas wobble on the tightrope and so the men's actions can be construed as being designed to symbolically knock

the elevated black man 'off his perch'. At this point, Cat and Hutch intervene and a standoff begins. As noted in the previous chapter, when black characters were slighted or racially insulted in American Westerns during this period a white associate would intervene and set the matter straight on their behalf. However, here Thomas swings down from the tightrope and asserts 'I'll join you if you don't mind.' Strapping on a gun, he lines up alongside Cat and Hutch and a close-up of his face captures his angry state. As it turns out, Thomas decides to humiliate his wife's attackers by skilfully trick-shooting their hats off. Cat affirms Thomas' independence and masculinity by telling him 'You certainly didn't need us to handle those guys.'

In *Boot Hill*, villains invade the circus twice in quick succession while searching for Cat. A wounded Cat has hidden in one of the circus wagons and the young black trapeze artist Joe (Maurizio Monetti) spots his leaking blood and alerts Thomas. The short sequence that follows sets Thomas up as the most self-determinate, in control and masterful black character to appear in a Western during the 1960s. Thomas unwraps a hidden pistol, slots it in his waistband and assumes full responsibility in dealing with the situation. Joe asks 'Don't you think it would be better if we called the others too?' to which a supremely confident Thomas replies 'All in good time.' After Thomas has seen the unconscious Cat and is making his way back to his own wagon one of the other Flying Men asks 'What's going on, Thomas?' to which he replies 'Nothing.' When three horsemen approach the circus from a distance, the clueless Mamy asks himself 'What do they want?' By contrast, Thomas instinctively knows that trouble is afoot and he tells Joe 'You look sleepy. Get into bed and go to sleep, stay there no matter what happens … Don't argue.' The three men are looking for Cat and when Cat shoots the one who finds him, Thomas shoots the remaining two before they have time to react.

To have Thomas spontaneously and brazenly shoot two white American characters dead without a flicker of doubt or emotion is undoubtedly a first for a major black character in a 1960s Western. It is also important to note that – unlike the black characters in contemporaneous American Westerns – Thomas does not commit this violent act in order to save a white hero figure. His primary concern here is to protect the young black boy Joe. And in the time that it takes to fire two rapid shots, Thomas

has equalled the tally for the number of white characters killed by a major black male character in all of the mainstream American Westerns of the 1960s. By the film's end Thomas will have exceeded that tally. Seemingly happy to adhere to archaic 'rules' that had their origins in the Production Code and thus preserve the status quo, Hollywood's Western directors would shy away from showing images of a member of an ethnic underclass asserting himself in such a violent manner. Obviously Colizzi was an Italian filmmaker and he did not have to be mindful of such rules but Thomas' bold and violent actions in *Boot Hill* do appear to possess a rebellious political dimension as they can be likened to the wider celebrations of ethnic-underclass assertiveness that are found in Italian Westerns such as Maurizio Lucidi's *My Name is Pecos* (*2 once di piombo*, 1967) and Sergio Sollima's *Run, Man, Run* (*Corri uomo corri*, 1968).

Thomas is not at this stage of the film caught up in any kind of moral struggle between good and evil. He is simply presented with a problematic set of circumstances, which he has to promptly and instinctively deal with. When the circus folk subsequently crowd around Cat, a medium close-up shot has Thomas placed in a position of control: in the foreground at the head of the crowd and centrally placed – a marked contrast to shots found in Hollywood Westerns such as *The Professionals* (1966) where Strode's Sharp is often placed in the background of busy shots. When a panicked Mamy, in essence the circus' true patriarch, asks 'And what do we do now?' it is Thomas who takes control again and supplies the answers. He assesses Cat's health and supervises the burial of the three gunmen's bodies and the disposal of their horses. Colizzi's blocking and camera placement choices are designed to ensure that Thomas dominates most of the shots that he appears in here. Thomas' ability to react to and take control of unforeseen circumstances contrasts sharply with those black characters from American Westerns such as *The Professionals* who were reliant on orders or instructions from white tacticians at times.

Soon after a barely recuperated Cat has left the circus, two more villains come looking for him and find evidence that he has been there. Looking around the big top as the Flying Men perform their act, one gunman callously shoots one of the supporting ropes on Thomas' swing just as the blindfolded Joe has launched himself towards him, expecting to be caught

by Thomas in mid-air. As Thomas struggles to adjust himself, Joe is sent hurtling past him to his death. The gunman's actions are undoubtedly racially motivated: a close-up shows him spitting the words 'damned monkeys' before he shoots and shots representing his point of view reveal that only Joe and Thomas are actively using the swings at that moment. Tangled in his swing's remaining rope, Thomas is left dangling upside down and swinging out of control and Colizzi supplies a number of shots that effectively capture Thomas' point of view: wildly swinging over the crowd, his world literally turned upside down. When the crowd begin to panic and leave their seats, Mamy declares that 'there's nothing to be alarmed about, the show goes on' before striking up the band and sending the cancan girls out to perform.

The way that Colizzi presents the aftermath of Joe's murder makes it all the more horrific and upsetting. After Joe is seen struggling to gasp his last breath in a close-up shot, Mamy removes Joe's blindfold to reveal that his eyes are still open. A long shot taken from above frames Joe's crumpled body while the following shots show the cancan girls starting their routine and the audience returning to their seats. Colizzi returns to a close-up of Joe's face – with his lifeless eyes breaking the 'fourth wall' and staring directly out of the screen at the audience – thirteen times, intercutting the shot with images of the dancing girls, the heartbroken faces of Joe's friends, the circus band playing and, finally, the audience who, having seemingly forgotten the tragic spectacle that unfolded before them a few moments earlier, are now rapturously applauding the dancers.

Colizzi shows Joe to be a victim of racially motivated violence, an act seemingly stimulated by the white gunman seeing two black men in an elevated position of equality and subsequently harbouring a desire to put them back in their previously subordinated place. *Boot Hill* was produced at a time when America's civil rights movement had caught the world's attention and within this context Joe's murder plays like a reminder of the high profile race killings of the period, such as the assassination of Martin Luther King Jr. Colizzi's staging of the events immediately following Joe's murder – the show going on as normal and the circus' wider audience soon recovering from the initial shock of the horror that they witnessed and speedily refocusing upon more frivolous matters – would seem to be a comment on wider society's ability to remain relatively unchanged in spite

of seismic events like King's death. By repeating the close-up of Joe's face that breaks the 'fourth wall', Colizzi prompts every spectator of the film to consciously contemplate the awfulness of the young innocent's fate. Images of black victimhood and death that are comparable to those that are presented in *Boot Hill*, *Lola Colt* and *The Great Silence* were rarely seen in American Westerns during the 1960s. Beyond the exploitative images seen towards the end of *The Scavengers*, the first American Western to show prolonged black victimhood and suffering of this kind was Alf Kjellin's *The McMasters* (1970). Here a black ex-Union soldier, Benjie (Brock Peters of *Ace High*), endures and barely survives a brutal and lengthy race-hate campaign when his neighbours discover that his former owner has signed half of his farm over to him.

Interestingly, hooks has discussed the idea that, historically, black male slaves felt emasculated because they were roundly denied the ability to 'assume full patriarchal responsibility for families and kin' (1992: 90). It is thus significant that, with the exception of Lyedecker in *100 Rifles* who has a brief but doomed dalliance with Sarita, none of the major black male characters who appeared in American Westerns during the 1960s were shown to have wives, girlfriends or children. In effect, these free black men out West remain just as emasculated as the historical slaves that hooks refers to. But this is not the case in *Ace High*. Thomas has a loving relationship with his attractive black wife and thus is portrayed as having a normal sexual identity. Furthermore, while it is never stated whether Thomas and young Joe in *Boot Hill* are related, it is clear that Thomas looks after the boy in a fatherly way and thus has a paternal identity. Both characters therefore signify a breakthrough in the way that black men were represented in Westerns. It would not be until 1971's *Man and Boy* that an American Western would feature a major black couple in a loving relationship and a meaningful black father–son relationship. Furthermore, there is no suggestion in either of Colizzi's films that the black characters are ex-soldiers who have learnt their shooting skills while serving the USA in a useful and patriotic way. In fact, it is even hinted in *Boot Hill* that Thomas is a reformed gunfighter who might be a runaway slave. This is significant because even late entrants in the American Blaxploitation Westerns wave, such as Larry G. Spangler's *Joshua* (1976), were still prone to present their lead black protagonists as former soldiers. In the American South, the moniker 'boy' was

historically employed to infantilize black men and the stereotype of the infantilized and childlike black man subsequently became a common character type in Hollywood films. However, in a scene where Thomas and the Flying Men are training, Thomas counters such stereotypes when he refers to the other three Flying Men as 'boys' and thus reinforces the unusually authoritative and paternal aspects of his character. In the same scene, the topless Thomas' masculinity is underscored by his physical appearance and prowess. Krin Gabbard indicates that a shaven head serves to reinforce its owner's masculine status by literally transforming them into a physical representation of a phallus (2004: 118). Towering above every other character in the frame and proudly displaying his sweat-soaked shaven head and rock hard muscular body, Thomas projects himself as an overtly and unmistakably phallic figure.

Black anti-heroes

The upshot of Joe's death in *Boot Hill* is that it prompts Thomas to become a vigilante vengeance-seeker. Will Wright observes that seeking vengeance was customarily frowned upon in American Westerns: in classic American Westerns the vengeance seeker usually responds to a representative of society's call for him to give up his revenge mission before narrative contrivances subsequently grant him a more legitimate excuse or unavoidable reason for killing those who had wronged him (1975: 68). By contrast, Sergio Leone's *For a Few Dollars More* (*Per qualche dollaro in piu*, 1965) presented vengeance-seeking as an honourable endeavour and it subsequently became one of the predominant themes that served to distinguish Italian Westerns from American Westerns. Thomas in *Boot Hill* is surely the first black vengeance seeker to appear in a Western from the 1960s. The first American Western to feature a black gunman undertaking a Spaghetti Western-like vengeance mission was Larry G. Spangler's aforementioned *Joshua*, in which Fred Williamson tracks down and executes the five white miscreants who killed his mother.

Furthermore, Thomas effectively becomes the first black Western anti-hero. Cynical white anti-heroes were the norm in Spaghetti Westerns and their presence was another key feature that distinguished Italian

Westerns from American Westerns at this time. The fact that Thomas' skin colour does not prevent him from operating as an equally cynical black anti-hero in *Boot Hill* serves to further highlight the differing attitudes of the Italian and American film industries when it came to representing African Americans out West. After Joe's death, Thomas tracks Cat and finds him camped outdoors and in a feverish state due to his festering wound. Once again, Colizzi presents an image of a dominant black character who is placed in a powerful and elevated position by filming Thomas, who is perched on a wall, from below. The following shot, which represents Thomas' point of view, places Cat in a weakened position as it is shot from a high angle. Thomas saves Cat's life again here and Cat tells him 'I don't like to have to thank somebody too many times.' Thomas sternly replies 'You don't have to ... you'll make good bait for my trap. That's the only reason for me to try to keep you alive.' It is clear that Thomas is not saving Cat for altruistic reasons this time.

Thomas in *Ace High* is perhaps a more affable character. His work as a tightrope walker involves balancing and he in turn comes to have a balancing effect within the film's 'circus troupe' team. Cat and Hutch are angry with Cacopoulos because he stole their money and when the duo arrive in Fair City and discover Cacopoulos, Thomas and his wife working in a saloon's kitchen, Hutch makes to assault the Greek. It is Thomas who bravely intervenes and appeals for calm, ordering Hutch to 'take it easy'. In a second street fair scene, Colizzi presents another powerful black character, the boxer Tommy Glancingblow. A bare-knuckle prize-fighter who takes on all-comers for money, the hulking Tommy is introduced knocking out a white challenger before Cat dupes Hutch into stepping into the ring. At first it appears that the mighty Hutch has met his match: Tommy's first two punches both knock Hutch to the floor and high angled shots show Hutch to be in an uncharacteristically weakened position. Colizzi subsequently employs a shot–reverse shot set-up that captures the multitude of blows that the two men trade.

This hard-fought bout actually possesses a distinctly carnivalesque and circus-like feel. The crowd forms a circle around the fight area and no barriers separate the crowd from the fighters. Indeed, the crowd plays an interactive part, picking the tired fighters up and pushing them back into the ring. When Tommy's concerned white manager – the authoritative

acting referee – tries to break the gruelling fight up, a defiant Tommy shoves him out of the way and sends him sprawling in an undignified manner. It takes more than twenty of Hutch's powerful punches – including a number of his trademark hammer swing blows – to defeat Tommy. Given that Spencer's strongman characters generally knock their opponents out with just one of their hammer swing blows, Colizzi presents Tommy as a dignified fighter who surely remains the strongest opponent that a Spencer character ever faced. *Ace High* also features minor black characters in more poignant roles. As Cat and Hutch ride to Fair City, they see blacks working in the fields who are supervised by whites on horseback and as they enter Fair City, they pass through an impoverished black quarter. Also, a black butler is visible at the meeting of public dignitaries that the villainous Drake attends. Clearly, there is nothing particularly fair about Fair City.

Thomas' rope artist's skills prove to be very important towards *Ace High*'s end when he is called upon to fix an impromptu trapeze swing to his tightrope, which he then uses to swing the ever acrobatic Cat onto the roof of Drake's casino. Once inside the casino, Thomas, Hutch and Cat discover that Drake has been defying the carnival's 'law' regarding the egalitarian nature of games of chance: a spy panel in the casino's ceiling and a communication pipe which runs into the casino's basement, from where the underside of the roulette wheel can be accessed and its winning number fixed via the application of a magnet, has allowed Drake to cheat the locals out of huge sums of money. What follows is an extended caper-like sequence wherein Thomas, Hutch, Cat and Cacopoulos set out to defraud the casino in order to get back the money that the Greek has lost there. This acts as a reminder that no major black character in an American Western of the 1960s was ever involved in this kind of forthrightly criminal behaviour. Arnold Laven's later *Sam Whiskey* (1969) does appear to be striving for a very similar feel and ambience to that of *Ace High* but in this American Western, Ossie Davis' black ex-soldier is part of a patriotic team of specialists that secretly breaks into the Federal Reserve in order to *return* gold that was previously stolen by a well intentioned but wholly misguided public servant whose good name must be preserved. Hence, in *Sam Whiskey* a black Western character is allowed to be involved in a caper-like scenario strictly because it is being played out for the good of the nation.

In the run up to *Ace High*'s denouement, Thomas is in the thick of the action, physically assaulting a number of Drake's white henchmen, rigging the roulette wheel from below so that Cacopoulos wins and rescuing Hutch from a couple of Drake's tough guys. When Cacopoulos keeps on winning, Drake is sent for and the scene is set for the film's final showdown. Drake opts to provoke a gunfight and one of his henchmen advises the 'circus troupe' that 'It would be better if you did leave. After all, it would be impossible for me to fight against a Negro on equal terms.' This racial slur is followed by a snap zoom shot that ends with a close-up of Thomas' outraged face, which is followed by a close-up of his gun being aimed at his tormentor. When his tormentor sneeringly adds 'Have I made myself clear?' another close-up of Thomas' angry face is presented. When the gunfight unfolds, the symbol of the carnival's egalitarian games of chance that Drake has abused – the roulette wheel – is spun and the gunmen agree to draw when the wheel stops spinning. As the two sides prepare to fight, they arrange themselves into two opposing lines that face each other across the roulette table and the table's ability to generate an egalitarian space similar to that found in the street fair becomes apparent: Drake's racist henchman *will* have to face a black man on equal terms.

Just as when he lined up alongside Cat and Hutch to take on his wife's tormentors at the street fair, a side angled medium long shot and a front angled medium shot reveal that Thomas is standing shoulder to shoulder with his comrades. This is a marked contrast to similarly set up scenes found in earlier American Westerns – such as *Vera Cruz* (1954) – wherein black team members tend to be positioned behind the lines that their white companions form. A series of close-ups and point of view shots reveal that Thomas is confidently facing the man who racially abused him and Thomas subsequently kills the man. Shohat and Stam note that Hollywood routinely sought to avoid the representation of 'images of racial anger, revolt, and empowerment' (1994: 203) and the aforementioned scene from *Ace High* clearly represents a groundbreaking advancement in this regard. Similar scenes involving black gunmen responding violently to racial slurs would not appear in American Westerns until the emergence of Blaxploitation Westerns such as *The Soul of Nigger Charley* in the early 1970s.

In *Boot Hill*, Thomas succeeds in his revenge mission. Fisher and his men and the miners that they have been intimidating, murdering and

defrauding are all invited to a performance by the circus folk. The two groups are allocated segregated seating and the first act is a *commedia*-like allegorical play in which a miner is abused and swindled by a businessman and his brutal cowboy henchman. John Rudlin notes that the *commedia*'s characters and their activities tried to present scenarios that everybody in the audience could recognize as moments from their own lives (1994: 35) and as this performance plays out in *Boot Hill*, the circus' audience members clearly recognize moments from their own lives: Colizzi presents a series of clever rapid cuts which serve to reveal that every member of the audience is imagining themselves to be a character in the performance, be it as victim or abuser. This allegorical play might also have spoken to some contemporary Italian cinemagoers who may have seen in it a condensation of their own work-based struggles with exploitative employers.

With the circus' audience suitably agitated, the cancan girls, backed by the midget clown band, put on a song and dance routine that has another carnivalesque audience participation element. As the song lyrics advise them to look under their seats, the miners find guns while Fisher and his villains find rattles. A further performance by the two white Flying Men dressed as miners becomes a eulogy to those miners killed by Fisher and his men. As the Flying Men call out names and tributes, one of the midget clowns sets off fireworks. Dunnage notes that the 'toll of deaths and injuries from police charges, bullets and tear gas' during Italy's mass demonstrations 'escalated from the end of 1968' (2002: 173). Parallels might thus be drawn between the film's eulogy to the fallen miners – who died as a consequence of asserting their workplace and civil rights – and the deaths of those protesting workers and civil rights activists who died on Italy's streets at this time

When one miner snaps and draws his gun, the same gunman who was responsible for Joe's death shoots him. Thomas immediately emerges from behind the backstage curtain and, masterfully framed in a medium close-up shot, he looks at the gunman and shouts 'Hey you, murderer.' As the man goes for his gun, Thomas draws and shoots him dead. In terms of the Western's traditional patterns of narrative and representation, Thomas' actions here represent a significant moment: a black man has successfully executed a revenge mission against a white man in order to see justice done on behalf of a black victim. It is perhaps not coincidental that Joe

was wearing a blindfold – one of the symbols of justice that demands that all people are treated the same in the eyes of the law – when he died. His mission complete, Thomas assists Cat, Hutch, Baby Doll and the two white Flying Men in the climactic battle against Fisher's thugs.

As in *Ace High*, when the protagonists walk down the main street of the town together to face the final confrontation an angled medium close-up shot reveals that Thomas is standing shoulder to shoulder with his friends, who form a perfect front-facing line. Significantly, as they draw closer to Fisher's men the protagonists form an arrowhead-like shape and Thomas is positioned at the very front, effectively leading the 'circus troupe' into battle. Bakhtin observes that the carnivalistic impulse 'brings together, unifies, weds and combines the sacred and the profane, the lofty with the low, the great with the insignificant, the wise with the stupid' (1984b: 123) while Hippisley Coxe notes that 'those who watch [the circus] are part of the show' (1980: 226). When a visiting judge and his officious assistant, the cancan girls, the midget clowns and the previously reluctant miners all join in the fight against Fisher's men, it becomes a patently carnivalesque free-for-all.

This final frenetic, acrobatic and at times slapstick expression of collective action is essentially a celebration and a reminder of all of the elements of the carnival, the *commedia dell'arte* and the circus that Colizzi has included in his Westerns. Indeed, the uniquely egalitarian atmosphere that these elements necessarily produce serves to provide convincing spaces for the emergence of strong and independent black gunfighters who can operate on equal terms with their white counterparts and thus transcend the race-related rules that governed contemporary Hollywood Westerns. Jim Pines asserts that the 'Blaxploitation Westerns [of the 1970s] attempted to recast the popular image of the West in black terms' (1988: 70). I would conclude that the Italian Westerns discussed in this chapter had already successfully initiated such a recasting during the previous decade. Interestingly, the international success of Italian-made Westerns during the 1960s prompted several British producers to engage with the Western genre during the early 1970s. These British Westerns and the local circumstances that resulted in them featuring progressive representations of strong women out West will be the focus of the final chapter.

PART III

Funny Men and Strong Women

The Representation of Frontier Femmes in British Westerns

Although he asserts that 'Britain's contribution to the Western has been on a par with Switzerland's contribution to naval warfare', Paul Simpson correctly notes that the British have been making Westerns since the early days of silent cinema (2006: 243). However, very few of these Westerns have attracted any form of detailed attention or criticism. The distinctive nature of German and Italian Westerns has allowed film historians to identify and classify them with relative ease. But the same film historians have been reluctant to recognize and treat British Westerns as a cogent corpus produced by a national cinema. In one rare but cursory overview of British cinema's engagement with the Western genre, Luke McKernan observes that the British have specialized in producing three types of Western films: 'straight attempts at Westerns, adaptations of the Western milieu to British Empire settings, and parodies' (1999: 1–2). As the focus of this book is confined solely to European Westerns featuring narratives that unfold specifically within what might be broadly termed the American West, those British productions that transpose the generic conventions of the Western to the wild historical frontiers of the British Empire will not be reviewed here. However, the British films that will be discussed can indeed be described as either parodies (produced between

1939 and 1966) or straight attempts at Westerns (produced during the early 1970s).

McKernan has suggested that the British Westerns produced during the early 1970s possess little in the way of 'Britishness' because they were made within a transnational context (1999: 15). This chapter will challenge McKernan's viewpoint by highlighting key themes that can be found in both the earlier parodies and the later more serious British Westerns. The British Western parodies were produced when Britain had a fully function-ing domestic film industry and it is possible to detect distinctly British cul-tural elements and concerns at play within these undeniably British films. When the later British Westerns are viewed with the earlier films in mind, it is possible to detect the presence of the same local cultural elements and concerns. Ultimately, close readings of British Westerns produced during both of the aforementioned time periods reveal that the films consistently feature noticeably independent, resourceful and strong female characters. Indeed, the appearance of hapless or unwilling male heroes in the British Western parodies, which were essentially vehicles for typically un-macho British music hall stars, seemingly opened up a cinematic space that was duly occupied by strong and active females. As such, an element of gender role-reversal can be found in each of the British Western parodies. The theme of gender role-reversal is not a given prerequisite of exercises in par-ody and it marks one of several narrative elements that serve to distinguish the British Western parodies from Hollywood's own variants.

Hughes observes that Hollywood's Western parodies tend to feature stock characters like 'bumbling heroes, crooked sheriffs, hopeless outlaws and damsels in distress' (2008: 269–270). While they do feature reluctant heroes who possess a tendency to bumble, the British Western parodies do not generally conform to Hughes' (2008) model. In three of the four British Western parodies examined here, the bumbling heroes actually become lawmen. And in all four films the female characters remain particularly strong, defiant and assertive when confronted by outlaws and villains who, rather than being hopeless, actually pose a very real threat. Moreover, it would seem that the gender swap scenarios found in these films are symp-tomatic of British cinema's willingness to mirror and work through the apparent crises of masculinity that have been periodically experienced in wider British society. Such crises are of course experienced by most nations

but the circumstances that are usually cited as being the cause of Britain's crises – primarily the ongoing collapse of the country's Empire and her reduced role as an international power – are deemed to have deeply affected the national psyche over a prolonged number of years. As such, British film trends as diverse as the New Wave, the *Carry On* series and Hammer horror films have all been adjudged to have passed allegorical comment on the contemporaneous state of masculinity in Britain.

Furthermore, despite being born out of transnational production processes, which mean that they often utilize non-British stars, directors and locations, the more serious British Westerns produced during the early 1970s continue to give voice to precisely the same cultural and thematic concerns that were found in the earlier parodies. Hardy suggests that the content of Raoul Walsh's British Western parody *The Sheriff of Fractured Jaw* (1958) represents 'an assault upon … masculinity' (1991: 270) and precisely the same could be said of *all* of the British Westerns examined here. Garfield's brief overview of the meagre number of actresses who managed to make an impression in American Westerns concludes that 'mainly the Western was blithely indifferent to its ladies. The heroine usually suffered thanklessly, playing a peripheral role at best' (1982: 85). Garfield's observations can be linked to Mulvey's (1986) study of films produced in Hollywood during the classical period. Mulvey employs a psychoanalytical approach that highlights the generally inactive nature of the female characters who appeared in classical Hollywood features while adding that those females who were uncommonly bold or unruly were invariably doomed to suffer ignominious fates – either tamed in some way by the lead male character or punished by death – for daring to upset patriarchal order. Significantly, the narratives of British Westerns rarely seek to tame or punish their strong and active female characters. Until now, this important aspect of the British Western has been overlooked.

Historically, the British public has embraced popular media texts that have consistently featured strong fictional female characters. Indeed, British popular entertainment forms like the music hall and gothic literature regularly foregrounded the subjective perspectives of active females. As will become apparent, the influence of the British music hall and gothic traditions can be felt in the British Westerns that are examined in this chapter and this results in the representation of empowered gendered

'Others' who are able to carry out ostensibly 'masculine' activities or challenge patriarchal order without being tamed or punished at a narrative level. By recognizing the British Western as a distinct national film form that possesses its own cultural characteristics, this chapter will endeavour to explore the groundbreaking ways in which these British films represent their strong female protagonists by comparing their content to that of typical Hollywood Westerns. I will thus argue that the representations of strong and active female characters found in these British Westerns prefigure the subsequent appearance of similar characters in later American Westerns. Ultimately the British Western's representation of strong women during the two time periods in question serves to problematize the Western genre's perceived evolutionary model.

7

British Westerns: International Reception and Local Influences

Most histories of the Western neglect to acknowledge that British film producers have had a small but sustained engagement with the genre. This may be because, unlike German and Italian Westerns, British Westerns never featured recurring actors who served to bring notable attention to the genre. The actor Sid James did appear in three of the British Western parodies but these films do not hold a dominant position in his wider filmography. Similarly, no particular directors became strongly associated with British Westerns though the British production company Benmar did briefly specialize in producing Westerns during the early 1970s. As such, critiques that approach the British Western as a distinct body of films are rare. And when they do appear they are often incomplete. For example, Marcus Stiglegger's (2012) brief overview of British Westerns references no films produced before 1960. Accordingly, Stiglegger concludes that exaggerated violence is the key element that best defines the UK's engagement with the genre (2012: 81). In lieu of detailed critiques of the British Western per se, the observations of contemporary critics who reviewed individual films remain useful and illuminating.

Early cinema commentator Leslie Wood reports that, when compared to Hollywood productions, the general *mises-en-scène* of Britain's silent Westerns were judged to be unrealistic and unconvincing (1947: 127–128).

163

McKernan goes as far as to describe the British Western as being 'a contradiction in terms' (1999: 16) and he asserts that the early British Westerns discussed by Wood possessed an inevitable 'sense of absurdity' that remained detectable in virtually every British Western that followed them (1999: 4). In short, McKernan declares that the persistent failure of British production companies to understand and authentically replicate the formal look and the cultural concerns of the Western genre, as defined by American Western productions, represented an habitual 'stumbling block' for the British, albeit one that 'just occasionally [could be] used well for its comic potential, or for an effective sense of otherness' (1999: 4).

Assessing the critiques of the British Western parodies produced between 1939 and 1966 and the more serious Westerns produced during the early 1970s results in a catalogue of largely negative observations. When covering Marcel Varnel's *The Frozen Limits* (1939), the *Monthly Film Bulletin*'s reviewer reported that the film's 'settings' were 'intentionally ludicrous' (1939: 200). This can perhaps more usefully be interpreted as meaning that Varnel's film does not possess the aesthetic look of an American-produced Western. Similar criticisms concerning *mise-en-scène* were directed at John Baxter's *Ramsbottom Rides Again* (1956): McKernan opines that viewers are perhaps 'never meant to believe that [the] film's reality lies anywhere other than on a North of England music hall stage' (1999: 12). Sue Harper and Vincent Porter describe *Ramsbottom Rides Again*'s general approach as being 'gruesomely ill-conceived' (2007: 107) while Robert Ross calls the film a 'ramshackle' production (2000: 86). John Howard Reid suggests that *Ramsbottom Rides Again* is 'jejune' (2006: 115) while Hardy asserts that this 'bizarre' film is 'only of curiosity value as a foreigner's view of the West that in fact reveals more about the humour of its country of origin than [it does] about the Western' (1991: 250).

Hardy also considers *The Sheriff of Fractured Jaw* to be 'bizarre' and 'the oddest of comedy Westerns' (1991: 270) while Ross asserts that 'the reassuring presence of [American Western veteran] Bruce Cabot gives the entire film an authentic Western edge' (2000: 102–103), which perhaps confirms that those British Western parodies that do not feature American actors are automatically assumed to be inauthentic cultural productions. Hardy again finds Gerald Thomas' *Carry On Cowboy* (1966) to be 'bizarre' (1991: 250) before concluding that it is a 'crudely made [film] with few redeeming features' (1991: 295). John Elliot simply lambasts the film for

being an 'inept period comedy' (1990: 128). Moving onto the more serious 1970s British Westerns, Gillian Hartnoll observes that, 'despite the high mortality rate', *A Town Called Bastard* (Robert Parrish, 1971) 'is essentially [a] tedious' film (1971: 126) and Mike Malloy declares that *Captain Apache* (Alexander Singer, 1971) 'is almost unwatchable' (1998: 52). Hardy laments that *Captain Apache* 'is an unimpressive film' (1991: 330) while Kevin Grant uses the term 'ill-conceived' to describe it (2011: 266).

Hardy quickly dismisses *Pancho Villa* (Eugenio Martin, 1972) for being 'dull' (1991: 334) but he does find some praise for Burt Kennedy's *Hannie Caulder* (1971), noting that, although the film 'uneasily mixes moments of gritty realism with light-hearted comedy', it is a 'surprisingly successful' show (1991: 331). However Garfield goes as far as to suggest that *Hannie Caulder*'s narrative is 'cynical, gruesome, distasteful – and insulting to the intelligence of a halfwit' (1982: 188). Seemingly dismissed outright for being strange-looking, bizarre or inept copies of Hollywood Westerns, these films have for the most part been forgotten by the public at large.

It would seem clear that the articulation of feminist concerns within British media texts and wider British society during the 1960s and early 1970s fed into the production of a cycle of British Westerns that featured untypically strong and active female characters. However, the presence of these striking representations of women in the British Westerns of the 1970s can perhaps also be linked to the British public's longstanding willingness to accept strong women as leaders, figureheads and characters in popular fiction. Indeed, antecedents of these remarkable Western females can be found in British legends and history, earlier British engagements with the Western genre and British popular culture more generally.

Legends and history

In recent history, two female monarchs have enjoyed unusually long periods of rule in Britain – Victoria (1837–1901) and Elizabeth II (1952–present) – resulting in a matriarchal figure overseeing the nation for the best part of two centuries. However, this does not necessarily mean that state, legislative and social attitudes towards women in Britain have been especially progressive. For example, Britain was relatively late in granting full suffrage to all women (over twenty-one) in 1928 when compared to other

Western countries such as the USA, Australia and Germany which granted full suffrage to all women over eighteen in 1920 or earlier. And a sense of sexual inequality endured – as, indeed, did chauvinistic attitudes and sexist media texts like *The Sun*'s daily 'page 3' photograph and the *Miss World* competition – throughout the 1970s despite second wave feminism's best interventions. Although Britain's acceptance of female leaders and figureheads stretches back to Roman times, Helen Castor notes that, throughout Britain's history, 'women and power have [always] made an uneasy combination' (2012). As such, the battle of the sexes for power, recognition and equality in Britain has often been hard fought on very public stages. For example, at the time of Elizabeth I's coronation in 1558, the Scottish clergyman John Knox declared in his polemical tract *The First Blast of the Trumpet Against the Monstrous Regiment of Women*:

> To promote a woman to bear rule, superiority, dominion or empire above any realm, nation or city is repugnant to nature, contumely to God, a thing most contrarious to his revealed will and approved ordinance, and finally it is the subversion of good order, of all equity and peace.
>
> (quoted in Castor, 2010: 32)

The story of Elizabeth I's struggle to gain monarchic power and her canny retention of it from 1558 to 1603 is well documented but evidence of the British people's propensity for accepting strong female leaders and figureheads can be found earlier in the nation's history.

Castor has detailed the stories of four noble women who held great power, influence and popular respect in England during medieval times: Matilda, the 'Lady of England' (2010: 35–126); Eleanor of Aquitaine, 'An Incomparable Woman' (2010: 127–222); Isabella of France, the 'Iron Lady' (2010: 223–314); and Margaret of Anjou, 'A Great and Strong Laboured Woman' (2010: 315–402). Although their attempts to become reigning monarchs of England never succeeded, these four women were involved in tenacious, hard fought, sometimes bloody and always very public power struggles that served to pave the way for Elizabeth I's eventual accession to the throne. Championed by their loyal subjects but despised by the guardians of patriarchal power, these women were disparagingly dubbed the she-wolves of England by their enemies (Castor, 2010). British

affection for strong matriarchal figures was perhaps first manifested when the goddess Britannia was chosen to represent the iconic personification of the islands of Great Britain during the time of the Roman Empire. The figure of Britannia has taken on several symbolic forms but the image that has endured is that of the female combatant. As Anne Helmreich observes, the Britannia we recognize today is a 'powerful, often stern, figure' who sports a warrior's 'breastplate and helmet, and carries a spear and shield' (2003: 17).

It was also during the Roman occupation of Britain that a flesh and blood warrior queen came to prominence. Circa AD 60/61 Boudica, Queen of the Iceni tribes, rallied her people and personally led a revolt against Britain's Roman occupiers that was initially successful: Boudica's insurgent forces overran Colchester before sacking both London and St Albans. Vanessa Collingridge observes that Boudica represented something completely 'alien and threatening to the patriarchal Roman mindset – a *woman* [Collingridge's emphasis] who dared to step outside the "normal" role of wife and mother, and to take up arms against Rome' (2006: 5). However, when Boudica's army engaged the Roman forces at the decisive battle of Watling Street, her revolt was crushed. Boudica's revolutionary campaign remains one of Britain's most enduring foundation stories and it is but one of several that feature iconic Celtic and Anglo-Saxon warrior women.

Collingridge notes that, as the female head of a mighty empire that was seeking to expand its areas of influence in South Africa by force, Queen Victoria made a conscious decision to symbolically align herself with the British warrior queen Boudica (spelled Boadicea during Victorian times) and the indomitable warrior goddess Britannia (2006: 374–375). Completed in 1902, Thomas Thornycroft's majestic statue *Boadicea and her Daughters* stands on the Embankment to this day as a testament to Victoria and her subjects' fascination with the rebellious warrior queen. It is then perhaps not surprising that the suffragette movement began to gain momentum in Britain during the Victorian period. The demand for female suffrage was an international cause during the late nineteenth and early twentieth centuries but the British manifestation was particularly militant. Wendell Robert Carr asserts that:

> No other part of the movement came close to duplicating the antics of Mrs. Emmeline Pankhurst's suffragettes, who

interrupted meetings, provoked clashes with police, hurled stones through windows of government offices and shops, and resorted finally to burning churches, railway stations, and other public buildings.

(1970: vi)

The spirit of Boudica could surely be felt in these extreme acts of feminine insurgency. Indeed, the suffragettes used Thornycroft's statue as a rallying point and Brian Williams indicates that some suffragettes dressed as Boudica when they marched on London in May 1911 (2005: 20). Carr observes that these 'late nineteenth century crusaders for [British] women's rights' had more than female suffrage on their agenda: they were also seeking the widespread reform of laws relating to job opportunities, education and marriage (1970: vi), the self same concerns that would occupy the second wave British feminists of the 1960s and 1970s. The influence that strong women have had on Britain's history surely goes some way to explaining why strong women appear in the country's popular entertainment forms with such regularity.

The British music hall

In order to further tease out the local elements found in British Westerns it is necessary to reflect upon the working practices of the British film industry. Tom Ryall asserts that it is possible to detect points in the history of British cinema where indigenous strands of popular culture, that possessed 'an established appeal in a range of other media and presentation forms', were specifically drawn upon in order to produce films that it was hoped would match the inherent tastes of domestic cinemagoers (2001: 10). The two examples that Ryall offers are the music hall-inspired films of Gracie Fields and George Formby and the later gothic literature-inspired features associated with Hammer Films (2001: 10). I will argue that both the British music hall and the British gothic tradition played a part in strong female characters appearing in British Westerns.

The music hall tradition had its origins in the spontaneous entertainment performances that would erupt in British public houses during the mid-nineteenth century. David R. Sutton observes that these often anarchic entertainment forms were duly refined and transplanted to 'grand,

purpose-built halls', which allowed the music hall to develop into the premier entertainment form favoured by those members of the working classes who 'were not addressed by the cultural products of the world of "high" art, literature and the legitimate stage' (2000: 65). As such, music hall performers drew upon working class experiences and concerns, treating them 'comically or sentimentally in songs, sketches, or humorous monologues' (Sutton, 2000: 65). The music hall soon generated its own 'star' system and these stars were natural choices when British filmmakers set about producing early feature films that they hoped would have popular domestic appeal.

As a result, for much of the 1930s and beyond British masculinity was represented on cinema screens by a stream of endearing but patently emasculated, bumbling and incompetent male characters who were played by music hall comedians such as the Crazy Gang, George Formby and Tommy Trinder. But while emasculated and infantilized male characters became the mainstay of the British music hall films, the female music hall star Gracie Fields became known for playing active and ever-resourceful film characters. Comparing Fields to her closest rival, Dave Haslam observes that she 'was as strong as [George] Formby was weak, perhaps reflecting the strong influence wielded by women in [British] working-class communities. She had a no-nonsense persona' (2000: 71). Interestingly, Paul Ward indicates that Fields has been referred to as 'the Lancashire Britannia' (2004: 70). Popular representations of the strong northern working class women pioneered by Fields would re-emerge in British social realist films and television shows at the end of the 1950s.

The British gothic tradition and 'the supernatural explained'

The British gothic tradition is also marked by its habitually atypical representations of gender. Clive Bloom asserts that the gothic world of popular fiction literally lies 'ready at hand' in Britain, where the spooky ruins of monasteries dissolved by Henry VIII still litter the landscape (2007: 294). And David Stevens notes that gothic design became 'the dominant aesthetic force in Britain' during the nineteenth century (2000: 13) which means that imposing gothic-styled buildings are still readily found in most British cities. Furthermore, Stevens suggests that the British public

possesses an innate cultural affinity for the gothic as a dark and unsettling entertainment form that stretches back to its roots in the works of William Shakespeare (2000: 47–48). But the 'British gothic tradition' per se remains relatively hard to characterize. Indeed, Fred Botting observes that it is virtually 'impossible to define a fixed set of conventions' for the gothic (1996: 15). First established as a literary form in the late eighteenth century but more popularly associated with the horror stories written by authors from the British Isles during the nineteenth century (Mary Shelley, Bram Stoker, Sheridan Le Fanu, Robert Louis Stevenson, *et al.*), David Pirie indicates that the gothic movement was marked primarily by its introduction of a 'new preoccupation with death, solitude and the visual/emotional appeal of ruins' (1973: 11).

Catherine Spooner and Emma McEvoy add that British gothic texts feature 'dominant tropes such as imperiled heroines, dastardly villains, [and] ineffectual heroes' (2007: 1). Interestingly, many writers of British gothic literature were women and Alison Milbank indicates that there was an emphasis on 'feminine qualities' in their stories (2007: 155). Indeed, Milbank asserts that gothic heroines, despite their weaknesses, 'always cause the downfall of the patriarchal figures or institutions that seek to [control or] entrap them' (2007: 155). And so, through the works of female writers such as Ann Radcliffe, Eliza Parsons and the Brontë sisters, the British public became accustomed to following the trials and adventures of uncharacteristically active female characters. Gothic texts written by men which were determinedly horrific or supernatural in nature, like Le Fanu's *Carmilla* and Stoker's *Dracula*, often featured females who possessed subjective positions within their narratives. However, E. J. Clery indicates that the more recognizably 'female' gothic texts (which were mostly written by women) tended to explore a slightly different engagement with the supernatural by employing 'the supernatural explained' device: first introduced by Ann Radcliffe in *A Sicilian Romance* (1790), the device can be detected when 'apparently supernatural occurrences are spine-chillingly evoked only to be explained away in the end as the product of natural causes' (1995: 106). The British gothic tradition's focus on active female characters and its inclusion of scenarios that are morbid, uncanny and (often only seemingly) supernatural in nature is replicated within the British Westerns under review in this chapter.

The inclusion of allusions to horror and the supernatural in British Westerns may appear incongruous but the 'supernatural explained' device has been regularly employed in a diverse range of British media productions. Although strict censorship guidelines meant that the production of horror films in Britain was discouraged until the late 1950s (Hutchings, 1993: 24), Pirie observes that prior to the rise of Hammer Films British filmmakers had habitually sought to include gothic-inspired imagery and supernatural-seeming scenarios in what were essentially non-horror films (1973: 25). Walter Forde's *The Ghost Train* (1941) and Wolf Rilla's *The Black Rider* (1954) are typical examples of this approach. The protagonists in both films encounter scary supernatural activity that is eventually revealed to be fake phenomena constructed by enemies of the state in order to ensure that their nefarious activities go undisturbed. It would seem that by employing the 'supernatural explained' device, British filmmakers were able to satisfy in part the British public's affinity for the gothic without upsetting the state censor. This affinity was fully re-engaged by Hammer's horror films in the late 1950s. Indeed, Pirie argues that Hammer's British gothic horror films possessed cultural 'roots as deep as those of the Gothic novel' which led to the horror genre subsequently becoming 'the most popular and frequently attempted cinematic form in England' (1973: 22).

Although gothic works are generally assumed to feature horrific or (seemingly) supernatural elements, Bloom concludes that 'the nature of the gothic is so disparate that it can include (because of formal similarities) works of fiction that contain neither supernatural nor horror elements but which do contain similar attitudes to setting, atmosphere or style' (2007: 1). As such, David Punter indicates that 'the uncanny' is often present in gothic works since it helps to reinforce the gothic's preoccupation with events and occurrences that, while not being supernatural per se, do 'run counter to everyday expectations' (2007: 131–132). Adding to Sigmund Freud's (1955) work on the subject, Nicholas Royle describes the uncanny as being concerned with 'the strange, the weird and mysterious, with a flickering sense (but not conviction) of something supernatural' (2003: 1) and representations of the uncanny can be found throughout the British Westerns under review here. While the seemingly supernatural and uncanny elements that are found in British Westerns rarely target or affect the films' female characters, they do

provide a gothic atmosphere in which the viewer naturally expects to encounter resourceful and active females. Significantly, David Punter and Glennis Byron assert that the gothic is 'a genre that re-emerges with particular force during times of cultural crisis and which serves to negotiate the anxieties of the age by working through them in a displaced form' (2004: 39). As will become apparent, a similar function can be attributed to the British Westerns too.

Crises of masculinity, strong females in British popular culture and second wave feminism

Having been a superpower with a mighty empire for most of the eighteenth and nineteenth centuries, Britain saw its influence and power begin to fade as the twentieth century approached its midpoint. As such, both the rise of Nazi Germany and autonomous actions by former Empire countries would prompt a series of crises of masculinity that were seemingly reflected in contemporaneous British media productions. Nazi Germany's aggressive foreign policy during the 1930s served to highlight the impotence of the League of Nations and British Prime Minister Neville Chamberlain's policy of appeasement suggested that Britain was no longer a significant military power. As noted earlier, emasculated music hall comedians became the pervasive cinematic representatives of the British male during the years of appeasement but the war years saw music hall stars like George Formby and Tommy Trinder appearing in films that showed their bumbling heroes assisting with Britain's war efforts in positive ways. However, as Vincent Terrace indicates, it was also during World War II that the eponymous character in the *Daily Mirror*'s popular comic strip *Jane* became a heroine who battled and defeated German spies (2002: 76). The comic strip's narratives usually ended with Jane losing her clothing, a contrivance that feminists would be at liberty to criticize today, and the strip was clearly intended to be a titillating morale booster for British troops. However, the *Jane* comic strip must still be recognized as an action narrative in which a female took the lead.

As Britain struggled to rebuild itself after the war, a series of morale boosting films were made that celebrated the country's tenacious fighting

spirit and the central role that it had played in the defeat of Nazi Germany. However, Britain was forced to recognize that its reign as an imperial power was ending and independence was granted to a number of Empire countries during the 1940s and 1950s. Furthermore, Alison Oram indicates that the heavy work carried out by British women during the war had prompted new public discourses surrounding equality and gender relations (1996: 53). Seemingly reflecting both Britain's fading power at an international level and the renewed calls for equality from domestic women's groups, a new generation of working class music hall comedians from the North of England found cinematic success playing emasculated men on screen. A more serious take on northern working class culture emerged towards the end of the 1950s with the films of the British New Wave. However, the New Wave's films reflected a new crisis of masculinity that Britain was deemed to be suffering due to the events surrounding the Suez Crisis. When the President of Egypt, Gamal Abdel Nasser, decided to nationalize the Suez Canal in July 1956, Britain and France felt compelled to initiate diplomatic and military action that was designed to take control of the canal and remove Nasser from power. However, intense pressure from the United Nations, the USA and the USSR forced Britain to climb down. Britain's Permanent Under-Secretary at the Foreign Office, Sir Ivone Kirkpatrick, felt that the UK's humiliating volte-face resulted in a feeling of national impotence that was similar to the one experienced during the 1930s and he duly observed that 'we [Britain] were reluctant to slap Hitler down because he was so strong and now we're reluctant to stop Nasser because he's so weak' (quoted in Johnman, 2000: 52).

Born out of the British documentary movement, the New Wave's films adopted a social realist mode that subsequently became a recognized and enduring aspect of British cinema and television productions. And, as Kara McKechnie observes, one convention that quickly became associated with British social realism was 'its focus on strong women', which resulted in 'a distinctive tradition of memorable female characters' (2007: 26). As such, the New Wave's films feature tough and angry but ultimately powerless young men who are constrained by their lowly class status and confounded by the matriarchal nature of the social milieu that they inhabit. In these films it is often strong and active women who are seen to act upon weak or incapable men. For example, the narrative of Tony Richardson's *A Taste of*

Honey (1961), which was based on a play by Shelagh Delaney, is led by two feisty, independent and sexually active females: the irresponsible Helen (Dora Bryan) and her wayward daughter Jo (Rita Tushingham). During the 1960s, the New Wave's strong northern female types migrated to British television when social realism-inflected soap operas such as *Coronation Street* (1960–present) became popular. At the other end of the social scale, Agatha Christie's thoroughly active and independent amateur detective, Miss Marple (Margaret Rutherford), made her big screen debut in 1961 in *Murder, She Said* (George Pollock). Based loosely on popular stories that had been published in Britain during the 1930s, 1940s and 1950s, Rutherford and Pollock would make a further three *Miss Marple* films and the character would go on to become a mainstay of British television.

In the realms of fantasy narratives, another independent and strong female character appeared in 1963 in the form of the gun-wielding martial arts expert and sometime British Secret Service employee Modesty Blaise. The *Modesty Blaise* comic strip was published in the *Evening Standard* and it went on to spawn a film of the same name that was directed by Joseph Losey in 1966. *Modesty Blaise* might have had an influence on the ongoing development of the contemporary British television show *The Avengers* (1961–1969), which featured a series of female secret agents, most notably Kathy Gale (Honor Blackman, 1962–1964) and Emma Peel (Diana Rigg, 1965–1967), who used their martial arts and weaponry skills to vanquish enemies of the state. Alain Carraze and Jean-Luc Putheaud describe Gale as being 'a woman ahead of her time: submissive to no one, independent and fully capable of looking after herself' (1997: 185). Indeed, Carraze and Putheaud assert that *The Avengers* 'became a major player in the battle of the sexes' precisely because 'these women were strong, independent and in control' (1997: 37). Interestingly, Carraze and Putheaud suggest that 'this leap forward in equality was made acceptable at the time because it blended seamlessly into a format that took escapism to new heights' (1997: 37). Those new escapist heights were most successfully achieved when the show's writers began adding outlandish gothic, uncanny and weird science fiction elements to the show's espionage-themed narrative framework. Following *The Avengers'* lead, *The Corridor People* (1966) was another British espionage series that featured remarkably strong female characters and decidedly gothic and uncanny occurrences.

In terms of the cinema, it is the products of the British studio Hammer Films that best represent the British gothic tradition on film. Pirie suggests that Hammer and other British filmmakers were able to successfully market gothic horror films precisely because much of the gothic movement's 'themes relate to certain psychopathological aspects of the English temperament' (1973: 11). And although Hammer started to go into decline in the late 1960s, James Park argues that the influence of the company's gothic horror films continued to be felt in a variety of British films that were produced during the early 1970s and beyond (1990: 113). Park's work (1990) suggests that, following Hammer's glory years, the British public were ever more willing to accept the appearance of gothic-inspired scenarios and employment of the supernatural explained device within non-horror films. As such, it is not surprising to find gothic horror elements foregrounded in the British Westerns from the early 1970s.

Furthermore, Hammer's early 1970s films reflect a new crisis of British masculinity. Fiona A. Montgomery observes that pressure from the Women's Liberation Movement and drives by mainstream British political parties to attract and retain female voters resulted in 'much legislation' concerning 'women's issues' being introduced during 'the late 1960s and early 1970s' (2006: 164). For example, the Equal Pay Act (1970) and the Matrimonial Property Act (1970) were both designed to bring about a new sense of equality amongst the sexes in Britain. Interestingly, the rather lackluster way in which some of these laws were observed resulted in a series of females-only pay strikes that were led by empowered women (Sandbrook, 2012). Furthermore, the publication of celebrity academic Germaine Greer's *The Female Eunuch* (1970) and the launch of *Spare Rib* magazine (1972) served to give feminism a high public profile in the UK.

As such, Peter Hutchings detects the reactionary appearance of a new type of female antagonist in Roy Ward Baker's 1970 Hammer film, *The Vampire Lovers* (1993: 160). Based on Le Fanu's gothic vampire story *Carmilla* (1872), which is told from the perspective of a female character, the film stars Ingrid Pitt as the vampiric interloper, Carmilla. A sexually aggressive lesbian, Carmilla is seen as 'a sexual liberator of females trapped within patriarchal households and definitions of the feminine' while also being characterized by the normally masculine attribute of free movement (Hutchings, 1993: 160–161). Having noted 'the wider rejection and casting

out' of male authority figures in Hammer's early 1970s films (1993: 159), Hutchings observes a recurrent configuration found in *The Vampire Lovers* that revolves around shots of a male character looking at a female character, followed by images of the male character in a state of powerlessness or inadequacy (1993: 163). As such, James Rose suggests that Carmilla represents 'the emergence of the strong, independent woman' whose demands for equality posed a threat to the norms of patriarchal society (2009: 19). The same dramatic configuration, in which females are seen to leave males rendered powerless or inadequate, can be found in a number of other contemporaneous British horror films and it also appears repeatedly in the British Westerns of the early 1970s.

Carmilla is essentially coded as a monstrous female and Hutchings notes that she is ultimately defeated, albeit by a group of weakened men who can only successfully act against her while she is sleeping and unresisting (1993: 163). By contrast, in the British Westerns of the early 1970s the female characters are not coded as monstrous and the forces of patriarchal order generally fail to tame or punish them. The severity of the crisis of masculinity experienced in Britain at this time is perhaps reflected in the fact that, before long, even the monstrous females of British horror films would emerge victorious over the powers of patriarchy. Pete Walker directed a series of such films, the most notable being *Frightmare* (1974) in which a murderous and cannibalistic mother (Sheila Keith) and daughter (Kim Butcher) are still at liberty to commit their heinous crimes at the film's end. Leon Hunt observes that Keith's steely performances as monstrous females in five of Walker's films 'are uncannily [Margaret] Thatcher-like', which is a pointed reference to Thatcher's 'initial popular incarnation as the Milk Snatcher' while serving as the Education Secretary in Edward Heath's early 1970s Conservative government (1998: 152). Significantly, Thatcher would provide further evidence of both Britain's propensity for accepting strong female leaders and the emergence of equality-driven women in Britain at the turn of the 1970s: after becoming the first female leader of the Conservative party in 1975, Thatcher's 'Iron Lady' persona contributed to her becoming Britain's (and Europe's) first female Prime Minister in 1979.

Clearly, the ongoing public debates concerning masculinity and feminism in Britain had some impact on the representation of females in British Westerns. But these local elements also helped to create a

cinematic space where it was possible to represent strong women who could indulge in masculine activities and strike against patriarchal order without fear of suffering narrative punishment. In order to fully assess the groundbreaking nature of these representations, it is necessary to first offer an overview of the way in which females have been represented in American Westerns.

8

The Representation of Women in American Westerns

The assertion that the Western is a masculine genre is beyond doubt and the producers of American Westerns have, by and large, neglected to incorporate female characters of substance in their films. Nanna Verhoeff indicates that some very early silent Westerns from America did feature a variety of active and resourceful females (2006: 394) but such characters soon faded from the genre. And a brief flurry of Hollywood Westerns from the early 1970s did feature relatively assertive female characters who were able to occupy a fairly central narrative space. However, R. Philip Loy observes that Hollywood's most notable and sustained efforts in this regard were not produced until the mid-1990s when Jonathan Kaplan's *Bad Girls* (1994) and Sam Raimi's *The Quick and the Dead* (1995) initiated a short cycle of feminist Westerns that featured female characters who were able to challenge patriarchal order without fear of suffering punishment at a narrative level (2004: 297).

Prior to the release of these films in the 1990s, the few assertive female characters who did appear in Hollywood Westerns rarely made it to the end of their films without being tamed or punished in some way. Here I will offer an overview and a re-evaluation of the prescriptive ways in which women were represented in the majority of Hollywood's Westerns. Thus when the British Westerns under review are examined in detail, the

extent to which their representations of strong women broke the genre's gender-based rules will become apparent. Hollywood's treatment of strong women out West has generated a reasonable amount of academic and critical writing and this section will review and critique some of this work in order to illustrate a catalogue of representational 'rules' that were employed to constrain and 'Other' the Hollywood Western's women.

The decorative, peripheral and immobile prize: *40 Guns to Apache Pass* (1967)

Frederick Woods observes that women in American Westerns 'always remain onlookers to the main action' (1959: 30). Indeed, in arguing that Westerns are male-dominated texts, Woods stresses that:

> Time after time, one can detach the females without endangering the structure of the main plot. The West is a man's world, and the women are relegated to mere decoration ... Most often they are prizes only, to be gathered in by the handsome hero when the gunsmoke has drifted away.
>
> (1959: 30)

Mulvey's (1986) work suggests that female characters were routinely represented in this way in films that were produced during the classical Hollywood period. However, although the classical Hollywood period is generally acknowledged to have ended in 1960, the same prescriptive approach to representing female characters would continue to be the norm in American Westerns made during the 1960s, the 1970s and beyond. Indeed, the content of William Witney's *40 Guns to Apache Pass*, a Western produced as late as 1967, offers firm evidence of this. With Apaches on the warpath Captain Bruce Coburn (Audie Murphy) calls at the Malone ranch in order to evacuate his girlfriend, Ellen (Laraine Stephens), and her family. Although he is primarily concerned with protecting her from marauding Indians until she is safely delivered to the Apache Pass outpost, Coburn finds opportunities en route to wear the blonde, beautiful and vulnerable Ellen as a 'decoration' on his arm. Once at Apache Pass, Coburn recruits Ellen's brothers and embarks on a dangerous mission to collect a consignment of guns. Ellen is subsequently

featured just twice more in the film and both of these appearances serve primarily as devices that bolster Coburn's heroic and manly status, thus confirming Rebecca Bell-Metereau's assertion that the Western is 'a genre dominated by masculine virtues' (1993: 80). When deserters conspire against him and Coburn returns to Apache Pass without the guns or her brothers, Ellen's distress negatively affects their relationship and makes Coburn feel guilty enough to disobey orders. He subsequently takes off in search of the deserters and when he triumphantly returns with the guns and one errant brother, a forgiving Ellen is there to offer herself as a prize for his heroic endeavours.

A purely decorative character who exists only to motivate Coburn's actions, Ellen is given screen time in just three locations (the Malone ranch, an overnight camp site and the Apache Pass outpost). Clearly positioned as a static representative of civilization and domesticity, each scene that Ellen appears in revolves around her romantic relationship with Coburn. As such, Ellen is a good example of the kind of passive female character that Mulvey (1986) found in classical Hollywood films. In keeping with Mulvey's observations, each onscreen appearance by the beautiful Ellen serves to 'freeze the flow' of the film's action by temporarily foregrounding 'moments of erotic contemplation [instead]' (1986: 203). Ellen is surely representative of the female characters found in 'countless Westerns' who, according to Teresa de Lauretis, simply function to represent or literally mark out 'the place' to which the active male hero will travel or return to (1984: 139). Indeed, in *40 Guns to Apache Pass*, the gender specific philosophies of American Western director Budd Boetticher can be clearly detected:

> What counts is what the heroine provokes, or rather what she represents. She is the one, or rather the love or fear she inspires in the hero, or else the concern he feels for her, who makes him act the way he does. In herself the woman has not the slightest importance.
>
> (quoted in Tuska, 1985: 224)

By contrast, Audie Murphy's Captain Coburn character is wholly representative of the commanding and active male hero, the 'ideal ego', that Mulvey saw repeatedly represented as a fully mobile 'figure in a landscape' in classical Hollywood films (1986: 204).

R. Philip Loy (2001 and 2004) loosely tries to read the representations of women in American Westerns as being reflective of women's general standing in contemporaneous American society. But while many females had proven that they could effectively look after themselves during the war years, Loy observes that even in American Westerns produced after World War II, female characters 'were likely to be nieces or daughters, dependent upon males for protection and supervision' (2001: 248). Ellen is such a character, at once a daughter, a sister and a girlfriend who is potentially protected by her father, her brothers and her boyfriend. Lenihan argues that the American Western heroine exists in order to exemplify 'both the virtuous moral fibre of the good community and its susceptibility to physical danger' (1985: 13) and these are functions that Ellen also serves to satisfy. All told, the content of *40 Guns to Apache Pass* seemingly confirms that the makers of Hollywood Westerns were generally reluctant to change the way females were represented within the genre.

Strong women punished: *Destry Rides Again* (1939) and *Duel in the Sun* (1946)

A minority of American Westerns have featured women who were tough, active and powerful characters when compared to *40 Guns to Apache Pass'* Ellen, but the gender-related rules of the genre continually serve to rein these characters in before their films' end. The rough or unladylike appearance of these initially unruly female characters is usually feminized before they are drawn into normative romantic relationships where they are confirmed to be the weaker partner. This normalizing process inevitably involves these striking female characters losing whatever power and independence they might possess. If an unruly or powerful female character cannot be tamed in this way, she is inevitably punished by death. Tuska observes that punishment also awaits dishonest female characters in American Westerns and, citing the events depicted in *Destry Rides Again* (George Marshall, 1939), he asserts that females who consort with villains must, like the villains themselves, die at the film's denouement (1985: 226). *Destry Rides Again's* Frenchy (Marlene Dietrich), an assertive and aggressive saloon girl who beats men at poker

and physically assaults anyone who upsets her, is thus doomed to die by virtue of her strong character and her relationship with the villainous Kent (Brian Donlevy). Interestingly, Frenchy's death means that the town's heroic deputy, Destry (James Stewart), is unable to draw her into a symbolically normative relationship by taming her and remoulding her into a suitable wife. As such, the film ends with his severely cowed and henpecked assistant, Boris (Mischa Auer), finally asserting himself and bringing his domineering wife to heel.

In King Vidor's *Duel in the Sun* (1946) the orphaned Indian half-breed Pearl Chavez (Jennifer Jones) contravenes various gender-specific rules of the genre, meaning that her death at the film's denouement is seemingly inevitable. Tuska observes that those women in Westerns who are 'less than completely white' must 'be prepared to settle for less' out of life (1985: 231) and this applies to Pearl. When Pearl is sent to stay with white relatives, she falls in love with the virtuous but seemingly unobtainable Jesse (Joseph Cotten). Before long, Jesse's villainous and abusive brother, Lewt (Gregory Peck), takes advantage of Pearl and draws her into a casual sexual relationship. E. Ann Kaplan has observed that female characters in Hollywood films who indulge in casual sex rather than seeking normative marital relationships tend to be punished because 'in symbolic systems there is simply no place for the single and sexual woman; patriarchal culture still fears the unattached woman' (1991: 82).

Furthermore, Pearl is essentially a tomboy who excels at masculine activities like horse riding and shooting but she remains stunningly beautiful and overtly sensual even when wearing masculine trousers and shirts. As such, she disrupts Loy's assertion that tomboys in American Westerns were generally regarded as big sister figures, the 'one to whom males turned for advice and solace but not companionship' (2001: 258). Ultimately Pearl represents an unnatural threat to patriarchal order that must be eradicated. Pam Cook has observed that if a Western heroine 'is allowed to be active, it is in the hero's cause rather than her own' (2005: 44). Thus, when Pearl discovers that Lewt is intending to kill Jesse, she takes up arms and again upsets patriarchal order by tracking Lewt down and shooting him. As a punishment for breaking the various gender-related rules previously outlined, Pearl is mortally wounded as she guns Lewt down.

Strong women tamed: *A Ticket to Tomahawk* (1950) and *Johnny Guitar* (1954)

Cook observes that it is 'unusual for the woman who starts out wearing pants, carrying a gun and riding a horse to still be doing so at the end of the movie' (2005: 44) and this can be confirmed by the content of Richard Sale's *A Ticket to Tomahawk* (1950). Here short haired, buckskin-clad and sharp-shooting tomboy Kit Dodge Junior (Ann Baxter) is charged with protecting a wagon train from saboteurs. She takes an instant dislike to the travelling salesman Johnny Behind-the-Deuces (Dan Dailey), but the pair are subsequently forced to work together. In keeping with Loy's observation that, even if women 'have substantial roles in the plot and action, [they] are almost always subordinate to the hero and lead villain' (2004: 274), Kit eventually takes a secondary role in the battle of wits that plays out between Johnny and the villainous Dakota (Rory Calhoun). Come the film's end, Johnny and Kit are married with five children and Kit is last seen wearing a glamorous dress. The narratives of such Westerns from the 1950s appear to mirror patriarchal American society's supposed need to curtail the sense of independence that women had necessarily enjoyed during World War II.

Even in its easy-going comedy-musical variations, the American Western remained a genre in which gender roles were highlighted and pre-scriptive gender-related rules were enforced. Bell-Metereau cites George Sidney's *Annie Get Your Gun* (1950) as a prime example of those Westerns in which 'women must hide their abilities in order to get a man' and David Butler's *Calamity Jane* (1953) as an equally good example of those Westerns in which 'a woman clothed as a man must put on a dress and act helpless to have any sex appeal' (1993: 89). Indeed, in both films, the female protagonists must deliberately play down their impressive shooting skills and rein in their outgoing and active natures in order to become socially accepted girlfriends and wives. By doing so, Annie (Betty Hutton) and Calamity (Doris Day) both effectively act to normalize and perpetuate the image of women as the weaker, acquiescent and second-best sex.

At first glance the content of Nicholas Ray's *Johnny Guitar* (1954) appears to circumvent the usual prescriptions that serve to constrain strong women in American Westerns. *Johnny Guitar*'s lead female character, Vienna (Joan Crawford), is brave and domineering and she

remains one of the most interesting female characters ever to appear in an American Western. The film's final shootout, fought between Vienna and her equally atypical female rival Emma Small (Mercedes McCambridge), remains striking to this day. However, Tuska notes that while American Westerns do sometimes feature female characters who are capable of riding 'roughshod over men, [and] owning and operating successful ranches or saloons', such characters usually 'have to be saved by a man, or at least come under the spell of a man and admit that they are somehow still the weaker sex' before their film ends (1985: 229). Vienna duly suffers much punishment before *Johnny Guitar*'s downbeat ending (losing the saloon she built, the customers who frequented it, the work force she bossed and the respect of the local community) and she is ultimately left only with her love and need for Johnny (Sterling Hayden). It seems that even *Johnny Guitar*, an American Western that has been rightfully recognized for its idiosyncratic approach and seemingly progressive content, was bound by a need to feature a denouement that ultimately supported patriarchal values.

Revenge is no pursuit for a lady: *Cat Ballou* (1965), *Welcome to Hard Times* (1967), *100 Rifles* (1969) and *True Grit* (1969)

Starring Jane Fonda as its eponymous vengeance-seeker, *Cat Ballou* (Elliot Silverstein, 1965) features one of the American Western's most notable and progressive female characters. Philip French has observed that the female characters in American Westerns who take up guns and seek revenge against male antagonists are fated to die as a punishment for stepping 'outside their appointed role' within the genre (2005: 42). Cat successfully seeks revenge, killing the man who ordered her father's murder, and she also, quite remarkably, manages to escape without suffering any physical punishment in return. However, in order for Cat to avoid the hangman's noose her four male companions – who had previously been embarrassingly impotent in the face of danger – are newly re-masculinized and cast as her heroic saviours. Thus Cat is conveniently moved back into her correct gender position at the film's denouement when she takes on the role of a helpless female in need of rescue from the gallows. Likewise, her male

associates have their masculinity reaffirmed when they successfully complete their rescue mission.

Cat's circumvention of gender-related generic rules proved to be something of an exceptional one-off. Indeed, the 1960s saw a run of American Westerns, bookended by John Sturges' *The Magnificent Seven* (1960) and Sam Peckinpah's *The Wild Bunch* (1969), that neglected to feature significant female characters at all. Sandra Schackel has asked whether it might be possible that, at a time when American women were beginning to demand equal rights, men in Westerns retreated into male-only relationships in order to signal patriarchal society's disapproval of such demands (1987: 213). It should be noted at this point that Herschell Gordon Lewis (using the pseudonym Mark Hansen) directed an obscure exploitation Western, *Linda and Abilene* (1969), that bucked this trend in a relatively novel manner. At the film's end patriarchal order is effectively erased when the nominal good guy (Kip Marsh) and the heinous villain (Tom Thorn) kill each other in a gunfight. This leaves the previously abused Linda (Roxanne Jones) and Abilene (Sharon Matt) to optimistically embark on a man free future together by fully developing their budding lesbian relationship. When female vengeance-seekers re-emerged in American Westerns towards the end of the 1960s, they were still being routinely punished for their transgressive actions, as is evidenced by the fates of Molly Riordan (Janice Rule) in Burt Kennedy's *Welcome to Hard Times* (1967), Sarita (Raquel Welch) in Tom Gries' *100 Rifles* (1969) and Mattie Ross (Kim Darby) in Henry Hathaway's *True Grit* (1969).

In addition to seeking vengeance against the man who raped her, Molly upsets patriarchal order in *Welcome to Hard Times* by repeatedly emasculating her partner, Blue (Henry Fonda), with her stinging accusations of cowardice and, as such, she is doomed to die. Sarita, who joins the Yaqui Indian revolution in order to kill the Mexican Federale soldiers who executed her activist father, similarly upsets patriarchal order in *100 Rifles*. Indeed, on occasion Sarita uses her sex appeal to lure her unsuspecting victims to their deaths. Referring to Sarita as 'a warrior', Loy observes that she is able to switch 'from being a sex object to a fighter, shooting as effectively as the men' (2004: 294) but he neglects to mention that her assertive actions – along with her casual sexual relationship with an African American – ultimately result in her punishment at a narrative

level when she is killed in the film's final battle. Mattie Ross survives the revenge mission she initiates in *True Grit* but she is severely punished at a narrative level. Loy describes Mattie as being a 'determined', 'persistent and brave young woman' (2004: 290), which she is. However, whenever Mattie attempts a masculine activity, like shooting a gun, disaster follows. And, at the film's end, she mournfully elects to become a spinster before indicating that she and her much older friend and saviour, Rooster Cogburn (John Wayne), will become a normative couple in death, bonded beyond the grave by virtue of the twin burial plot she has planned.

Changes for the better? *McCabe & Mrs Miller* (1971), *The Hired Hand* (1971) and *The Train Robbers* (1973)

It is in American Westerns from the early 1970s that Schackel first detects 'a decided improvement in roles for women, a change that does reflect society's rising consciousness of female equality' (1987: 213). That may be so but the female characters that Schackel likens to 'the strong, determined "modern" woman' (1987: 213) are still roundly punished when they challenge patriarchal order. In declaring that the brothel madam Mrs Miller (Julie Christie) in Robert Altman's *McCabe and Mrs Miller* (1971) is 'a self-sufficient, capable woman' with a shrewd business mind, Schackel has to concede that 'the price she pays for success precludes her ability to develop a warm, loving relationship with' the film's nominal hero, Warren Beatty's McCabe (1987: 214). McCabe dies because Mrs Miller is unable to get him to take seriously the threats made by the company that wants to buy his land and business and the film ultimately suggests that independent and successful businesswomen do not deserve to be part of a happy normative relationship. There is a gap of several years between *McCabe and Mrs Miller* and the next cycle of American Westerns that Schackel feels feature significant female characters: Arthur Penn's *The Missouri Breaks* (1976), Alan J. Pakula's *Comes a Horseman* (1978) and Richard Pearce's *Heartland* (1979) (1987: 200).

A similar though smaller gap can be found in Loy's assessment of the representation of women in American Westerns during the same period. Loy cites Verna Bloom's appearance as Hannah Collins in Peter Fonda's *The*

Hired Hand (1971) as being significant. When Hannah's husband Harry (Peter Fonda) and his friend Arch (Warren Oates) return home after years wandering the West, Hannah treats them like hired hands, making them work for their keep and forcing them to sleep in the barn. Here Hannah is the dominant partner in their businesslike interactions and, as Loy observes, when Hannah and Harry eventually 'renew their [romantic] relationship' it is 'on *her* [Loy's emphasis] terms' (2004: 291). However, Hannah reveals that she had sexual relations with a number of the hired hands who helped her to run the ranch in Harry's absence, thus invoking Kaplan's observations regarding the punishment of sexually active single women in Hollywood films (1991: 82). Hannah is punished for her active sexuality, her dominance of Harry and her contravention of patriarchal order when her husband is subsequently killed rescuing Arch from a villain. The film again implies that strong, dominant and sexually active women do not deserve to be part of a happy normative relationship.

Loy has to jump to 1973 for the next American Western – Burt Kennedy's *The Train Robbers* – that he feels marks a sense of progress for female characters (2004: 290). This film is indeed highly significant. Here a female character, Mrs Lowe (Ann-Margaret), dupes Lane (John Wayne) and his men into helping her find the $500,000 in gold that her late husband stole and hid. Believing that Mrs Lowe intends to hand the gold over to the railway authorities in order to clear her husband's name, Lane and his men agree to let her keep all of the insurer's reward money. However, once she has departed with the gold they learn that she is in fact a confidence trickster. Loy observes that the film's narrative hangs on the idea that 'a man as macho as John Wayne' could 'be taken in by a woman' (2004: 290) and this seemingly leads Garfield to dismiss the film's denouement as being simply 'a cynical surprise ending' (1982: 326). The fact that a female, Mrs Lowe, takes care of herself on the arduous journey to the gold, fires a rifle when needed to, dupes the representatives of patriarchal order out of $500,000 and gets away with it without suffering narrative punishment does represent something of a major breakthrough for American Westerns. It would seem that Tuska's observation that 'whatever the shifting reality of women's roles in American society, when it comes to women in [American] western films the prescriptions have been unrelentingly the same' (1985: 225) rings

true right up until 1973 when a tangible sense of change can be detected within *The Train Robbers*.

The American Westerns that Burt Kennedy directed before *The Train Robbers* all tended to follow the genre's gender-related rules. It is therefore interesting to note that, prior to working on that film, Kennedy had encountered a strong female character out West when he was commissioned to direct the British Western *Hannie Caulder* for Tigon Films in 1971. After confessing that he could not 'abide' European Westerns and chose (at that time) to watch only American productions (2005: 3), Philip French was able to declare in 1973 that, 'whatever may be happening in other branches of the cinema, the western remains a place dominated by men' (2005: 42). Had French taken the time to watch recent British Westerns his assessment may have been markedly different. My contention is that, by naturally building upon the representations of strong female characters traditionally found in the British Western parodies, a plethora of British Westerns produced during the early 1970s introduced female characters who were able to act completely independently and physically strike against patriarchal order without suffering the gender-based punishments or prescriptions still found in contemporary American Westerns. The findings of this chapter suggest that if British Westerns are taken into account, a new sense of continuity and progression in the representation of strong women in Westerns becomes apparent. This in turn problematizes the received model of the Western's evolutionary development.

9

The Representation of Women in the British Western Parodies Produced Between 1939 and 1966

On reflection, it would seem that the curious mixing of music hall sensibilities and supernatural, gothic or uncanny motifs with the established generic iconography of the Western might have been present in even the earliest of British engagements with the genre. Andy Medhurst indicates that the music hall comedian Dan Leno starred in the Western parody *Burlesque Attack on a Settler's Cabin* (director not known, 1900) (1986: 172) while the British Film Institute's description of Cecil M. Hepworth's trick film *The Indian Chief and the Seidlitz Powder* (1901) (2009) indicates the presence of special effects that are truly uncanny in nature. British silent films had featured a number of music hall artists who were skilled in practising sight gags but Medhurst notes that the arrival of sound during the 1930s resulted in a new generation of British music hall performers finding film stardom, and amongst these were the Crazy Gang (1986: 173).

The Crazy Gang were often likened to the Marx Brothers (Medhurst, 1986: 176) but it is worth noting that their Western, *The Frozen Limits* (1939), appeared a full year before the Marx Brothers' own Western-themed vehicle, Edward Buzzell's *Go West* (1940). Filmed at the height of Neville Chamberlain's policy of appeasement but released after Britain had declared war on Germany, *The Frozen Limits* features a lively

mix of music hall comedy routines and Western iconography and its central narrative thread served to set a rough template that each of the later British Western parodies would follow. Here six emasculated, eccentric and poverty-stricken English variety performers (Bud Flanagan, Chesney Allen, Jimmy Nervo, Teddy Knox, Charlie Naughton and Jimmy Gold) journey to a ghost town in the Yukon because they are led to believe that the gold rush is still ongoing in 1939. The region has not changed since the days of the Wild West and the absence of local law and order agents results in the Englishmen being reluctantly drawn into conflict with a villain who is determined to grab gold-rich land from a beleaguered local woman, Jill (Eileen Bell). The Crazy Gang's lack of enthusiasm for a fight here appears to reflect Britain's contemporaneous approach to foreign policy.

Significantly, the *Kinematograph Weekly*'s reviewer made pointed references to two unusual aspects of the film. Firstly, the reviewer perceived Jill to be an untypical female character as far as Westerns go, describing her as being 'pretty and by no means spiritless' (*Kinematograph Weekly*, 1939: 17). Secondly, the reviewer was particularly taken by a sequence set in a spooky derelict theatre that seemingly pays host to a phantom audience (*Kinematograph Weekly*, 1939: 17). The film's other decidedly un-generic elements include a ride on a phantom bus and a character who is adversely affected by the full moon and subsequently sleepwalks like a zombie. Strong female characters and allusions to the uncanny or eerie gothic horror would appear to some degree in all of the subsequent British Westerns that I examine in this chapter. Set and released in 1956, the same year as the Suez Crisis, *Ramsbottom Rides Again* details the misadventures of a cash-strapped and emasculated publican (Arthur Askey) who travels to the Wild West town of Lonesome in Canada in order to claim a family inheritance. A stipulation attached to his inheritance results in Ramsbottom being forced to become the region's deputy sheriff. Initially full of optimistic bravado, Ramsbottom soon becomes reluctant to confront Black Jake (Sid James), a villain who is determined to grab the land that the Englishman has inherited. Again, it is tempting to draw parallels between the film's narrative and the contemporaneous feeling that Britain's foreign policy was becoming increasingly impotent.

Ramsbottom Rides Again's narrative content greatly informed that of two later British Western parodies, *The Sheriff of Fractured Jaw* (1959)

and *Carry On Cowboy* (1966). In the former a mild-mannered English gunsmith, Johnathan Tibbs (Kenneth More), finds love with Kate (Jayne Mansfield), an assertive and tough but glamorous saloon owner, who assists him when he is duped into becoming a sheriff. Much of the film was shot in Spain, a location that would also be used by the producers of the more serious British Westerns of the 1970s. Kenneth More's lead role as a very proper Englishman, and appearances by Robert Morley and Ronald Squire, make *The Sheriff of Fractured Jaw* an obviously British engagement with the Western genre. In *Carry On Cowboy*, Marshal P. Knutt (Jim Dale) and Annie Oakley (Angela Douglas) come into conflict with the villainous Rumpo Kid (Sid James) and the glamorous-but-tough saloon owner Belle (Joan Sims). Knutt is a mild-mannered English sanitation engineer who has been mistakenly given the sheriff's job and Annie is a tough-but-feminine, sharp-shooting vengeance-seeker. Although *The Sheriff of Fractured Jaw* does feature comedy, and some song and dance routines, its upper class English hero distinguishes it from the other British Western parodies a little. As such, *Carry On Cowboy*'s earthy humour and working class hero served to reassert the British music hall's influence on the British Western parodies.

Curiously, the central narrative hook of all four of the British Western parodies – English characters traversing the world in order to find employment or riches in the Wild West – can be linked to Bloom's observation that the British gothic tradition features plots in which 'material borders or metaphorical frontiers' are routinely crossed (2007: 233–234). Furthermore, all four films feature the kind of 'dastardly villains, [and] ineffectual heroes' that Spooner and McEvoy (2007: 1) observe to be present in British gothic texts. And, most significantly, all four films feature the kind of resourceful and active female characters that Milbank (2007: 155) detects in British gothic literature. In terms of gothic atmosphere, both *The Sheriff of Fractured Jaw* and *Carry On Cowboy* include noticeably large roles for undertakers and their attendant funereal humour and coffin and hearse-based imagery. An element of the uncanny is present in both films too: Tibbs invents a spring-loaded device that propels a hidden Derringer into his hand and grants him an impossibly fast gun draw speed while Knutt effectively becomes an invisible assailant by manically dashing around spooky sewage tunnels in order to shoot at his perturbed

enemies from barely opened sewage grates. Interestingly, the incredibly long shooting range that is a feature of the rifles that are used by Ruger (Gene Hackman) and his friends in the later British Western *The Hunting Party* (Don Medford, 1971) grants the men a similarly uncanny sense of invisibility when they begin picking off members of Calder's (Oliver Reed) outlaw gang from a great distance.

Northern humour out West: *Ramsbottom Rides Again* (1956)

A typical example of a British Western parody, the content of *Ramsbottom Rides Again* offers evidence of the ways in which British filmmakers assimilated the Western genre into wholly British filmmaking traditions. Made in 1956, *Ramsbottom Rides Again* shares common concerns with the British working class comedy genre and the British New Wave. It is significant that both of these distinct schools of filmmaking featured meditations concerning the state of masculinity and gender relations within wider British society. The film opens with a held shot of a painted panorama that consists chiefly of closely packed house rooftops. The picture's dark and foreboding skyline, along with the factory chimneys and gasometers that can be seen in the distance, suggest that the film's diegetic action is set to unfold somewhere in the industrial North of England. A mild sense of the uncanny is evoked when television aerials suddenly start appearing on a number of the rooftops in quick succession but the jaunty nature of composer Billy Ternent's accompanying non-diegetic music serves to diffuse the potentially sinister nature of the sequence. In due course, the camera pans down the picture to reveal that a public house, the Bull & Cow, was the last building in the area to have a television aerial installed. As the camera continues to pan downwards, a transitional edit is employed to inform the viewer that they are now watching events that are unfolding inside the pub.

The downward panning camera comes to rest with a medium establishing shot that focuses upon a number of male customers who are standing with their backs to the viewer. The men are gathered around something (as yet unseen by the viewer) that has captured their collective attention. The pub's landlord, Bill Ramsbottom (Arthur Askey), is positioned in the

foreground of this shot and his state of emasculation is immediately signified on two levels. Firstly, he is physically small in stature, something that director John Baxter exaggerates in later shots by having the camera shoot Askey from above. Secondly, with his view obscured by a dense wall of backs Ramsbottom is unable to look directly upon the still unseen object that is holding the other men's attention. Hence he is denied the ability to assert the power of the gaze, an activity that Mulvey (1986) argues is traditionally a masculine action and privilege within films. A subsequent point of view shot, which is taken from a high angle indicating that it is not Ramsbottom's, reveals that the men are looking at a television set on which a Western serial is being broadcast.

This shot (which effectively displays a screen within a screen) and the sequence that follows it actually serves to date the film. Charles Barr has noted the 'intense TV-consciousness' found in British cinema films between the years 1953 and 1963 (1986: 206). Fully aware that television posed a commercial threat to their livelihoods, British filmmakers of the period frequently employed the image of 'the screen within the screen' in an attempt to stress the inferiority of the new medium when compared to the cinema (Barr, 1986: 206). Ramsbottom's pub is revealed to be situated in Pontefract and, while no actual location footage is presented onscreen, this serves to link the film to the northern working class milieus that are usually encountered in the British New Wave's films. Interestingly, John Hill indicates that in the New Wave's films, television is regarded as a threat to working class culture while watching it is perceived to be a feminine activity that serves to emasculate men (1986: 153–156).

In *Ramsbottom Rides Again*, watching television instead of taking part in traditional pub games or conversation signals television's negative effect on working class culture. And the specific presence of a Western on the television screen can be read as an expression of concern regarding the influence of American popular culture on the British working class. One disgruntled customer requests that Ramsbottom gets the television set 'converted to "commercial"' and this reference to the between show advertisements that were found only on commercial independent television can be read as an expression of concern about the consumer society that such advertisements are a tool of. By indulging in the feminine activity of watching

television, and expressing an interest in consumerism, Ramsbottom's male customers are thus seen to be an emasculated collective.

Antony Easthope observes that drinking alcohol is 'a particularly masculine activity' (1990: 75) and the working class male characters in British New Wave films such as *Saturday Night and Sunday Morning* (Karel Reisz, 1960) and *This Sporting Life* (Lindsay Anderson, 1963) measure their masculinity in terms of how much alcohol they can drink. Ramsbottom's customers' state of emasculation is thus further emphasized when Ramsbottom reveals that watching television has resulted in their alcohol consumption being reduced to just half a pint of beer each a night. Equally emasculated here are Ramsbottom's two male associates. Charlie (Glenn Melvyn) is a stuttering, middle-aged bachelor while Danny (Danny Ross) is a nervous, excitable and infantilized young man who is unsuccessful in his attempts to woo Ramsbottom's daughter Joan (Shani Wallis). When Ramsbottom inherits a saloon and some valuable land near the town of Lonesome in Canada, his family and friends endeavour to travel there with him by boat. The three Englishmen's continued state of emasculation subsequently serves to create a space within the film's Western setting for strong women characters to operate.

Representing the gothic and the uncanny

The boat journey to Canada features a number of typically British working class comedy scenarios but it also draws upon elements of the gothic tradition. Unable to afford tickets for themselves, cash-strapped Ramsbottom and Charlie become stowaways. The pair hide inside clothes trunks that are stored in the ship's dark and spooky hold and parts of this sequence play like a reference to Count Dracula's boat journey to Whitby. With suspenseful and funereal music playing on the soundtrack, director John Baxter creates an eerie atmosphere by having the camera track along a line of shadow-shrouded trunks and cases before coming to a stop at the trunk that Ramsbottom is hiding in. A close-up shot captures Ramsbottom's grasping hand, which is suddenly seen to emerge from a hole in the trunk and clasp at the trunk's lock, evoking the familiar cinematic image of a vampire's hand extending from a partly opened coffin. The camera tracks back and Ramsbottom successfully forces the trunk's

lid open as he springs into a standing position. His body is draped in a motley array of garments from the trunk which, in the half-light, gives him an indistinct and monstrous profile. The suggestion that Ramsbottom has undergone a metamorphosis into something monstrous is perhaps a reference to Robert Louis Stevenson's *Strange Case of Dr. Jekyll and Mr. Hyde* (1886). Having been trapped in a cramped position within the trunk, when Ramsbottom emerges he briefly moves with a stiff-legged lumbering gait, his right arm menacingly outstretched in front of him and his right hand twisted into a claw, bringing to mind Boris Karloff's interpretation of the monster from Mary Shelley's *Frankenstein* (James Whale, 1931).

In the same scene the uncanny is also evoked. Andrew Bennett and Nicholas Royle observe that the uncanny 'has to do with making things *uncertain* [Bennett and Royle's emphasis]: it has to do with the sense that things are not as they have come to appear through habit and familiarity, that they may challenge all rationality and logic' (2004: 35). Bennett and Royle assert that animism is one form that the uncanny can take (2004: 36) and animism is in evidence here. When Ramsbottom and Charlie are heard talking from within their trunks it appears that the trunks themselves are talking. When Charlie's legs protrude through the bottom of his trunk and he starts walking around, it looks as though the trunk itself is alive and walking. Uncanny animism occurs at a later stage of the boat trip when Ramsbottom secretes himself within a deck funnel and subsequently makes the funnel seemingly move of its own accord in order to get closer to his sunbathing wife and daughter.

Bennett and Royle indicate that anthropomorphism is another form that the uncanny may take (2004: 36). As such, a distinct sense of the uncanny arises later in the film when, on two separate occasions, wall-mounted stags' heads seemingly take on human-like qualities. In the first instance, a stag's head performs nodding and shaking motions in order to guide Ramsbottom's card choices during a tense poker game with Black Jake. In the second instance, a stag's head falls from its wall mount and envelops Ramsbottom's own head. As Ramsbottom crouches and scurries about behind the saloon's bar in a frantic effort to escape from Black Jake, it appears as though a sentient stag with distinctly human qualities is moving around behind the bar.

Funny men and strong women

Robert Murphy observes that being 'too old or too ugly or too peculiar' looking meant that most British comedians of the period allowed more suitable co-stars to handle any romantic scenarios demanded by their films' plots (1989: 194). It could be argued that the male characters in all four British Western parodies fit within Murphy's too old/too ugly/too peculiar model to some extent. However, Ramsbottom does have a romantic interest in the form of his wife Florrie (Betty Marsden) even if he does use her to infantilize himself when he calls her 'Mother'. And, by the end of the film, the interventions of two strong women result in both Charlie and Danny becoming involved in romantic relationships too. Similarly, the lead protagonists in both *The Sheriff of Fractured Jaw* and *Carry On Cowboy* also find romance against the odds. Again, these relationships do not come about by dint of strong ideal men exerting patriarchal power over powerless females, as seen in the classical Hollywood films examined by Mulvey (1986). These relationships are all initiated by assertive women who are able to openly express desire without suffering narrative punishment and it remains clear that these women will be the partners who exercise power within the relationships.

When Ramsbottom's party arrives at Lonesome they find that very little has changed since the days of the Wild West. The first strong woman that Ramsbottom meets is Susie McTavish (Anthea Askey), the great granddaughter of the town's legal representative. She has short hair, dresses in masculine clothing (a cowboy-styled hat, tight-fitting dungarees, shirt and boots), chews gum and wears a gun. She looks a little like Kit Dodge Junior from *A Ticket to Tomahawk* and Vienna from *Johnny Guitar* but she is a more playful tomboy-type, projecting a still recognizably feminine figure that is similar to Doris Day's interpretation of Calamity Jane. Mulvey has indicated that, in classical Hollywood films, it is the active male character who is seen as a mobile 'figure in a landscape' (1986: 204). However, Susie is associated with activity and mobility throughout the film. She is twice seen in expansive long shots that show her riding into town on horseback and, when Ramsbottom's party arrives in the locality, it is Susie who collects them and transports them to town on her horse-drawn wagon. As the wagon's driver, Susie occupies the centre of the frame in the group medium

shots that detail the journey. When Ramsbottom and Charlie go prospecting for uranium it is Susie who transports the pair and their equipment on her wagon.

When Susie sees that Danny's love for Joan is unrequited, she asserts that 'there's plenty of other girls in the world ... I wouldn't let nobody make a doormat out of me' and she is appalled and angry when the submissive Danny replies that Joan could walk all over him if she wanted to. Whenever Susie fires her gun, Danny collapses to the floor in a nervous heap. Danny's behaviour can thus be linked to Spooner and McEvoy's observation that, in some gothic tales, the imperilled heroine figure is replaced by 'a male hysteric' (2007: 1). Indeed Danny, Ramsbottom and Charlie could all be described as male hysterics. However, Danny and Susie do enter into a romantic relationship and this development runs counter to Loy's observation that tomboys in American Westerns were regarded as big sister figures, the 'one to whom males turned for advice and solace but not companionship' (2001: 258).

Tuska suggests that Western heroines who wear masculine clothing are quickly seen to change into feminine dresses when they want to embark on a romantic relationship (1985: 228) and this kind of transformation can be observed in Samuel Fuller's American Western *Forty Guns* (1957) when tough-talking and masculine costume-wearing Jessica Drummond (Barbara Stanwyck) begins dressing more femininely in order to cement her budding relationship with an itinerant lawman (Barry Sullivan). But while Susie does wear slightly more feminine tops in the two scenes where her relationship with Danny develops (it should be noted that the first occasion is a public dance where she would be expected to be dressed more femininely and the second occasion finds her still driving her wagon and wearing a gun), she does not switch between masculine and feminine clothing or undergo the accompanying changes in personality and vulnerability to the same extreme degrees as Jessica in *Forty Guns*.

Bell-Metereau suggests that tomboys must 'hide their [masculine] abilities' and 'put on a dress and act helpless to have any sex appeal' (1993: 89) but Susie successfully attracts Danny without adopting any of these compromises. Clearly Susie defies or sidesteps a number of gender-based generic rules, none more so than Pam Cook's suggestion that if the tomboy Western character 'has not abandoned her transvestite

garb for the arms of the hero by the end of the movie, then she comes to a sticky end' (2005: 45). In the film's climactic scene, which sees Black Jake's men launching an attack on Ramsbottom's saloon, Susie is in her regular masculine outfit and she plays the heroic role, battling her way through the violent melee gun in hand and subverting genre expectations by rescuing the petrified Danny before telephoning the Mounties and requesting assistance. Furthermore, while characters like Jessica in *Forty Guns* essentially lose status, wealth, strength and power at the end of their films, Susie does not.

Ramsbottom Rides Again's second strong woman is Bella who works at the saloon that Ramsbottom inherits. Bella wears feminine if utilitarian clothing (a plain long skirt, a short sleeved shirt and shoes) that is similar to that worn by Jill in *The Frozen Limits*. Bella possesses a number of character traits that can be likened to those associated with Mae West's film characters and it would be illuminating to briefly discuss West's engagement with the Western genre. West's forays into Westerns provided two of the strongest and most remarkable female characters ever to appear in American Westerns but her distinctive approach to sexual equality and feminine assertiveness was little copied in Hollywood. Her characters are consistently active in their own causes and Jacqueline Levitin goes as far as to assert that West's *Klondike Annie* (Raoul Walsh, 1936) and *My Little Chickadee* (Edward F. Cline, 1940) are the only two Westerns (to her knowledge) that truly 'bear the stamp of a woman's point of view, and the only ones that deal with the West from the perspective of women's power' (1982: 104).

In *Klondike Annie*, the Frisco Doll (West) kills her abusive, jealous and over-possessive partner before striking out for a new life in the remote Klondike region. As such, Jill Watts asserts that *Klondike Annie* complies with the 'typical structure' of a Western whilst substituting 'a woman in place of a man' (1999: 60). The focus of an intense manhunt, the incognito Frisco Doll brazenly lies and bluffs her way through a succession of interrogations by male characters and, as Levitin observes, she 'accepts or refuses the advances of men as she chooses. She's always in control' (1982: 104). In the comedy Western that she made with W. C. Fields, *My Little Chickadee*, West's Flower Belle Lee is a glamorously dressed and sexually aggressive confidence trickster who is also well versed in gunplay. In one impressive

scene set on a train, Flower coolly and convincingly uses her shooting skills to successfully thwart an Indian attack while the train's male passengers simply cower on the floor in fear.

Although Kaplan has observed that female characters in Hollywood films who indulge in casual sex rather than seeking normative marital relationships tend to be punished at a narrative level (1991: 82), Flower refuses to be tied to just one lover in a normative relationship and, at the film's denouement, she elects to keep her options and her desire open and active without suffering narrative punishment of any kind. While West's Westerns exercised no discernable influence over subsequent American Westerns and rarely get more than a cursory mention in serious studies of the genre, they may have had an influence on the British Western parodies. *Klondike Annie* is set in the same Gold Rush territory as *The Frozen Limits* and its director, Raoul Walsh, would later be commissioned to direct *The Sheriff of Fractured Jaw*. And in *My Little Chickadee*, W. C. Fields plays an incompetent stand-in sheriff, a character type that would resurface in three of the British Western parodies. West and Fields were both veterans of the vaudeville tradition, an entertainment form that had much in common with the British music hall tradition, so it is perhaps unsurprising that the British Western parodies and West's Westerns share some similarities.

Although Bella is not as glamorous as a typical Mae West character, she is just as sexually assertive, demanding and plain talking as West's characters when it comes to her interactions with men. Richard Dyer refers to 'the convention of looks and glances' that are exchanged during the early stages of heterosexual attraction wherein 'men stare at women, [while] women submit to being looked at, or at most steal a glance [back]' (2002: 97), but a typical Mae West character will flout these rules by staring directly at the man she wants and candidly voicing her desires via the employment of clever sexual innuendo. Mary Ann Doane observes that women communicate 'sexual purity' by averting their gaze (1984: 83). The way that West's characters cast powerful and unwavering looks towards men serves to telegraph their confidence and pride in their overtly sexual identities.

Bella behaves in much the same way and she talks with a voice that is similar to West's. She effortlessly emasculates Ramsbottom with quips about his glasses and his height when she first meets him but as soon as she sees Charlie her desire is communicated in a direct manner. Hand

199

provocatively on hip, she looks straight at Charlie while asserting that she 'does the cooking and the cleaning and *whatever else happens to come along*'. When Bella is formally introduced to Charlie, a close-up shows the desire in her eyes and she is seen to suggestively wink at him before forcibly grabbing him by the arm and dragging him to one side for a more personal, sexual innuendo-laden chat that culminates in her aggressively kissing him. John Ellis indicates that aggressive and openly expressed heterosexual desire is normally a masculine trait (1992: 48) but Bella confidently indulges in such activity.

Just like Jill in *The Frozen Limits*, Bella wears a gun over her skirt. Both women never actually use their guns but both are seen to instinctively draw them when danger is perceived to be close by. Bella is also seen cleaning and loading pistols prior to Black Jake's assault on the saloon. Bella is physically strong too and she is capable of using her strength to best and humiliate men: in one scene she pushes over a man who insults her and in another she effortlessly lifts and moves a box that Charlie was struggling to budge. At one point she physically manhandles Charlie as she warns him off looking at other women and she subsequently twists his words into a marriage proposal. In some ways, Bella resembles the lovelorn and overly amorous harridans that the male characters in the *Carry On* films are generally seen trying to escape from: Miss Haggard's (Hattie Jacques) dogged pursuit of Kenneth Soaper (Kenneth Williams) and his subsequent attempts to escape from her in *Carry On Camping* (Gerald Thomas, 1969) is a prime example of this.

However, the significant difference here is Charlie's attitude to Bella. He is not unhappy with her advances and he is not seeking to escape from her. Bella is not a conventional beauty in the same way that Charlie is not the ideal masculine type associated with Mulvey's (1986) work. However, their love and their relationship is real and there is something progressive and refreshing in non-ideal types finding a happiness together that seemingly transcends the romantic rules of classical Hollywood cinema observed by Mulvey (1986) and the romantic rules of contemporary British comedy observed by Murphy (1989). Kaplan argues that scenarios involving strong women interacting with weak men generally do nothing for either sex 'since nothing has essentially changed: the roles remain locked in their static boundaries' (1983: 331). While it is perhaps true that some of the

binary oppositions associated with sexual difference are still present (albeit reversed) in the British Western parodies, there is no denying that their female characters are empowered women whose bold actions and outlook contravene many of the Western genre's gender-related rules in a refreshing and pleasing way.

The final battle in *Ramsbottom Rides Again* involves the whole community of Lonesome taking a stand against Black Jake and his men after Ramsbottom reasons 'we stand a better chance if we're all together'. Significantly, it is Bella who vanquishes Black Jake, aggressively smashing three bottles over his head before delivering a knockout punch. Lost in the heat of battle, Bella immediately chases after another bad guy, inadvertently leaving Ramsbottom and Charlie to take the credit for the villain's defeat. Pam Cook observes that if a Western heroine 'is allowed to be active, it is in the hero's cause rather than her own' (2005: 44) but this is not the case with Bella, who is essentially acting in the whole community's cause. In terms of the Western genre, Bella and Susie are quite remarkable representations of women but subsequent British Western parodies would bring further advancements in the ongoing development of strong female characters in British Westerns.

Ongoing developments: *The Sheriff of Fractured Jaw* (1958) and *Carry On Cowboy* (1966)

Just like Susie and Bella in *Ramsbottom Rides Again*, the lead female characters in *The Sheriff of Fractured Jaw* (Kate) and *Carry On Cowboy* (Belle and Annie Oakley) all manage to upset and contravene the gender-related rules typically associated with Hollywood Westerns. Kate and Belle both represent a fusion of glamour and hardness that appears to relate back to Mae West in *My Little Chickadee* and Marlene Dietrich in *Destry Rides Again*. Both wear feminine saloon girl dresses that are tailored to show off their curvaceous, womanly figures and both women are sexually attractive. Equally, Kate and Belle both talk in a sexually direct manner while being assertive and physically aggressive: each character is seen throwing troublemakers out of their saloons by themselves and Belle even roughs up her lover, the villainous Rumpo Kid. And both characters are seen to be experts

in gunplay. Furthermore, Kate and Belle both possess the phallic power that Jennifer Peterson attributes to *Johnny Guitar*'s Vienna (1996: 11): each character is financially independent, governing male employees while running their own saloons, and each character controls their own sexual relations, choosing which men they ultimately want to be with. Significantly, Peterson observes that Vienna is 'most helpless when in a dress ... and ... most powerful when in pants' (1996: 12). Kate and Belle remain powerful women despite only ever being seen in dresses.

Citing Frenchy from *Destry Rides Again* as a prime example, Cheryl J. Foote asserts that 'charming and vivacious' dancehall girls are representatives of 'vice and decadence' and, as such, they are not suitable matches for 'the upstanding hero' (1983: 66). Kate in *The Sheriff of Fractured Jaw* defies this generic rule when she marries the upstanding Englishman Tibbs. Interestingly, Calder observes that the colourful dancehall girls found in Hollywood Westerns traditionally operate as 'a necessary foil to the young innocent [female] whom the hero may win' (1974: 165). Alas, no young innocent females as such appear in either *The Sheriff of Fractured Jaw* or *Carry On Cowboy* and the colourful dancehall girls, Kate and Belle, are free to get the men of their choice unhindered. And despite Tuska's assertion that female characters who consort with villains must die at their film's denouement (1985: 226), Belle in *Carry On Cowboy* manages to defy this generic rule and escapes alive.

Carry On Cowboy's Annie Oakley is a sharp-shooting weapons specialist who is out for revenge. And though French suggests that female revenge-seekers in Westerns are likely to be punished by death (2005: 42), Annie survives the film unscathed. Like Mae West's Flower Belle Lee, Annie is seen using her cool head and shooting skills to fend off an Indian attack in one action-packed scene. Unlike Kate and Belle, Annie does change into masculine cowboy clothing on two occasions. However, on the first occasion at least, the costume change is effected to protect her identity rather than being something that she has to do in order to carry out masculine activities. Indeed, later in the film Annie shoots a man dead while dressed in her feminine clothing. Somewhat reminiscent of Kate from *The Sheriff of Fractured Jaw*, Annie confirms her beauty and femininity by wearing a scanty showgirl outfit and performing a song and dance routine in the saloon at one point. Similarly, both Kate and Annie are shown attempting

to teach their hapless men how to shoot before they depart for their final confrontations with their villainous enemies. Just like Susie in *Ramsbottom Rides Again*, Kate, Belle and Annie are all associated with mobility and activity. Indeed, all three are seen galloping on horseback and all three protect and initiate rescues of their male love interests. These scenarios all work to upset Tuska's suggestion that female characters in Westerns are introduced in order to give the male hero somebody to rescue or protect (1985: 224).

Many of the local themes found in the four British Western parodies can also be detected in Richard Quine's surreal British Western *A Talent for Loving* (1969). Originally conceived as a vehicle for The Beatles, this shot-in-Spain oddity serves as a handy transitional film that directly links the British Western parodies to the more serious British Westerns of the 1970s. In Quine's film a supernatural curse results in Evalina (Caroline Munro), a Mexican girl who lives in an incongruous looking gothic castle, becoming a sexually aggressive nymphomaniac. Evalina duly acts upon an impoverished English salesman who is travelling the West (Derek Nimmo). Elsewhere in the film the soul of Evalina's deceased grandfather (Cesar Romero) is seen ascending to the heavens while uncanny animism brings the four Queens held in a hand of cards to life and uncanny anthropomorphism results in a stuffed stag's head being granted disturbingly human qualities. While the British Westerns of the 1970s feature slightly less in the way of eccentric humour when compared to *A Talent for Loving*, these later films do foreground obviously gothic elements and noticeably strong and active females.

10

The Representation of Women in British Westerns Produced During the Early 1970s

Park notes that the major American film studios began investing heavily in film production in Britain during the early 1960s (1990: 121). However, as the decade wore on hit movies could no longer be guaranteed and a number of costly flops resulted in the major American studios shutting down their production offices in the UK (Park, 1990: 126). After 1970, the void they left was filled by smaller business concerns, chiefly independent film financiers who were interested in establishing international co-production deals and producing relatively small scale, popular cinema films. One such company was Benmar, a London-based outfit that produced four British Westerns during the early 1970s. In the years between the end of the cycle of British Western parodies (1966) and the year that a new form of more serious British Western began to be made in noticeable numbers (1971), the Italian Western had proved to be popular at box offices the world over. In the July 1971 edition of *Films and Filming*, David Austen reports that several major European Westerns had been in production during the past year and he concludes that, despite divided opinions about their cinematic worth, 'the Continental Westerns definitely look as though they're here to stay' (1971: 36). Austen observes that:

> Most of these films are international co-productions bringing together stars, directors, and technicians from many different countries to film Western stories on location and in studios all over the continent ... nearly all of the films will receive a wide showing throughout the English-speaking market, and the chances are that most of them will be commercially successful.
>
> (1971: 36)

Austen goes on to offer a brief overview of eight recent European Westerns and two of them are British productions, *The Hunting Party* (1971) and Robert Parrish's *A Town Called Bastard* (1971). Confirming Austen's observation that European Westerns were still regarded as profitable ventures and providing a context for the rebirth of the British Western, Thomas Weisser notes that, 'in a desperate attempt to compete with the influx of Spaghetti Westerns various British film investors financed some Italian-Spanish [co]-productions, in the old "if you can't beat 'em join 'em" show biz tradition' (1992: 326).

McKernan asserts that in most of the 1970s Westerns that British production companies made in conjunction with foreign co-producers 'the Britishness is hard to define at all' (1999: 13) and he suggests that the blurred cultural boundaries prompted by international co-production deals resulted in titles like *A Town Called Bastard* being classifiable as British films on paper only (1999: 15). Indeed, McKernan asserts that British Westerns like *A Town Called Bastard* are indistinguishable from the 'conventional violent spaghetti Westerns of the period' (1999: 15). In actuality, this is not the case. They may share the same locations and supporting casts but the aesthetic look of these British productions and the kinds of story that they tell do set them apart from Italian Westerns. Indeed, although most of the British Westerns produced during the early 1970s were born out of transnational production processes, they continued to give voice to the same cultural and thematic concerns that were found in the earlier British Western parodies. The strong female characters found in these films are even more assertive and active, consistently striking against patriarchal order without fear of punishment. And while the influence of the British music hall is perhaps less pronounced in these British Westerns, the influence of the British gothic tradition and Britain's Hammer films is more obviously apparent.

205

Benmar's British Westerns: an overview

Personnel connected to the British film company Benmar were responsible for four Westerns that were produced between 1971 and 1972: *A Town Called Bastard, Captain Apache, Bad Man's River* and *Pancho Villa*. Although these four Westerns are regarded as British films (Gordon, 1999: 257), they are precisely the kind of transnational co-productions that Austen (1971: 36) has described. Even so, all four films continue to support the argument that British Westerns consistently featured strong female characters who refused to conform to the constricting gender-related rules that governed the behaviour of female characters found in contemporary Hollywood Westerns. Furthermore, other British Westerns from this period – see *Hannie Caulder, The Hunting Party*, Sam Wanamaker's *Catlow* (1971) and Peter Collinson's *The Man Called Noon* (1973) – feature untypically strong female characters too.

The American scriptwriter Bernard Gordon recalls that a former associate, the American script-writer-cum-producer Philip Yordan, invited him to Europe to work for Benmar in 1970 (1999: 235). Interestingly, years earlier Yordan had worked on the screenplay for *Johnny Guitar*, an American Western that had attempted to offer interesting representations of women out West. Gordon indicates that after a spell working in Spain, Yordan had been searching for film financing in England and had teamed up with two new associates, Ben Fisz and Bobby Marmor (1999: 235). Marmor had amassed a personal fortune through London property deals and had 'excellent financial connections with the London Merchant banks' (Gordon, 1999: 235). As such, Yordan was able to offer the duo 'Hollywood contacts and expertise plus invaluable Madrid contacts and know-how' (Gordon, 1999: 235). And so the use of Marmor and Yordan's finances and Yordan's local contacts resulted in the company building a bizarrely gothic-looking Western town set and film studio just outside Madrid (Gordon, 1999: 235). The incongruous look of this set would bring a wholly gothic ambience to the majority of the company's Westerns.

The first Benmar Western, *A Town Called Bastard*, tells the story of a widow, Alvira (Stella Stevens), who arrives in a strangely gothic-looking Mexican town in order to exact revenge on her husband's killer. A close

reading of this film will be undertaken later in this chapter in order to show how British Westerns from this period foregrounded gothic influences as well as strong female characters. This film was followed by *Captain Apache*, in which an Indian army Captain (Lee Van Cleef) attempts to discover who murdered a local Indian commissioner. He discovers a conspiracy to assassinate the president and encounters a mysterious woman, Maude (Carroll Baker), who appears to know more than she lets on. It is never revealed whether she is a government agent or a mercenary but Maude is both active and ruthless. She uses a gun, provokes the deaths of a number of people and oversees the brutal interrogation of one man while resisting the Captain when he interrogates her. She has a visible and active sexuality, seducing and sleeping with men who might be able to assist her, including the Captain himself. John Lenihan observes that 'women in Westerns have generally not enjoyed a happy relationship with the Indian' (1985: 74) but Maude defies the Western genre's rules regarding both miscegenation and promiscuous women. At the film's denouement, the emasculated and exasperated Captain acknowledges that her wily methods are superior to his own and begs to become her pupil with the words 'teach me the ways of the white man'.

Captain Apache features much in the way of gothic influences. At one point a witch uses a potion on the Captain that grants him a nightmarish vision of a Hell-like world and seemingly enables him to communicate with the dead. And paying a crooked priest a visit results in the Captain apparently being buried alive during an unorthodox funeral service. A frighteningly puritanical Indian hunter called J. P. Soames is introduced at one point and two strange villains who are lookalike albino brothers provide a bizarre doppelganger effect. Following *Captain Apache*, Gordon recalls that he readied a Western script called *They All Came to Kill* which told the story of 'a beautiful Indian girl who, having been raped by a gang of scruffy outlaws, for revenge sets out to kill them all. *By herself*' (1999: 237, Gordon's emphasis). The emphasis employed indicates how groundbreaking this plot twist was and the fact that Tigon Films independently developed the similarly themed *Hannie Caulder* in the same year surely confirms that the Westerns being produced in Britain during this period shared a particular attitude in their approach to representing strong women. A close reading of *Hannie Caulder* will thus be provided later in this chapter. *They All Came*

to Kill was never filmed but Benmar's personnel did start work on another Western, *Bad Man's River*.

Although the film was set up, financed and cast by the usual Benmar executives operating out of offices in London (Gordon, 1999: 252), the company's Spanish lawyer, Paco Lizarza, 'managed to torture the rules of Spanish nationality' in order to make the best use of tax breaks and import quota rules: *Bad Man's River* was subsequently classified as a 'Spanish' film for tax purposes (Gordon, 1999: 248) and a Spanish director who had worked in England, Eugenio Martin, was recruited for the project. Here a clever femme fatale, Alicia (Gina Lollobrigida), bigamously marries an outlaw, King (Lee Van Cleef), in order to steal the money he robbed from a bank. Some time later she convinces King to help her steal a bank draft for $1,000,000 that her other husband, Montero (James Mason), has diverted from the Mexican authorities. Parallels can be drawn between *Bad Man's River* and Burt Kennedy's later American Western *The Train Robbers*. Just like Mrs Lowe in *The Train Robbers*, Alicia manages to dupe her male partners and she successfully absconds with the stolen money at the film's end. Alicia's open expressions of sexuality and desire, her scheming and bigamous ways and her theft of male property all goes unpunished here. Gina Lollobrigida clearly caught the significance of Alicia's actions when she observed that 'usually the Western is just for men. But in this one the man is the weaker one. The woman is more important [here]' (quoted in Canales, 1990: 187).

Bad Man's River has less gothic content than Benmar's previous two Westerns but Alicia herself, a fraudster and bigamist who plays the part of a mourning widow in order to attract new victims, is a character straight out of British gothic fiction. And she has King committed to an asylum, a popular location in the gothic imagination, even though he is not mentally ill. Later in the film the protagonists are forced to negotiate a fortress' catacombs and a spooky, cobweb strewn secret tunnel in their efforts to escape from their enemies. Benmar's fourth and final Western, *Pancho Villa*, is a retelling of the Mexican revolutionary's (Telly Savalas) fleeting invasion of the USA. Here, the lead female character Flo (Ann Francis) is a relatively minor character but her actions are significant. Flo is separated from but still married to Villa's American friend, Scotty (Clint Walker). When the pair's paths cross, she makes it plain that he has no claim on her and

she flatly denies him his conjugal rights. She then adds insult to injury by openly exhibiting desire and romancing a new boyfriend in front of her estranged husband. However, Flo's open defiance of patriarchal order goes unpunished.

In terms of the gothic, *Pancho Villa* features some interesting elements. A dead man's body is surreptitiously manhandled so that it appears to be looking through a door window before seemingly walking through the door in a zombie-like manner. At one point Villa is mistakenly pronounced dead and he subsequently terrifies the assassins who enter his room to examine his cadaver. At the film's finale Villa's American enemy, Colonel Wilcox (Chuck Connors), is so badly injured that he has to be plastered and bandaged from head to toe like an Egyptian Mummy, and Villa finds General Goya laid out in an open coffin. After *Pancho Villa*, Benmar stopped producing Westerns and instead made a genuine gothic horror film, *Horror Express* (Eugenio Martin, 1972), which starred Hammer's leading horror icons Peter Cushing and Christopher Lee.

A British gothic Western: *A Town Called Bastard* (1971)

Bernard Gordon remembers that *A Town Called Bastard*'s original script was bloody and violent (1999: 235) and this is reflected in the finished film. In this respect, the film appears to be attempting to emulate and surpass the much-criticized levels of violence found in Italian Westerns. Set in 1905, the film tells the story of an American woman, Alvira, who travels to the Mexican town of Bastard accompanied by a hired gun, Spectre (Dudley Sutton). She is seeking to avenge her husband's death and she offers a reward of $20,000 to the person who can name the guilty party. The reward will be paid when Alvira and the body of her husband's killer reach El Paso. Violence and mayhem subsequently ensue as the town's nefarious inhabitants attempt to falsely claim the reward money. Key characters include the Priest (Robert Shaw), the town's bandit mayor Don Carlos (Telly Savalas), his villainous right hand man La Bomba (Al Lettieri) and a cruel Federale Colonel (Martin Landau) who affects aristocratic pretensions. The presence of these characters ties in with Botting's assertion that

gothic landscapes are populated by 'evil aristocrats, monks and … bandits' (1996: 1). Interestingly, Botting notes that the gothic is often concerned with 'the barbarity and tyranny of feudal power' (1996: 93) and such a focus can be found in *A Town Called Bastard* when both Don Carlos and the Colonel use the power afforded by their official positions to abuse Bastard's cowed citizens.

The lingering influence of the British music hall

Although the influence of the British music hall tradition is less pronounced here, Parrish's film does feature a number of elements that appear to refer back to the content of the British Western parodies. The town's cantina is run by a couple who provide a small element of comic relief. Part of their comedic aspect lies in the fact that the husband is a submissive and diminutive fellow while his wife, who is nearly twice his size, is dominant and assertive. The wife is seen dragging her husband around by the scruff of his neck on a couple of occasions, bringing to mind Bella's domination of Charlie in *Ramsbottom Rides Again*. Interestingly, when Bomba assassinates Don Carlos, the wife nonchalantly continues cooking while the husband drops to the floor for cover as soon as he hears gunfire. His instinctive but over-the-top reaction to the sound of gunfire is very similar to Danny's in *Ramsbottom Rides Again*. In a flashback where the Priest finds Paco (Michael Craig) spending the Revolution's funds in an El Paso saloon, a three minute long musical sequence plays like a bizarre variety routine. The song 'The Battle of New Orleans' is heard on the soundtrack while Paco and a host of extras dance around the saloon in a very staged and stylized manner. The scene recalls Sutton's observation that the music hall's influence in Britain resulted in 'a kind of cinema marked by interruption, variety and disparate attractions' (2000: 60–61) and its content can be likened to the similarly incongruous-seeming musical interludes found in the earlier British Western parodies. When the Priest subsequently attacks Paco and gives him a severe beating, the local sheriff observes what is happening but does not act, recalling the attitudes of the reluctant sheriffs found in the British Western parodies.

Gothic imagery and the supernatural

A brief prologue set in 1895 introduces *A Town Called Bastard*'s obviously religious and spiritual subtexts. Bastard's then priest is shown burying dead revolutionaries in unconsecrated ground with the words 'For them there is no salvation, no hope. Let them burn in hell.' Here it is revealed that the characters that viewers will come to know as the Priest and the Colonel were once revolutionary brothers in arms and they attack Bastard and instigate a massacre inside its church. At the climax of the attack, the Priest kills his namesake, denying him sanctuary and damaging a symbolic ornamental cherub in the process. As the front titles roll, the film's time frame jumps to 1905 and its engagement with the gothic is immediately foregrounded. A medium long shot that frames the legs of two horses and the spinning wheels of the vehicle that they are pulling works to suggest that a Western stagecoach is approaching the camera. However, as the camera pans from right to left in order to keep the legs and wheels in frame, it simultaneously tilts upwards and zooms out to reveal that the vehicle is a hearse. When the hearse stops, its sallow looking and black clad driver, Spectre, dismounts and draws back the curtains that hide the hearse's contents. The body of an apparently dead woman, Alvira, is laid out in an open coffin but when Spectre assertively commands 'wake up, we're almost there' Alvira's eyes flicker open and she smiles at him rapturously. When he commands 'whatever happens, you do what I tell you' she nods in subservient affirmation before closing her eyes again. With Spectre shot in a commanding close-up from below and Alvira shot in a position of submission from above, the sequence brings to mind those scenes in Hammer's *Dracula* films where subservient vampire brides are held in thrall of their dominant master.

Medium close-ups of Alvira as she lies in the coffin, which is positioned so that it diagonally cuts across the frame, are also reminiscent of similar shots found in Hammer's numerous vampire films. When the duo's journey is resumed another iconic micro-narrative from Hammer's horror films is evoked. Up to this point, the sequence's non-diegetic music features a simple and repetitive electric guitar refrain and generically atypical choral voices in the style of Gregorian chants. As the hearse moves away from the camera the music changes key, dramatic and foreboding horns come into play and the camera tilts upwards to reveal Bastard's malevolent

211

silhouette atop a distant hill. Similar narrative patterns, wherein a horse drawn carriage is seen journeying to a foreboding gothic castle on a hill, regularly play out in Hammer films such as *Dracula: Prince of Darkness* (Terence Fisher, 1966).

When Alvira meets the Priest, he reveals that he has been having nightmares that she appears in: 'You have a knife. You come into my room. Put the knife in my back.' The Priest's nightmare is subsequently represented onscreen when a supernatural variant of Alvira is seen slowly and menacingly advancing toward the camera. Dressed in a black nightgown that billows in the wind, she sports a cadaverous skin tone and wild and unkempt hair. Effectively a vengeance-seeking spirit or zombie, the supernatural Alvira holds a ceremonial dagger that she eventually raises above her head in a ritualistic pose before effecting a downward stabbing motion. On the soundtrack spooky music that incorporates the use of a Theremin for added supernatural effect is heard. As well as again suggesting the influence of Hammer's films, this sequence also adds a supernatural slant to the proceedings. In the first instance, it suggests that the Priest is blessed with the power of premonition. It also invites an abstract reading of the film: the cadaverous Spectre (whose name alone is loaded with supernatural connotations) could well be the angel of death incarnate who has chosen to resurrect Alvira in order to grant her vengeance from beyond the grave.

Italian Westerns had attempted to present a sense of realism via the employment of costumes that appeared to be well worn and soiled and the foregrounding of poverty-stricken and grime-laden *mises-en-scène*. Parrish's film adopts the same approach but takes it to new levels of excess. Punter and Byron note that 'in the eighteenth century "Gothic" meant to do with what was perceived as barbaric and to do with the medieval world' (2004: 7). The microcosmic society found within Bastard's imposing walls is distinctly medieval and barbaric. Squalor, deprivation and acts of extreme cruelty and brutality are commonplace and rotten teeth, unkempt hair and filthy hands and faces abound. A sequence where a brother and sister are falsely accused of a crime they did not commit before being tortured and hanged brings to mind events played out in Michael Reeves' British gothic shocker *Witchfinder General* (1968).

Liminal spaces and gothic locations

Rachel Hutchinson observes that the border towns that appear in Italian Westerns such as *A Fistful of Dollars* are essentially liminal spaces and she goes on to suggest that by being 'beyond definition, the liminal space is open to any possibilities we can project upon it' (2007: 183). The town of Bastard is such a liminal space. Situated in a barren region close to the US–Mexico border, the town projects a strangely timeless and limbo-like aura. Two Americans who are taken to the town as prisoners at the start of the film say that they are in the locality because they are 'lost'. When Alvira asks Don Carlos how her husband died, he answers 'I don't remember, senora. I don't even remember him'. Alvira is perplexed by his response and asserts that 'it was not so long ago'. The use of gothic and supernatural imagery throughout the film suggests that on one level Bastard might actually be interpreted as being a place of purgatory. Carol Zaleski (2008) defines purgatory as:

> the condition, process, or place of purification or temporary punishment in which, according to medieval Christian and Roman Catholic belief, the souls of those who die in a state of grace are made ready for heaven.

The Priest has spent his recent years atoning for his sins by repairing the damage done to the church during the insurgent raid that he led ten years earlier and offering religious counsel to the town's wayward inhabitants. It is also revealed via an unannounced flashback that the Priest remains troubled by a specific memory from his days as a revolutionary: his decision to let the untrustworthy foot soldier Paco live resulted in a betrayal that led to the deaths of the revolutionary leader 'Aguila' and most of his men. However, the near-completed restoration of the church and the re-hanging of the ornamental cherub seemingly symbolize that the Priest's period of atonement is nearing its end. Zaleski (2008) indicates that during time spent in purgatory an individual 'may undergo correction, balance [their] life's accounts, satisfy old debts, cleanse accumulated defilements, and heal troubled memories' and the Priest certainly appears to be working through such a process.

Curiously, the Priest confirms that time spent in the town inevitably results in a journey to the next plane of existence when he observes that 'every other stranger who's come to this town's ended up in the cemetery'. The two Americans, the Priest, Don Carlos, Bomba, the Colonel and countless others have all been drawn to the town in some way and by the film's end they are all dead. These deaths also mirror 'the wider rejection and casting out' of male authority figures that Hutchings detects in Hammer's early 1970s films (1993: 159). Punter and Byron observe that 'the male gothic generally has a tragic plot, with the protagonist punished for his breaking of … taboos' (2004: 278–279). Here the Priest is punished primarily for the taboo murder of a priest ten years earlier and the other major characters that meet untimely deaths here can be thought of as receiving just retribution too. It is perhaps appropriate that the film was re-titled *A Town Called Hell* for its American release.

Botting has noted that 'Gothic atmospheres – gloomy and mysterious – have repeatedly signalled the disturbing return of pasts upon presents' (1996: 1) and here in the mysterious town of Bastard the Priest's past has certainly returned to haunt and disturb him with a vengeance. Punter and Byron note that the gothic 'has always been concerned' with 'issues of secrecy' (2004: 70) and this notion is played out in the search for Alvira's husband's killer. It is clear from the outset that the Priest is being secretive and is withholding information concerning the death of Alvira's husband. The whole mystery revolves around the secret identity of the revolutionary known only as 'Aguila' and Alvira's determination and assertiveness eventually result in her forcing a confession out of the Priest. He explains that, upon being wounded, her husband asked him to kill him as an act of mercy that would also perpetuate the spirit of their revolution. His confession simultaneously brings closure to Alvira's suffering and signals his own imminent departure for the next plane of existence via a bullet from her hired killer, Spectre.

Stevens notes that in gothic tales, 'in some instances, the setting itself appears to be the main character and gives the novel a title: *Wuthering Heights*, for example, in which characters and setting seem fused together' (2000: 55). This is very much the case with *A Town Called Bastard*, where the town pays host to a disparate community that has seemingly been brought together and subsequently trapped by fate. Bastard's crumbling

and dilapidated walls and buildings, and its prominently featured church and graveyard, all relate directly to Botting's observation that 'medieval edifices – abbeys, churches and graveyards –' presented in 'generally ruinous states' are key gothic locations (1996: 2). Referring to Horace Walpole's *The Castle of Otranto* (1764), Punter and Byron suggest that 'it is possible to see how architecture, the labyrinthine and claustrophobic spaces of castles, monasteries, ruins and prisons, will come to serve an important function in suggesting such emotions as fear and helplessness' (2004: 179). Numerous flights of steps that lead nowhere seem to symbolize that escape from Bastard is impossible and the two American prisoners certainly find this to be true. Indeed, Bloom indicates that much of the gothic 'can be boiled down to relentless persecutions and agonizing efforts to escape' (2007: 234) and this is reflected in countless scenarios found in Parrish's film. With the balance of power within Bastard continually shifting, all of the film's major characters find themselves the victims of vicious persecutions that, despite their best efforts, they are unable to escape.

The crossing of thresholds

Bloom asserts that:

> the crossing of thresholds constitutes a recurrent motif in [gothic fiction] ... [Indeed the] gothic tends to display the threshold motif not only in symbols but as an integral part of its plots; characters are regularly seen advancing through doors, crossing either physical or figurative thin red lines, violating material borders or metaphorical frontiers.
>
> (2007: 233–234)

There are an inordinate number of such threshold crossings present in *A Town Called Bastard* and it is possible to group a number of them into symbolic clusters. Punter and Byron observe that in Margaret Oliphant's gothic works 'images of gates, windows and doors' embody 'the barriers between life and death' (2004: 153). Similarly, more often than not death follows or precedes a threshold crossing in Parrish's film. In the prologue, the Priest, the Colonel and their revolutionary forces are seen passing through the town's gateway and crossing the threshold of the church before carrying

215

out their bloody massacre. The two American prisoners are dragged into town through the same gateway and, in their attempts to escape, are seen emerging from a doorway and a window before being shot dead. After stealing coins and buying wine, Jose (Cass Martin) emerges from the cantina's doorway and then retreats through its window when he sees Don Carlos approaching. At Don Carlos' request, Jose then re-emerges via the cantina's doorway. Moments later he is hanged. When Perla (Maribel Hidalgo) is executed, her distraught mother is seen running through the church's doorway in order to seek counsel and, later on, Bomba passes though the cantina's doorway moments before he shoots Don Carlos in the back.

The Colonel passes through the gateway of the holding pen where the town's citizens are being held in order to select a prisoner for execution, and the prisoner is subsequently dragged over the gateway's threshold and killed. Later, more prisoners are dragged across the threshold of the holding pen's gateway for execution and the Colonel is seen emerging from the cantina's doorway in order to watch. When the prisoners revolt, they pour over the threshold of the holding pen's gateway and attack and kill their Federale oppressors. Soon after, the Colonel and the Priest are both seen to enter the church at the same time via two different doorways. The pair are reminded that there is no such thing as sanctuary when the town's insurgent populace flood over the church's threshold and kill the Colonel. Alvira and Spectre are both seen to enter the church through its main doorway and, after Alvira uses the same doorway to leave, Spectre shoots the Priest before also departing through the self same doorway.

Often, an indication of the Priest's outlook follows a threshold crossing. When Alvira and Spectre first pass through Bastard's gateway, the Priest is seen to emerge from the church's doorway in order to see who has arrived in town and he looks unusually pensive. The Priest emerges from the church's doorway when Calebra (Aldo Sambrell) is tormenting Jose and Perla's mother and he courageously strikes the bandit. At the height of the revolt, the Priest emerges from the church's doorway with a rifle but he does not fire it, seemingly confirming that he is an emasculated man who no longer believes in the revolution. Interestingly, when a revolutionary and a deserting Federale soldier both enter and leave the cantina via its doorway, and then enter the church together, their sense of insurgent union is at once made apparent and confirmed when they jointly shoot

some soldiers. After being shot by Spectre, the Priest is seen dragging himself over the church's threshold and uttering 'Aguila' to the soldier-deserter before dying. This act seemingly demonstrates that his belief in the revolution has been reinvigorated and he passes the spirit of 'Aguila' on to the next generation of insurgents.

The crossing of thresholds is also tied to the Colonel's power to command. Bomba is escorted through the cantina's doorway when the Colonel summons him and he is also seen being dragged across the threshold of holding pen's gateway on the Colonel's orders. Similarly, an old blind man and Alvira are both seen crossing the cantina's threshold when the Colonel demands audiences with them. In adopting an abstract reading of the film, in which Bastard might be regarded as purgatory, it is possible to suggest that Spectre (as the angel of death) and Alvira (as a vengeful spirit) have crossed the metaphysical threshold that separates the living from the dead in order to travel to the town. Returning to a more realist approach, it can be assumed that the pair have at least crossed the border that separates Mexico from the USA in order to reach Bastard and the same can be said of the two American prisoners. At the film's end Alvira and Spectre, along with the Priest's body, pass over the threshold of the town's gateway for the final time.

The gothic heroine out West

Punter and Byron observe that in female gothic texts, the heroine will ultimately find herself 'trapped and pursued' within a 'labyrinthine space' where threats 'to her virtue or to her life' will be made (2004: 279). Alvira does become trapped when Don Carlos' men close Bastard's gates and the town itself does represent a labyrinthine space. The angles that the town's main spaces are filmed from often result in a sense of spatial disorientation and the gothic ornamental archways and pillars that crowd the backgrounds of many shots make it impossible to determine what lies beyond them. The town's graveyard is featured on a number of occasions but it is unclear how the protagonists navigate their way from the church to the graveyard. Furthermore, Don Carlos threatens both Alvira's virtue and her life. When she first arrives in town, he instructs Bomba to 'take the senora to the hotel and see that we [reflective pause], see that she gets a nice clean

room'. Later, Don Carlos agrees with Bomba that it is time to 'kill the witch' and she and Spectre come under attack.

Intriguingly, while Spectre is commanding and dominant at the start of the film, and clearly able to talk, once he is inside Bastard's walls he becomes a brooding deaf mute while Alvira is seen to be a particularly active and commanding woman. Alvira is a strong character who is determined to avenge her husband's death, whatever the cost to others in terms of hurt and mishaps. However, while Alvira can deal with every unpleasant or violent eventuality that comes her way – she watches others die without flinching and stays cool while under attack, dodging bullets and instinctively dashing for suitable cover – she never actually physically initiates or responds to violence herself. The plain but smart appearance of Alvira's turn of the century mourning dress looks like something from a British gothic story but it also gives her the look of an educated and cultured lady from East Coast America. Calder describes this type of Western character as 'the decorative heroine, who is associated with civilisation, domesticity, the schoolhouse and the church' (1974: 170). Furthermore, the symbolic rules of the Western genre suggest that Alvira's blonde hair and fair complexion are signs that she is 'decent', 'respectable' and law-abiding (Calder, 1974: 171), much like the blonde and smartly dressed Ellen in *40 Guns to Apache Pass*.

However, Alvira transcends the prescriptions attached to this Western stereotype: she is an active and assertive character whose decisions and actions ultimately steer the direction of the film's narrative and result in patriarchal order being disturbed. Alvira impertinently questions a number of men of authority during her search for her husband's killer but she is not punished for her actions. The fact that the film's villains target Alvira for a sustained period does make her a Western variant of the British gothic movement's persecuted woman type. However, her ability to keep her nerve and avoid hysterical breakdowns and panics means that she is stronger and more focused than most gothic heroines. Douglas Kellner has observed that in American Westerns women are generally 'stereotyped as either whores or submissive representatives of the domestic order, thus reproducing patriarchal ideologies' (1998: 357). However, Alvira resists placement in either category of stereotype.

Although Alvira is exoticized to some extent by virtue of her being the only Anglo female in a town populated by Mexicans, she is rarely

objectified. Her period mourning dress means that her body and legs are never put on display and no attempts are made to turn her into an erotic spectacle. The fact that she is still mourning for her husband means that any form of classical Hollywood cinema-inspired romantic subplot is out of the question. Don Carlos may lust after her and be prepared to kill her for her gold but the film's narrative spares Alvira the trauma of rape and other scenarios involving extreme peril and/or misogyny. And although Spectre does provide her with protection, at no point does Alvira find herself in a situation where she needs to be actively rescued by a man. It might be that Alvira's Anglo status and apparent wealth grant her a sense of privilege in the town of Bastard. But the fact remains that she is generally treated as an equal by the film's male protagonists and is free to traverse any area of the town and engage with people at any level of its society.

Milbank notes that 'Gothic heroines always cause the downfall of the patriarchal figures or institutions that seek to entrap them' (2007: 155). Furthermore, Milbank asserts that the gothic heroine's 'resistance to patriarchal control' makes her 'a proto-feminist' (2007: 155). Both observations could be readily applied to Alvira. Perhaps most importantly, Alvira's resolve remains steadfast when she discovers the true circumstances of her husband's death. The Priest explains that killing 'Aguila' was very much an act of mercy but that makes no difference to Alvira. Stevens indicates that the gothic is governed by 'the emotional rather than the rational' (2000: 46) and so, although the Priest's explanation legitimizes his actions, Alvira still satisfies her desire to have her husband's killer executed by Spectre. Here the film presents an extreme variation of the configuration that Hutchings finds in *The Vampire Lovers*, wherein shots of a male character looking at a female character are followed by images of the male character in a state of powerlessness or inadequacy (1993: 163). The Priest pleads his case and throws himself at Alvira's mercy but his facial expression indicates that he knows that he cannot sway the vengeful widow.

Significantly, the film transcends the gender-related limitations of both the British gothic tradition and Hammer's early 1970s horror films whilst also breaking new ground for the Western genre. The gothic is able to treat its female characters as both heroines and monsters depending upon the nature of the narrative in which they appear (Punter and

219

Byron, 2004: 26). And Alvira could be considered to be both a hero-ine and a monster depending upon how *A Town Called Bastard* is read. While female gothic tales allow their heroines to enjoy fantastic adven-tures in which their experiences 'become the focus of attention', these stories favour a happy ending in which traditional gender boundaries are restored when the heroine 'is reintegrated into a community and acquires a new identity and a new life through marriage' (Punter and Byron, 2004: 279). Alternatively, where female monsters who enjoy narrative focus and agency are featured in the gothic, traditional gender bound-aries are necessarily restored by the death of the monster (Hutchings, 1993: 163). Both types of ending can be found in Hammer's horror films too. However, neither of these prescriptive endings, nor any of those traditionally associated with the Western genre, are employed in order to confine Alvira or to restore traditional gender boundaries in *A Town Called Bastard*. Alvira leaves as she came and suffers absolutely no pun-ishment for the challenge and defeat of patriarchal order that she has successfully completed.

The female characters who appear in Benmar's next three Western productions share Alvira's active and assertive nature, successfully taking on and defeating or embarrassing the representatives of patriarchal order without being punished. And Hutchings' configuration, wherein shots of male characters looking at a female character are followed by images of the male characters in a state of powerlessness or inadequacy (1993: 163), can be found in all of Benmar's Westerns. Featuring a main character (Richard Crenna) who is suffering from amnesia, Peter Collinson's *The Man Called Noon* (1973) is another gothic British Western that features strong women. In one notable scene it is revealed that the corpse laid out in an open coffin is still alive and at the film's end two female characters face each other in a gunfight. However, it was the British production company Tigon Films who took the character of the Western female vengeance-seeker and devel-oped it to its most logical limits with *Hannie Caulder*.

'A hard woman': *Hannie Caulder* (1971)

Regarded as competitors of Hammer Films, Tigon had been responsible for a number of British gothic-themed exploitation films, most notably Michael

Reeves' *Witchfinder General* (1968) and Piers Haggard's *The Blood on Satan's Claw* (1971). Tigon had also co-produced Michael Reeves' *The Sorcerers* (1967) with Curtwel Productions, the London-based production company set up by Patrick Curtis and his actress wife, Raquel Welch, and the two companies joined forces again to produce *Hannie Caulder* in 1971. In some ways, *Hannie Caulder's* thematic content is essentially exploitation film fare transposed to the Wild West. When they bungle a bank robbery, Emmett Clemens (Ernest Borgnine) and his brothers Frank (Jack Elam) and Rufus (Strother Martin) make good their escape from pursuing Mexican Federales. When they come across a remote stagecoach station, they kill the owner and gang rape his wife, Hannie Caulder (Raquel Welch), before leaving her for dead. But Hannie survives her ordeal and subsequently convinces a bounty hunter, Thomas Luther Price (Robert Culp), to teach her how to shoot. She then sets out to track down and kill the Clemens brothers.

Tigon commissioned the prolific American Western director Burt Kennedy to direct *Hannie Caulder*. Described as being 'one of the great Western directors' by the actor Ernest Borgnine (2008: 168), Kennedy's most popular and financially successful films were the American-made comedy Westerns *Support Your Local Sheriff!* (1969) and *Support Your Local Gunfighter* (1971) (Hunter, 2001: 16). However, Kennedy had also shot two Westerns in Europe – *The Return of the Seven* (1967) and *The Deserter* (1971) – that were serious takes on the genre. Both of these films focus primarily on male protagonists who are members of specialist, all-male fighting groups. Kennedy's American Westerns tended to follow the hard and fast, gender-related rules of the genre. As noted earlier, Molly in Kennedy's *Welcome to Hard Times* (1967) is punished by death when she tries to coerce various male characters into helping her kill the man who raped her. *Support Your Local Sheriff!* (1969) features an interesting female character in Prudy Perkins (Joan Hackett). She makes a fortune from an accidental oil strike, gets involved in a mass brawl and knows how to shoot a rifle. But she gives up her independence in an instant when she dutifully and unquestioningly accepts heroic Jason McCullough's (James Garner) assertion that she is his girl and, as such, will soon be living in Australia because that is where he is headed.

There are indications that Kennedy actually had a problem with the idea that a Western might feature an active and aggressive female protagonist

who is capable of taking on and defeating the representatives of patriarchal society without suffering punishment. Kennedy's rather sexist diary entry for the second of December 1970 reads: 'going to make [a] picture starring Raquel Welch. Raquel is playing [a] woman gunfighter in a serape. Sergio [Leone] would probably call it *A Titful of Dollars*' (1997: 45). Most of the actresses found in British Westerns are attractive women who naturally connote a sense of what Mulvey termed 'to-be-looked-at-ness' (1986: 203). However, Pam Cook notes that in *Hannie Caulder* Kennedy shows 'an obvious intention to titillate' male viewers (2005: 38). Lead actress Raquel Welch was regarded as a glamorous sex symbol and Kennedy duly exploits this in scenes where Hannie is dressed only in an ill-fitting blanket-cum-poncho or is seen trying on soaking-wet jeans. That said, Hannie does get to rebut the sexist comments that her body image provokes and the tenacious nature of her successful revenge mission does mark a huge step forward in terms of the Western genre's representation of strong female characters. Interestingly, further diary entries indicate that the producers' vision of the film differed to Kennedy's (1997: 46–47) and John Hamilton confirms this, adding that Kennedy 'had some reservations about [the film's] narrative' (2005: 197). Rather chauvinistically, Kennedy confessed: 'the main problem I had in *Hannie Caulder* was to try and make the woman utterly believable. I mean, can you imagine a woman taking up a gun [and going] after three men?' (quoted in Hamilton, 2005: 197). Clearly, what worked and was believable for Tigon, a British production company producing a British Western, did not work and was not believable for Kennedy, an American writer-director who 'specialised in westerns' and whose work 'encompassed every aspect of the genre' (Hunter, 2001: 16).

Public femininities and the influence of earlier British Westerns

There seems to be a very real sense of cultural and ideological distinction present in Kennedy's negative attitude towards *Hannie Caulder* and Hamilton confirms that while the film 'was reasonably well received' in the UK it received a 'poor reception in the US' (2005: 221). Despite being a British Western, *Hannie Caulder* has been the focus of a reasonable amount of critical writing. R. Philip Loy suggests that Welch's character

'offers viewers a different kind of heroine' (2004: 294) while Peter Lehman has identified the film as being the very first female-centred rape-revenge film (2007: 103). Jacinda Read adds that:

> the rise of second-wave feminism in the early 1970s, and the concomitant emergence of specifically *female*-centred [Read's emphasis] deployments of the rape-revenge structure, resulted in a movement of women from the margins of the western's symbolic world to its frontier. The western myth thus became one of the arenas in which the changing relationship between men and women could be articulated and made sense of, in which stories of the west could become stories of feminism and femininity.
>
> (2000: 125)

Clearly, to those who discuss the film without being familiar with the history and evolution of the British film industry's take on the Western genre, vengeance seeking, patriarchy-defying Hannie seemingly comes out of nowhere, guns a blazing. Conflating Loy's (2004), Lehman's (2007) and Read's (2000) assertions about *Hannie Caulder* results in one overriding meta-narrative: *Hannie Caulder* was an original and groundbreaking genre film that finally gave female characters an equal voice and allowed the genre to start articulating ideas about gender, feminism and femininity.

But this take on the film has only been accepted and perpetuated because the British Westerns that preceded *Hannie Caulder* have been ignored. The path that Hannie treads may have been unfamiliar territory for female characters from American Westerns. But it is a path that was well trodden by the strong female characters who had appeared in earlier British Westerns. Read observes that 'the trajectory of the female rape-revenge western is not towards masculinity (that is, sameness), but towards a renegotiation of difference as it is articulated around the [Western's] public [masculine]/private [feminine] opposition, towards, in other words, public femininities' (2000: 134). As such, Read suggests that *Hannie Caulder* is *the* Western film text that marks the starting point of a new evolutionary cycle within the genre, a cycle which is able to significantly transform the terms of the genre's engagement with gender politics. My contention is that, rather than being the start of this transformative

process, *Hannie Caulder* actually represents its final stage. Hannie did not simply ride into town from nowhere: she steadily and inevitably grew out of the progressive representations of strong and active women that were specifically and consistently found in earlier British Westerns.

The renegotiation of the gendered binary opposition associated with the Western genre's take on public (masculine) and private (feminine) spaces that Read alludes to has long been a consistent feature of British Westerns. In *Ramsbottom Rides Again* there is no part of the town or the surrounding countryside that is not open to Susie and she traverses these spaces, both public and private, with authority and confidence. The same is true of Alvira in *A Town Called Bastard*. Indeed, Alvira traverses public spaces that are loaded with extreme risk and danger in an assertive and unperturbed manner. Interestingly, the introduction of the UK's Sex Discrimination Act (1975) would lift restrictions that had prevented British women enjoying access to precisely the kinds of masculine public spaces that the heroines of British Westerns trespass upon. For example, the El Vino wine bar in London had routinely refused to serve women at its main bar and had insisted that female customers drank in a back room, where table service was provided, until angry female journalists initiated successful legal action following the Act's introduction (Sandbrook, 2012).

The idiosyncratic and typically un-generic characteristics that served to consistently differentiate the strong female characters found in British Westerns from the majority of their American counterparts all appear to coalesce in the character of Hannie Caulder. The withering quips that Hannie uses to emasculate a sexist sheriff (Sheriff: 'You're a hard woman, Hannie Caulder.' Hannie, looking at him scornfully: 'There aren't any hard women, only soft men.') can be traced back to the snappy dialogue that Bella uses to emasculate Ramsbottom in *Ramsbottom Rides Again* (Ramsbottom: 'I'm Bill Ramsbottom!' Bella, scornfully noting his short stature: 'What? All of you?'). And Hannie's ability to handle guns links her to a number of the female characters found in the British Western parodies. Furthermore, Hannie's ability to foster hate and to mount a revenge mission connects her to Annie Oakley from *Carry On Cowboy* and her determination to successfully complete the mission can be compared to Alvira's tenacious approach in *A Town Called Bastard*.

Further references to themes that were first established in the British Western parodies can also be found within *Hannie Caulder*. As in the earlier British Westerns, the representatives of law and order – in the form of the Federales who unsuccessfully try to capture the Clemens brothers and two cowardly sheriffs that Hannie encounters – are shown to be either unable or unwilling to do their jobs properly. The first sheriff has knowingly allowed a wanted man to live in his town for a month without confronting him and the second sheriff allows the wanted Clemens brothers to go about their nefarious business without trying to arrest them. When the dying Frank crashes into the street outside a brothel and lands on one of her girls, the brothel madam (Diana Dors) physically assaults and humiliates an observing male customer who tries to make light of the situation. In the course of doing so, she knocks a glass of beer (a signifier of masculinity) out of his hand but she suffers no punishment for her actions. The ineffectual nature of these male characters, along with Price's unexpected death, can also be linked to Peter Hutchings' observations concerning the scenarios found in contemporary Hammer films wherein male authority figures are rejected and the inadequacies of patriarchal order are foregrounded (1993: 159). Interestingly, when Hannie kills two of the Clemens brothers and is seen collecting the bounties on their heads, she is actually completing a job that Price had set out to do. As such, her actions actually chime with contemporaneous debates in Britain concerning the Equal Pay Act (1970) and equality in the workplace.

Finding the gothic in Hannie Caulder

The influence of the British gothic tradition can be detected in *Hannie Caulder* at a narrative level. As noted previously, Spooner and McEvoy assert that British gothic texts regularly feature 'dominant tropes such as imperiled heroines, dastardly villains, [and] ineffectual heroes' (2007: 1). Initially, at least, Hannie is the classic imperiled or persecuted woman of gothic literature. Punter and Byron indicate that the 'traditional Gothic apparatus' includes 'terrified heroines' who are threatened with 'murder and rape' (2004: 161). Hannie is not just threatened, she is raped by the film's dastardly villains who then leave her for dead. And the doomed bounty killer, Thomas Luther Price, is to all intents and purposes an ineffectual

hero. Clive Bloom's observations regarding the gothic's preoccupation with the crossing of thresholds and borders, and its liking for displaying characters walking through doorways (2007: 233–234) is of significance here too. Indeed, the film's end credits reuse individual shots of all five of the film's principal characters walking through doors.

Particularly important here is Punter and Byron's observation that, in Margaret Oliphant's gothic works, 'images of gates, windows and doors' embody 'the barriers between life and death' (2004: 153). The crossing of such thresholds is almost exclusively linked to death and destruction in *Hannie Caulder*. Having crossed the US–Mexico border, the three Clemens brothers are seen walking into a Mexican bank before slaughtering most of its occupants during their bungled robbery. They subsequently leave the bank via the same doorway and make good their escape. The trio cross back over the border and come across the Caulders' stagecoach station. After killing Jim Caulder, Rufus is seen crossing the threshold into the Caulders' kitchen where a point of view shot in the form of a snap zoom reveals that he has seen Hannie standing there petrified. Rufus skips back over the kitchen's threshold and excitedly calls to his brothers. All three of them are then seen entering the kitchen via its doorway and Hannie is subsequently raped. While the rape is taking place, the stagecoach station is presented onscreen via a held extreme long shot and Rufus is seen to be ejected out of one door, only to then re-enter the station via a second door. He is then ejected from the first door again and again. This continual and potentially endless loop of threshold crossing seemingly reflects the sustained and horrific nature of the assault being experienced by Hannie inside the station.

The next day, the trio are observed emerging from the station's doorway and Rufus sets fire to the building, leaving Hannie for dead. Hannie is subsequently seen emerging from the burning building through the same doorway. Naked except for the blanket that she has hastily wrapped around her body, this shot seemingly represents the birth of a new Hannie, rising out of the flames like a phoenix reborn. Indeed, when Hannie has a nightmare about her ordeal, a long shot of the burning stagecoach station is superimposed over shots of the rape. This dramatic use of a double exposure effect suggests that the fire imagery carries as much significance as the rape ordeal itself. After Hannie has met the bounty killer Price, the

pair arrive at a town and Price is seen emerging from the doorway of the sheriff's office, counting his blood money. Later, Hannie is seen entering the saloon before Price shoots and kills another wanted man. Price is subsequently seen carrying the dead man's body over the threshold of the sheriff's office. Hannie and Price then cross the border into Mexico before re-crossing the border in order to return to the USA.

In what is one of the film's most pivotal sequences, a quick succession of threshold crossings play out in just a matter of a few minutes, seemingly indicating that a death of some significance is about to occur. Price exits a hotel via its front door and sees Emmett and Rufus walking into a saloon via its front door. Frank is then seen walking out of a barber's shop's doorway and Price accosts him. However, Emmett and Rufus can be seen coming out of the saloon's doorway at the same time. Emmett throws his knife at Price before skipping back over the saloon's threshold in order to dodge the bullet that Price has fired at him. As the knife hits Price and fatally wounds him, Emmett rushes out of the saloon's doorway and runs off down the street. Hannie emerges from the hotel's front doorway and sees what has happened. Interestingly, when Price and Hannie first meet, their first meaningful exchange of words takes place with Hannie laid on the ground, shot from above in a submissive position while Price is shot from below, standing in a commanding position. Their respective positions are reversed when the pair say their final goodbyes: Price is laid dying in bed, shot from above, while Hannie leans over him, shot from below. Hannie's move to a physically dominant position within the film's *mise-en-scène* seemingly indicates that she is now ready to initiate her revenge on the Clemens brothers. Technically, Price does guide Hannie from beyond the grave as she consciously draws upon memories of his voice intoning the content of his gun fighting lessons whenever she faces a Clemens brother in combat.

In the film's next big action scene, another quick succession of shots showing thresholds being crossed is presented, again seemingly indicating the importance of what is about to unfold. Hannie is seen leaving the hotel via its main door before entering the saloon through its front door. She crosses the saloon floor (a traditionally male space) before climbing a flight of stairs into the saloon's brothel area. She then enters the room that Frank is in via its door and initiates a gunfight. She shoots Frank dead

while sustaining an arm injury herself. A similar scenario plays out when Hannie dispatches Rufus. Rufus spots Hannie in a clothes and perfume shop and he is seen entering the shop's front door before antagonising Hannie. Although he has her covered with a shotgun, she is able to shoot him with the pistol that she has secreted in her injured arm's sling. The final confrontation with Emmett Clemens takes place in the grounds of an abandoned prison after both parties are seen passing through the prison's front gates. Windows are of significance in this film too. Jim Caulder observes the Clemens brothers through a window before he approaches them and is killed while Rufus nonchalantly tosses a burning oil lamp through the stagecoach station's window in order to kill Hannie. And both Rufus and Frank smash through windows when Hannie shoots them.

More formal hints of the British gothic tradition can be found littered throughout the film. The Caulders' home becomes a burnt out ruin and graveyard imagery is evoked when Hannie buries her husband in a makeshift grave. The location where Hannie first meets Price features a ruined well and various ruined buildings. It is dark when Price approaches the ruins and his second horse clearly has a corpse wrapped in a sheet draped over it. More graveyard imagery is encountered during the lengthy sequence wherein Emmett and Rufus bury Frank and discuss their revenge tactics. These elements tie in with Botting's observation that ruins and graveyards are key gothic locations (1996: 2). At one point a gang of bandits attack the hacienda of an English gentleman-gunsmith (Christopher Lee), a scenario that can be linked to Botting's assertion that gothic landscapes are populated by bandits (1996: 1). Interestingly, at the time of the film's production, actor Christopher Lee was known primarily for his appearances in Hammer's gothic horror films.

Punter and Byron indicate that prisons are gothic sites, adding that their 'labyrinthine and claustrophobic spaces' function in the same way as those of 'castles, monasteries, [and] ruins' by acting to suggest 'such emotions as fear and helplessness' (2004: 179). The abandoned prison where the film's final confrontation takes place is a sprawling construction that features a disorientating network of external stairways and ramparts, and Emmett's face ultimately displays the emotions of fear and helplessness when he lies dying after the shootout with Hannie. It is at the prison that a mysterious Man in Black acts to help Hannie. Read asserts that the Man in

Black's lack of a name and silent demeanour must represent 'an oblique reference to the star persona of Clint Eastwood and to the spaghetti westerns of the period' (2000: 139). But there is a difference between the mute (the Man in Black) and the taciturn (Eastwood and his Man With No Name character). The Man in Black has more in common with Spectre from *A Town Called Bastard* (both dress in black and both are mute) and as such he might represent the angel of death incarnate.

The Man in Black first appears at the gentleman-gunsmith's hacienda just as the new gun barrel that has been especially constructed for Hannie's use has been successfully tested for strength. The test results in a blinding gunpowder flash and a plume of smoke that is similar to the stage and film effect that is often used to signal/cover the arrival or departure of a supernatural creature connected to the black arts: for a comparative example, see the departure of the satanic Goat of Mendes when it is confronted by the Duc de Richleau (Christopher Lee) and Rex Van Ryn (Leon Greene) in Hammer's *The Devil Rides Out* (Terence Fisher, 1968). As the smoke begins to clear, revealing that Hannie's gun will work and that she will indeed soon be equipped to kill, the three characters of Price (the professional killer), the gunsmith (the supplier of weapons that kill) and Hannie (the vengeance-seeker who wants to kill) become united in a triangle linked by death.

As the gunsmith looks up from the smoking barrel, a point of view shot shows the Man in Black arriving. The sequence suggests that he may be a Mephistopheles-like entity summoned from the great beyond in order to ensure, for the price of a life – or, perhaps more specifically, the aptly named Price's life – success for Hannie's mission. Later, he knowingly watches Hannie and Price ride past the abandoned prison as they journey to the town where Price will die and he is still lurking at the prison when Hannie and Emmett meet there for the film's final gunfight. His occupation of the prison's tower seemingly places him in an omniscient position, looking down on the mortal lives that play out below him. If the Man in Black is a mortal, he would appear to at least be blessed with the power of supernatural foresight. Furthermore, the character can be likened to another unexplained man dressed in black who is intermittently seen silently observing events throughout Hammer's *The Vampire Lovers*. Hutchings notes that this character's ultimate appearance at the end of *The Vampire Lovers* marks

him 'as a final, somewhat arbitrary guarantor of the male look – he seems to have some sort of power over Carmilla – which implicitly underlines its weakness elsewhere in the film' (1993: 164). The Man in Black in *Hannie Caulder* might well have been assigned a wholly similar function.

More gendered spaces

Read (2000) has attached some importance to the gendered nature of the sites where Hannie encounters each Clemens brother when seeking her revenge, and her observations warrant further discussion. Read argues that Hannie, despite her training and determination, only performs competently 'in the private feminine spaces (the prostitute's bedroom, the perfume shop) where she kills the first two rapists' (2000: 139). I would hesitate to class the prostitute's bedroom as being a private feminine space since any man who has the requisite amount of money can technically invade this space with ease. Doane has observed that in women's films 'the window has special import in terms of the social and symbolic positioning of the woman – the window is the interface between inside and outside' (1984: 72). In such films, as in traditional American Westerns, interior/domestic spaces are deemed to be feminine spaces while exterior/public spaces are deemed to be masculine spaces. When Hannie shoots Frank she sends his body crashing through the brothel's window, effectively expelling him and symbolically signalling that the female prostitute's bedroom is now (momentarily at least) the private feminine space that it should be. Hannie's will and show of force dictates that Frank should breathe his last in the public/masculine space of the street below the brothel.

Hannie first meets the Clemens brothers in another gendered space – her kitchen at the stagecoach station – and it is important to examine the events that play out in this location before discussing the scene in the perfume shop where Rufus meets his end. The events that unfold in this early section of the film possess two important functions. Firstly, they can be used as the 'before' in the necessary 'before and after' comparison exercise that charts Hannie's transformation from a housewife into a female avenger. Secondly, they offer a significant degree of insight into the character of Rufus, which has an impact on how later sections of the film that feature him are read. Before they enter the feminine space of

Hannie's kitchen an argument breaks out between the Clemens brothers. Emmett orders Rufus to 'go and find us something to eat' while Frank adds 'and cook it'. Rufus unsuccessfully tries to resist their orders by protesting 'That's woman's work ... God damned cook ... you're always cutting off my cojones [testicles].' Clearly, Rufus' awareness that his brothers are continually castrating him symbolically and his inability to stop them makes him a particularly emasculated figure. It is, then, somewhat appropriate that he is the first of the three to enter Hannie's kitchen and he does so with ease.

The references to cooking continue when Rufus sees Hannie and exclaims 'look what we got for supper'. The point of view shot that represents what Rufus sees serves to emphasize the domestic and thus feminine nature of Hannie's character at this point in the film: she is framed by the hanging pans and a ladle that occupy the wall behind her. Although this domestic space is essentially Hannie's domain, she is represented as being powerless despite her best efforts. Hannie struggles and smashes a bottle over Rufus' head but this has no discernable effect and he is able to easily subdue her, perhaps because he, as the trio's emasculated cook, is also operating within one of his own natural spaces of power. Indeed, when Rufus subdues Hannie, the point of view shot that represents what his arriving brothers see reveals that Rufus is now himself framed by the hanging pans and ladle.

Interestingly, Emmett and Frank only enter the kitchen after being invited to do so by Rufus. Furthermore, it is Rufus who is seen manhandling Hannie onto her bed and initiating the assault on her by ripping her clothes off. This again suggests that Rufus, as an emasculated man, is the best placed of the three to take initial control of the events that play out within the private feminine space of Hannie's bedroom. However, while the impression is given that Emmett and Frank spend all night raping Hannie, Rufus appears to rape her just the once: his subsequent repeated ejection from the stagecoach station suggests that he is lacking whatever 'manly' qualities are needed to be part of the sustained sexual assault that his brothers busy themselves with. At a later point in the film, Emmett and Frank question Rufus' masculinity and his ability to perform sexually by aggressively dismissing his boasts concerning other sexual adventures.

Rufus' emasculated state seemingly informs the location of his death, the second feminine space that Read (2000) refers to. This space is a woman's perfume and clothing shop where Hannie is seen sampling some scent. It is significant that Rufus is distractedly looking at the wares in the window of this shop (the medium shot employed here has him framed by a lady's hat and dress) when he spots Hannie at the counter and he subsequently enters the shop with ease. Interestingly, medium shots of Rufus inside the shop have him framed by more fancy dresses. When Hannie shoots Rufus, his body crashes into the shop's front window, again giving the impression that Hannie wants to physically expel him from a feminine space that has been invaded. However, Rufus' body does not pass completely through the window. While his head, his left arm and his right hand protrude into the street (the public/masculine space), his torso is caught in the window's display area while his legs remain in the shop (the interior/feminine space). It appears that some part of this emasculated character was completely at home in feminine spaces and so, despite Hannie's best efforts, his body cannot be fully expelled from the shop. It seems somehow appropriate and inevitable that Rufus should breathe his last cast adrift in an indeterminate and un-gendered no-man's land, his body draped over a window's sill which functions as the symbolic buffer where masculine and feminine spaces meet.

Read observes that 'in the public masculine space of the prison' Hannie 'needs male help' (2000: 139) in order to succeed in her mission. This may be because this section of the film closely aligns itself to the narrative demands of the British gothic tradition. Here, a sand storm results in the restricted sense of vision usually provided by extreme darkness or thick fog in gothic tales while an endless network of external staircases and ramparts stands in for the traditional gothic labyrinth. True to gothic generic form, with her vision obscured by the sand storm Hannie loses her way in the labyrinth and Emmett looks set to take advantage of the situation by throwing a knife into her back. However, the Western has its own generic demands, one of which is a final settling of accounts in the form of a duel that is undertaken fairly and so the mysterious Man in Black shoots Emmett's knife from his hand and oversees a fair gunfight that Hannie subsequently wins.

Read asserts that Hannie's revenge is 'compromised' because of her need for the Man in Black's assistance and because 'the three rapists are largely portrayed as inept buffoons' (2000: 139). In terms of the Man in Black's assistance, *Hannie Caulder* appears to simply be referencing the suspense-laden finales of Italian Westerns such as *For a Few Dollars More, The Big Gundown* and *A Professional Gun*, which feature climactic gun-fights that are supervised by similarly fair-minded third parties. In terms of her assessment of the Clemens brothers, Read (2000) is overly reductive. The trio are inept when it comes to robbing banks and stagecoaches. Indeed, the comedic tone that is attached to both their bungled attempts at robberies and their dastardly demeanours plays like a reference to the purposefully overplayed villains found in the British Western parodies. But the brothers are experts when it comes to killing, even managing to get the better of the professional bounty hunter Price. As such, Hannie's revenge mission is a resounding success that proves that she possesses the abilities needed to best dangerous men like the Clemens brothers.

Significantly, none of the brothers die from the effects of the first bullet that Hannie hits them with. In the cases of Frank and Emmett, they are stood facing Hannie for some time, shocked, unable to retaliate and fully aware of their predicament, before she hits them with follow-up shots. As such, Hutchings' configuration from *The Vampire Lovers*, wherein shots of a male character looking at a female character are followed by images of the male character in a state of powerlessness or inadequacy (1993: 163), is played out here in a very dramatic and torturous way. While *Hannie Caulder* would seem to bear the influence of *The Vampire Lovers* at a number of levels there is one crucial difference that must be noted. Hannie, like the other female characters in the British Westerns examined here, manages to transcend the prescriptive gendered denouements associated with both the British gothic tradition and the Western genre. She is neither tamed nor punished at the film's end. And whilst the chauvinistic reactions of the Clemens brothers and the second sheriff try to position Hannie as an unnatural feminine monster, it is clear to the viewer that she holds the moral high ground and is in fact a bona fide heroine. The film's final long shot may show Hannie riding away with the Man in Black but traditional gender boundaries have not been restored. It is clear that there is no romantic link between

the characters and Hannie's transformation into a woman who is able to successfully take on the representatives of patriarchal order and win is complete. Hannie Caulder, much like the other female characters that appear in the British Westerns that I have discussed, remains a remarkable representation of a strong woman out West.

Final Thoughts

While critics and canon creators chose to treat the European Western as the 'Other' to the Hollywood Western, the European Western in turn embraced and promoted the 'Other' (Native Americans, African Americans and strong females) in positive ways. Indeed, the comparative analyses employed in my study show that the inclusive and equality-driven representations of the 'Other' found in European Westerns prefigured the appearance of similarly progressive representations of the 'Other' in Hollywood Westerns. As such, my findings serve to problematize the received – US-centric and long unchallenged – evolutionary model of the Western genre.

Interestingly, when I recently reviewed much later examples of German, Italian and British Westerns I was gratified to note that each national cinema's engagement with the genre has continued to represent its respective 'Other' in noticeable and significant ways. Germany has continued to produce smaller scale but resolutely pro-Indian Karl May adaptations both as live action films – see Frank Zimmermann's *Winnetou und der Schatz der Maikopas* (*Winnetou and the Treasure of Maikopas*, 2006) – and feature length cartoons – see Gert Ludewig's *Winnetoons – Die Legende vom Schatz im Silbersee* (*Winnetoons – The Legend of the Treasure of Silver Lake*, 2009). Perhaps the most significant

German Western of recent times is Michael Herbig's *Manitou's Shoe* (*Der Schuh des Manitu*, 2001). A phenomenal success at the German box office, *Manitou's Shoe* 'lovingly parodies the key themes and generic symbolism associated with the' *Winnetou* films of the 1960s (Broughton, 2013: 91).

Italian Westerns have likewise continued to foreground black characters. *Django Strikes Again* (*Django 2: Il grande ritorno*, Nello Rossati, 1987) features a savage but active and powerful 'Black Venus' who indirectly assists the hero's (Franco Nero) cause when she turns against her villainous master (Christopher Connelly) in a fit of jealousy. Enzo G. Castellari's *Jonathan of the Bears* (*Jonathan degli orsi*, 1994) features a number of black townsfolk and a prominent black gunman, Williamson (Bobby Rhodes), who assists the film's hero (Franco Nero). Giovanni Veronesi's *My West* (*Il mio West*, 1998) also features a prominent black gunslinger, Rastafarian (Kwame Kwei-Armah). Furthermore, British Westerns have continued to foreground strong women and supernatural/uncanny elements. Edgar Wright's *A Fistful of Fingers* (1995) features a phantom cowboy (William Cornes) and an Indian with supernatural powers, while David Lister's *The Meeksville Ghost* (2001) features a phantom cowboy (Judge Reinhold) and a formidable female villain (Lesley-Anne Down) who bosses and abuses her henchmen. Paul Matthews' *Hooded Angels* (2002) details the adventures of a gang of Civil War-era females who, under the guidance of Widow (Amanda Donohoe), take revenge upon the Union troops who raped them before attacking patriarchal society by becoming ruthless bank robbers.

Equally interesting is the fact that Hollywood filmmakers have themselves returned to the theme of the 'Other' out West in a trio of recent releases. And each of these releases appears to be engaged in a dialogue with earlier European Westerns. Germany's Constantin Film were reported to be working with Michael Blake, the writer of *Dances With Wolves*, on a new *Winnetou* adaptation that was to be filmed in New Mexico (Meza, 2011). This project has yet to surface but the representation of white–Indian cooperation out West was brought back to the big screen via Gore Verbinski's *The Lone Ranger* (USA, 2013). Starring Armie Hammer as the eponymous Ranger and Johnny Depp as the Indian Tonto, Verbinski's film radically reworks the unbalanced interracial relationship dynamics that were associated with the old *Lone Ranger* stories.

In Chapter I of this book, I quoted Donald L. Kaufmann's observations regarding Tonto's traditional relationship with the Lone Ranger: 'whatever the Lone Ranger was, Tonto was less – less fast, less a sharpshooter, less domineering … when the Lone Ranger judged a situation, Tonto played out his role as monosyllabic yea man' (1980: 30). The quotation was employed comparatively in order to illustrate how progressive Winnetou's relationship with Old Shatterhand was in the West German Karl May adaptations of the 1960s. In Verbinski's film the Lone Ranger is a completely emasculated and ineffectual character until the final portion of the show. Tonto is by far the most active, decisive and determined half of the duo and it is Tonto who teaches and guides the Lone Ranger for much of the film's running time.

Furthermore, Tonto is revealed to be on a Spaghetti Western-like revenge mission (numerous references to Sergio Leone's films can be found throughout the film) against a white villain, and his mission is successful. Here, Tonto is acting in his own cause, not the cause of the white hero or the white community. This, and the film's central narrative themes that are concerned with the breaking of treaties, the illegal laying of railway tracks on Indian territory, the theft of Indian silver and the needless slaughter of Indian braves results in a pro-Indian ambience that begs comparison to the *Winnetou* films. In keeping with a number of the *Winnetou* films, Tonto is the first major character introduced to the audience at the start of *The Lone Ranger* and he is the last major character seen at the end of the film. Furthermore, Tonto (rather than a white surrogate character) is telling the film's story after-the-fact, which suggests that he is the character that the audience should be identifying with. Some have argued that Depp's Tonto is still a stereotypical representation of a Native American and that may be so. But, in terms of his relationship with the Lone Ranger and his active positioning with the film's narrative, Depp's Tonto surely represents a significant improvement in this particular Indian's lot.

Quentin Tarantino's *Django Unchained* (USA, 2012) openly takes its main inspiration from the Italian Western. Django (Franco Nero) was of course the eponymous anti-hero in Sergio Corbucci's infamous Spaghetti Western from 1966. Such was the popularity of Corbucci's *Django* that a lengthy cycle of Italian Westerns with the name 'Django' in their title appeared between 1966 and 1987. In most cases, the characters

237

called Django in these films were completely unrelated to the character originally played by Nero: these films simply sought to either cash-in on, or perpetuate the myth of the Django name. Perpetuating the myth of the Django name is surely what Tarantino had in mind when he devised his film. It should be noted that the director had previously starred in *Sukiyaki Western Django* (Takashi Miike, Japan, 2007), which was a more recent example of *Django*'s influence being acknowledged by a current filmmaker.

Of interest to this book is the fact that in Tarantino's film, Django (Jamie Foxx) is an active and empowered African American. A former slave who successfully executes a Spaghetti Western-like revenge mission, Django's activities recall the sense of ethnic-underclass insurgency that was generated in the Italian Westerns that were directed by Giuseppe Colizzi. Furthermore, *Django Unchained* abounds with references to Spaghetti Westerns: everything from re-appropriated music cues by Ennio Morricone to a guest appearance by Franco Nero. Finally, *Sweetwater* (AKA *Sweet Vengeance*, USA, 2013) directed by Logan and Noah Miller, offers an image of a strong, active and empowered woman out West. A fanatical religious leader and landowner, the Prophet Josiah (Jason Isaacs), secretly murders Sarah Ramirez's (January Jones) husband before imposing himself upon her sexually. When Sarah learns the truth about her husband's death she sets out on a successful revenge mission that turns into a killing spree. Skilled in the use of firearms, Sarah punishes every local man who ever wronged her before taking on Josiah and his underlings. *Sweetwater*'s female vengeance narrative brings to mind British Westerns such as *Hannie Caulder* and *A Town Called Bastard*, as does its at times decidedly gothic ambience. With his long black hair, dark clothing and dark demeanour, the psychopathic Josiah is presented just like a villainous character from a British gothic novel. Clearly, there is a renewed desire amongst Hollywood Western makers to produce genre films that offer interesting engagements with the 'Other'. But in order to fully understand the significance of these American films it is imperative that Westerns that were produced outside the USA are brought into our analytical frames of reference and allowed to take their rightful places within the Western's recognized evolutionary model.

Select Filmography

Part I

The Big Trail (Dir. Raoul Walsh, USA, 1930)
Broken Arrow (Dir. Delmer Daves, USA, 1950)
The half-breed / Winnetou und das Halbblut Apanatschi (Dir. Harald Philipp, West Germany, 1966)
Last of the Renegades / Winnetou – 2. Teil (Dir. Harald Reinl, West Germany, 1964)
The Treasure of Silver Lake / Der Schatz im Silbersee (Dir. Harald Reinl, West Germany, 1962)
Winnetou the Warrior / Winnetou – 1. Teil (Dir. Harald Reinl, West Germany, 1963)

Part II

Ace High / I quattro dell'Ave Maria (Dir. Giuseppe Colizzi, Italy, 1968)
Boot Hill / La collina degli stivali (Dir. Giuseppe Colizzi, Italy, 1969)
Duel at Diablo (Dir. Ralph Nelson, USA, 1966)
The Great Silence / Il grande silenzio (Dir. Sergio Corbucci, Italy, 1968)
Lola Colt (Dir. Siro Marcellini, Italy, 1967)

Part III

40 Guns to Apache Pass (Dir. William Witney, USA, 1967)
Hannie Caulder (Dir. Burt Kennedy, UK, 1971)
Ramsbottom Rides Again (Dir. John Baxter, UK, 1956)
A Town Called Bastard (Dir. Robert Parrish, UK, 1971)

Bibliography

Aleiss, A. 2005. *Making the White Man's Indian* (Westport, CT & London: Praeger).

Allum, P. 2000. 'Italian Society Transformed', in *Italy Since 1945*, ed. by P. McCarthy (Oxford: Oxford University Press), 10–41.

Austen, D. 1971. 'Continental Westerns', *Films and Filming*, 17: 10, 36–44.

Bakhtin, M. 1984a. *Rabelais and His World*, trans. by Helene Iswolsky (Bloomington: Indiana University Press).

_____ 1984b. *Problems of Dostoevsky's Poetics*, ed. and trans. by C. Emmerson (Manchester: Manchester University Press).

Barr, C. 1986. 'Broadcasting and Cinema 2: Screens Within Screens', in *All Our Yesterdays: 90 Years of British Cinema*, ed. by C. Barr (London: British Film Institute), 206–224.

Barrera, G. 2003. 'Mussolini's Colonial Race Laws and State–Settler Relations in Africa Orientale Italiana (1935–41)', *Journal of Modern Italian Studies*, 8: 3, 425–443.

Bean, R. 1965a. 'Sex, Guns and May', *Films and Filming*, March, 52–56.

_____ 1965b. 'Way out West in Yugoslavia', *Films and Filming*, September, 49–51.

Bell-Metereau, R. 1993. *Hollywood Androgyny, 2nd Edition* (New York: Columbia University Press).

Bennett, A. & N. Royle. 2004. *An Introduction to Literature, Criticism and Theory* (Philadelphia, PA: Trans-Atlantic Publications).

Benshoff, H. M. & S. Griffin. 2009. *America on Film: Representing Race, Class, Gender and Sexuality at the Movies, 2nd Edition* (Malden, MA: Wiley-Blackwell).

Bentley, N. 1977. *The History of the Circus* (London: Michael Joseph).

Bergfelder, T. 2005. *International Adventures: German Popular Cinema and European Co-Productions in the 1960s* (New York & Oxford: Berghahn Books).

Bloom, C. 2007. *Gothic Horror: A Guide for Students and Readers, 2nd Edition* (Basingstoke: Palgrave MacMillan).

Bogle, D. 2001. *Toms, Coon, Mulattoes, Mammies & Bucks: An Interpretive History of Blacks in American Films, 4th Edition* (London: Continuum).

Bondanella, P. 1983. *Italian Cinema: From Neorealism to the Present* (London: Continuum).

_____ 1992. *The Cinema of Federico Fellini* (Princeton, NJ: Princeton University Press).

Borgnine, E. 2008. *Ernie: The Autobiography* (New York: Citadel Press).

Botting, F. 1996. *The Gothic* (London: Routledge).

Bowser, P. & B. Cram. 1994. *Midnight Ramble* (USA: Northern Light Productions documentary).

British Film Institute. 2009. 'The Indian Chief and the Seidlitz Powder', *BFI*, http://ftvdb.bfi.org.uk/sift/title/65674?view=synopsis [Accessed 17 March 2009].

Broughton, L. 2011. 'Crossing Borders Virtual and Real: A Transnational Internet-based Community of Spaghetti Western Fans Finally Meet each other Face to Face on the Wild Plains of Almeria, Spain', *Language and Intercultural Communication*, 11: 4, 304–318.

———— 2013. 'Western', in *Directory of World Cinema: Germany 2*, ed. by M. Langford (Bristol: Intellect Books), 86–92.

———— 2014. 'Captain Swing the Fearless: A Turkish Film Adaptation of an Italian Western Comic Strip', in *Impure Cinema: Intermedial and Intercultural Approaches to Film*, ed. by L. Nagib & A. Jerslev (London: I.B.Tauris), 102–118.

Broyles-Gonzalez, Y. 1989. 'Cheyennes in the Black Forest: A Social Drama', in *The Americanization of the Global Village: Essays in Comparative Popular Culture*, ed. by R. Rollin (Bowling Green, OH: Bowling Green University Press), 70–86.

Brunetta, G. P. 2009. *The History of Italian Cinema*, trans. by J. Parzen (Oxford: Princeton University Press).

Buscombe, E. 2006. *'Injuns!' Native Americans in the Movies* (London: Reaktion Books).

———— & R. E. Pearson. 1998. 'Introduction', in *Back in the Saddle Again: New Essays on the Western*, ed. by E. Buscombe & R. E. Pearson (London: British Film Institute), 1–7.

Buss, R. 1989. *Italian Films* (London: Batsford).

Calder, J. 1974. *There Must Be a Lone Ranger* (London: Hamish Hamilton).

Calloway, C. G. 2002. 'Historical Encounters across Five Centuries', in *Germans & Indians: Fantasies, Encounters, Projections*, ed. by C. G. Calloway, G. Gemünden & S. Zantop (Lincoln: University of Nebraska Press), 47–81.

Canales, L. 1990. *Imperial Gina: The Strictly Unauthorized Biography of Gina Lollobrigida* (Boston. MA: Branden Publishing Company).

Carlson, M. 2002. 'Germans Playing Indian', in *Germans & Indians: Fantasies, Encounters, Projections*, ed. by C. G. Calloway, G. Gemünden & S. Zantop (Lincoln: University of Nebraska Press), 213–216.

Carr, W. R. 1970. 'Introduction' in *The Subjection of Women* by J. S. Mill (London: MIT Press), i–xxix.

Carraze, A. & J. L. Putheaud. 1997. *The Avengers Companion*, trans. by P. Buck (London: Titan).

Castor, H. 2010. *She-Wolves: The Women Who Ruled England Before Elizabeth* (London: Faber and Faber).

———— 2012. *She-Wolves: England's Early Queens* (UK: BBC TV documentary series).

Cawelti, J. G. 1999. *The Six-Gun Mystique Sequel* (Bowling Green, OH: Bowling Green State University Popular Press).

Chadwick, B. 2001. *The Reel Civil War: Mythmaking in American Film* (New York: Alfred A. Knopf).

Churchill, W. 2003. *Acts of Rebellion: The Ward Churchill Reader* (London: Routledge).

Cinerama Releasing Corporation. 1971. *Pressbook for Today We Kill ... Tomorrow We Die!* (Los Angeles: Cinerama Releasing Corporation).

Clapham, W. C. 1974. *Western Movies: The Story of the West on Screen* (London: Octopus Books).

Clery, E. J. 1995. *The Rise of Supernatural Fiction, 1762-1800* (Cambridge: Cambridge University Press).

Collingridge, V. 2006. *Boudica* (New York: Random House).

Conrad, R. 1989. 'Mutual Fascination: Indians in Dresden and Liepzig', in *Indians and Europe: An Interdisciplinary Collection of Essays*, ed. by C. F. Feest (Lincoln: University of Nebraska Press), 455–473.

Cook, P. 2005. *Screening the Past: Memory and Nostalgia in Cinema* (Abingdon: Routledge).

Cooke, P. 2006. 'The Continually Suffering Nation? Cinematic Representations of German Victimhood', in *Germans as Victims*, ed. by B. Niven (New York: Palgrave MacMillan), 76–92.

Cox, A. 2009. *10,000 Ways to Die: A Director's Take on the Spaghetti Western* (Harpenden: Kamera Books).

Coyne, M. 1997. *The Crowded Prairie: American National Identity in the Hollywood Western* (London: I.B.Tauris).

Cracroft, R. H. 1967. 'The American West of Karl May', *American Quarterly*, 19: 2, Part 1 (Summer), 249–258.

Cripps, T. 1993a. *Making Movies Black: The Hollywood Message Movie from World War II to the Civil Rights Era* (New York: Oxford University Press).

_____ 1993b. *Slow Fade to Black: The Negro in American Film, 1900-1942* (New York: Oxford University Press).

Croft-Cooke, R. & P. Cotes. 1976. *Circus: A World History* (London: Elek).

de Lauretis, T. 1984. *Alice Doesn't: Feminism, Semiotics, Cinema* (Bloomington: Indiana University Press).

Deloria, V. 1980. 'Foreword: American Fantasy', in *The Pretend Indians: Images of Native Americans in the Movies*, ed. by G. M. Bataille & C. L. P. Silet (Ames: Iowa State University Press), ix–xvi.

Dickie, J. 1996. 'Imagined Italies', in *Italian Cultural Studies*, ed. by D. Forgacs & R. Lumley (Oxford: Oxford University Press), 19–33.

Doane, M. A. 1984. 'The "Woman's Film": Possession and Address', in *Re-vision: Essays in Feminist Film Criticism*, ed. by M. A. Doane *et al.* (Los Angeles: The American Film Institute), 67–80.

Doherty, T. 2007. *Hollywood's Censor* (New York: Columbia University Press).

Donalson, M. 2003. *Black Directors in Hollywood* (Austin: University of Texas Press).

‗‗‗‗‗‗ 2006. *Masculinity in the Interracial Buddy Film* (Jefferson, NC: McFarland & Company).

Duncan, D. 2008. 'Italy's Postcolonial Cinema and its Histories of Representation', *Italian Studies*, 63: 2, 195–211.

Dunnage, J. 2002. *Twentieth Century Italy: A Social History* (Harlow: Pearson Education).

Durgnat, R. 1968. 'The Good, the Bad and the Ugly', *Films and Filming*, November, 48–49.

Dyer, R. 2002. *The Matter of Images: Essays on Representation, 2nd Edition* (London: Routledge).

Easthope, A. 1990. *What a Man's Gotta Do: The Masculine Myth in Popular Culture* (London: Routledge).

Ebert, R. 1969. 'Pontecorvo: We Trust the Face of Brando', *RogerEbert.Com*, http://rogerebert.suntimes.com/apps/pbcs.dll/article?AID=/19690413/PEOPLE/41008001 [Accessed 12 June 2012].

Ebony. 1967. 'Lola Falana: The World is Her Oyster', *Ebony*, 22: 9, July, 114–118.

Eisner, L. H. 1973. *The Haunted Screen*, trans. by R. Greaves (Berkeley: University of California Press).

Eleftheriotis, D. 2002. 'Genre Criticism and the Spaghetti Western', in his *Popular Cinemas of Europe: Studies of Texts, Contexts and Frameworks* (London: Continuum), 92–133.

Elliot, J. 1990. *Elliot's Guide to Films on Video* (London: Boxtree).

Ellis, J. 1992. *Visible Fictions, Revised Edition* (London: Routledge & Kegan Paul).

Elsaesser, T. 1989. *New German Cinema* (London: MacMillan).

Erickson, G. 2001. 'Vera Cruz', *DVD Savant*, 1 May, http://www.dvdtalk.com/dvdsavant/s241vera.html [Accessed 12 February 2010].

‗‗‗‗‗‗ 2006. 'The John Ford Collection', *DVD Savant*, 28 May, http://www.dvdtalk.com/dvdsavant/s2013ford.html [Accessed 22 February 2010].

‗‗‗‗‗‗ 2009. 'Inglourious Basterds', *DVD Savant*, 11 December,http://www.dvdtalk.com/dvdsavant/s3082bast.html [Accessed 8 December 2010].

Everson, W. K. 1969. *A Pictorial History of the Western Film* (New York: The Citadel Press).

Fay, J. 2008. *Theaters of Occupation: Hollywood and the Reeducation of Postwar Germany* (Minneapolis: University of Minnesota Press).

Fellini, F. 1976. *Fellini on Fellini*, ed. by A. Keel & C. Strich, trans. by I. Quigly (London: Eyre Methuen).

Fenin, G. N. & W. K. Everson. 1962. *The Western: From Silents to Cinerama* (New York: Orion Press).

243

Fisher, A. 2011. *Radical Frontiers in the Spaghetti Western: Politics, Violence and Popular Italian Cinema* (London: I.B.Tauris).

Foote, C. J. 1983. 'Changing Images of Women in The Western Film', *The Journal of the West*, 21, October, 64–71.

Forgacs, D. 1990. *Italian Culture in the Industrial Era, 1880–1980: Culture Industries, Politics and the Public* (Manchester: Manchester University Press).

Frayling, C. 1970. 'Sergio Leone', *Cinema* 6 & 7, August, 35–38.

_____ 1981. *Spaghetti Westerns: Cowboys and Europeans from Karl May to Sergio Leone* (London: Routledge & Kegan Paul).

French, P. 1973. *Westerns: Aspects of a Movie Genre* (London: Secker and Warburg).

_____ 2005. *Westerns: Aspects of a Movie Genre and Westerns Revisited* (Manchester: Carcanet).

Freud, S. 1955. 'The 'Uncanny', in *Standard Edition*, Vol. 17, trans. J. Strachey (London: Hogarth Press), 217–256.

Gabbard, K. 2004. *Black Magic: White Hollywood and African American Culture* (New Brunswick, NJ: Rutgers University Press).

Gallagher, T. 1995. 'Shoot-Out at the Genre Corral: Problems in the "Evolution" of the Western', in *Film Genre Reader II*, ed. by B. K. Grant (Austin: University of Texas Press), 246–260.

Garfield, B. 1982. *Western Films: A Complete Guide* (New York: Rawson Associates).

Gemünden, G. 2002. 'Between Karl May and Karl Marx: The DEFA Indianerfilme', in *Germans & Indians: Fantasies, Encounters, Projections*, ed. by C. G. Calloway, G. Gemünden & S. Zantop (Lincoln: University of Nebraska Press), 243–256.

Gorbman, C. 2001. 'Drums Along the L.A. River: Scoring the Indian' in *Westerns: Films Through History*, ed. by J. Walker (New York & London: Routledge), 177–195.

Gordon, B. 1999. *Hollywood Exile or How I Learned to Love the Blacklist* (Austin: University of Texas Press).

Gordon, M. 1983. *Lazzi: The Comic Routines of the Commedia dell'Arte* (New York: Performing Arts Journal Publications).

Graham, G. 2007. *The Re-enchantment of the World: Art versus Religion* (Oxford: Oxford University Press).

Grant, K. 2011. *Any Gun Can Play: The Essential Guide to Euro-Westerns* (Godalming: FAB Press).

Greb, J. K. 1998. 'Will the Real Indians Please Stand Up?', in *Back in the Saddle: Essays on Western Film and Television Actors*, ed. by Gary A. Yoggy (Jefferson, NC & London: McFarland & Company), 129–144.

Günsberg, M. 2005. *Italian Cinema: Gender and Genre* (Basingstoke: Palgrave, MacMillian).

Hake, S. 2008. *German National Cinema* (Abingdon: Routledge).

Hamilton, J. 2005. *Beasts in the Cellar: The Exploitation Film Career of Tony Tenser* (Godalming: FAB Press).

Hardy, P. 1991. *The Western* (London: Aurum Press).

Harper, S & V. Porter. 2007. *British Cinema of the 1950s: The Decline of Deference* (Oxford: Oxford University Press).

Hartnoll, G. 1971. 'A Town Called Bastard', *Monthly Film Bulletin*, 38: 449, June, 126.

Haskell, M. 1987. *From Reverence to Rape: The Treatment of Women in the Movies, 2nd Edition* (Chicago & London: University of Chicago Press).

Haslam, D. 2000. *Manchester, England: The Story of the Pop Cult City* (London: Fourth Estate).

Hay, J. 1987. *Popular Film Culture in Fascist Italy* (Bloomington & Indianapolis: Indiana University Press).

Hayward, S. 2000. *Cinema Studies: The Key Concepts, 2nd Edition* (London: Routledge).

Helmreich, A. 2003. 'Domesticating Britannia: Representations of the Nation in *Punch*: 1870–1880', in *Art, Nation and Gender: Ethnic Landscapes, Myths and Mother-Figures*, ed. by T. Cusack & S. Bhreathnach-Lynch (Aldershot: Ashgate), 15–28.

Helmreich, W. B. 1984. *The Things They Say Behind Your Back: Stereotypes and the Myths Behind Them* (New Brunswick, NJ: Transaction).

Herzberg, B. 2008. *Savages and Saints: The Changing Image of American Indians in Westerns* (Jefferson, NC: McFarland & Company).

Hilger, M. 1995. *From Savage to Nobleman: Images of Native Americans in Film* (Lanham, MD & London: The Scarecrow Press).

Hill, J. 1986. *Sex, Class and Realism* (London: British Film Institute).

Hippisley Coxe, A. 1980. *A Seat at the Circus* (London & Basingstoke: The MacMillan Press).

hooks, b. 1982. *Ain't I a Woman: Black Women and Feminism* (London: Pluto Press).

_____ 1992. *Black Looks: Race and Representation* (London: Turnaround).

Hughes, H. 2004. *Once Upon a Time in the Italian West: The Filmgoers' Guide to Spaghetti Westerns* (London: I.B.Tauris).

Hughes, H. 2008. *Stagecoach to Tombstone: The Filmgoers' Guide to the Great Westerns* (London: I.B.Tauris).

Hugill, B. 1980. *Bring on the Clowns* (London: David and Charles).

Hunt, L. 1998. *British Low Culture: From Safari Suits to Sexploitation* (London: Routledge).

Hunter, A. 2001. 'Burt Kennedy', *The Scotsman*, 13 March, 16.

Hutchings, P. 1993. *Hammer and Beyond: The British Horror Film* (Manchester: Manchester University Press).

Hutchinson, R. 2007. 'A Fistful of *Yojimbo*: Appropriation and Dialogue in Japanese Cinema', in *World Cinema's 'Dialogues' with Hollywood*, ed. by P. Cooke (Basingstoke: Palgrave MacMillan), 172–187.

Jane, I. 2004. 'Africa Blood and Guts', *AVManiacs.Com*, 28 July, http://www.avmaniacs.com/review.php?id=87 [Accessed 26 March 2010].

Janisse, K. 2007. *A Violent Professional: The Films of Luciano Rossi* (Godalming: FAB Press).

Jarvie, I. C. 1970. *Towards a Sociology of the Cinema* (London: Routledge & Kegan Paul).

Johnman, L. 2000. 'Playing the Role of a Cassandra: Sir Gerald Fitzmaurice, Senior Legal Advisor to the Foreign Office', in *Whitehall and the Suez Crisis*, ed. by S. Kelly & A. Gorst (London: Frank Cass), 46–63.

Kael, P. 1980. 'Americana: Tell Them Willie Boy Is Here', in *The Pretend Indians: Images of Native Americans in the Movies*, ed. by G. M. Bataille & C. L. P. Silet (Ames: Iowa State University Press), 163–165.

Kaes, A. 1989. *From Hitler to Heimat* (Cambridge, MA & London: Harvard University Press).

Kapczynski, J. M. 2010. 'Armchair Warriors: Heroic Postures in the West German War Film', in *Screening War: Perspectives on German Suffering*, ed. by P. Cooke & M. Silberman (New York: Camden House), 17–35.

Kaplan, E. A. 1983. 'Is the Gaze Male?', in *Desire: The Politics of Sexuality*, ed. by A. Snitow *et al.* (London: Virago Press), 321–338.

———— 1991. *Women and Film: Both Sides of the Camera* (London: Routledge).

Kaufmann, D. L. 1980. 'The Indian as Media Hand-me-down', in *The Pretend Indians: Images of Native Americans in the Movies*, ed. by G. M. Bataille & C. L. P. Silet (Ames: Iowa State University Press), 22–34.

Kellner, D. 1998. 'Hollywood Film and Society', in *The Oxford Guide to Film Studies*, ed. by J. Hill & P. Church Gibson (Oxford: Oxford University Press), 354–362.

Kennedy, B. 1997. *Hollywood Trail Boss: Behind the Scenes of the Wild, Wild Western* (New York: Boulevard Books).

Kezich, T. 2007. *Federico Fellini: His Life and Work*, trans. by Minna Proctor with Viviana Mazza (London: I.B.Tauris).

Kilpatrick, J. 1999. *Celluloid Indians: Native Americans and Film* (Lincoln & London: University of Nebraska Press).

Kimmelman, M. 2007. 'In Germany, Wild for Winnetou', *New York Times*, 12 September, http://www.nytimes.com/2007/09/12/arts/design/12karl.html?scp=1&sq=winnetou&st=cse [Accessed 12 June 2011].

Kinematograph Weekly. 1939. 'The Frozen Limits', 273: 1698, 2 November, 17.

King, A. 2003. 'Placing *Green is the Heath* (1951): Spatial Politics and Emergent West German Identity', in *Light Motives: German Popular Film in Perspective*, ed. by R. Halle & M. McCarthy (Detroit, MI: Wayne State University Press), 130–147.

Kitses, J. 1969. *Horizons West: Anthony Mann, Budd Boettcher, Sam Peckinpah: Studies of Authorship Within the Western* (London: Secker & Warburg).

Klein, T., I Ritzer & P. W. Schulze (eds). 2012. *Crossing Frontiers: Intercultural Perspectives on the Western* (Marburg: Schüren).

Knight, J. 2004. *New German Cinema: Images of a Generation* (London: Wallflower Press).

Koven, M. J. 2001. *Blaxploitation Films* (Harpenden: Pocket Essentials).

Landy, M. 2000. *Italian Film* (Cambridge: Cambridge University Press).

Lawrence, N. 2008. *Blaxploitation Films of the 1970s: Blackness and Genre* (New York: Routledge).

Leavitt, Charles L. (2013), 'Impegno nero: Italian Intellectuals and the African American Struggle', *California Italian Studies*, 4: 2, 1–23.

Lehman, P. 2007. *Running Scared: Masculinity and the Representation of the Male Body, New Edition* (Detroit, MI: Wayne State University Press).

Lenihan, J. H. 1985. *Showdown: Confronting Modern America in the Western Film* (Urbana & Chicago: University of Illinois Press, Illini Books Edition).

Levitin, J. 1982. 'The Western: Any Good Roles for Feminists?' *Film Reader* 5, 95–108.

Lischke, U. & D. T. McNab. 2005. '"Show Me the Money": Representations of Aboriginal People in East-German Indian Films', in *Walking a Tightrope: Aboriginal People and Their Representations*, ed. by U. Lischke & D. T. McNab (Waterloo, ON: Wilfred Laurier University Press), 283–303.

Loxton, H. & D. Jamieson. 1997. *The Golden Age of the Circus* (London: Grange Books).

Loy, R. P. 2001. *Westerns and American Culture, 1930–1955* (Jefferson, NC & London: McFarland & Company).

———— 2004. *Westerns in a Changing America, 1955–2000* (Jefferson, NC & London: McFarland & Company).

Lucas, T. 2006. 'A Fistful of Deutschmarks', *Sight & Sound*, January, 87.

Lumley, R. 1990. *States of Emergency: Cultures of Revolt in Italy from 1968 to 1978* (London: Verso).

Lutz, H. 2002. 'German Indianthusiasm: A Socially Constructed German National(ist) Myth', in *Germans & Indians: Fantasies, Encounters, Projections*, ed. by C. G. Calloway, G. Gemünden & S. Zantop (Lincoln: University of Nebraska Press), 167–184.

Maher, V. 1996. 'Immigration and Social Identities', in *Italian Cultural Studies*, ed. by D. Forgacs & R. Lumley (Oxford: Oxford University Press), 160–177.

Malloy, M. 1998. *Lee Van Cleef: A Biographical, Film and Television Reference* (Jefferson, NC: McFarland & Company).

Manchel, F. 1995. 'The Man who Made the Stars Shine Brighter: An Interview with Woody Strode', *The Black Scholar*, Spring, http://0-lion.chadwyck.co.uk. wam.leeds.ac.uk:80/searchFulltext.do?id=R01293466&divLevel=0&queryId=. /session/1271682141_11073&trailId=1277BAAC65D&area=abell&forward=c ritref_ft [Accessed 2 April 2010].

———— 1997. 'Losing and Finding John Ford's "Sergeant Rutledge" (1960)', *The Historical Journal of Film, Radio and Television*, 17: 2, 245–259.

Mann, K. 1940. 'Karl May: Hitler's Literary Mentor', *The Kenyon Review*, 2: 4, Autumn, 391–400.

Marubbio, M. E. 2006. *Killing the Indian Maiden: Images of Native American Women in Film* (Lexington: University of Kentucky Press).

McKechnie, K. 2007. *Alan Bennett* (Manchester: Manchester University Press).

McKernan, L. 1999. 'Cockney Cherokees on the Sky-Line', *Luke McKernan*, http://www.lukemckernan.com/cherokees.pdf [Accessed 25 March 2009].

McVeigh, S. 2007. *The American Western* (Edinburgh: Edinburgh University Press).

Medhurst, A. 1986. 'Music Hall and British Cinema', in *All Our Yesterdays: 90 Years of British Cinema* ed. by C. Barr (London: British Film Institute), 168–188.

Meza, E. 2011. 'Schwentke Eyes "Poison Kitchen"', *Variety*, 9 August, http://www.variety.com/article/VR1118041085?refcatid=19 [Accessed 12 September 2011].

Milbank, A. 2007. 'Gothic Feminities', in *The Routledge Companion to Gothic*, ed. by C. Spooner & E. McEvoy (London & New York: Routledge), 155–163.

Miller, C. J. & A. B. Van Riper. 2014. *International Westerns: Re-Locating the Frontier* (Plymouth: Scarecrow Press).

Mitchell, L. C. 1996. *Westerns: Making the Man in Fiction and Film* (Chicago: University of Chicago Press).

Moliterno, G. 2008. *The A to Z of Italian Cinema* (Plymouth: Scarecrow Press).

Monthly Film Bulletin. 1939. 'The Frozen Limits', *Monthly Film Bulletin*, 6: 71, November, 200.

_____ 1969. 'Mercenario, Il (A Professional Gun)', *Monthly Film Bulletin*, 36: 431, December, 269–270.

Montgomery, F. A. 2006. *Women's Rights: Struggles and Feminism in Britain c. 1770–1970* (Manchester: Manchester University Press).

Mulvey, L. 1986 [1975]. 'Visual Pleasure and Narrative Cinema', in *Narrative, Apparatus, Ideology: A Film Theory Reader*, ed. by P. Rosen (New York: Columbia University Press), 198–209.

Murphy, R. 1989. *Realism and Tinsel: Cinema and Society in Britain 1939–49* (London: Routledge).

Nagib, L. 2006. 'Towards a Positive Definition of World Cinema', in *Remapping World Cinema: Identity, Culture and Politics in Film*, ed. by S. Dennison & S. H. Lee (London: Wallflower Press), 30–37.

Newman, K. 1990. *Wild West Movies* (London: Bloomsbury).

Nolley, K. 2003. 'The Representation of Conquest: John Ford and the Hollywood Indian (1939–1964)', in *Hollywood's Indian: The Portrayal of the Native American in Film, Expanded Edition*, ed. by P. C. Rollins & J. E. O'Connor (Lexington: University Press of Kentucky), 73–90.

O'Healy, A. 2009. '[Non] e una somala': Deconstructing African Femininity in Italian Film', *The Italianist*, 29, 175–198.

Oram, A. 1996. '"Bombs don't Discriminate!" Women's Political Activism in the Second World War', in *Nationalising Femininity: Culture, Sexuality, and British Cinema in the Second World War*, ed. by C. Gledhill & G. Swanson (Manchester: Manchester University Press), 53–69.

Palfreyman, R. 2010. 'Links and Chains: Trauma Between the Generations in the Heimat Mode', in *Screening War: Perspectives on German Suffering*, ed. by P. Cooke & M. Silberman (New York: Camden House), 145–164.

Park, J. 1990. *British Cinema: The Lights that Failed* (London: B. T. Batsford).

Pearson, R. E. 2001. 'Indianism? Classical Hollywood's Representation of Native Americans', in *Classic Hollywood, Classic Whiteness*, ed. by D. Bernardi (Minneapolis: University of Minnesota Press), 245–262.

Peckham, M. 1985. 'Cultural Transcendence: The Task of the Romantics', in *English and German Romanticism: Cross-Currents and Controversies*, ed. by J. Pipkin (Heidelberg: Carl Winter), 35–57.

Peterson, J. 1996. 'The Competing Tunes of "Johnny Guitar": Liberalism, Sexuality, Masquerade', *Cinema Journal*, 35: 3, Spring, 3–18.

Pines, J. 1975. *Blacks in Films: A Survey of Racial Themes and Images in the American Film* (London: Studio Vista).

———— 1988. 'Blacks', in *The BFI Companion to the Western*, ed. by E. Buscombe (London: Andre Deutsch), 68–71.

Pirie, D. 1973. *A Heritage of Horror: The English Gothic Cinema 1946–1972* (London: Gordon Fraser).

Ponzanesi, S. 2005. 'Beyond the Black Venus: Colonial Sexual Politics and Contemporary Visual Practices', in *Italian Colonialism: Legacy and Memory*, ed. by J. Andall & D. Duncan (Bern: Peter Lang), 165–189.

Porter, V. 1999. 'Sergeant Rutledge', *Badazz MoFo*, 4, 25.

Pratt, M. L. 1992. *Imperial Eyes: Travel Writing and Transculturation* (London: Routledge).

Price, J. A. 1980. 'The Stereotyping of North American Indians in Motion Pictures', in *The Pretend Indians: Images of Native Americans in the Movies*, ed. by G. M. Bataille & C. L. P. Silet (Ames: Iowa State University Press), 73–91.

Punter, D. 2007. 'The Uncanny', in *The Routledge Companion to Gothic*, ed. by C. Spooner & E. McEvoy (London & New York: Routledge), 129–136.

———— & G. Byron. 2004. *The Gothic* (Oxford: Blackwell Publishing).

Rausch, A. J. 2009. 'Larry Spangler', in *Reflections on Blaxploitation*, ed. by D. Walker, A. J. Rausch & C. Watson (Plymouth: Scarecrow Press), 149–156.

Read, J. 2000. *The New Avengers: Feminism, Femininity and the Rape-revenge Cycle* (Manchester & New York: Manchester University Press).

Reid, J. H. 2006. *Great Hollywood Westerns: Classic Pictures, Must-See Movies & 'B' Films* (Morrisville, NC: Lulu Press).

Rentschler, E. 1996. *The Ministry of Illusion: Nazi Cinema and Its Afterlife* (London: Harvard University Press).

Richards, K. & L. Richards. 1990. *The Commedia dell'Arte* (Oxford: Basil Blackwell).

Rose, J. 2009. *Beyond Hammer: British Horror Cinema Since 1970* (Leighton Buzzard: Auteur).

Ross, R. 2000. *The Complete Sid James* (London: Reynolds & Hearn).

Royle, N. 2003. *The Uncanny* (Manchester: Manchester University Press).

Rudlin, J. 1994. *Commedia dell'Arte: An Actor's Handbook* (London: Routledge).

Ryall, T. 2001. *Britain and the American Cinema* (London: Sage Publications).

Sandbrook, D. 2012. *The 70s* (UK: BBC TV documentary series).

Sarf, W. M. 1983. *God Bless You, Buffalo Bill: A Layman's Guide to History and the Western Film* (London: Cornwall Books).

Schackel, S. 1987. 'Women in Western Films: The Civilizer, the Saloon Singer, and Their Modern Sister', in *Shooting Stars: The Heroes and Heroines of Western Film*, ed. by A. P. McDonald (Bloomington & Indianapolis: Indiana University Press), 196–217.

Schneider, T. 1998. 'Finding a New *Heimat* in the Wild West: Karl May and the German Western of the 1960s', in *Back in the Saddle Again: New Essays on the Western*, ed. by E. Buscombe & R. E. Pearson (London: British Film Institute), 141–159.

Shohat, E. & R. Stam. 1994. *Unthinking Eurocentrism: Multiculturalism and the Media* (London & New York: Routledge).

Sieg, K. 2002. *Ethnic Drag: Performing Race, Nation, Sexuality in West Germany* (Ann Arbor: The University of Michigan Press).

Simmon, S. 2003. *The Invention of the Western Film* (Cambridge: Cambridge University Press).

Simpson, P. 2006. *The Rough Guide to Westerns* (London: Rough Guides).

Sims, Y. D. 2006. *Women of Blaxploitation: How the Black Action Film Heroine Changed American Popular Culture* (Jefferson, NC & London: McFarland & Company).

Slotkin, R. 1998. *Gunfighter Nation: The Myth of the Frontier in Twentieth-Century America, Oklahoma Paperbacks Edition* (Norman: University of Oklahoma Press).

Smith, H. N. 1950. *Virgin Land: The American West as Symbol and Myth* (New York: Vintage Books).

Smith, P. 1993. *Clint Eastwood: A Cultural Production* (London: UCL Press).

Sontag, S. 1980. *Under the Sign of Saturn* (New York: Farrar, Straus & Giroux).

Spooner, C. & E. McEvoy. 2007. 'Introduction', in *The Routledge Companion to Gothic*, ed. by C. Spooner & E. McEvoy (London & New York: Routledge), 1–3.

Staig, L. & T. Williams. 1975. *Italian Western: The Opera of Violence* (London: Lorrimer).

Stevens, D. 2000. *The Gothic Tradition* (Cambridge: Cambridge University Press).

Stiglegger, M. 2012. '"It's the Singer, not the Song": Notes on British Westerns (1960–1975)', in *Crossing Frontiers: Intercultural Perspectives on the Western*, ed. by T. Klein, I. Ritzer & P. W. Schulze (Marburg: Schüren), 77–86.

Strathausen, C. 2001. 'The Image as Abyss: The Mountain Film and the Cinematic Sublime', in *Peripheral Visions: The Hidden Stages of Weimar Cinema*, ed. by K. S. Calhoon (Detroit, MI: Wayne State University Press), 171–190.

Bibliography

Strode, W. & S. Young. 1990. *Goal Dust: The Warm and Candid Memoirs of a Pioneer Black Athlete and Actor* (Lanham, MD: Madison).

Sutton, D. R. 2000. *A Chorus of Raspberries: British Film Comedy 1929-1939* (Exeter: University of Exeter Press).

Terrace, V. 2002. *Crime Fighting Heroes of Television* (Jefferson, NC: McFarland & Company).

Tompkins, J. 1992. *West of Everything: The Inner Life of Westerns* (New York & Oxford: Oxford University Press).

Tuska, J. 1985. *The American West in Film: Critical Approaches to the Western* (Westport, CT: Greenwood Press).

Verhoeff, N. 2006. *The West in Early Cinema: After the Beginning* (Amsterdam: Amsterdam University Press).

von Moltke, J. 2002. 'Evergreens: The *Heimat* Genre', in *The German Cinema Book*, ed. by T. Bergfelder, E. Carter & D. Gokturk (London: British Film Institute), 18-28.

Wagstaff, C. 1992. 'A Forkful of Westerns: Industry, Audiences and the Italian Western', in *Popular European Cinema*, ed. by R. Dyer & G. Vincendeau (London: Routledge), 245-261.

Walker, D. 1999. 'Black Westerns', *Badazz Mofo*, 4, 17-19.

Wallington, M. 1970. 'The Italian Western: A Concordance', *Cinema* 6 & 7, August, 32-34.

Ward, P. 2004. *Britishness Since 1870* (London: Routledge).

Watts, J. 1999. 'Sacred and Profane: Mae West's (re)Presentation of Western Religion', in *Over the Edge: Remapping the American West*, ed. by V. J. Matsumoto & B. Allmendinger (Los Angeles: University of California Press), 50-64.

Weisser, T. 1992. *Spaghetti Westerns - the Good, the Bad and the Violent* (Jefferson, NC: McFarland & Company).

Williams, B. 2005. *Women Win the Vote, 6 February 1918* (London: Cherrytree).

Wood, L. 1947. *The Miracle of the Movies* (London: Burke Publishing).

Woods, F. 1959. 'Hot Guns and Cold Women', *Films and Filming*, March, 11-30.

Wright, W. 1975. *Sixguns & Society: A Structural Study of the Western* (Berkeley & Los Angeles: University of California Press).

Zaleski, C. 2008. 'Purgatory', *Encyclopaedia Britannica Online*, http://www.britannica.com/EBchecked/topic/483923/purgatory [Accessed 18 December 2008].

Zanola, R. 2010. 'Major Influences on Circus Attendance', *Empirical Economics*, 38: 1, 159-170.

Zantop, S. 2002. 'Close Encounters: Deutsche and Indianer', in *Germans & Indians: Fantasies, Encounters, Projections*, ed. by C. G. Calloway, G. Gemünden & S. Zantop (Lincoln: University of Nebraska Press), 3-14.

Index

Index

Index

Index

Index

Index

Index

Index

Index

Cinema and Society series
General Editor: Jeffrey Richards